# Classic Chic

CALIFORNIA STUDIES IN 20TH-CENTURY MUSIC

*Richard Taruskin, General Editor*

1. *Revealing Masks: Exotic Influences and Ritualized Performance in Modernist Music Theater,* by W. Anthony Sheppard

2. *Russian Opera and the Symbolist Movement,* by Simon Morrison

3. *German Modernism: Music and the Arts,* by Walter Frisch

4. *New Music, New Allies: American Experimental Music in West Germany from the Zero Hour to Reunification,* by Amy Beal

5. *Bartók, Hungary, and the Renewal of Tradition: Case Studies in the Intersection of Modernity and Nationality,* by David E. Schneider

6. *Classic Chic: Music, Fashion, and Modernism,* by Mary E. Davis

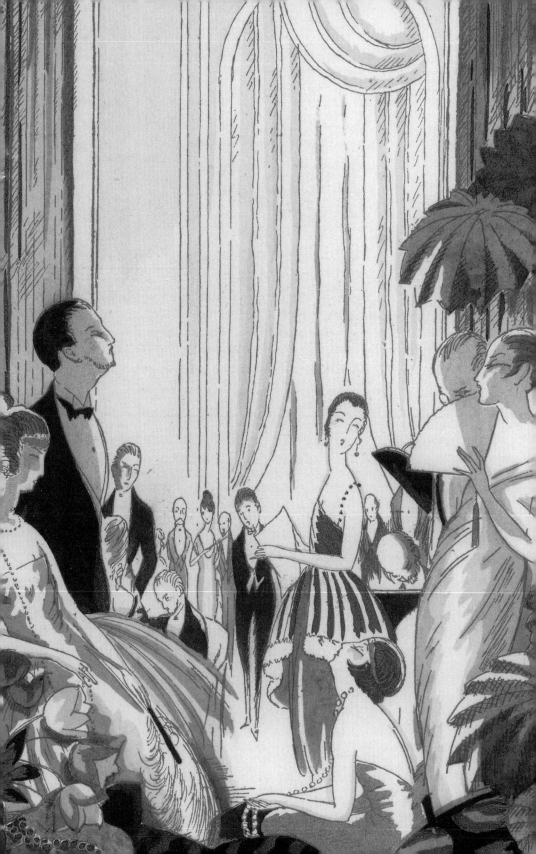

# Classic Chic

## MUSIC, FASHION, AND MODERNISM

Mary E. Davis

UNIVERSITY OF CALIFORNIA PRESS

BERKELEY    LOS ANGELES    LONDON

The publisher gratefully acknowledges the generous
contribution to this book provided by the Ahmanson
Foundation Humanities Endowment Fund of the
University of California Press Foundation.

University of California Press, one of the most distinguished university
presses in the United States, enriches lives around the world by
advancing scholarship in the humanities, social sciences, and natural
sciences. Its activities are supported by the UC Press Foundation and by
philanthropic contributions from individuals and institutions. For more
information, visit www.ucpress.edu.

University of California Press
Berkeley and Los Angeles, California

University of California Press, Ltd.
London, England

© 2006 by The Regents of the University of California

Library of Congress Cataloging-in-Publication Data

Davis, Mary E., 1959–.
Classic chic : music, fashion, and modernism /
Mary E. Davis.
p.     cm.
Includes bibliographical references and index.
ISBN-13: 978-0-520-24542-6 (cloth : alk. paper)
ISBN-10: 0-520-24542-3 (cloth : alk. paper)
1. Musicians—Clothing—20th century.   2. Fashion—History—20th
century.   3. Popular culture.   4. Popular music—History and
criticism.   I. Title.   II. Series.
ML3470.D37   2006
700.9′041—dc22                                              2005035586

Manufactured in the United States of America

15  14  13  12  11  10  09  08  07  06
10  9  8  7  6  5  4  3  2  1

For Richard Gordon

# Contents

*List of Illustrations*    xi

*Acknowledgments*    xvii

### 1
MAGAZINES, MUSIC, AND MODERNISM    1

### 2
PAUL POIRET    22

### 3
*LA GAZETTE DU BON TON*    48

### 4
GERMAINE BONGARD    93

### 5
*VANITY FAIR*    117

### 6
COCO CHANEL    153

7

*VOGUE*   202

*Notes*   255
*Works Cited*   287
*Illustration Credits*   301
*Index*   309

# List of Illustrations

FIGURES

1. Eduardo Benito, "Palmyre danse la Sévillane," from *Vogue* (Paris), 1923   2

2. Concert-room evening dress, from *La Belle Assemblée*, November 1809   7

3. Women at the piano, from *La Mode Illustrée*, January 1859   12

4a. Photo of Natalia Trouhanova, from *Comoedia Illustré*, program for the Ballets Russes season of 1911   18

4b. Portrait of Natalia Trouhanova on the cover of *Le Courrier Musical*, July 1913   19

5. Fashion reportage in *Le Courrier Musical*, June 1922   20

6. Paul Poiret   25

7. Paul Poiret, white satin dress with a black mousseline tunic, from *Vogue* (New York), 1912   27

8. Horace Vernet, "Merveilleuse," 1812   28

9. Paul Poiret, "Joséphine," costume by Paul Poiret, 1908   29

10. Article on Poiret in *Vogue* (New York), 1913   30

11. Models in sultana skirts, designed by Paul Poiret, from *L'Illustration*, 1911   33

12. Aladin perfume, from *Les Parfums de Rosine*   36

13. Bernard Naudin, program for a concert of chamber music hosted by Poiret, 1911   40

14. Le Butard   41

15. Bernard Naudin, illustration from a program of chamber music hosted by Poiret, 1911   41

16. Guy-Pierre Fauconnet, program for Les Festes de Bacchus, 1912   43

17. Paul Iribe, *Les Robes de Paul Poiret*, plate 1, 1908   45

18. Georges Lepape, *Les Choses de Paul Poiret*, plate 2, 1911   46

19. Lucien Vogel with Countess Karolyi, 1932   50

20. Georges Lepape, "Serais-je en avance?" from *Gazette du Bon Ton*, 1912   55

21. Georges Lepape, "Lassitude," from *Gazette du Bon Ton*, 1912   56

22. Georges Lepape, "Dancing," from *Gazette du Bon Ton*, 1920   58

23. Thayaht, "De la fumée," from *Gazette du Bon Ton*, 1922   59

24. Charles Martin, cartoon from *Le Sourire*, 1911   60

25. Charles Martin, "De la pomme aux lèvres," from *Gazette du Bon Ton*, 1913   61

26. Léon Bakst, "Philomèle," from *Gazette du Bon Ton*, 1913   62

27. Susanne Valadon, portrait of Erik Satie, ca. 1893   64

28. Erik Satie, "Le Yachting," 1914, from *Sports et divertissements*   66

29. Charles Martin, design for "Le Yachting," from *Sports et divertissments*   66

30. Charles Martin, illustration for "Le Yachting," 1922, from *Sports et divertissements*   67

31. Table of Contents, *Femina*, Spring 1913   68

32. Table of Contents from *Sports et divertissements*   69

33. Article on "Yachting," from *Femina*, 1913   70

34. Charles Martin, "Pauvre bougre!" from *Sous les pots de fleurs*, 1917   72

35. Charles Martin, "Le Carnaval," 1914, from *Sports et divertissements*   72

36. Edward Steichen, "Pompon," costume by Paul Poiret, from *Art et Décoration*, 1911   73

37. Charles Martin, "Le Feux d'artifice," 1914, from *Sports et divertissements*   74

38. Edward Steichen, "Battick," evening coat by Paul Poiret, from *Art et Décoration*, 1911    76

39. Erik Satie, "Le Golf," 1914, score from *Sports et divertissements*    76

40. Charles Martin, "Le Golf," 1914, illustration from *Sports et divertissements*    77

41. Charles Martin, "Le Golf," 1922, illustration from *Sports et divertissements*    78

42. Erik Satie, "Le Bain de mer," 1914, score from *Sports et divertissements*    79

43. Charles Martin, "Le Bain de mer," 1914, illustration from *Sports et divertissements*    80

44. Charles Martin, "Le Bain de mer," 1922, illustration from *Sports et divertissements*    81

45a. Charles Martin, "Le Water-chute," 1922, illustration from *Sports et divertissements*    82

45b. Erik Satie, "Le Water-chute," 1914, from *Sports et divertissements*    83

46. "Beau Brummels of the Brush," from *Vogue*, 1914, reproducing Charles Martin's illustration for "Le Tango (perpétual)" from *Sports et divertissements*    85

47. Georges Bizet, title page from *Jeux d'enfants*, 1871    88

48. Adolphe de Meyer, photograph of Count Etienne de Beaumont    95

49. Henri Manuel, photograph of Germaine Bongard, 1923    98

50. Profile of Germaine Bongard's fashion salon in *Vogue* (New York), 1912    99

51. Jacques-Emile Blanche, *Portrait of Les Six*, 1922    100

52. Amédée Ozenfant, "The Necklace of Victory," from *L'Elan*, 1915    103

53. Chazalviel, "No Wagner on the Horizon?" from *L'Elan*, 1915    105

54. Olga Koklova, Pablo Picasso, and Jean Cocteau in Rome, 1917    120

55. Pablo Picasso, curtain for *Parade*, 1917    121

56. Mary Pickford in 1921    122

57. Lydia Sokolova as the "Little American Girl" in *Parade*    123

58. Gino Severini, *The Bear Dance at the Moulin Rouge*, 1917    124

59. Manzano and La Mora on the cover of Salabert's edition of the "celebrated American song," "Mystérious Rag," by Irving Berlin and Ted Snyder, 1913    126

60. Carrie Lilie in a cameo photograph on the cover of "That Mysterious Rag," by Irving Berlin and Ted Snyder, 1911    127

61. Exhibit of French fashion at the Industrial Arts Palace at the Panama Pacific International Exposition, featuring gowns by Madame Valerio and a setting modeled after the gardens of Versailles    136

62. Georges Lepape, cover for the special French and English edition of the *Gazette du Bon Ton* commemorating the fashion displays at the Panama Pacific International Exposition, 1915    137

63. Advertisement for the *Gazette du Bon Genre*, from *Vanity Fair*, 1921    138

64. "What You Shall Wear for the Tango-Teas," *Vanity Fair*, 1913    140

65. Les Six at the Eiffel Tower, from *Vanity Fair*, 1921    148

66. Marie Laurencin, *Portrait of Jean Cocteau*, 1921; reproduced in *Vanity Fair*, 1922    151

67. Marie Laurencin, *Portrait of Mademoiselle Chanel*, 1923    155

68. Chanel and her aunt, Adrienne, in front of the Deauville boutique, 1913    159

69. Sem, caricature of Chanel and Boy Capel, 1914    159

70. Illustration for "Chanel's Charming Chemises," from *Harper's Bazaar*, 1916    162

71. Sem, advertisment for Chanel No. 5, 1921    164

72. Gabrielle Chanel, the "Ford signed Chanel," from *Vogue* (New York), 1926    165

73. Illustrations from "Before and After Taking Paris," from *Vogue* (New York), 1924    166

74. Article on Paul Thévenas, with portrait of Igor Stravinsky, from *Vanity Fair*, 1916    173

75. André Marty, "The Opera Ball," from *Vogue* (New York), 1921    176

76. "Colombine à travers les âges," from *Vogue* (Paris), 1922    177

77. Profile of Igor Stravinsky, from *Musical America*, 1921    182

78. Jean Cocteau, "Stravinsky at Chanel's House," 1930    195

79. Vladimir Rehbinder, photograph of Genica Atanasiou in *Antigone,* costumed by Chanel, from *Vanity Fair,* 1923    196

80. Lydia Sokolova and Anton Dolin in *Le Train bleu,* costumed by Chanel, 1924    198

81. Pablo Picasso, *Deux femmes courant sur la plage,* 1922    199

82. "The Maecenas of Paris Entertains," from *Vogue* (New York), 1924    204

83. John Quinn, photograph of Jeanne Robert Foster on the golf course at St. Cloud with Erik Satie, Henri-Pierre Roché, and Constantin Brancusi, 1923    215

84. Léon Bakst, poster of Caryathis as "La Belle Excentrique," 1920    217

85. André Marty, "A L'Oasis," from *Modes et manières d'aujourd'hui,* 1919    219

86. Illustration of "Le Boeuf sur le toit," featuring Vance Lowry, from *Vogue* (Paris), 1923    222

87. Vladimir Rehbinder, photograph of Cécile Sorel costumed by Callot Soeurs for the "Sunset" Ball, from *Vogue* (Paris), 1921    225

88. Photograph of Edith de Beaumont, from *Vogue* (Paris), 1921    227

89. Vladimir Rehbinder, photograph of Princess Soutzo costumed by Chéruit as a Christmas tree for the Beaumont Bal des Jeux, from *Vogue* (Paris), 1922    228

90. Vladimir Rehbinder, photograph of Valentine Hugo costumed as a merry-go-round for the Beaumont Bal des Jeux, from *Vogue* (Paris), 1922    229

91. Dorys, photograph of the "Alsatian Entrée," from *Vogue* (Paris), 1923    231

92. Vladimir Rehbinder, photograph of the Marquise de Polignac costumed for the Beaumont Bal Louis XIV, from *Vogue* (Paris), 1923    234

93. Photographs from the 1922 Ballets Russes productions, from *Vogue* (New York), 1922    236

94. Photographs from the 1922 Ballets Russes productions, from *Vogue* (Paris), 1922    237

95. "Stravinsky's *Le Noces* Registers as a Terrific Success," from *Vogue* (Paris), 1923    253

## MUSICAL EXAMPLES

1a. Bizet, "L'Escarpolette"  89

1b. Satie, "La Balançoire"  89

2a. Bizet, "Quatre coins"  90

2b. Satie, "Les quatre coins"  90

3a. Stravinsky, Waltz from "Three Easy Pieces"  189

3b. Satie, "Sa taille"  189

LIST OF ILLUSTRATIONS

# Acknowledgments

This book was inspired by my mother, Dorothy Davis, who loved music, fashion, and all life's pleasures. As a scholarly project, it began to take shape when I was a graduate student at Harvard University writing a dissertation on Erik Satie, which to my surprise revealed meaningful connections between composition and haute couture in the early twentieth century. As I have explored these intersections over the past decade, I have had the support of many individuals and a number of institutions, and I am delighted to acknowledge them here.

My friends and colleagues have lent remarkable support, encouragement, and expertise to this endeavor. Georgia Cowart has been a careful and enthusiastic reader of my work for many years, and her knowledge of music and culture in *ancien régime* France proved especially helpful as I pursued this study. Christine Cano, John Kmetz, Jann Pasler, Andrew Shenton, and Steven Whiting all read sections of the manuscript and offered valuable comments; I am grateful for their suggestions and advice. I wish also to thank Reinhold Brinkmann, who helped me develop these ideas as my thesis advisor at Harvard, and Ornella Volta, President of the Fondation Satie in Paris, who nurtured my initial interest Satie's connections to the Parisian elite.

Colleagues at UCLA, The Ohio State University, and Boston University generously invited me to speak at their institutions, and I am grateful to students and faculty at those schools for their valuable feedback and encouragement. I am also indebted to staff at the Cleveland Museum of Art, for their guidance on art historical issues and for inviting me to present a lecture-recital based on my research. Staff at the Rock and Roll Hall of Fame and Museum also contributed ideas to the study; I am grateful in particular to Terry Stewart for his support. At Case, students in my graduate

seminar on music and fashion in 2004 stimulated my thinking as this manuscript neared completion. Several excellent research assistants also participated in this project while pursuing graduate studies at Case; I am grateful to Francy Acosta, Adam Booth, Paul Cox, Sarah Tomasewski, and Matthew Weldon for their careful assistance. I wish also to thank Bill Milhoan and Josh Senick, who provided expert technical support.

My initial research was generously supported by Harvard University, which provided me with an Eliot Fellowship and numerous Paine Traveling Fellowships, and by the American Musicological Society, which recognized my project with an AMS 50 Fellowship. At Case Western Reserve University I benefited from an appointment to the inaugural Robson Junior Professorship and have had the support of several W. P. Jones Presidential Fellowships as well as a Glennan Teaching Fellowship. In addition, a publication subvention from the American Musicological Society provided funding for many of the images included in the book.

This project has taken me to many archives and libraries where staff members have offered guidance and assistance that proved invaluable. In Paris, I wish especially to thank the staff of the Bibliothèque Nationale de France, and particularly Catherine Massip and the personnel at the Département de la Musique; also those at the Bibliothèque de l'Arsenal, the Bibliothèque Doucet, the Musée de la Mode de la Ville de Paris, the Musée de la Mode et du Textile, and the Musée de la Musique. At Harvard University, I thank Tom Ford and other staff at the Houghton Library and the Harvard Theater Collection, as well as staff at the Fine Arts Library, the Loeb Music Library, and the Widener Library. At Case, Stephen Toombs and Jeffrey Quick in the Kulas Music Library provided steady help and friendly advice. I also benefited from the assistance offered by staff at the Library of Congress, the Georgetown University Library, and the Rare Book, Manuscript, and Special Collections Library at Duke University. I am especially grateful to Michael Stier and Gretchen Fensten at Condé Nast Publications, and to Kim Bible at Merrill David Photography in Cleveland, for their kind assistance with images for the book.

I am deeply indebted to my editor, Mary Francis, who assisted in all phases of the preparation and publication of this book, and I wish to thank the three scholars to whom she sent it for review. I also wish to thank Kalicia Pivirotto, Ruth Steinberg, and Kate Warne at the University of California Press for the many improvements they made as the project came to fruition.

Finally, a special debt is owed to friends and family. Much of this book was written in the lovely Paris apartment of my good friend Sylvia Temmer,

to whom I will always be grateful. I also wish to thank my dear friend Martha Keates and her daughter Bailey, my brother Jim Davis and his family, and my father Francis X. Davis for the many kinds of support they provided over the life of this project. Above all, however, the book made the leap from concept to reality thanks to my husband, Richard Gordon. He made everything possible, and I dedicate this work to him with love, gratitude, and great happiness.

ACKNOWLEDGMENTS

# MAGAZINES, MUSIC, AND MODERNISM

Every revolution begins with a change of clothes.

RENÉ BIZET

In the June 1923 issue of French *Vogue,* an unusual portrait of an unlikely subject appears amid the fashion plates. Accompanying a story about the adventures of a fictional Parisian named Palmyre, the drawing is fashion illustrator Eduardo Benito's sketch of the "good musician" Erik Satie, "bearded and laughing like a faun." The composer is just one of the characters in the larger tale of Palmyre's "escapades in the world of artists," which is part of the magazine's feature series tracing the lives of six stylish young women in the French capital. Palmyre, in this installment, dines with Raymond Radiguet, the "author of stunning novels," then accompanies him to the fashionable club Le Boeuf Sur le toit, "where the jazz band is all the rage." She rubs shoulders with the Boeuf's habitués, including Jean Cocteau, Francis Poulenc, Georges Auric, and Darius Milhaud, but the high point of the adventure is an encounter with Satie, "simple and good like a child." These outings, "the dearest to Palmyre's heart," allow her to "partake in the current taste of elegant Parisians for nightclubs."[1]

*Vogue*'s spotlight on Satie and his club-hopping friends not only provides surprising evidence of the group's celebrity status in the 1920s, but also suggests that the upscale fashion press played a more significant role in defining and advocating musical modernism than has been recognized. In articles, fiction, and illustrations, a range of publications directed at a largely female readership promoted a bold ideal of good taste premised on the convergence of fashion and art, and led the way to a rejuvenating makeover of cultural life. The glossy pages of these journals offered the

FIGURE 1. Eduardo Benito, "Palmyre danse la Sévillane,"
from *Vogue* (Paris), 1923

fashionable Parisienne a guide to music in the French capital, and more importantly created momentum for the spread of a cosmopolitan musical style that was remote from the hermetic and abstract high modernism championed by contemporary music critics. In the guise of reporting on good taste, the fashion magazine in essence proposed an alternative strand of French musical modernism that found its raison d'être and its largest base of support in the feminine sphere.

### THE *MERCURE GALANT* AND THE BIRTH OF THE FASHION PRESS

Although it has gone unremarked, the alliance of music and fashion is one of the oldest conventions of the periodical press, dating almost to its inception in *ancien régime* France.[2] The *Mercure Galant*, one of the first French periodicals, made the connection as early as 1672, covering both topics on its pages and introducing the notion that they were essential components of an elegant lifestyle.[3] With a title that evoked the mythological messenger of

the gods, as well as the sensibility of pleasure and amusement that characterized the court of Louis XIV, the magazine provocatively promised in its inaugural editorial to report on a mélange of "all the things that other magazines won't cover."[4] It held to its word: while it followed the *Gazette de France* by printing political news, and imitated the *Journal des Savants* by publishing erudite literature, the *Mercure Galant* went beyond the scope of either of these publications by also offering a mix of society gossip, news of marriages and deaths, notices of curiosities (Siamese twins, bearded ladies, and the like), and reviews of plays, operas, and new books.[5] Published weekly and supplemented by a more elaborate *numéro extraordinaire* each quarter, the magazine was designed to appeal to Parisians and provincials of both sexes, and like many contemporary publications it adopted the device of the letter as its mode of communication, taking a tone that suggested good breeding and intimate snobbishness. In short, the *Mercure Galant* was dedicated to providing the tools necessary for a lifestyle of elegance and panache, and it established the centrality of both music and fashion to the enterprise of living well.

Creating a model that remained standard in the style press for centuries, the *Mercure Galant* introduced a two-part formula for the treatment of music, promoting musical connoisseurship by printing criticism and feature articles, and accommodating the vogue for amateur music making by publishing scores.[6] In its reviews, the magazine reported on performances at court and private aristocratic *fêtes* as well as entertainments at public venues, such as the annual celebration of carnival and the regular outdoor fairs held on the outskirts of Paris. Occasional discussions about musical instruments and techniques also appeared on its pages, including an article complete with graphic instructions addressing the complex matter of theorbo tablature. In addition, the magazine printed scores for at least two musical works in the "Amusements" section of each issue, a practice that intensified after 1710, when Charles Dufresny, a great-grandson of Henri IV and a respected composer himself, assumed editorial control of the journal.[7] The published repertoire, limited to pieces simple enough to be performed by most musically literate readers, included everything from popular chansons and bawdy drinking songs to airs from the latest operas, and while a number of these scores appeared in earlier collections issued by the music publisher Ballard, most came into print for the first time on the magazine's pages.[8]

The coverage of music and fashion in the *Mercure Galant* fit perfectly with the magazine's view of itself as a tastemaking journal. By publishing both music criticism and scores, the magazine allowed readers to participate

in varying levels of contemporary musical life, encouraging a sophisticated familiarity with professional performances while providing the tools for the pleasurable pursuit of amateur music making. By mingling reviews of music associated with high culture—exemplified by Lully's operas and other court genres—with the publication of *airs à boire* and vaudevilles drawn from the culture of the public sphere, the magazine conveyed the ideal of a broad appreciation of music, and defined this as encompassing lowbrow fare as well as music considered to be serious and sophisticated. Finally, by printing a steady stream of new musical works, the *Mercure Galant* participated in the nascent music publishing business, engaging readers with a constantly changing repertoire. Projecting music's qualities of diversity and ephemerality, the *Mercure Galant* thus presented this art as one of the pleasant amusements of everyday life.

Much as it introduced music criticism and score publication in the regular periodical press, the *Mercure Galant* broke new ground by reporting on fashion. Not the first journal to cover matters of dress—the daily paper *Le Courrier Français* (established 1649) and the society paper *La Muse Historique* (established 1652) had each devoted a few random pages to the topic—the *Mercure Galant* was the first to afford it a place of importance, and more importantly introduced a new tool for the task: namely, the fashion plate.[9] Borrowing the idea for visual representations of fashions from the costume books and almanacs that flourished from the fifteenth century onward, the *Mercure*'s editor and publisher Jean Donneau de Visé began to use illustrations captioned with descriptive texts to convey the latest looks in his journal in 1678, after he was granted a royal privilege allowing him to include engraved plates in the publication.[10] The *Mercure Galant*'s first fashion spread, published in a special issue that January, included six such engravings: two representing men's clothing, three depicting women's ensembles, and one showing a man and a woman together in front of a Parisian boutique. Finely wrought, these plates were commissioned from two of the most prominent artists affiliated with the court at Versailles—Jean Bérain and Jean Le Pautre—and they reflected the styles and tone set by Louis XIV and his aristocratic followers.[11] The captions that ran under each image identified the clothes generically as "winter dress" or "spring dress," but an accompanying text explained in some detail the various elements of the luxurious costumes, from the "silk ecru bonnet" in one outfit to the "brocaded hem banded in ermine" of the next. The plates also included the names and addresses of the various purveyors of the ensemble, thus implicating advertising in fashion reportage. This mix of image, text, and advertising quickly

gained widespread acceptance, and has remained the standard format for fashion layouts for more than three centuries.

Right up through the Revolution, the *Mercure Galant*'s many innovations served a central goal, establishing the concept that a magazine could be a comprehensive resource and guidebook for elegant living. Stylish in its own right, it mixed multiple modes of text, including illustrations and musical scores, with articles on a range of topics across disciplines, creating a lively format for reports on the latest trends. Continually renewing the present and largely indifferent to the past, it forged a link between the elements of daily life and the construction of an idealized lifestyle. Perhaps most importantly, in its content, design, philosophy, and strategy, the *Mercure Galant* inaugurated the association of periodical publication with modernity, thus laying the groundwork for the development of the fashion magazine.

## MUSIC AND THE RISE OF THE FASHION PRESS

As fashion ceased to be the prerogative of rank or birth in the early eighteenth century, it became the subject of ever increasing coverage in the French periodical press. A range of new magazines targeted to female readers situated dress in its contexts, reporting on styles and tastes in popular salons and public venues. More than simple fashion books, these journals printed literary criticism and moral debates, as well as etiquette tips, recipes, medical cures, advertisements, and advice columns; among the most erudite was the monthly *Journal des Dames*, founded in 1759, which focused on politics and literature, publishing the works of Voltaire and other *philosophes*. This sector of the press grew rapidly: between 1710 and 1785, twenty such women's journals were launched, at the rate of one every four or five years, and with the appearance of the *Cabinet des Modes* in 1785, France had its first self-professed fashion magazine.[12] This fortnightly journal, which promised news of the latest styles in dress, home decoration, and jewelry, all "described in a clear and precise manner and represented by engraved colored plates," was affordable, beautifully presented, and teeming with illustrations.[13] Wildly successful, it inspired a wealth of new publications, and the fashion press as we know it today was born.

Following the model established by the *Mercure Galant*, the *Cabinet des Modes* and other new fashion magazines outlined a set of standards for elegant living in which the appreciation of music, along with literature and the fine arts, figured prominently; as the *Journal des Dames* declared in

1761, "We will not be afraid to associate the arts with the most frivolous of fashions, since one ought to find Montesquieu and Racine alongside pompoms and ribbons on a well-equipped toilet table."[14] These publications also followed the *Mercure Galant* by encouraging women to cultivate dual modes of musical existence, privately dispensing pleasure as performers while publicly displaying expertise as consumers of musical culture, and they provided tools for both pursuits. For the domestic sphere, where women were expected to exhibit competency and connoisseurship, magazines encouraged self-instruction and private music making; the *Journal des Dames*, for example, printed articles on composers and their works, and included decorative foldout music scores, choreographed contradances, and even a magnificent illustration of Benjamin Franklin's glass harmonica for the delectation of its readers.[15] For the public sphere, where women were expected to be arbiters of musical taste and authorities on the city's fashionable cultural events, magazines selectively chronicled the available offerings and singled out certain venues as stylish and desirable. More often than not, discussions of public performances did not take shape as reviews, but focused instead on the spectacle at hand—especially the clothing, jewelry, and hairstyles of the society women in the audiences—rather than on the music, which often went completely unmentioned.

The central preoccupation of these journals, after all, was fashion, and to this end they adopted and developed the fashion plate as a primary means of communication. Through much of the eighteenth century, these illustrations, like the plates in the *Mercure Galant*, were straightforward, typically featuring a formally posed mannequin standing against a minimal background in a manner intended to show the clothing to best advantage. With the introduction of the *Journal des Dames et des Modes* in 1797, however, the fashion plate became a more creative artwork. The weekly magazine, which was directed by the artist Pierre de La Mésangère, included in each of its issues eight pages of text devoted to fashion, along with one or two fashion illustrations, which were engraved and hand-colored by some of the finest artists of the day.[16] Featuring more relaxed mannequins in enhanced settings, it presented images that laid the foundation for an iconography of the fashion plate in which women were portrayed in the context of modern Parisian life. By the end of the century, the fashion plate had developed into a *tableau vivant* of upscale urban life, in which stylish clothing was firmly associated with women's activities and environments.

As the fashion plate became commonplace in the press, conventions took hold: foreign, historical, and religious settings became typical; formal poses

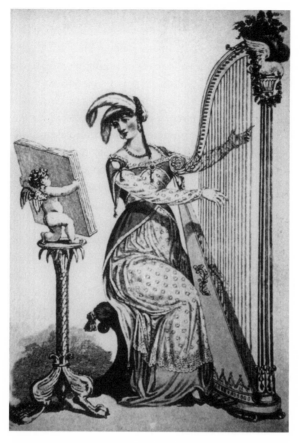

FIGURE 2. Concert-room evening dress, from *La Belle Assemblée*, November 1809

and passive facial expressions became the norm; and certain feminine activities were depicted repeatedly. Among the most popular of these was the image of a woman (or women) making music, most often playing the harp or singing. The illustration of these musical pursuits served multiple purposes, allowing the clothing designs to be shown to good advantage, highlighting the contemporary vogue for feminine musical accomplishment, and implicating musicality as an integral part of both domestic life and high style. Reinforcing the connections between music, fashion, and femininity, the musical fashion plate reflected social and cultural issues as well as trends in dress.[17]

Like the press in general, the fashion press expanded and diversified at an astonishing rate throughout the nineteenth century, stimulated in part by the heightened demand for periodicals that developed as bourgeois French-women became an increasingly vital force in society. As demand rose costs also fell, due primarily to technological improvements, especially in the manufacture of paper. The industrialization of printing and the upgrading of postal service had an impact, as did the introduction and rapid spread of lithography in France, which facilitated the mass production of fashion plates beginning in 1816.[18] The expansion of advertising as a revenue source also lowered the prices of fashion periodicals, and the century saw numerous relaxations of French censorship rules, culminating in the elimination of censorship in 1881. In total, these developments led to both a wider range of journals and a broader consumer base.

In the wake of these changes, a dizzying array of fashion magazines appeared (and disappeared), each claiming a distinguishing niche: *L'Observateur de la Mode* (established 1818), for example, aimed to judge fashion "as philosophy and history," and *Le Petit Courrier des Dames* (established 1822) billed itself as the "new journal of fashion, theater, literature, and art."[19] The mid-century saw the introduction of increasingly specialized journals, focused on everything from the mechanics of sewing to the glamour of Parisian society. Magazines such as *Le Musée des Modes: Journal des Tailleurs* catered to professionals in the fashion industry, while publications devoted to domestic and family life flourished; magazines implicating serious literature in their mix of fashion reportage, household advice, and etiquette tips likewise gained a stronghold among readers.[20] From simple and didactic to luxurious and escapist, nineteenth-century fashion magazines addressed the gamut of women's concerns and kept pace with the changes that affected their lives.

The first burst of activity in this sector of the press occurred between 1830 and 1848, during the July Monarchy of so-called "citizen-king" Louis-Philippe. His education policies, mandating primary and secondary schooling for most of the country's citizens, increased literacy levels and spurred a demand for magazines and other reading materials; his commitment to abolishing the rigorous censorship laws imposed by his predecessor, Charles X, also stimulated the development of the periodical press.[21] During Louis-Philippe's reign, fashion publication became an industry in its own right, as more than a hundred new magazines devoted to the topic entered circulation and significant conglomerates emerged: one of the earliest publishing

moguls was Louis-Joseph Mariton, who controlled nine separate fashion journals, including *Le Follet* (1830–82), *Le Journal des Demoiselles* (1833–1923), and *La Mode Illustrée* (1860–1930), as well as the English-language magazine *La Belle Assemblée*.[22] Remarkable even among the vast number of publications that appeared in France during these years was the literary-oriented fashion journal *La Mode*, which included among its contributors Victor Hugo, Eugène Sue, and Honoré de Balzac—whose "Treatise on the Elegant Life," published in the magazine in 1830, was a veritable manifesto of high style.[23] *La Mode*'s pages featured the designs of artist Sulpice-Guillaume Chevalier, who signed himself Gavarni; famous for his biting political caricatures, he also advanced the model of a new kind of fashion illustration in which the everyday looks and gestures of Parisians were rendered with integrity and panache. Gavarni's fashion artwork—which the Goncourt brothers breathlessly characterized as "Paris! Love! Paris! Women! Paris! The Parisian! All of Paris!"—intensified the association of the fashion plate with modernism and laid the groundwork for Charles Baudelaire's later claim that fashion illustration transcended the banal to capture the "moral and aesthetic feeling" of a given era.[24]

Fashion itself was a powerful stimulus to growth and change in the fashion press during the nineteenth century. In keeping with Louis-Philippe's bourgeois ideals, the prevailing styles were simple and unornamented during his reign, but following the Revolution of 1848 and the establishment of the Second Empire under Napoleon III in 1852 things took a luxurious turn. With Empress Eugénie and her court serving as conspicuous models, sumptuous clothing regained its function as a site for the display of wealth and taste, and in addition took on new importance as a locus for the expression of political sentiment. In particular, fashion became a centerpiece for the promotion of traditional French luxury items such as lace (made in Calais) and silk (manufactured primarily in Lyon), bolstering industries in the provinces and linking the country's farther-flung regions to the capital city's fashion business. Fashion-related commerce was also fueled by the mid-century hoop skirts known as crinolines, which simply due to their volume significantly expanded the market for French fabric and decorative embellishments.

As fashion became more lavish in the 1850s it developed an accordingly more prestigious sector, known as haute couture. This high end of the fashion industry, which focused on the hand production of made-to-measure garments for individual clients, quickly became the standard against which all else was measured. Haute couture transformed fashion into a credible art form, and in the process fundamentally altered perceptions about its cul-

tural merit. This elevation of fashion in turn gave rise to a genre of upscale journals devoted to exploring the nexus of fashion and art, including curiosities such as *Le Stéréoscope* (founded 1857), which provided subscribers with eyeglasses allowing them to view its fashion plates in three dimensions; *L'Aquarelle-Mode* (founded 1866), which featured a selection of elegantly colored lithographs in each of its weekly issues; and *La Mode Artistique* (founded 1869), which was directed by the illustrator Gustave Janet. Most unusual of all, perhaps, was the magazine *La Dernière Mode*, single-handedly produced between September and December 1874 by Symbolist poet Stéphane Mallarmé.[25] The eight issues of this journal featured articles by Mallarmé on matters of dress, jewelry, and accessories, as well as fine dining, travel, and theatrical and musical events in Paris. Writing under a variety of pseudonyms, including "Marguerite du Ponty" and "Miss Satin," Mallarmé held forth on mundane topics ranging from hemlines and earrings to vacations and menus in this "Gazette du Monde et de la Famille."

At almost the same moment that fashion's elite sector expanded, high style first became accessible to middle-class women. Throughout the seventeenth and eighteenth centuries, fashions were set by wealthy women who frequented dressmakers; the vast majority of others purchased castoffs from wardrobe dealers who operated stalls at the Palais Royal, the Temple, and other Parisian venues.[26] In the 1820s, however, the introduction of ready-to-wear clothing skewed this system, and by the 1840s women could buy inexpensive garments in varying sizes, patterns, and forms off the rack. With the arrival of the sewing machine and new technologies in fabric production in the 1860s, French fashion was further transformed and democratized. Perhaps most importantly, the market for ready-to-wear was boosted by the opening of the great Parisian department stores, which purveyed these garments in an upscale environment amenable to the tastes of the ever-growing bourgeoisie.[27] Palaces of consumerism, these stores sold stylish clothes and fashion accessories along with everyday items like bedding, cookware, and household utensils. Following the model of the shop known as Les Trois Quartiers, which operated between 1827 and 1829, Parisian department stores appeared in rapid succession: Le Bon Marché opened its doors in 1849, Le Louvre in 1855, Le Printemps in 1865, and La Paix in 1869.[28] These shops not only made clothing accessible and affordable, but also shifted perceptions about fashion by making shopping itself a pleasurable and inherently stylish leisure-time pursuit. Naturally enough, the mostly middle-class women who spent their days in these stores sought guidance from the fashion press as they navigated the wealth of merchan-

dise before them, and this fueled the development of new journals designed to address their concerns.

Surprisingly, as both fashion and its press proliferated, the fashion plate fell into a decline. Illustrations became increasingly stereotyped and ultimately settled into a limited set of banal silhouettes and background settings: women, stiffly posed, sat or stood either in elegant interiors, lush parks, or upscale social venues such as the theater or the races. Functional and informational, these fashion plates aimed above all to present the details of clothing, and the accurate depiction of minutiae such as the number and location of buttons on a particular garment came to take precedence over creativity or artistic sensibility. While some illustrations, notably those in the *Journal des Modes,* were executed with care and individuality, most plates in the middle- and lower-brow fashion press were workmanlike at best.

Across the fashion magazine's varied incarnations, however, music remained a fixture, ever present in its iconography and written content, and a ready identifier of femininity. With the diversification of the fashion press, in fact, came a marked intensification of the coverage of musical topics. This was fostered, in turn, by the general rise of musical culture in the public sphere in Paris throughout the nineteenth century—a phenomenon so marked that one critic proclaimed in 1837 that music was the "new art of France. . . . It is our new passion, it is our daily study, it is our national pride."[29] As musical performances became more extensive and accessible, magazines served as invaluable guides to the available offerings, steering their female readers to appropriately stylish venues, reviewing select performances, and showcasing female performers. In addition, just at the moment that domestically oriented magazines designed primarily for bourgeois women gained circulation and status in the beginning of the century, a new instrument—the piano—was taking center stage in Parisian musical life, ruling the scene from concert halls to fashionable middle-class households.

As female amateurs took to the piano in droves, fashion magazines promoted the instrument as a tool for feminine education, a mechanism for imparting social and physical discipline, a measure of female accomplishment, and a means of creating harmony—literally and figuratively—in the domestic sphere.[30] The image of a woman (or women) at a piano became a trope of the nineteenth-century fashion plate, in part because of the instrument's popularity, but also because it provided a natural focal point for the detailed display of clothing from multiple angles. Many fashion magazines added to their coverage of music in these years by publishing sheet music

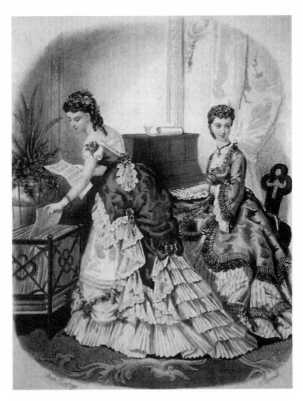

FIGURE 3. Women at the piano, from *La Mode Illustrée,*
January 1859

on a regular basis, typically favoring simple compositions for piano in salon
genres such as nocturnes, quadrilles, and romances. The magazine thus
reflected and shaped concepts of appropriate feminine musicality, right
down to the amateur-level repertoire it provided for its female readership.

By the 1860s, the craze for domestic music making had faded, and by
1869 musical scores for home use had begun to disappear from many fash-
ion magazines. With increased access to education as well as other leisure
activities, women were less likely to remain engaged with the piano, and
the rise of a few female pianists to professional concert careers portended a
new understanding of music as not simply a feminine accomplishment but
a serious artistic pursuit.[31] The change was registered by one critic who
wrote with enthusiasm about the new generation's "immunity from use-
less piano practice":

Unless there is discovered a sharply defined aptitude, a girl is kept away from the stool and pedals. Instead of . . . relentless technical exercises, our young woman golfs, cycles, rows, runs, fences, dances, and pianolas! While she once wearied her heart playing Gottschalk, she now plays tennis, and freely admits that tennis is greater than Thalberg. . . . Piano-playing as an accomplishment is passing. . . . Life has become too crowded, too variously beautiful, for a woman without marked musical gifts to waste it at the piano. . . . If she must have music, she goes to a piano recital and hears a great artist interpret her favorite composer.[32]

Indeed, by the 1870s fashion magazines had begun to shift emphasis away from musical activity in the domestic interior, instead reporting on performances at the opera or theater. In most publications, music came to be represented more as a purely social pursuit rather than as a pastime or genteel accomplishment, an art ripe for consumption rather than practice.

## ALTERNATE VIEWS:
## THE FASHION PRESS AND THE MUSICAL MAINSTREAM

The fashion magazine proved to be a significant locus for the coverage of music in France well into the nineteenth century, in part because the country had no specialized music press. A few journals devoted to music, including *Le Journal de Musique* (established 1764) and *Le Journal de Musique, Historique, Théorique et Pratique* (established 1770), emerged as music was liberated from political associations following the death of Louis XIV, but these publications were short-lived; musical aesthetics instead were discussed either in privately printed pamphlets, in the daily press, or in journals in the non-musical fields of literature, philosophy, and the dramatic arts.[33] There was no shortage of heated controversy about musical matters: to cite just a few well-known examples, partisans of Lully warred with adherents of Jean-Philippe Rameau beginning in 1733; the *Querelle des Bouffons*, arguing the merits of Italian versus French opera, was launched in 1752; and a debate setting Gluck against Piccinni raged in 1774. These disputes coincided with the arrival of the discipline of music theory in France, which provided an analytical and quasi-scientific underpinning for discussions of music in general.[34]

Only with the introduction of *La Revue Musicale* in 1827, however, did a periodical press specifically devoted to music criticism come into existence. Founded by François-Joseph Fétis, the weekly magazine remained in circulation until 1880, under the title *La Revue et Gazette Musicale de Paris*, and was arguably the most important and influential music periodical in

France during its lifespan.[35] Other publications that appeared in the 1830s and 1840s changed the direction, dimensions, and style of the journalistic discussion about music; among the best known were *Le Ménéstrel*, introduced in 1833 and in circulation for over a century, and *La France Musicale*, first published in 1837. Marking the important juncture where trained professional musicians supplanted literary critics and dilettantes as commentators on music, these publications established new criteria for evaluating music as well as new modes of discourse, setting a standard that would hold well into the twentieth century.

A particular ambition of some of these early-nineteenth-century musical journals, including *La Revue Musicale,* was the elevation of music to the more esteemed status of literature and visual arts as an expression of French cultural values. As Katherine Ellis has argued, the editors of *La Revue Musicale* aimed especially to reshape long-standing perceptions of music as a frivolous and ephemeral art, and saw as one means to this end the creation of a canon of great works.[36] The definition of such a historical tradition required agreement on an accepted set of standards and analytical methods by which music could be judged, and this in turn helped to delineate both the magazine's content and its readership: since musical excerpts were part of the substance of these journals, readers needed to have facility with score reading as well as the patience and interest necessary to work through complex discussions implicating musical examples. Finally, in creating a canon, this sector of the music press focused primarily on autonomous instrumental music, devoting itself to the symphonic and chamber works of Haydn, Mozart, and Beethoven, a repertoire that was both unassailable in status and inherently suited to analysis.

Not all music journals, of course, were invested in establishing a canon of great works. Like the fashion press of the nineteenth century, the music press developed as a vast and diverse field, with journals designed to address the interests and concerns of a wide market.[37] Periodicals ranged from *La Chronique Musicale*, which included substantive reviews as well as composer biographies and historical studies, to *La Revue du Monde Musicale et Dramatique,* which described itself simply as a "frivolous album." Music magazines of this period not only represented a wide spectrum of tastes, but also served a variety of agendas. *L'Art Musical,* for example, was one of the many periodicals produced by a music publisher and intended to promote the wares of the publishing house—in this case, the director was Léon Escudier, who held the French rights to Verdi's music. Other journals were printed by instrument makers, including most notably the piano manufacturer Edouard Mangeot, whose *Le Monde Musical* developed as important

site for music criticism at the same time it served as a publicity arm for his firm. Parisian music institutions also produced journals intended to increase public awareness of their programs; among the most popular of these magazines was *La Tribune de Saint-Gervais*, established in 1895 by Charles Bordes, which promoted the programs and aesthetic agenda of the Schola Cantorum. In addition to these Parisian periodicals, a large number of respectable music journals flourished in the provinces; these included *La Musique à Bordeaux* (founded 1877), *La Gazette Musicale de Nice* (1880), and *La Gazette Artistique de Nantes* (1885).

This field of journals also included a number of periodicals that treated music as an element of style in much the same vein as the fashion press. This intersection could be seen perhaps most obviously in the magazine *Musica*, launched just after the turn of the century. Billing itself as "the most beautiful illustrated music journal in the world," it included in each issue an editorial designed to give readers a sense of the current musical scene, as well as photographs and drawings evoking the scenes of the latest concerts, operas, and other musical events.[38] Seeking to attract stylish readers, it followed the example of the fashion press by offering gifts to subscribers—from belt buckles engraved with the journal title to satin camisoles made of fabric in a special *"Musica"* print—and intensified its appeal to female readers by publishing advertisements for face creams and hygiene products as well as sheet music.

## THE BALLETS RUSSES AND NEW PARADIGMS FOR THE PRESS

With the arrival of the Ballets Russes in Paris in 1909, the connection of music and fashion was given an especially compelling expression. The troupe's intense popularity and far-reaching influence made its performances impossible to ignore, and the publishers of both music journals and fashion magazines avidly followed each *saison russe* from 1909 forward. While they differed in their assessment of the Russian ensemble—with the music press taking a generally less enthusiastic stance—critics from both fields found common ground in reporting on this group, since it brought music and fashion into direct and dramatic contact.

As with most aspects of the Ballets Russes enterprise, press coverage was controlled and cultivated down to the details by the group's impresario, Sergei Diaghilev. In his interactions with the media, Diaghilev could fall back on his earlier experiences as one of the principal animators of the St. Petersburg journal *Mir Iskusstva*, or *World of Art*, an oversized and lavishly illustrated publication that appeared fortnightly between 1898 and

1904. This ambitious journal included commentary on Russian and European arts and crafts, coverage of artistic events in Russia and the West, and reviews of exhibitions, books, and concerts; Diaghilev oversaw the aesthetic content as well as the production details.[39] His experiences with this publication made him keenly aware of the high potential magazines held for communicating and generating support for new art, and he marshaled his expertise in Paris with the aim of cultivating a stylish following for his new dance ensemble.

This audience, as Lynn Garafola has demonstrated, was constituted of a blend of socialites, industrialists, financiers, artists, writers, and *demi-mondaines*; this was a stylish mix of personalities and professions that both assured the ensemble's financial stability and guaranteed its cultural cachet.[40] Many Parisian journals catered to this elite public, but the standout among them was *Comoedia Illustré*, a weekly supplement to the French daily newspaper *Comoedia*, which itself was devoted to coverage of the arts.[41] Directed by Maurice de Brunhoff, scion of one of the most powerful publishing families in France, the glossy new magazine was a hybrid that combined the arts coverage typical of *Comoedia* with the conventions of contemporary fashion magazines; it offered up a mix of photographs, illustrations, reports on popular entertainers, and reviews of art exhibitions, plays, and musical performances. As Diaghilev recognized, it was the perfect vehicle for cementing the ties between his ensemble and the public he desired to attract, and from the outset he tended carefully to his relationship with de Brunhoff and his magazine.[42]

Launched in 1909, coincident with the Russian ballet's first Paris season, *Comoedia Illustré* addressed matters of taste, style, and consumerism—the lifeblood of the Ballets Russes crowd—prescribing a cultural guide for its discerning readers and promoting a select group of artists as especially worthy of attention and patronage. With a focus on fashion, the magazine advanced the link between style and artistic celebrity, devoting numerous covers and pages of each issue to descriptions of the chic couture ensembles and coiffures sported by top female performers, often accompanied by photographs—which were not commonplace in the press at the time.[43] These fashion reports described famous performers as well as the women in the audience, who were typically attired by the same couturiers; thus *Comoedia Illustré* linked the imaginary sphere of the stage with the (more or less) realistic world of the paying clientele. This connection was acknowledged in the magazine's regular fashion feature entitled "Today's Fashion on Stage and in Town: Artistic and Mondaine Chronicle," as an excerpt from the column of 1 June 1909 reveals:

Right now, the Russian season and its uncontested prestige dominates all our theatrical attractions. . . . The originality of their national costumes borrowed from eras now past ravishes the eye! . . . But I want above all to talk of the audience, which is my domain in this chronicle of elegances. . . . What can I tell you that hasn't already been said about the audience for the *répétition générale,* where all the notable and artistic elite were present? The intermissions were enchanting, and [at these intervals] one simply left one sort of ravishment to enter into another. . . . On the balcony were . . . the most beautiful dancers . . . Isadora Duncan, Mlle Trouhanova in a sparkling tiara . . . and one could smell a new perfume created by Oriza, called "The Gardens of Armide."[44]

Illustrated with photographs, the column followed the conventions of the fashion magazine's society pages and advice chronicles, taking an intimate tone by addressing the reader as *"vous"* rather than the more impersonal *"on,"* and identifying its author with a sobriquet, in this case, the vaguely Russian-sounding "Vanina." Surrounded by advertisements for women's products ranging from facial creams to corsets, the column sealed the identification of the Ballets Russes with feminine consumer culture.

With its glamorous dancers, spectacular productions, scandalous subjects, and intense visual impact, the Ballets Russes proved to be a perfect centerpiece for *Comoedia Illustré.* In fact, the productions and personalities of the troupe loomed so large that the line between reporting on the Ballets' performances and advertising for them quickly became blurred. Publicity pieces, such as the seven-page panegyric commissioned from Jean Cocteau by Gabriel Astruc—trumpeting the virtues of the "young, supple, erect" Nijinsky—appeared as serious reviews, but were barely distinguishable from the extensive and lavishly illustrated reports offered by the magazine's own critics.[45] Indeed, within months of its founding, the magazine formalized a commercial relationship with the Ballets Russes, under which *Comoedia Illustré* produced programs for the Ballets' performances, issuing expensive folios that mimicked the magazine layout, complete with lavish color plates, captioned photographs, and fawning articles. Sold for two francs and coveted as collectors' items in their own time, these programs for the Ballets Russes inspired de Brunhoff to publish a special issue of the magazine devoted solely to the ensemble in June 1914, and to produce a book about the Ballets culled from the programs and "most beautiful issues" of *Comoedia Illustré* in 1922.[46]

A glance at the program for the *saison russe* of 1911 reveals some reasons for the popularity of these booklets, not the least of which was the publication of risqué images. Among the program's illustrations, for example,

FIGURE 4a. Photo of Natalia Trouhanova, from *Comoedia Illustré*, program for the Ballets Russes season of 1911

was a photograph of the dancer Natalia Trouhanova, who rose meteorically to fame after her performances in Gabriel Astruc's 1907 Paris production of *Salomé*, at which Richard Strauss himself conducted the orchestra. Reclining on a richly carpeted step, the barefoot Trouhanova smiles enigmatically and raises her arm in a gesture of welcome; her body, roped in jewelry, is otherwise revealed by a transparent dress allowing a clear view of her breast and nipple. Sensual and seductive, the image conveys the sensibility of the Ballets Russes rather than a specific moment from its repertoire, and its eroticism is heightened by the orientalizing context, which by 1911 was firmly associated with Diaghilev's troupe.

Given this image of Trouhanova, it is somewhat surprising to find her photograph gracing the cover of the July 1913 issue of *Le Courrier Musical*, a serious music journal that published musical scores and boasted contributors including Gabriel Fauré, Jean d'Udine, and Louis Laloy. Posed formally and attired in a fashionable empire-waisted dress, she is presented in a manner designed to evoke specific themes associated with the Ballets Russes: her portrait is framed by a border of pink roses recalling the troupe's early success with *Le Spectre de la rose,* and her dress is decorated with images of Greek dancers and musicians in arrested poses that recall the productions of

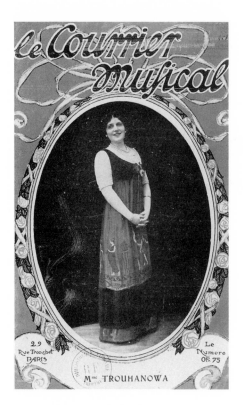

FIGURE 4b. Portrait of Natalia Trouhanova on the cover of *Le Courrier Musical*, July 1913

*L'Après-midi d'une faune* and *Narcisse*. That a ballerina from Diaghilev's troupe should be featured in this manner seems especially striking given the general hostility that the magazine's critics routinely expressed in their assessments of the Ballets Russes. Reviewing the inaugural performances of *Armide, Le Festin,* and *Prince Igor* in June 1909, for example, the critic Victor Debray described a "lyrical pot-pourri" of "mediocre artistic interest at best," and derided the composite score for *Prince Igor* by Borodin with contributions by Rimsky-Korsakov and Glazunov as "vulgar and insignificant"; in the journal's next issue, he reported with similar hesitation on the performance that included *Les Sylphides* and *Cléopâtre,* complaining that it was "nothing more than a big spectacle."[47]

Yet even as *Le Courrier Musical* printed negative reviews of the Ballets' performances it projected an ideal of fashionability inspired by the Russian troupe. In the same issue for which Trouhanova served as cover girl, in fact, the magazine introduced a column devoted entirely to fashion, entitled "La Mode à Travers les Arts." A departure from the journal's regular fare, this

FIGURE 5. Fashion reportage in *Le Courrier Musical*, June 1922

feature lacked any substantive discussion of musical topics, but instead appears to have been intended specifically to raise the magazine's appeal to female readers. The inaugural column at least attempted a connection, reporting on the latest fashions seen in the theaters and concert halls, including "muslin floral print dresses . . . that only a season ago appeared to us to be sweetly rococo," and "pleated skirts, a little shorter in front." By the following month, however, the coverage had become more elaborate and further removed from music: under the title "En dinant," the column recounted the adventures of a fictional young aristocratic couple named Germaine and André-Louis de Lignac as a pretense for describing in detail Germaine's dress, a transparent confection of Chantilly lace, "geranium

satin" and "rose tea" silk. Debating the appropriateness of such "undress" for a dinner party, they agree in the end that it is indeed quite fitting— "because it's in fashion, and with that everything is settled. It doesn't matter if something is ugly or awkward; it's Fashion with a capital F."[48]

Framed by advertisements for cognac, champagne, hotels, psychics, manicures, and other amenities of fashionable life, this little story conveys an attitude of high style that extends beyond the realm of dress and dining to music, where fashion also plays its role. Although the Ballets Russes is never mentioned explicitly in this column, the troupe is invoked via a large advertisement that appears just beneath the text, promoting the Bichara perfumes "Sakountala" and "Nirvana," which capture "the voluptuous feeling of the Ballets Russes" and conjure "the decorative seductions of *Schéhérazade*." As this pairing of commentary and advertisement suggests, the popularity, glamour, and high society cachet of the Russian dancers was crucial to the solidification of the link between fashion and music, and helped to legitimize the discussion of fashion in the serious music press. This connection continued to resonate in intellectual and social circles before the war, leading to new modernist musical styles and repertoires in which dance—and the ideals of fashionable society that were encapsulated in the phenomenon of the Ballets Russes—held sway.

# 2

# PAUL POIRET

Snobs are indispensable to fashion and the arts.
FRANCIS POULENC

So chic was the Russian ballet that the line between stage and couture salon collapsed: in 1912 Diaghilev's designer, Léon Bakst, offered his first fashion collection to the public. Working with couturiere Jeanne Paquin, Bakst created "street dresses" that recalled key Ballets Russes productions, evoking the mythological past of *L'Après-midi d'un faune* as well as the exotic orientalism of *Schéhérazade*. As one French journal reported in April 1913, these gowns, given suggestive names such as "Isis" and "Niké," were the talk of fashionable Paris, envied "in the salons and artist's ateliers, in tea houses and theaters, in the halls of grand hotels and transatlantic steamships, and in deluxe train compartments."[1] American readers of *Vogue* enjoyed a look at the "Bakst–Paquin Combination" a few months later thanks to a full-page article complete with photographs of three of the ensembles, each of which included "hat, veil, shoes, gloves, and coiffure—all designed by Léon Bakst." "The inevitable has happened," *Vogue* proclaimed of Bakst's entry into fashion. "With his wonderful eye for color and for line, and his sense of picturesqueness, is it not natural that he should wish to create garments that could be worn by *les élégantes* of the twentieth century?"[2]

With his celebrity status and artistic credentials, Bakst not only brought the cachet of the Ballets Russes to bear on dress design but also exemplified the idea that fashion and fine art were mutually reinforcing fields. This concept was hardly new by the time Bakst entered the arena; in fact, it had been a foundational principle for the man credited with creating haute couture

in 1858, Charles Frederick Worth. As Elizabeth Ann Coleman has noted, the British-born Worth changed the face of dressmaking by shifting its orientation from artisanal to artistic production, and under his aegis, "during the 1860s haute couture—the presentation of a collection of models, from which could be selected a complete gown or appropriate parts—came to replace *couture à façon*, or dressmaking for the individual. In *couture à façon* the dressmaker had generally been a technician executing an outfit in the fabric and design of the client's preselection. In haute couture, however, the house supplied both the design ideas and the fabric selections, sometimes even having the fabrics executed after their own designs."[3] Worth could thus be personally involved in each stage of the development of his gowns—from the sketching of the initial idea to the stitching of the last detail, producing a "creation" that could be likened to an individual and complete work of art. This sense of artistry was heightened by his use of rare fabrics and exquisite decorations, including hand embroidery and handmade lace, and as if to reinforce the point that his fashions were on a par with painting and sculpture, the designer included a label bearing the signature of his atelier in every garment.[4] More obviously, Worth styled himself as an artist, donning a velvet coat and beret and adorning himself with rings and other jewelry, and living in a villa in the countryside west of Paris that was eclectically and luxuriously decorated.[5] With a clientele that included the Empress Eugénie and members of the nobility as well as wealthy Americans—who, he liked to say, had "faith, figures, and francs"— Worth saw his designs on constant display in the most fashionable settings on both sides of the Atlantic. In large part due to his initiatives, the interconnection of dress, celebrity, and artistry was established as a haute couture hallmark.

By the time Bakst ventured a dress collection in 1912, these relationships were being redefined by Paul Poiret (1879–1944). In a pathbreaking career, Poiret brought connoisseurship and business acumen to bear on the development of an expansive enterprise that situated haute couture at its center. His distinctive mix of orientalizing and classicizing references was arguably the major influence on fashion in the early twentieth century, and his involvements in interior decoration, theatrical costuming, and architecture guaranteed that his ideas had resonance in those spheres as well. Like Worth, Poiret cultivated the notion that he was an artist above all, and he worked to forge new links between dress and the fine arts, ultimately emerging as one of the century's top tastemakers. Among his many passions, music ranked as a favorite, and although it has gone largely unnoticed, Poiret was strongly influential in cosmopolitan Parisian musical circles from

the years before World War I through the 1920s. His affinity for the French past, and particularly the grand siècle, led him to explore and support musical repertories of that era, giving early impetus to the sophisticated brand of modernism that would come to be known as Neoclassicism.

A son of city shopkeepers who described himself as "Parisian from the heart of Paris," Poiret gravitated to the arts as a child, haunting the Louvre and the Comédie-Française and playing violin in a musical ensemble that strolled the streets of the Marais neighborhood performing for spare change.[6] Fascinated with women's fashion—according to his biographer Palmer White, he spent the intermissions of the plays and concerts he attended sketching the outfits he observed on stage—he gained his first professional experience in the employ of couturier Jacques Doucet, one of the most sought-after designers in Paris.[7] For the nineteen-year-old Poiret, this was a plum assignment; the most fashionable women in the city, from aristocrats and socialites to actresses and *demi-mondaines*, frequented Doucet's atelier, located near the Worth Boutique on the rue de la Paix. Known for delicate silk pastel dresses (which were so original that they earned Doucet the distinction of being the only male dress designer cited by name in Proust's *A la recherche du temps perdu*), the Doucet couture firm had developed from the family lace-making and lingerie business, and was thriving at the time of Poiret's employ. At the Maison Doucet, Poiret learned the trades of dressmaking and tailoring, and immersed himself in the full range of activities associated with haute couture. Doucet, Poiret recalled, likened his young apprentice to a "dog thrown into the water to learn how to swim," and "so I swam."[8]

For Poiret, the lessons learned went far beyond practical matters of fashion into the realm of self-invention. The couture business was at best a secondary interest for Doucet; in fact, Coleman claims that he "came to regard any association with fashion as frivolous and demeaning."[9] Instead, like Worth, Doucet allied himself with the arts, amassing important collections of fine art and rare books. His first collection, devoted to eighteenth-century art, included paintings and sculptures by Boucher, Chardin, Fragonard, Hubert Robert, Vigée-Lebrun, and Watteau, as well as rococo furniture and interior design objects; he sold it at auction in 1912 and the following year began to build a collection of works by Impressionist, Post-Impressionist, and contemporary artists, including Derain, Matisse, and Picasso. Complementing his collections of visual art was an extensive library of nineteenth- and twentieth-century literature, which included works by Baudelaire, Verlaine, and Rimbaud as well as Apollinaire, Cocteau, and Proust. For the young Paul Poiret, Doucet demonstrated by

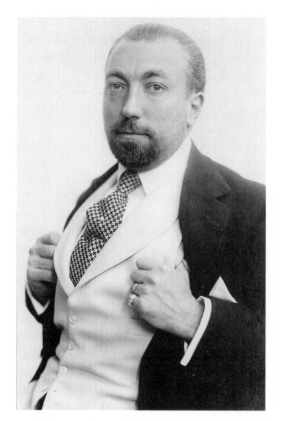

FIGURE 6. Paul Poiret

example that the design of luxurious clothing could be a refined pursuit compatible with and comparable to artistic connoisseurship. The older couturier, Poiret recalled, was "the perfection of handsomeness and elegance, exceedingly soigné," and, without hesitation, Poiret determined to be "the Doucet of the future."[10]

Doucet's involvements in art had immediate benefits for Poiret: while his boss was otherwise occupied, he seized the opportunity to launch his own high-fashion career as a Doucet employee, gaining notoriety for his tailored dresses as well as his costumes for actresses such as Gabrielle Réju (better known by her stage name, Réjane) and Sarah Bernhardt.[11] By the time he left Paris to fulfill his compulsory military duty in 1900, Poiret was recognized as a promising young designer in the city's most fashionable circles, and when he returned in 1901 it was to an assignment at the Maison Worth. Under the direction of the Englishman's sons Gaston and Jean-Philippe, the still-prestigious firm continued to produce opulent clothing for European

royalty and international high society. As a Worth employee, however, Poiret was relegated to designing ordinary casual clothes for the shop's patrons—or as Jean Worth so bluntly put it, creating the clothing equivalent of "fried potatoes" for a clientele that nourished itself on "nothing but caviar."[12] Finding this subordinate rank untenable, Poiret resigned and opened his own couture salon in 1903, outstripping the Worths and Doucet as the darling of Parisian fashion in a matter of months.

## POIRET AND THE NEOCLASSICAL IDEAL

Established in his own shop just behind the Opéra, at No. 5, rue Auber, Poiret made his first mark by challenging fashion's most firmly established conventions. In the early twentieth century, most women's clothing still divided the female body into two distinct sectors articulated by the waistline, with stiff corseting gripping the torso and ribcage and voluminous underskirts plumping the backside—giving women, in Proust's memorable description, "the impression of being made up of different pieces that had been badly fitted together."[13] Inspired by the lithe figure of his wife and muse, Denise Boulet, Poiret broke with this ideal, instead creating gowns that hewed to the body, falling to the floor in a single straight line from an artificially high waist placed just below the bust. More than just a style swing, this was a radical moment in fashion that would change the course of women's dress for years to come.[14] The streamlined design of Poiret's new look was intensified by his insistence that the gowns be worn without a full corset, thus even more fully revealing the female body. For many critics, including social conservatives and fashion traditionalists, Poiret's naturalness was a regression to the primitive: "To think of it!" the popular magazine *L'Illustration* exclaimed in horror, "under those straight gowns we could see their bodies!"[15] "They are hideous, barbaric!" Jean Worth protested. "They are really only suitable for the women of uncivilized tribes. If we adopt them, let us ride on camels and ostriches!"[16]

In reality, Poiret's designs were neither barbaric nor especially new, but simply the latest manifestation of a taste for historicizing styles that had characterized French fashion almost from its inception. Most obviously, his gowns paid homage to the neoclassical tastes that prevailed in the years after the Revolution, and particularly during the French Directory (1795–99), when dresses inspired by the robes of ancient Greece and Rome were worn by young women known as the "Merveilleuses"—a group that included in its ranks the famous Mme Récamier and the future Empress Joséphine.[17] Audaciously revealing, these clothes followed the body's curves in flimsy

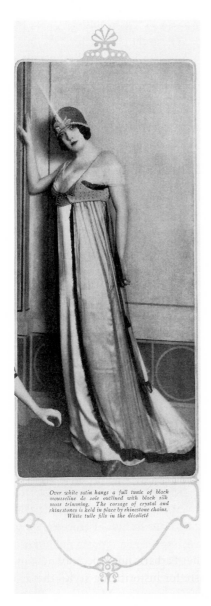

Over white satin hangs a full tunic of black
mousseline de soie outlined with black silk
moss trimming. The corsage of crystal and
rhinestones is held in place by rhinestone chains.
White tulle fills in the décolleté

FIGURE 7. Paul Poiret, white satin dress
with a black mousseline tunic, from
*Vogue* (New York), 1912

fabrics such as tulle and muslin, allowing a view of the figure that was con-
sidered scandalous even in the heady post-Revolutionary atmosphere.
Adding to their outré appearance, the Merveilleuses wore furs and exotic
shawls, turbans, and decorative feather ornaments, all of which became
more widely available as the Napoleonic conquests multiplied. Poiret's

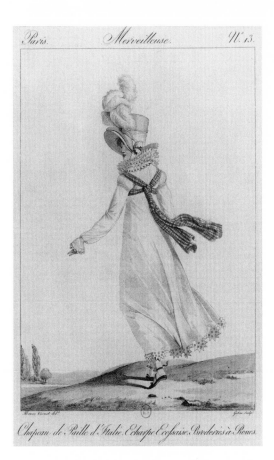

FIGURE 8. Horace Vernet, "Merveilleuse," 1812

engagement with their look was apparent even in his first collections, which featured two distinctive appropriations of the naturalism *à l'antique* that had inspired the fashions of the Merveilleuses in the first instance. In 1909, he harked back to ancient Greece itself with "Hellenic" gowns that draped the body like tunics; the following year, he offered his own take on the Directory look, adopting the high waists and straight skirts that had characterized the style—although in a bow to early-twentieth-century modesty he incorporated veiled bodices in these designs and realized them in heavier, nontransparent fabrics. Many of the new gowns were given names that referred explicitly to his sources of inspiration, including "Joséphine" and "1811," and all were shown with simplified coiffures, classicizing headbands, and minimized jewelry that evoked the earlier period but ran counter to the con-

FIGURE 9. Paul Poiret, "Joséphine," costume by Paul Poiret, 1908

temporary taste for elaborate hair-dos and extravagant millinery. The political overtones of these historicizing styles did not go unnoticed: Poiret's dresses self-consciously recalled for members of the early-twentieth-century Parisian upper class the post-Revolutionary years, during which the urban aristocracy reasserted its political, social, and cultural power. As the couturier knew well, this association would not be lost on the high-society women who constituted his target clientele.

The straight silhouettes of Poiret's first collections alluded to classical and neoclassical values not only via these direct references, but also through their overall aesthetic of simplicity. In comparison to the highly embellished styles that were popular just after the turn of the century, Poiret's designs were strikingly plain, signaling his rejection of the decoration that had defined haute couture from its inception. Although this stripped-down approach was perceived in some quarters as unrefined, a number of important fashion commentators viewed it as a fundamental strength of Poiret's work. By 1913, the critics at *Vogue* magazine had anointed him "The

*My wife, Denise, was my inspiration for my dress theories. It was she who inspired me to preach and follow the creed of simplicity. I do not hold to the idea that every woman should dress as I dress Mme. Poiret, because a woman is ill-dressed who does not allow her clothes to express her individuality; but I make for my wife the gowns and hats that exploit the very best ideas of my creed. She is the expression of all my convictions.*

*Slim, dark, young, uncorseted, untouched by paint or powder, "straight as a lance at rest," untrammeled by high heels, pointed shoes, or tight gloves, Mme. Poiret is dressed to bring out these features. My belief is that every woman should strive for this simplicity as she does for health, intelligence, mental and moral purity, honesty, and the other qualities which go to make an admirable woman. Why make of your bodies, any more than your minds, a temple of useless things?*

*In dressing Mme. Poiret I strive for omission, not addition. It is what a woman leaves off, not what she puts on, that gives her cachet.*

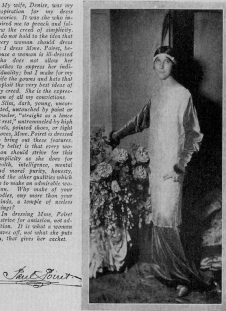

Copyright, 1913, by Geisler and Baumann

A Minaret tunic, a big, black velvet hat—the fashions of the moment— "But not for my wife," says Poiret, though his wife wore it in America

Copyright, 1913, by Geisler and Baumann

Mme. Poiret in her accustomed style, here of straight, silver cuirass, cut in the quaint style of the middle ages, falling over a straight, blue velvet gown

# THE PROPHET *of* SIMPLICITY

### M. Poiret Has Accomplished the Impossible—He Is a Prophet Honored in His Own Home, for His Wife Expresses His Convictions on Dress in All Her Gowns

ONE night at the Hotel Plaza, during her recent visit to America, Mme. Poiret, wife of the famous designer, wore at supper the gown shown in the upper, left corner of this page. It was of white satin with a Minaret tunic and a shoulder scarf of blue tulle. The large hat was of black velvet, white satin, and blue tulle. Her long-vamped, satin slippers were blue, and her stockings were white. In brief, she wore the clothes of the moment. They were like the pictures of fashionable clothes one sees in the magazines.

M. Poiret could not look at this costume without wildly throwing up his hands and saying something in French that in the mouth of an American husband would mean, "How awful!" Later in the evening, he persuaded her to change her costume, and she reappeared in the costume shown at the top of the opposite page. It was of wonderful Chinese brocade, white, made in a straight line from the shoulders, with wide, kimono sleeves and a classic neck-line. On her head was an Indian turban of the material, around her neck a long, green, silken cord holding a pear-shaped pearl, and on her feet were white silk stockings and long-vamped, green satin slippers without ornament. Poiret's face smoothed out into an expression of delight. "Now," he said, "you are yourself again, and my ideal."

The photograph at the upper right of the page likewise shows the simplicity of line which Poiret insists upon in his wife's clothes. A long tunic, cut on the lines of a coat of mail, girdled with a broad band of pearls and brilliants, and finished with a fringed edge, falls over a skirt of mandarin-blue velvet which matches the material of the sleeves.

#### A REALLY UNCORSETED FIGURE

Denise Poiret has never worn corsets. She is a slight, young creature, not much larger than her youngest boy, one of three children. She is exceptionally dark, and against her smooth skin Poiret places brilliant colors as well as white. No matter how her costumes may differ, they follow one dominant idea; the lines are straight, there is no appearance of the gown being fitted to the figure, and there is no useless ornament. She is notable in any gathering by reason of this startling primitiveness of line and color.

Every garment falls free of her body, and her gloves and shoes are made especially for her, so that her feet and hands will be covered, but not encased. Poiret introduced those high, wrinkled morocco boots through his wife; she wears them always for the street. They are square-toed, the heels are flat, and the uppers are closely wrinkled on the legs nearly to the knees. Mme. Poiret has them in white, in yellow, red, and green. These high boots conceal the leg when the skirt is slashed, as is shown in the photograph at the lower right of the opposite page. The suit shown is of gray velvet with a *cache-nez* of soldier-red duvetyn swathed muffler-wise about the neck and dropped over the left shoulder. The loosely cut, straight-up-and-down coat falls over a skirt, straight, and as slim as well may be. The slash of the skirt which is outlined on one edge with buttons and with corresponding buttonholes, discloses high, draped turban worn with this costume is of gray velvet. The street costume shown at the lower left is also in the simple style characteristic of Mme. Poiret's gowning. The short, green duvetyn coat is collared in Chinese embroidery and the simply draped skirt is of white cloth.

#### DOWN WITH BONED COLLARS

Mme. Poiret it was who first wore the plain satin slipper in vivid colors without buckle or bow, and the stocking to match the skirt in color. The fashionable world has at last adopted these artistic slippers, but Poiret's wife has worn them a half-dozen years. And one thing she has not done: she has never worn a high collar; ruffles and turnovers, yes, but never the "civilized" boned bits of torture.

(Continued on page 142)

FIGURE 10. Article on Poiret in *Vogue* (New York), 1913

Prophet of Simplicity," quoting the designer at length as he explained that his goal was to achieve an impression of "simple charm, of calm perfection . . . comparable to that which is felt when standing before an antique statue." "It is what a woman leaves off," he asserted, "not what she puts on, that gives her cachet."[18] His gowns, Poiret maintained, were distinguished "precisely because of the absence of workmanship, the absence of trimmings, precious or complicated":

> I find my gowns satisfying only when the details of which they are composed disappear in the general harmony of the whole. For this reason they may seem disappointing to the ignorant. . . . [They] confound that which is rich with that which is beautiful, that which is costly with that which is elegant. . . . I wish with all my force to combat the decayed technique of those charlatans who produce such glittering atrocities, for richness has never been lovely in itself. . . . If you wish to know my principles, I would say that they consist of two important points: the search for the greatest simplicity, and the taste for an original detail and personality.[19]

Poiret's was thus an architectural approach to clothing, focused on form rather than decoration, and it was intensified by the use of vibrant color and richly textured fabrics. Tired of the "soft, washed out and insipid" grays and "morbid mauves" that were the height of fashion at the turn of the century, he claimed that he "threw into the sheepcote a few rough wolves . . . reds, greens, violets, royal blues, that made all the rest of the colors sing loud."[20] Sensual and vivid, this palette eventually earned Poiret the *New Yorker Magazine*'s acclaim as "one of the continentals who has helped to change the modern retina," an honor he shared with Bakst and Henri Matisse—although of this trio, the magazine noted, Poiret was especially important, since "as dominant decorator and dressmaker" he was able to make his ideas "popularly felt."[21]

## THE SHOCK OF THE *STYLE SULTANE*

Poiret's influence over the "modern retina" registered with force in 1911, when he introduced to Paris the look that became known as the *style sultane*. The new aesthetic was foreshadowed earlier that year by the appearance of the hobble skirt, a gown that, in Poiret's words, "shackled the legs" by becoming so narrow between the knee and ankle that it made simple movement difficult. The hobble dress inspired responses ranging from snide satirical cartoons to a denouncement by the Pope, but these reactions were mild in comparison to the outcry that erupted the following year when Poiret introduced the *jupe-culotte,* or harem pant, a billowing, ankle-

tied trouser-dress that not only defied fashion conventions but also was perceived as a challenge to social and political norms. Considered by critics to be a potentially dangerous appropriation of male prerogatives, such pant-wearing by women was seen by many as a sartorial manifestation of the liberties that accrued to them after the Napoleonic Civil Code was revised in the 1880s.[22] One outcome of these reforms was the convening of the First International Congress on Women's Rights and Feminine Institutions at the Universal Exposition in Paris in 1889; although far from radical—they rallied around banners proclaiming the virtues of motherhood, *patrie*, and *pot-au-feu*—these feminists set the stage for the subsequent woman's movement in France.[23] Equally important, newly mandated education reforms provided women with their first access to the public secondary schools, permitting some female students to prepare for the *baccalauréat*, the requirement for entry into the professions and higher education. By 1900, female graduates of the public secondary schools were filling positions in fields formerly restricted to men, including medicine, law, and the sciences.[24]

More worrying for some critics than the role that the *jupe-culotte* played as a signifier of social change was its supposed political message. Perceived as a fashion emanating from the Orient, Poiret's harem pants were viewed as a racially based challenge to the French status quo, suggesting dangerously unrestrictive value systems, loose moral codes, and sexual availability. Hardly new, such associations depended heavily on the traditional French construction of the East, which, as Peter Wollen has noted, from the seventeenth century onward invoked the myth of "Oriental despotism" to reflect France's own "political anxieties and nightmares."[25] This theme had been taken up by French writers in a line extending from Montesquieu through Voltaire and Flaubert, and by artists including Gérôme and Delacroix, all of whom used the Orient as a site for the expression of erotic and often sadomasochistic fantasy as well as political commentary. Against this backdrop, Poiret's harem pants were open to critique on the basis that they situated fashion in the broad and contentious context of cultural identity and sexual play. In August 1915 this became more than a debate among fashion insiders, as the magazine *La Renaissance Politique, Littéraire, et Artistique* alleged that Poiret's orientalizing designs reflected his "boche taste" and German-leaning politics. This nasty attack against the couturier culminated in a lawsuit brought against the publication by Poiret for defamation of character.[26]

Poiret defended his harem pants against the range of allegations they incited, arguing that they were designed for the "chic woman with delicate

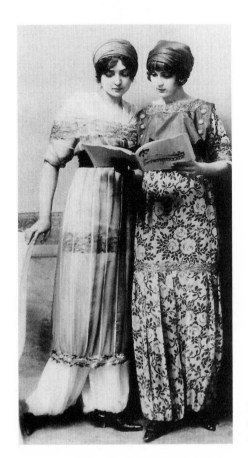

FIGURE 11. Models in sultana skirts, designed by Paul Poiret, from *L'Illustration*, 1911

joints," and insisting that rather than "masculinizing" a woman they showed her "in all the harmony of her form and all the freedom of her native suppleness."[27] As to their evocation of the East, Poiret's personal experiences no doubt played a role; he studied Modern Greek at the School of Modern Oriental Languages in Paris in the 1890s, and claimed to have spent hours in the Louvre studying the collections of Greek sculpture.[28] In addition, despite his vows to the contrary, the influence of the Ballets Russes must have been inescapable, especially since Poiret and his wife were regulars in Diaghilev's audience. The Ballets' imaginings of the East in *Cléopâtre, Les Orientales* (both 1909), and *Schéhérazade* (1910), all predated the couturier's orientalizing line, and the vivid palette and body-conscious naturalism of Diaghilev's productions seems obvious in Poiret's early collections.[29] The vogue for orientalism in France in the early twentieth century

of course extended far beyond either the couture salon or the ballet stage, and was certainly stimulated by the publication of a new French translation of *The Arabian Nights* in the fashionable Symbolist journal *La Revue Blanche*, between 1899 and 1904. In contrast to earlier translations of these tales, the new version, created by Joseph Charles Mardrus, emphasized the erotic and exotic qualities of the stories, thus appealing to contemporary sensibilities of excess and decadence.[30] Poiret's *style sultane* collection was perfectly attuned to these same extravagant leanings, and, falling somewhere between costume and dress, represented a renegotiation of the relationship between art and fashion.

## THE POIRET FASHION EMPIRE

The *style sultane* attracted the attention of critic Paul Cornu, the librarian at the Parisian Union Centrale des Arts Décoratifs, who made Poiret and his new look the focus of an article published in the April 1911 issue of the institution's premier publication, *Art et Décoration*. The appearance of such an article in a serious journal devoted to architecture and interior design, and the title, "The Art of the Dress," signaled Cornu's intent, which was to posit Poiret as the augur of a new era in which dress would be considered a decorative art. Poiret's clothes, Cornu proposed, were best seen "against a modern décor, where the design of the furniture and the coloring of the fabrics all reflect the same aesthetic tendencies," and he cited the couturier's collaborations with artists Bernard Naudin and Bernard Boutet de Monvel, and architect Louis Süe, as evidence of the collective nature of his work. Cornu likened Poiret's approach to the unified expressiveness known in the arts as the *Gesamtkunstwerk*, noting that this ideal of synthesis had already been absorbed "at the theater, in music, or in literature."[31] Distinguishing Poiret from his contemporaries, according to Cornu, was a "necessary mixture of traditional grace and modernity," such that his references to historical dress—from Egypt, Greece, Japan, and the French nineteenth century— contained an unmistakable whiff of the contemporary world: "a perfume that has so intoxicated us that we can barely smell it—the perfume of modernity that his gowns exhale." Whimsical illustrations by Georges Lepape conveyed this sense of the new, and intensified Poiret's association with the fine arts, as did the thirteen photographs of mannequins, dressed in Poiret's clothes and posed in his couture salon, that accompanied the article. These were the first fashion photographs taken by Edward Steichen.[32]

Poiret advanced the conception of dress as an art as he expanded his business in the early years of the century and promoted his couture designs as

part of an idealized lifestyle. He insisted that in order to serve "fashion, coquetry, [and] women" a designer had to "live his dream, excite the imagination of the public, incessantly develop his concepts of beauty . . . enrich his mind by traveling, acquire art objects, inspire emulation by painters, illustrators, embroiderers, and silk manufacturers, open new paths of research for 'spices and unknown savors' . . . collect documents about—and authentic samples of—adornment that are inaccessible to everyday people, and cultivate public taste for them."[33] The expression of style according to this creed became Poiret's obsession, leading him to create a network of enterprises to provide the materials essential to his vision of elegance, and to devise a series of high-profile events in order to showcase his ideals.

One of Poiret's most productive forays was into the area of decorative arts. Inspired by a visit to the workrooms of the Vienna *werkstätte* in 1910, he founded an interior-design school of his own the following year, thus becoming the first couturier to annex decoration to fashion. The school, named after Poiret's second daughter Martine, had a philanthropic mission, providing apprenticeships and a living wage for poor but artistically inclined girls.[34] Although unsupervised and essentially untrained, Atelier Martine students won acclaim for their naïve textiles and decorative objects, even securing two rooms at the prestigious Salon d'Automne in 1912 for the display of their works.[35] So successful was the initiative that it spawned an interior-design firm, also named Martine, which involved professional artists, including Raoul Dufy, André Dunoyer de Segonzac, and Guy-Pierre Fauconnet, as well as the student apprentices. Producing everything from furniture and textiles to porcelain and pottery, the Martine enterprise was noted for its distinctively unaffected style and its brightly colored stylizations of natural forms, a look that in short order became synonymous with the name Poiret.

The Martine initiative thus went well beyond the simple production of isolated decorative objects. Its creations were tied closely to Poiret's other endeavors, from his couture business, where Martine fabrics were used as material for dresses and accessories, to his salon and home, which were decorated with its signature wallpapers. The atelier quickly gained a reputation, and was commissioned to design complete sophisticated interiors for some of the best-known celebrities in Paris. For the popular actress Spinelly the Martine artists created a sumptuous bathroom with a sunken tub and elaborate mosaic tiling; for Isadora Duncan they devised a sultry boudoir that the owner described as a "veritable domain of Circe . . . beautiful, fascinating, and at the same time, dangerous."[36] Martine served a clientele that included artists, European royalty, and members of high society, but

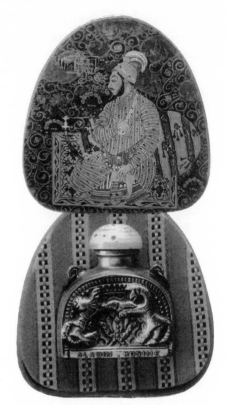

FIGURE 12. Aladin perfume, from
*Les Parfums de Rosine*

the style was not to everyone's liking; the tastemaking Duchess de Gra-
mont, for one, likened the atelier's painted furniture to "a night of bad
dreams after eating potted hare."[37] Many of the firm's patrons wore Poiret
couture clothing in performance and in private life, and by engaging his
designers to decorate their homes they extended his signature look to their
personal environments.

Poiret's other main sideline in these years, a beauty and perfume busi-
ness named for his first daughter, Rosine, further expanded the ways in
which fashion-conscious Parisiennes could cloak themselves in the Poiret
mystique. A decade before Coco Chanel launched her famous No. 5, Poiret,
aided by a team of experts, introduced a signature scent, and eventually, an
entire line of perfumes. Opened in 1911, the Rosine perfumery was allied
with the Martine decorators, who created distinctive hand-painted bottles
for the various fragrances and developed advertising materials for the
beauty products. The Eastern themes and neoclassical references that Poiret
developed in his couture collections all found application in this sphere,

and provided a conceptual grounding for the individual products: the perfume "Le Balcon," for example, came packaged in a glass bottle encased in balcony-like ironwork; the scent called "Arlequinade" evoked the character of the *commedia dell'arte* with its prism-shaped bottle etched in the diamond pattern characteristic of the harlequin's traditional costume; and the perfume "Aladin" was presented in a carved metal flacon stopped with an ivory cork, which sat in an elaborate box decorated with a reproduction of a Persian miniature.

## POIRET AND THE *BON VIVANT* LIFESTYLE

Clothing, interior decoration, and beauty products: Poiret's integrated luxury enterprises promoted a vision of elegant living and supplied the materials necessary for the realization of the ideal. Dramatic and redolent with allusions, his couture creations, perfumes, and decors provided the elements for the theatrical performance of everyday life.[38] It seems natural, then, to find Poiret expanding into areas of more conventional public culture, including theater, music, and visual art, in the years before World War I. One of the first couturiers to design for the dance, his influence was such that Diaghilev and Nijinsky paid a visit to his atelier in early 1910, only months after the Russians were established in Paris. Poiret dressed the off-duty stars of the Ballets Russes in a range of fantastic ensembles, famously clothed Isadora Duncan in iconic Hellenic dresses and knee-high boots, and outfitted Ida Rubenstein in the bejeweled bustiers that became her trademark. As already noted, his reputation had been made thanks to the actresses Réjane and Sarah Bernhardt, and in 1910, after the costumes he designed for actress Eve Lavallière to wear in the hit play *Bois sacré* were reviewed enthusiastically in *Comoedia Illustré* as the "quintessence of Parisianism," his connections to the stage multiplied rapidly. He dressed the players in productions including *Sauf vot' Respect* (1910), which starred the wildly popular actress and singer Mistinguett; *Nabuchodonosor* (1911), an orientalizing fantasy featuring Diaghilev's star dancer Natalia Trouhanova; and *Le Minaret* (1913), a lavish historical drama set in the East that starred Cora Laparcerie. Much as this last play launched the style-setting "lampshade," or "Minaret," tunic, so Poiret's distinctive costumes for all of these productions were transformed in his salon into styles agreeable and available to his couture clients. While these designs were not for everyone—*Vogue* opined that the "virile" Minaret tunic was "unfitted for human nature's daily wear"—Poiret's theatrical connections unquestionably served a dual purpose, blurring the lines between street and stage and

reinforcing the thematic connections that linked French high society to the imaginary realm of theater.[39]

Poiret pushed these same boundaries with a series of extraordinary private costume parties that were artistic productions in their own right. In 1909 he purchased an eighteenth-century *hôtel particulier* on the avenue d'Antin, refurbishing it to serve as both his couture salon and family home; the property's extensive gardens were the site of many of these *fêtes*. The parties were inaugurated with the legendary "Thousand and Second Night" party thrown in the summer of 1911, during which Poiret, attired as a sultan, ruled over his wife, who was dressed as his "favorite" and held captive in a gilded cage, as well as three hundred guests dressed "in Persian costume." The scene, as recounted by one partygoer, was lavish:

> The guests came to find themselves beneath a vast awning. There they were greeted by six ebony-black negroes, stripped to the waist and wearing baggy trousers of muslin silk in Veronese green, lemon, orange, and vermillion. They bowed low before us: "Come!" And so you passed on through the salons, which were strewn with cushions of all colors, and arrived in the gardens spread with Persian rugs. There were parrots in the trees and little bands of Eastern musicians and flute-players hidden among the bushes. Your way was discreetly lit by little twinkling lights. As you advanced you came across booths of the sort found in Arab souks, craftsmen at work and acrobats of all kinds. Your footsteps were muffled by the rugs, but you could hear the rustle of the silk and satin costumes. . . . Suddenly a miniature firework flared from behind a bush, then another and another. It was like fairyland.[40]

The evening's entertainers were among the most in-demand performers in Paris, including Trouhanova, who danced on oriental rugs laid in the center of the garden, and actor Edouard De Max, who read passages from Mardrus's translation of *The Thousand and One Nights*. Reporting on the event for the magazine *Femina*, Lucie Delarue Mardrus, wife of the translator, compared this "fête of art and magnificence" to the "most beautiful ballet of the Russians"; the festivities stretched on until dawn, and the evening has gone down in history as the apotheosis of pre-war orientalism.[41] "From then on," according to Peter Wollen, "alongside the all-pervasive influence of the Russian Ballet, the Oriental look dominated the fashion world and the decorative arts."[42]

## POIRET AS MUSICAL TASTEMAKER

Music was a cornerstone of Poiret's vision for elegant living as well as one of his consuming passions, and it was always a centerpiece of his parties.

Indeed, although his musical involvements have received virtually no attention, Poiret wielded considerable influence in sophisticated circles, helping to define a repertoire that was both stylish and modern and ultimately shaping the musical taste of a key segment of upper-class society. His first initiative in the musical sphere was the creation of a series of invitation-only musical soirées at his home, which effectively lent his imprimatur to specific performers and repertoires. In 1910 and 1911 these house concerts featured the well-respected Parent Quartet in performances of chamber music by Beethoven and Schumann, but in short order he began to use these gatherings to stimulate a revival of music dating from the *ancien régime,* a repertoire that was largely obscure in the early twentieth century. The first of these historicizing concerts took place in May 1912 and featured eighteenth-century chamber music by François Couperin, Rameau, Daquin, Leclair, and Feuillard, as well as a concerto for violin and guitar by Luigi Boccherini. Well in advance of the trend for historically informed performances in France, which is often ascribed to Nadia Boulanger's influence in the 1920s, Poiret insisted that the music be played on early instruments, including harpsichords and violas da gamba and d'amore.

On this particular evening, music was but one means of evoking the grand siècle in order to celebrate Poiret's acquisition of one of the architectural gems of the eighteenth century, the pavilion known as Le Butard. Located in the Fausses-Reposes forest west of Paris, adjacent to the grounds of the Versailles Palace, Le Butard had a storied past: designed in 1750 by the architect Ange-Jacques Gabriel (1698–1782), who also designed the Ecole Militaire and the Place de la Concorde, it was built by Armand-Claude Mollet, who oversaw the construction of Versailles. Used as a hunting lodge by Louis XV and Louis XVI, the building was seized during the Revolution but in 1802 was "reacquired" by the Empress Joséphine, who viewed it as an extension of her bucolic retreat at the Trianon and often passed days there with her female entourage. Occupied by the Germans during the siege of Paris in 1870, Le Butard was abandoned, left to fall into disrepair and ruin. In his autobiography, Poiret recalled stumbling onto the remains of the pavilion in the course of a walk through the forest and determining on the spot that he would "return this jewel to its former luster and majesty." Under an arrangement that allowed him to occupy Le Butard in exchange for renovating it, Poiret worked to restore the original features and to furnish the interiors in an historically appropriate manner. High on his list of priorities was the inclusion of musical instruments of the period in the decor, from a clavecin in the main sitting room to violas de gamba and violas d'amore hanging on the walls. In the restored pavilion, "the

FIGURE 13. Bernard Naudin,
program for a concert of chamber
music hosted by Poiret, 1911

musicians of the seventeenth and eighteenth centuries, Gluck, Daquin, and
Couperin, were played," Poiret remembered, and the building "reacquired
the smiles of its happiest days."[43] This ideal was captured on the cover of
Bernard Naudin's program for the concert in May 1912, which depicts a
rococo musical ensemble gathered around a clavecin located under the
cupola in Le Butard's main salon.

So successful was this concert that Poiret decided to create a more elab-
orate event on historical French themes later that summer at Le Butard,
and thus was born the infamous costume party known as the "Festes de
Bacchus." Organized on the model of the "Thousand and Second Night,"
the party's theme was classical antiquity as viewed through the lens of the
French rococo; the invitation, created specially for the event by Naudin,

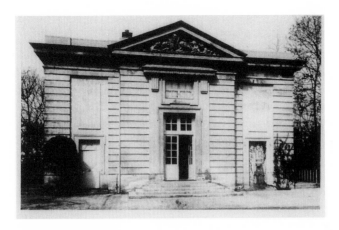

FIGURE 14. Le Butard

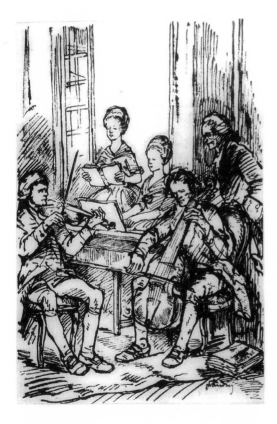

FIGURE 15. Bernard
Naudin, illustration from a
program of chamber music
hosted by Poiret, 1911

instructed guests to dress as characters drawn from the "mythology of Louis XIV," and the program, designed by Guy-Pierre Fauconnet, depicted on its cover masked and costumed dancers in the park at Le Butard, with the pavilion clearly in view. Poiret and his wife, dressed as Jupiter and Juno, presided over the three hundred guests in their garden, where, under trellises, "pyramids of watermelons, pomegranates, and pineapples" were set out along with "tubs filled with scarlet shrimps, baskets full of grapes, cherries, and gooseberries," and over nine hundred liters of champagne.[44]

Even more glorious than the gastronomic offerings were the evening's musical performances. Heard in the garden of Le Butard were solo airs from the cantatas *L'Impatience* and *Diane et Actéon*, both included in the *Oeuvres complètes* of Jean-Philippe Rameau, which had been published in France just before the turn of the century (only later was *Diane* properly attributed to Jacques Bodin de Boismortier). Also performed were works by the Italian madrigalist Benedetto Pallavicino, court composer to the powerful Gonzaga family in Mantua in the late sixteenth century. The party's musical showpiece, however, was a revival of Jean-Baptiste Lully's ballet *Les Festes de Bacchus,* a work that had fallen into obscurity almost immediately after its premiere in May 1651. According to Poiret, Naudin found the manuscript for this composition in a Paris library and the two men subsequently decided to reconstruct it "with the aid of taste and ingenuity."[45]

While Poiret and Naudin probably knew little of the ballet's history, the production of *Les Festes de Bacchus* for the party was an inspired choice. One of the first ballets created for Louis XIV, it established a model for the genre of the court ballet, securing the format and setting the tone for the ballets that would prevail in his court entertainments for nearly a decade.[46] Following *Les Festes de Bacchus,* ballets at court were organized in two balanced parts, each introduced by a recitative and including a number of entrées (in this case, totaling thirty-one) featuring characters drawn from a variety of sources including allegory, mythology, and French history. The convention of using machines and special effects to add emphasis to the plot was also initiated in this work. Most relevant to Poiret's *fête,* however, was the subject matter of *Les Festes:* it was the hedonistic celebration of Dionysus, intended to evoke the feelings of liberation and release associated with the legendary Bacchic rituals of ancient Greece, which often took place at the time of the pre-Lenten carnival. Poiret must have delighted in the work's opening recitative, in which the characters of Indigence and Sobriety are evicted from the "golden island" that will be the ballet's main setting, only to be supplanted by a formidable array of fun-loving drinkers, gods and goddesses, and characters from the Italian *commedia dell'arte,*

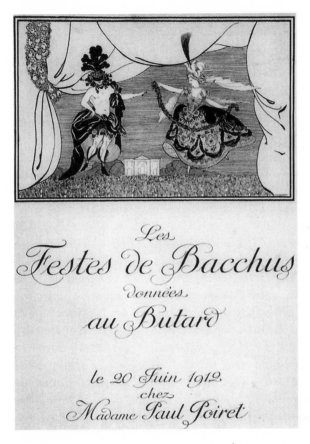

FIGURE 16. Guy-Pierre Fauconnet, program for Les Festes de Bacchus, 1912

who dance and sing with abandon. In Poiret's own garden, an orchestra of forty musicians played while the work was danced by stars from the Paris Opéra on a specially built platform in the woods decorated by André Dunoyer de Segonzac, and the festivities went on until dawn.

Poiret's *fêtes* in this mold continued into the 1920s, occupying the ground somewhere between professional entertainment and decadent orgy. Showcases for his couture designs and his *bon vivant* lifestyle, they reinforced his role as a prime Parisian tastemaker, providing a forum for *le tout Paris* to act out his (and their own) changing fantasies. In this arena, as in his luxury enterprises, the imaginary ideal was based on the revival of aristocratic traditions for the newly constituted twentieth-century elite,

and the recovery of music from the *ancien régime* served as an effective bridge between old and new. Indeed, the French rococo proved to be a perfect touchstone for Poiret's exploration of orientalist and antique themes, grounding his vision in the glorious French past while validating his appreciation for sensuality and extravagant excess.

### REFASHIONING THE FASHION PLATE

Poiret looked not only to the past but also to the present for inspiration, and his style was informed significantly by modernist art. Following Doucet's example, he amassed a collection of contemporary painting and sculpture that was considered to be among the finest in Paris, and his connoisseurship was intensified by personal relationships with artists including Maurice Vlaminck, André Derain, Dunoyer de Segonzac, Fauconnet, and Guy Arnoux. Poiret's involvement in the art world resonated in every facet of his business and personal life, to the extent that he even maintained an art gallery, the Galerie Barbazanges, in the storefront adjacent to his couture boutique on the avenue d'Antin. This profound interest in visual art led Poiret to explore the potential that avant-garde art held for fashion and prompted him to explore new possibilities for the visual representation and marketing of his couture designs. To this end, in 1908 he began to engage progressive young artists to create deluxe albums depicting his collections and thus became the first couturier to market his designs not only as wearable garments but also as art. The albums, printed in limited-edition runs on fine paper, were distributed without charge to a select few (including the Queen of England), solidifying Poiret's alliance with his targeted clientele and distinguishing him from the couture competition. The commission for the first catalog project went to twenty-five-year-old artist Paul Iribe, who was fresh from a collaboration with Jean Cocteau on the creation of a stylish and explicitly Ballets Russes–influenced magazine entitled *Schéhérazade*.[47] For Poiret, Iribe prepared a groundbreaking album entitled *Les Robes de Paul Poiret racontées par Paul Iribe,* illustrating the designs of the couturier's Directoire collection. Published in 1908, the album was produced in a limited run of 250 copies, all of which were signed and numbered. In the book's ten fashion plates Iribe depicted seventeen gowns and three coats in the Poiret collection, and illustrated seven distinctive hairstyles. Far more than a simple costume book, however, *Les Robes de Paul Poiret* established a new standard for upscale fashion publications, transforming both the content and techniques of fashion illustration. First, in

FIGURE 17. Paul Iribe, *Les Robes de Paul Poiret*, plate 1, 1908

lieu of showing models in the stiff poses that had become standard fashion plate fare, Iribe instead grouped them standing in expressive combinations suggesting action, conversation, or introspection, thus promoting clothing as well as a more relaxed and natural attitude for the new century. Second, to capture the impact of Poiret's bold colors in his illustrations, Iribe adopted the traditional stenciling technique known as *pochoir*, which hitherto had been used most typically in France for the production of popular prints known as *images d'épinal*.[48] An intricate and labor-intensive process that involved coloring individual prints by hand, *pochoir* had long been considered impractical for fashion illustration, but Iribe perceived the ways in which its projection of deep color and its clear sense of outline were perfectly suited to Poiret's new look.[49] Furthermore, he recognized that the

FIGURE 18. Georges Lepape, *Les Choses de Paul Poiret*, plate 2, 1911

hand-coloring of the plates would ensure that each illustration was a unique artwork, making the book a collector's item as well as a catalog and thus reinforcing Poiret's program to elevate fashion illustration to the domain of art. This sense was heightened even further in 1909 when Poiret arranged to have the plates exhibited, along with the more standard array of paintings, drawing, and sculpture, at the Salon d'Automne.

The album's success led to a second commission three years later, this time from Georges Lepape. *Les Choses de Paul Poiret vues par Georges Lepape,* designed for wider circulation, was produced in a run of 1,000 copies, 300 of which were signed and numbered, while the less luxuriously printed 700 were made available to the general public at a cost of fifty francs. The album coincided with Poiret's introduction of the notorious *style sultane,* and its twelve distinctive plates captured the new look's emphatic sensibility of exoticism. Lepape's illustrations depicted waifish models, their heads wrapped in turbans, lounging on cushions, gardening in harem pants, and in one case even accepting fruit from a small black slave—an obvious reference to the Ballets Russes' hit production of *Schéhérazade.*[50]

Poiret seized on the fine-art quality of Lepape's illustrations, displaying them once again at the Salon d'Automne, as well as at his own Galerie Bar-

bazanges, where the visitors in March 1911 included fashion publisher Lucien Vogel. He and Poiret were introduced at this exhibit, and from their meeting emerged the concept for a luxurious journal where art, culture, and haute couture would meet on new terms; thus was born the extraordinary magazine *La Gazette du Bon Ton*.[51]

# 3

# LA GAZETTE DU BON TON

Fashion, the ephemeral, shares the last laugh
with art, the eternal.
CECIL BEATON

"A new era, with new methods, needs new pages." So declared *La Gazette du Bon Ton* in its inaugural editorial, published in November 1912, and from this date until its demise in 1925 the magazine set the standard for elegance and luxury in the fashion press. Announcing on its masthead a devotion to "arts, fashions, and frivolities," the monthly *Gazette* resembled a deluxe book more than a fashion periodical, and quickly became required reading for sophisticated Parisiennes who warmed to its tone of elegance and exclusivity. Produced on fine paper and illustrated with exquisite hand-colored plates, it presented a highly stylized take on up-to-date fashion that was both witty and worldly. While promoting modernity, it held fast to French tradition, offering a "little perfume Louis-Philippe of the best quality," and by tapping into a particularly aristocratic heritage it played a seminal role in revitalizing the cultural cachet of the French elite.[1] Linking *ancien régime* refinement to early-twentieth-century avant-gardism, the *Gazette* proposed an urbane brand of modernism based in the connection of fashion and art, all under the guise of good taste. In the years before World War I, music fell under the magazine's sway, opening the way to new compositional approaches that reflected and resonated with fashionable culture.

The man behind the *Gazette* was Poiret's new acquaintance, Lucien Vogel. Recognized as an innovator in the fashion and style press by the time he met the couturier, Vogel had good connections: he was the son of the popular illustrator Herman Vögel and was married to Cosette de Brunhoff—

the daughter of *Comoedia Illustré*'s publisher Maurice de Brunhoff and the sister of both Michel de Brunhoff, the editor of French *Vogue,* and Jean de Brunhoff, creator of the beloved cartoon elephant Babar. Vogel studied architecture but spent his career in publishing, working first as art director for the mass-circulation fashion magazine *Femina,* then as editor-in-chief for *Art et Décoration,* the official publication of the French Librairie Centrale des Beaux-Arts.[2] Between 1912 and 1925, while he created and tended to the *Gazette,* he also founded and directed the women's magazines *Le Style Parisien* and *L'Illustration des Modes,* and in the early 1920s was artistic director of French *Vogue.* Outside the arena of fashion, Vogel is best remembered as the publisher of deluxe books and as founder of two groundbreaking French news journals, *Lu* and *Vu,* the latter of which served as the prototype for *Life* magazine. Dynamic and erudite, he was described by *Vogue*'s formidable editor Edna Woolman Chase as the very personification of Gallic fashionability, a "dandified frog" who favored "a black and white checkered suit and an ascot tie."[3]

With Vogel at the helm, the *Gazette du Bon Ton* was clear about its ambitions: it would consider fashion as the fourth of the *beaux-arts,* thus elevating dress and related enterprises to the level of painting, drawing, and sculpture in the highest reaches of the official French art world. "The clothing of a woman," the magazine's inaugural editorial proclaimed, "is a pleasure for the eye that cannot be judged inferior to the other arts."[4] Fashion's upgrade to art mandated a corresponding approach in the press: from the choice of paper to the design of the page layouts, every element would have to reinforce the magazine's higher mission. As editor Henri Bidou explained:

> When fashion becomes an art, a fashion gazette must itself become an arts magazine. Such is *La Gazette du Bon Ton. . . .* The revue will itself be a work of art: everything should be a delight to the eye . . . nothing has been overlooked, no element will be neglected that is necessary to make the *Gazette du Bon Ton* the ultimate revue of art and fashion, a precise chronicle of the elegant life of our day.[5]

Although the sensibility of good taste and refinement encapsulated in the of idea of "bon ton" was a longstanding French tradition, the term itself entered the language only in the mid–eighteenth century, connoting, as Bidou explained to his later readers, a particular quality of well-mannered behavior:

> To be possessed of *bon ton* it is not enough to be elegant. One can be elegant in a thousand ways, even sensationally so; but *le bon ton* is the same for all. Elegance changes, *le bon ton* is unvarying; the one follows

FIGURE 19. Lucien Vogel with Countess Karolyi, 1932

fashion, the other the dictates of taste. *Le bon ton* is not strait-laced, yet it is discreet. It is not showy, yet it is inventive. . . . Ingenious in its innovations, it does not draw attention to itself; it has a feeling for grace and beauty but a horror of ostentation; it is witty in design and in the lively orchestration of colors; and because it is witty it appears relaxed.[6]

Taste, timelessness, subtlety, and humor: Bidou's claim upon these qualities of the coveted *bon ton* suggests that the *Gazette* was to be no run-of-the-mill fashion tome. "Deliciously disguised as something antiquated," the magazine promised to show readers "how to live in a charming atmosphere, with a ravishing snobbism," and self-consciously mimicked the most elegant of its eighteenth- and early-nineteenth-century predecessors.[7] Like those earlier journals, the magazine relied on a variety of strategies to strike an elitist tone. Available by subscription only, at the considerable cost of 100 francs per year, its price alone guaranteed a certain prestige. In addition, the fashions depicted on the journal's pages could not be seen elsewhere, under the terms of the exclusive contracts Vogel established with seven of the city's top couture houses: Cheruit, Doeuillet, Doucet, Paquin, Poiret, Redfern, and Worth. To create a literary cachet, the *Gazette* cultivated well-known authors established in areas remote from fashion, including novelist Marcel Astruc, playwright Henri de Régnier, decorating authority Claude Roger-Marx, and art historian Jean-Louis Vaudoyer. In

their fetishizing and witty considerations of such weighty subjects as "Winter Hats" and "Hairstyles for Theater-going"—for such was the standard fare of the *Gazette*—these writers provided "an irreverent account of the latest creations, couched in somewhat mocking and ironic terms."[8] Above all, however, the *Gazette*'s high-toned sensibility was conveyed through its exquisite illustrations. Aiming to revive the French tradition of the finely wrought fashion plate, the magazine modeled its artwork on the illustrations of Pierre de La Mésangère's *Journal de Dames et des Modes*, and cited the careful depictions of clothing in paintings by Antoine Watteau, Sébastien Leclerc, and Gabriel de Saint-Aubin as validation of fashion's relevance to art.[9]

With its literary and artistic pretensions, the *Gazette* did far more than report on dress: the magazine viewed itself as a journal of taste and style, in which visual art was featured and fashion served as a centerpiece. From its focus on the minutiae of dress to its whimsical and one-of-a-kind illustrations, the magazine conveyed an artistic tone and an aristocratic aura that firmly distinguished it from the ever-burgeoning ruck of fashion periodicals.

## PRIVILEGE AND PRIMITIVISM: THE BALLETS RUSSES AND THE *BON TON* FASHION PLATE

The *bon ton* tastemaking of the *Gazette* was brought to bear with special force on matters of culture, which the magazine promoted as a key element of its idealized lifestyle. A feature entitled "Le Goût au Théâtre," for example, written by critics René Blum and Lise-Léon Blum—the brother and wife, respectively, of future French Prime Minister Léon Blum—promised to capture "the grace of our present age . . . in the woods and theaters, on the racecourses, at tea parties, at dinner or at balls." In their eclectic and unconventional reports, covering everything from lowbrow vaudeville acts to performances of classical theater at the Comédie-Française, the Blums declined to pass "categorical judgments about intrinsic merit," as arts reviews typically did, but instead offered "rapid remarks" about the "diverse elements that constitute an artwork." In lieu of critiquing a work or performance, they instead aimed to register its immediate impact, or more specifically, the impression created while there is a "misunderstanding between . . . feelings and intelligence," before one's "critical sense has a chance to be engaged."[10]

This was a brilliant approach, for it allowed the *Gazette*'s critics to steer clear of technical discussions, thus remaining accessible to the audience of aficionados and aristocrats who both patronized Parisian entertainments

and purchased the magazine. Largely nonjudgmental about works or performances, the Blums instead exercised their snobbism by limiting their purview to artworks they perceived to be stylish and au courant. Gossipy and entertaining, their columns exuded an elitism that stemmed not from intellectual or analytical authoritarianism but rather from the simple association of culture with the broader world of fashion and its dictates.

The *Gazette* arrived on newsstands just as Parisians were obsessed with a cultural phenomenon perfectly suited to this fashion-conscious approach, namely, the Ballets Russes. Promoting a decorative and cosmopolitan aesthetic that, in Cocteau's words, "splashed all Paris with colors," Diaghilev's troupe had since its inaugural season in 1909 offered up a heady mix of fashion, spectacle, and scandal to a cultivated and well-heeled audience that sought in turn to imitate the Ballet's sensibility in everyday life.[11] There was much to assimilate; as the keen fashion observer Cecil Beaton reported, a "world that had been dominated by corsets, lace, feathers, and pastel shades soon found itself in a city that overnight had become a seraglio of vivid colors, harem skirts, beads, fringes, and voluptuousness."[12] The Ballets' admiring audience, as has been noted, looked not only to the stage but also to the upscale fashion press for guidance about just how to adjust to these trends, and after 1912 turned to the *Gazette* for the most rarefied and sophisticated perspectives.

Seizing on the similarity between its own editorial agenda and the Ballets' glamorous meshing of fashion and art, the *Gazette* reported faithfully on the troupe's performances. By the time of the magazine's founding in late 1912, the Russian dancers had already provided fodder for a range of fads that had taken the city by storm, creating a craze for the French rococo with *Armide* (1909); intensifying the Parisian taste for orientalism in the extravagant displays of *Cléopâtre* (1909), *Schéhérazade* (1910), and *Le Dieu bleu* (1912); participating in the revival of interest in antiquity with *Narcisse* (1911), *L'Après-midi d'un faune,* and *Daphnis et Chloé* (both 1912); and offering up *commedia dell'arte* fare in *Carnaval* (1909) and *Petrouchka* (1911). As Joan Acocella has observed, these ballets intrigued Diaghilev's upper-class audience not only because they represented a rejection of bourgeois values, but also because their subjects—*femmes fatales* and androgynous boys, Pierrots and Harlequins, characters from history and mythology—were familiar figures from fin-de-siècle art and literature.[13] Teeming with pashas, sultanas, *bayadères,* and other imagined exotics, Diaghilev's ballets appealed to contemporary Parisians in much the same way as Poiret's orientalizing fashion designs, tapping a French fascination with the East that dated back centuries.

The *saison russe* of 1913, the first covered by the *Gazette,* abruptly broke with this successful formula. Of the Ballets' three new works that year, only *The Tragedy of Salomé,* with music by Florent Schmitt, remained in the tradition of Diaghilev's decorative spectacles, while *Jeux,* with music by Claude Debussy, and *The Rite of Spring,* with music by Igor Stravinsky, introduced radically new aesthetic idioms. At one extreme, *Jeux* celebrated sports and other pleasures of the contemporary *beau monde,* right down to its costumes, which were created by the Bakst-Paquin team; at the other end of the spectrum, *The Rite of Spring* imagined a past that was both mysterious and remote. The shock of these subjects was reinforced by Vaslav Nijinsky's radical choreography, and even by the venue in which they were presented—the newly opened Théâtre des Champs-Elysées, which sparked its own controversy because of its supposedly "Germanic" architecture.[14]

The *Gazette*'s critics registered the dilemma posed by these productions, and in particular by the *Rite of Spring*: simply put, how could the primitive sensibilities of these ballets be reconciled with their appeal to refined and cultivated Parisians? Soon after the premiere performance of the *Rite,* Lise-Léon Blum noted this tension, reporting that the work's "equally sensational and bizarre" decors, choreography, and music left the audience "divided by two contrary currents," which "led to polemics and quarrels." But she hedged the question of the work's appeal, noting only that she was uncertain if the *Rite* was "absurd and forgettable" or the harbinger of "a new stage in our taste," leaving readers to mull it over simply as a "dangerous moment in our aesthetic culture."[15]

A year later, however, as the Ballets Russes became ever more popular with elite Parisian audiences, she returned to the subject, venturing an explanation. "The Russians are back," Blum proclaimed, "and still we do not tire of them":

> Perhaps it is because they confuse us. . . . Nothing is more foreign to our senses than these violent outbursts, frenzied and intensive dances, instinctive candor and unbridled fantasy. . . . The simple truth is that the Russians enchant us because they excite us. They are a young race welcomed to the ancient city, the beautiful stranger taking her place by the family hearth. And those who like them best are the most cultivated and the most jaded.[16]

"Foreign," "violent," and "frenzied," the Ballets Russes, Blum maintained, held a powerful attraction for even—and perhaps especially—the most erudite balletomanes, precisely because their productions laid bare the conflict between the sensual and intellectual dimensions of artistic expression.

This blend of primitivism and sophistication, she hinted, gave the Ballets Russes its appeal, but it could only go so far: in her view Diaghilev's troupe could never compare with sophisticated French ballet, no matter how fully its raw expression was tempered by a refined approach. "The Russians are children at play," she opined, "and their games are not our own."[17]

## THE BALLETS RUSSES AND THE *BON TON* FASHION PLATE

Rare was the review of Diaghilev's troupe that appeared in the *Gazette* without artwork. In depictions that ranged from small line drawings to elaborate full-page plates, the magazine's illustrators reproduced the bold colors and elaborate designs of the Russian productions, transferring the intensity of Diaghilev's spectacles onto the printed page. A review of dancer Tamara Karsavina's performances in *Le Coq d'or* and *Midas* in July 1914, for example, was matched with a series of lavish illustrations tipped in silver and gold, while André Marty's renderings of scenes from the *Rite of Spring* in the same issue of the magazine evoked the vibrancy of the costumes and decors, the essence of choreographic moments, and the fashionability of the glittering audience gathered at the Théâtre des Champs-Elysées.[18]

Nowhere was the mutually reinforcing nature of Diaghilev's enterprise and Parisian fashion made clearer than in the *Gazette*'s fashion plates, which adopted the Russian Ballet's bold palette and reductive backdrops to depict couture ensembles inspired by the same Eastern and classical themes that animated the troupe's productions. Georges Lepape's fashion plate entitled "Am I Early," published in the *Gazette*'s second issue, illuminates the connection. Showcasing a couture evening coat, its central character is a woman taking her seat in an elegantly appointed—and nearly empty—theater, perhaps even the site of a Ballets Russes production. Outfitted in an oversized kimono-style wrap and a jeweled turban topped with an extravagant plume—perfect examples of Poiret's *style sultane*—she wears heavy makeup that distorts her features and suggests an orientalizing mask. The mustard, emerald, and fuchsia tones of her ensemble vibrate on the page, and are matched in the fantastical depiction of the theater itself, with its yellow and orange seats and bright pink railings. Completed in late 1912, the scene suggests the general sensibility of the Ballets Russes and evokes with particular clarity the exotic world and stunningly aggressive color scheme of *Schéhérazade*.

Lepape's plate was typical of the illustrations created by the team of artists Vogel recruited to his magazine, which also included Charles Martin,

FIGURE 20. Georges Lepape, "Serais-je en avance?" from *Gazette du Bon Ton*, 1912

Pierre Brissaud, Bernard Boutet de Monvel, Georges Barbier, and André Marty. Nicknamed the "Beau Brummels of the Brush" because of their own dandified manner, these "gilded youth of Paris" were recognized for making the leap from fine art to fashion. As *Vogue* magazine reported in 1914:

> It is not so very long ago that for an artist, one who had made a serious study of the very foundations of art, to have stooped to dabble in a thing so materialistic as the fashions, or to have mixed the colors of his palette for a scheme of interior decoration, would have been considered a profanation of his talent. But today, not so! Art has come down from its heights and decided to carry off with it the fascinating damsel Fashion to join in its gay revels and even play for it the Muse.[19]

*Vogue* noted that these "young men of birth and Beaux Arts training," were all students of Fernand Cormon, a conservative artist best known for his huge paintings depicting stone-age landscapes and biblical subjects.[20] Though he would seem an unlikely tutor of modernism, Cormon's students at the Ecole des Beaux-arts (where he served as president) included Henri de Toulouse-Lautrec, Vincent van Gogh, Henri Matisse, and Francis Picabia, as well as the so-called Beau Brummels. Though far less well known

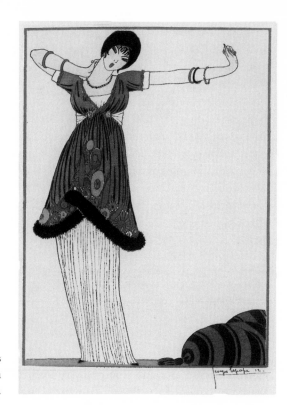

FIGURE 21. Georges
Lepape, "Lassitude," from
*Gazette du Bon Ton,* 1912

than their confreres, the illustrators advanced a distinctive brand of avant-
gardism grounded in the connection of modernist art and high style, and in
*Vogue*'s words, "made fashion the art of the day instead of art being the
fashion."[21]

Vogel made fashion plates the *Gazette*'s centerpiece: ten full-page illus-
trations ran in each issue, seven of which depicted couture ensembles, while
the remainder presented imaginative and fantastical designs inspired by
the clothes but "invented by the artists themselves."[22] Produced, like the
illustrations in Poiret's earlier catalogs, as boldly colored *pochoir* prints,
each of the *Gazette*'s hand-colored plates had a theatrical quality, suggest-
ing a witty scenario or small narrative, and each included a caption that
cleverly communicated the essence of the moment depicted. Lepape's illus-
tration of a Poiret dinner dress, published in the *Gazette*'s first issue, is typ-
ical: the model, dressed in an orientalizing gown and a stylish turban,
extends her arm and rubs her neck as she leans to one side, luxuriating in

the physical stretch, and the sensibility of this private and indulgent moment is captured in the illustration's one-word caption—"Lassitude."

Following traditions of the fashion press, Lepape and his colleagues portrayed women in social settings and at sporting venues, at home with children or pets, and out of doors in parks or gardens, and alluded to subjects from mythology, history, and literature. But they updated this iconography by exploiting the prevailing taste for orientalizing themes and scenes from the Italian *commedia dell'arte*, by portraying women in modern milieux, including the golf course and tennis court, and by providing glimpses of automobiles, airplanes, steamships, and other marvels of contemporary technology. As these classically trained illustrators recognized, however, the settings were not the only aspect of the fashion plate in need of a makeover: aiming to capture the spirit as well as the fashion of the age, they turned to the fine arts for inspiration.

## CUBIST CHIC

For the *Gazette*'s illustrators, artistic modernism provided a crucial link between haute couture and high culture, and Cubism was the style that proved most influential. Beginning in early 1914, only a short time after Cubism made its public debut at the Salon d'Automne, the *Gazette*'s artists adapted its multiple perspectives and geometric shapes for use in their fashion plates. The need to portray details of the garments being depicted remained a consideration, however, dictating that the connection to realism never be entirely severed, and thus resulted the softened and repackaged version of Cubism that came to be known as the "Art Deco" style after World War I.[23] From Lepape's depiction of a coat by Poiret in the plate entitled "Dancing" (1920), which features striking angular shapes and linear exaggerations while remaining largely realistic, to the game of lines and images in the depiction of a Madeleine Vionnet dress in the plate "De la fumée" (1922) by Ernesto Michaelles (better known by the pseudonym Thayaht), Cubism marked the *Gazette*'s plates.

The "Beau Brummel" illustrators absorbed more than just the angular style and fractured perspectives of Cubism; they also adopted its irreverent stance and engagement with everyday culture. A vehicle for parody, irony, and satire, Cubism was from the outset a locus for the witty interplay of high and low, exemplified by the collage and *papier collé* works of Picasso and Braque, which explicitly brought popular culture into the domain of "serious" visual art by incorporating phrases, headlines, letters, and illus-

FIGURE 22. Georges Lepape, "Dancing,"
from *Gazette du Bon Ton*, 1920

trations cut from daily newspapers and placed directly on the canvas. Hardly haphazard, these cutouts often created visual and word-based puns and double entendres. One of Picasso's favorite puns, for example, involved chopping the standard of the daily paper *Le Journal* to read "Le Jou," opening a double allusion to the French words *jouer*, "to play," and *jouir*, "to derive sexual pleasure," and signaling the fact that collage itself involved an epistemological game. As art historian Kirk Varnedoe noted, such wordplay, despite its "parallels in an unexceptional branch of French schoolboy wit," had broader implications, functioning as one of the "central elements in the innovative force of the art," important "not despite [its] commonplace nature but because of it."[24]

One "everyday" source for the witty approaches Picasso and Braque brought to the fore in their early Cubist works was the Parisian satirical press, where many artists, including Picasso, Marcel Duchamp, and the *Gazette* illustrators Iribe, Martin, and Lepape, began their careers as cartoonists.[25] In newspapers and journals such as *Le Rire* (established 1894) and *Le Sourire* (established 1899), topical cartoons on social, political, and moral themes proliferated. The relationship between these cartoons and the *Gazette*'s fashions plates is striking: above all, the *Gazette*'s plates follow the format of the cartoons, providing a witty caption for each image

FIGURE 23. Thayaht, "De la fumée," from *Gazette du Bon Ton*, 1922

rather than following the fashion press convention of including a dry description of the garment being depicted. In addition, they adopt the visual puns characteristic of the cartoons, as can be readily seen by comparing a full-page cartoon by Martin, which was published in the January 1911 issue of *Le Sourire*, with a fashion plate he created for the February 1913 issue of the *Gazette*. In the cartoon, two elegantly dressed and seemingly disengaged women take aperitifs at a bar, and the caption reads, "Lily? Yes dear, she has married: she is *empoisonnée*." The last word of the text creates the pun: *empoisonnée* can mean "poisoned," or, more colloquially, "bored," and clearly the intention here is to invoke the double meaning to humorous effect. The wit is simple and yet urbane, reliant not only on wordplay but also on evocations of class and social convention, and the effect is heightened by the stylish portrayal of the characters and milieu. Martin has even drawn one of the dresses to recall a fish tail, adding another level to the pun by suggesting the homophone—*poisson*, or "fish."

Like the cartoon, a fashion plate by Martin that appeared in the October 1914 issue of the *Gazette*, depicting a dress by the couturier Redfern, relies on a visual pun: by exaggerating the sinuous qualities of the garment's

FIGURE 24. Charles Martin,
cartoon from *Le Sourire,*
1911

shiny green fabric, slinky train, fitted hood, and scale-like closures, Martin
portrays the model as a modern-day Eve in the Garden of Eden. A woman
clothed as a snake, she is both victim and protagonist, sniffing the fruit on
the tree with a sensual self-satisfaction while a partly eaten apple, lying
conspicuously in the foreground, fixes the moment after the fall. The joke
is heightened by the caption, "De la pomme aux lèvres," which embeds
multiple wordplays: while in a straight reading the phrase translates as
"From the apple to the lips," in French slang the word *pomme* connotes a
stupid or naïve person, while *lèvres* can be translated not only as "lips" but
also as "crevasse " or "fault line." The caption thus puns cleverly on Eve's
naïveté and the resulting fall of man.

In even more elaborate fashion, Léon Bakst's illustration of the dress
captioned "Philomèle," which appeared in the *Gazette*'s April 1913 issue,
invokes sophisticated allusions and creates a moment of theater in which
the Greek myth of Philomela is revealed to be inscribed in the clothing
design itself. The familiar myth mixes tragedy with the macabre: raped,

FIGURE 25. Charles Martin, "De la pomme aux lèvres," from *Gazette du Bon Ton,* 1913

mutilated, and imprisoned by her sister Procne's husband, King Tereus, Philomela—whose tongue was cut out by the king to prevent her from reporting his crimes—documents his transgressions in a tapestry, sends it to Procne, and with her sister murders Tereus's son Itys. The two women feed the corpse to the unsuspecting king; he initiates a pursuit that ends in the transformation of all three into birds, with Philomela becoming a nightingale. Bakst's illustration emphasizes qualities of the dress that evoke aspects of the myth, from the tongues of kid leather that dangle from the tight waistline and the tongue of ribbon that flies away from the mannequin's bonnet, to the overall binding of the dress, which extends from the high neckline through the bodice and cinched waist to the leather forearms, and the remarkably narrowed hem of the hobble skirt—which in its own right seems to represent a tongue. For the *Gazette*'s insider audience, the simple caption "Philomèle" unlocks the theatricality held within the stiff and seemingly formulaic pose of the mannequin, making these connections readable, and the sense of play is only heightened by the model's delicately drawn, closed-mouth features.

FIGURE 26. Léon Bakst,
"Philomèle," from *Gazette
du Bon Ton,* 1913

## STYLE À LA SATIE

The *Gazette du Bon Ton* made a strong and arguably unprecedented con-
nection between fashion and visual art, which was manifested in its illus-
trations and overall design as well as in its elegant tone and sophisticated
content. An influential model for the fashion press, it introduced new
approaches and methods in illustration that changed the industry. Yet, it
did not print musical scores, and its coverage of music was sketchy at best.
What, then, was the *Gazette*'s relevance for modernist music? In short, the
magazine provided the inspiration for an extraordinary composition that
introduced an entirely new musical aesthetic based in the feminine world
of the fashion magazine, namely, Erik Satie's *Sports et divertissements.*
Composed in 1914, this work brought music and fashion together on the
ground of modernism, establishing a foundation for the development of a
fresh and distinctively French musical style and bringing a *bon ton* sensi-
bility to the musical sphere.

Satie, whose own offbeat sartorial sensibilities are the stuff of legend, would seem an unlikely interpreter of high fashion. At his most conventional, as a student and struggling composer in fin-de-siècle Montmartre, he wore a Bohemian costume, a look captured by his lover, the painter Suzanne Valadon, in a portrait done just before the end of their affair in 1893. As the leader of his own church—the Eglise Métropolitaine d'Art de Jésus Conducteur—later that year, he wore priestly cassocks and sober vestments. In 1895, coincident with the demise of his church, he purchased seven identical maroon suits, complete with matching caps, and wore them for the following seven years, earning the nickname "The Velvet Gentleman" in the process. Finally, in 1906 he settled on the bureaucratic style that that would remain definitive until his death in 1925, dressing in dark suits and wing collars, and accessorizing the look with a bowler hat and walking stick, looking, in the words of his first biographer, Pierre-Daniel Templier, more like a "quiet school teacher" than an avant-garde composer.[26]

Satie's lifestyle, at least through the 1910s, was likewise remote from the pursuits of the *beau monde*. Impoverished during much of this period, he inhabited a series of ever smaller and progressively more rundown apartments on Montmartre, finally settling in a single room in an industrial building in the seedy eastern suburb of Arceuil in 1898. Once relocated, he affiliated himself with the unfashionable political left wing, joining the Socialist Party on 31 July 1914—the day that party leader Jean Jaurès was assassinated. A self-described "Old Bolshevik," he was preoccupied in these years with matters other than those of style, including schoolwork: in 1905, nearing age forty and describing himself as "tired of being reproached with an ignorance I thought I must be guilty of," Satie had enrolled in composition and counterpoint courses at the Schola Cantorum, the Parisian music academy founded in 1894 by Vincent d'Indy, Charles Bordes, and Alexandre Guilmant.[27] Over the next seven years, while working by day on the chorales, fugues, and other academic exercises required for his diploma, he eked out a living by night playing piano in Parisian cabarets and music halls, employment he later denounced as "more stupid and dirty than anything."[28]

In 1913, a year after completing his studies at the Schola, Satie met the woman who would provide him entrée into the world of high style. Valentine Gross (1887–1968) was one of the few female members of the art staff at the *Gazette du Bon Ton,* hired after sketches she made during the rehearsals for *The Rite of Spring* caught the eye of Lucien Vogel's father-in-law, Maurice de Brunhoff. During the war, while her male colleagues were away from Paris, she became one of the magazine's featured artists, pro-

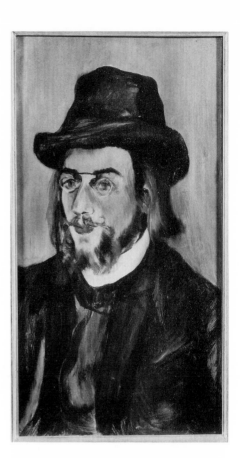

FIGURE 27. Suzanne Valadon,
portrait of Erik Satie, ca. 1893

ducing small designs and full-page plates for the publication. Gross and
Satie met at about the same time she became affiliated with the *Gazette,*
and while the details of their first encounters are lost to history, the two
obviously became fast friends. By October 1913, Satie was referring to her
as "one of the good ones" and dedicating his children's pieces *Menus pro-
pos enfantins* to her, while, for her part, Gross was working her magazine
connections on his behalf.

Among the potential patrons to whom Gross introduced Satie that year
was Vogel, and in 1914 the publisher offered him the commission for a
work on themes of fashion, which was to be titled *Sports et divertisse-
ments.*[29] Legend holds that Vogel first offered Igor Stravinsky the project
but, unable to meet the composer's fee, he turned to Satie—who when
offered a smaller sum refused at first, fearing that such a large commission

might be compromising. Although colorful, this scenario runs directly counter to the reality of Satie's vigilant attention to his finances, a trait evident even on the pages of the sketchbooks for *Sports et divertissements*, where the composer meticulously recorded Vogel's installment payments on the commission. Amounting to the handsome sum of 3,000 French francs, it was the largest payoff that Satie had ever received for one of his works.

Vogel's investment funded an extraordinary and category-defying work that celebrated and cemented the relationship between music and fashion in the early twentieth century. With its mix of piano pieces, texts, graphic designs, and color illustrations, *Sports et divertissements* is nothing short of a musical adaptation of the fashion magazine, complete with up-to-date illustrations depicting the latest styles. Even its title originates in the fashion milieu: the phrase "sports et divertissements" was a widely used slogan designed to attract upscale tourists to trendy resorts and it can be found in advertisements published in popular women's magazines from the 1910s onward. The work's twenty brief multimedia compositions take as their subjects the pastimes of contemporary Parisian society, ranging from real sports, such as tennis and golf, to social sports, such as flirting and dancing the tango. In its format, too, the musical album is inspired by the fashion press: just as the fashion magazine relies on the simultaneous presentation of interconnected texts and images to convey its messages, so *Sports et divertissements* depends on correspondences among art forms, adding music to the established mix. Each of its subjects is represented by a title page with a small design encapsulating the topic; the reverse side of this page contains Satie's score, which combines music and texts; and the page facing the score contains a full-page color illustration of the theme.

The focus on style in *Sports et divertissements* clearly reflects Vogel's role in the creative process. Before founding the *Gazette,* he had become attuned to the rising popularity of leisure activities among well-heeled women, and had begun to publish semi-annual issues of his magazines dedicated to seasonal amusements—and the wardrobes they required. These special issues, combining articles on the latest trends with photographs and illustrations of stylish women enjoying the amenities of preferred resorts, reinforced the seasonal cycle of fashion and became a convention of the mainstream fashion press. The leading periodical in this market was *Femina,* where Vogel served on the editorial team up to 1909, and its issue for Spring 1913 is exemplary of the new approach. Devoted to "fashion, sports, and outdoor pleasures," the magazine advertised its focus on "games and outdoor life" and promised coverage of "le footing"—the

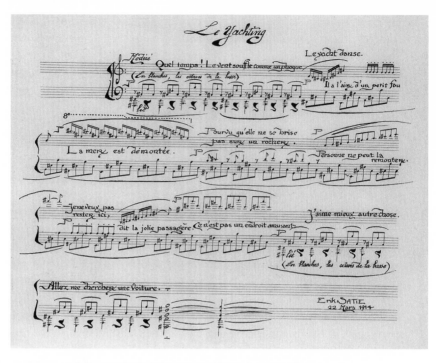

FIGURE 28. Erik Satie, "Le Yachting," 1914, from *Sports et divertissements*

FIGURE 29. Charles
Martin, design for
"Le Yachting," from *Sports
et divertissements*

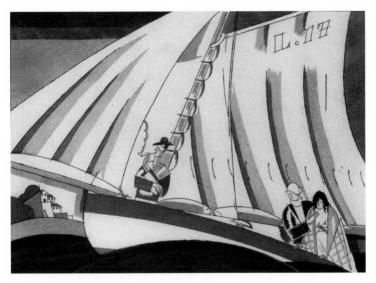

FIGURE 30. Charles Martin, illustration for "Le Yachting," 1922, from *Sports et divertissements*

daily promenade in the Bois de Boulogne that was de rigueur—as well as "tennis, golf, the horses, yachting, climbing: all the sports in which the modern woman freely gives reign to activity and grace." With a woman golfer as its cover girl, the issue reported on sports and entertainments including "races, garden parties, parties day and night." These activities were evoked "with pencil and paintbrush by the masters of the genre," and the issue was "rounded out" with "beautiful photographs" and a series of "documentary articles," each written by a woman and devoted to an individual sport or pastime.[30]

These special issues of *Femina* served as the specific model for *Sports et divertissements*, as a comparison of the musical album's table of contents and the Spring 1913 issue of the magazine reveals. The two publications share subjects, including tennis, golf, yachting, horse racing, outdoor parties, and evening balls, and like the magazine, *Sports et divertissements* treats the subjects separately, as "Le Tennis," "Le Golf," "Le Yachting," and so forth. Even the visual presentation of these topics in the musical score mirrors the magazine model: *Femina*'s elaborately scripted titles, each embellished with an emblem of the activity at hand, are echoed in Satie's careful calligraphy and in the small abstract designs associated with each subject.

FIGURE 31. Table of Contents, *Femina,* Spring 1913

While its format derived from *Femina, Sports et divertissements* un-
questionably adopted its design features and sophisticated tone from the
*Gazette.* Like Vogel's magazine, the musical album makes its first impres-
sion as a luxurious, collectible portfolio: it is oversized at approximately
seventeen inches square, covered in fine paper, and backed by flyleaves in
an Art Deco print extolling the virtues of "love, the greatest of all games."
Produced as an unbound folio, the album opens to reveal a stylized title
page featuring an icon of leisure and fashionable decadence—a modern
odalisque. Satie's score appears in lavish facsimile; the musical notation is
dramatic and flowing, with notes in black on red staves. No bar lines inter-
rupt the visual effect, and the text, in Satie's elegant calligraphy, is pur-

FIGURE 32. Table of Contents from *Sports et divertissements*

posefully placed on the page so that it may be read—but not sung or spoken—along with the music.

The ironic wit characteristic of the *Gazette* is reflected at the outset of the work, in Satie's preface, which is also written in careful calligraphy and reproduced in facsimile. Laden with puns, his brief text advises readers to "leaf through the book with a kindly and smiling finger," and warns off deeper analysis with the admonition, "Don't look for anything else here." Accompanying this commentary is a brief composition, the *Unappetizing Chorale*, which Satie notes was composed "in the morning, before breakfast." His preface elaborates on his intentions:

> For the shriveled up and stupid I have written a serious and proper chorale.
>
> I have put into it all I know of boredom.
>
> I dedicate this chorale to all those who do not like me.
>
> I withdraw.

Satie's use of a chorale to introduce a work devoted to fashionable themes is deliciously ironic; few genres could be more antithetical to the pursuit of stylish pastimes than this symbol of Protestant piety and music pedagogy. Informed by his intensive study of counterpoint at the Schola Cantorum, the piece is a crafty parody of the chorale tradition, bearing closest resemblance in its rhythmic and melodic contours to the chorale "Herr Gott, dich loben alle wir." Satie seems to have modeled his humorous version of the chorale most closely on Bach's four-part setting of the tune (BWV130),

# Le YACHTING

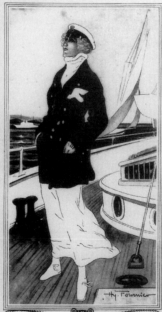

Qu'y a-t-il de plus joli qu'une goélette marchant « au plus près », bien gréée, couverte de toiles blanches, portant ses focs, ses flèches, ses hautes et précises voiles gonflées d'air et coupant l'eau bleue d'une étrave onduleuse?

N'y a-t-il pas toute la grâce d'un corps féminin dans les lignes de la coque, lignes plus nourries dans le yacht de croisière que dans celui de course, mais si fines encore, à peine coupées par des garde-corps aussi invisibles que possible.

Dans le petit bateau pour les sorties quotidiennes, ce que les Anglais appellent le « day-boat », il n'y aura, la plupart du temps, qu'un « cockpit », sorte d'ouverture dans le pont, garnie de banquettes et de coussins ; la sortie n'ayant lieu que le temps au beau fixe, nulle pluie, nul orage n'est à craindre ; assises presque au ras de l'eau si nous le voulions, nous laisserions, en nous penchant, traîner notre main dans le sillage écumant.

Il faut arriver à 20 tonneaux au moins pour avoir une véritable chambre-salon et toutes les dépendances indispensables ; à 40 tonneaux, on pourra posséder un salon et quelques chambres pour loger ses amis.

**LA TENUE DU YACHT** C'est alors que peut commencer à régner l'élégance et que les lois du « chic » entrent en scène.

De la boiserie, de la boiserie: pas de tentures, pas d'étoffe : c'est le thème ; tous les bois peuvent être mis à contribution ; la symphonie des jaunes et des ocres empruntés aux frênes, aux érables, aux platanes ou aux bois précieux, s'épanouit en de larges marqueteries ; le vernis scintille dans l'ombre ; les ferrures et les cuivres, ces joies de l'œil, lancent leur note claire. Condamnons les capitonés, vouons à la réprobation ces innombrables coussins dont s'encombrent les improvisées « yachtwomen ».

Les cuirs doivent régner en maître, les peaux de truie recouvriront les sièges.

**LE COSTUME DE LA YACHTWOMAN** La question du costume est des plus simples : l'uniforme est de rigueur, la fantaisie est admise juste ce qu'il faut pour que chaque femme puisse témoigner d'un peu de personnalité. Deux seules couleurs sont admises dans la symphonie bleue et blanche de la mer et du ciel, et ces deux couleurs sont évidemment le blanc des nuages, des mouettes et de l'écume, le bleu des flots et des lourdes mers d'orage. Blanches ou bleues nous ne pouvons paraître autrement sur le royaume d'Aphrodite.

Donc, costumes de lainages, de flanelle, de serge, de ratine, soyez les bienvenus, car vous seuls êtes de mise. Que les jupes, soient plates et droites, que les jaquettes soient sobres et nettes : la mer ne s'encombre pas de dessins et de fioritures : elles n'offre que des lignes adorablement claires ; soyons comme elle, essayons de lui ressembler. Et si le vent s'élève, que le grand manteau de ratine blanche ou bleue, tombant jusqu'à terre et affectant l'allure des manteaux d'officiers de marine vienne à notre secours et que dans l'ombre de la nuit qui tombe, accotées sur la lisse, nous disparaissions dans le noir, sans pensée, sans désir, heureuse de participer au néant merveilleux de l'heure.

Qu'un chapeau de feutre blanc recouvre nos cheveux ou adoptons la casquette de yachtman si nous voulons jouer à l'homme. Auréolons notre figure d'un voile de mousseline et n'oublions pas autour de notre chemisette la ceinture de daim blanc sur laquelle seront incrustés le pavillon, la devise et le nom de notre bateau.

Ainsi, nous pouvons partir avec les vents du sud ou ceux du nord; nous pouvons aller chercher les brises favorables et si le cœur nous en dit, ou plutôt si le tonnage de notre yacht le permet, voguer, poussées par les vents alisés, vers le Pacifique immense et doux...

LILY JEAN-NOUGUÈS.

TENUE DE BORD. *L'uniforme est de rigueur : vareuse bleue, jupe blanche.*

FIGURE 33. Article on "Yachting," from *Femina*, 1913

adopting the same C-major tonality and triple meter as well as Bach's tendency toward melodic descents at cadence points, but subverting each of these qualities by adding dissonance, complicating the cadential figurations, and reworking the triple rhythm to evoke the patterning of a sarabande. "My chorales," he wrote in the preface to his earlier *Choses vues à droite et à gauche,* "equal those of Bach with this difference: there are not so many of them and they are less pretentious."

## MAGAZINE AESTHETICS AND THE MUSICAL SCORE

The score for *Sports et divertissements* is a work of art in its own right, but the illustrations seal the identification with the *Gazette:* brilliantly colored *pochoir* plates, they are the work of Charles Martin, one of the magazine's prized Beau Brummel artists.[31] Born in Montpelier in 1894, Martin studied in Paris at the Académie Julian, the city's largest art school, before entering Cormon's studio at the Ecole des Beaux-arts. Affiliated with the *Gazette* from its inception in 1912, his contributions to the magazine, as well as to the French periodicals *Femina, L'Illustration des Modes, Les Feuillets d'Art,* and the American publications *Vogue, Vanity Fair,* and *Harper's Bazaar,* made him a key arbiter of sophisticated contemporary style. Also an important book illustrator, he produced plates for fine editions of classics such as Alfred de Musset's ten-volume *Complete Works* and Jean de La Fontaine's fables, and for erotic fiction, including Prosper Merimée's *Carmen* and Maurice Rostand's *Life of Casanova.* As the influential critic Léon Moussinac remarked in 1923, the "charm, fantasy, humor, and irony" of Martin's artworks made them perfect reflections of the times.[32]

During the war, while assigned to a camouflage unit at the front, Martin even created his own illustrated book, which documented life in the trenches in a series of original ink drawings and short poems. Entitled *Sous les pots de fleurs* and dedicated to his friends at the *Gazette,* the book was described by one of Martin's colleagues as containing "the most beautiful drawings inspired by the war; pictures in black and white of a gruesome truth, crossed by an arabesque of shells, where plumes of black unfold heavily."[33] Neither heroic nor abstract in approach, it stands as his singular, subtle, and almost entirely overlooked contribution to the literature of World War I.

Before and after the war, however, Martin's preoccupation was *Sports et divertissments.* In the spring of 1914, just after receiving the commission from Vogel, he produced one set of illustrations to accompany Satie's music and texts; the album was complete by summer, but never went to press

FIGURE 34. Charles Martin,
"Pauvre bougre!" from
*Sous les pots de fleurs,*
1917

FIGURE 35. Charles Martin, "Le Carnaval," 1914, from *Sports et divertissements*

FIGURE 36. Edward Steichen, "Pompon," costume by Paul Poiret, from *Art et Décoration*, 1911

because of the European conflict. On his return to Paris, Martin revisited the project and revised all the plates, updating them to capture the look of the new fashions of the day. In combination, the two sets of illustrations offer a unique perspective on the dramatic change in style and taste that occurred during the First World War and illuminate the significant social and cultural shifts that marked the period.

Because Martin's revised illustrations were used for the publication, the original plates for *Sports et divertissements* remain largely unknown. Representational and direct, these black-and-white line drawings convey with some precision the cutting edge of pre-war fashion. Poiret's designs dominate: the dress in "Carnaval," for example, is a rendition of his 1911 creation, "Pompon," while the women in "Feux d'artifice" wear the oversize kimono coats that Poiret began to popularize in 1908, including the model "Battick," recognizable by its ornamental tassels and extravagant drapery.[34] The women shown playing the game Quatre Coins in Martin's illustration even wear Poiret's controversial *style sultane* harem pants, and many of the

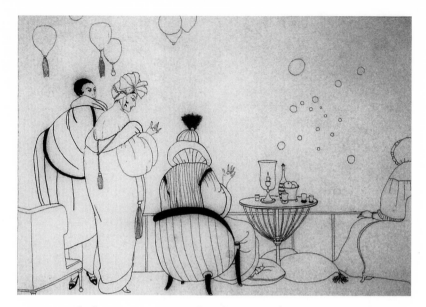

FIGURE 37. Charles Martin, "Le Feux d'artifice," 1914, from *Sports et divertissements*

mannequins are either coiffed in the latest head-hugging style or sport stylish turbans and close-fitting hats.

In contrast to this focus on Poiret, no single fashion designer is represented in the revised illustrations. Indeed, it is difficult to discern much at all about the clothing beyond a vague preference for shorter hemlines, fuller skirts, dropped waists, and see-through bodices. Instead of showcasing the clothes, these plates foreground the Cubist style of illustration that had come to dominate the *Gazette*'s fashion plates, building clothing into an overall scene that is rendered with fractured perspectives and geometric angularity. Making the connection between modern fashion and modern art, Martin's revised plates attest to the transformation of both clothing and modes of illustration between 1914 and 1922. More than a shift of style was at stake, however. Satie's score was not revised when the drawings were redone, and Martin's two sets of illustrations correspond with differing levels of immediacy to the events and images conveyed in the music and texts. *Sports et divertissements* thus exists in two distinct versions: in the original conception, music, text, and visual art are tightly integrated, while in the revised version a looser set of relationships among art forms prevails.

FIGURE 38. Edward Steichen, "Battick," evening coat by Paul Poiret, from *Art et Décoration,* 1911

Consider the case of *Le Golf.* Satie's score is built around a text that recounts a surprising incident on the course:

The colonel is dressed in shocking green "Scotch Tweed."

He will be victorious.

His "caddie" follows him carrying his "bags."

The clouds are amazed.

The "holes" are all trembling: the colonel is here!

Now he takes his swing:

His "club" breaks into pieces!

Long popular in Britain, golf had been introduced as a French pastime around the turn of the century, and discussions of the sport and the clothing appropriate for afternoons on the links quickly became standard fare for fashion magazines; an article in the July 1913 issue of the *Gazette* even noted the importance of a "Scotch tweed" outfit for stylish players. Martin's original drawing conveys the sense of chic that attached to the sport while faithfully portraying the details of Satie's narrative, depicting the

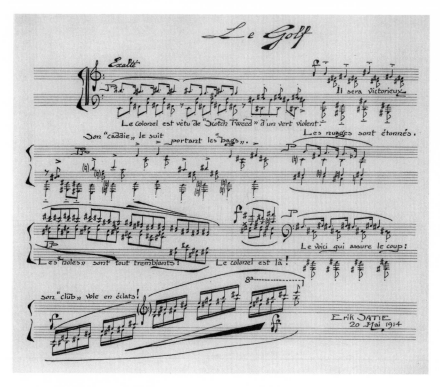

FIGURE 39. Erik Satie, "Le Golf," 1914, from *Sports et divertissements*

caddy standing by with a golf bag strapped across his chest as the colonel makes his shot and shatters his club. In the original conception, then, Martin followed the model of the *Gazette*'s fashion plates, illustrating the witty story suggested by Satie's composition as an up-to-date fashion scene.

By the time Martin revised the illustration, however, both the clothing and culture of golf had changed; attitudes concerning women's participation in the sport, in particular, had evolved. While female adepts of the game in 1913 were characterized by *Femina* as a small, "passionate clan" struggling with the rudiments of golf, the fair sex took so enthusiastically to the sport that by 1921 the magazine was sponsoring an annual national tournament for women with prizes including a silver cup, cash, and jewelry by Cartier.[35] Martin's revised plate for *Le Golf* takes account of these changes. While in the original illustration three well-dressed women watch passively from the sidelines as the drama of the colonel's breaking club unfolds, the later plate foregrounds a woman confidently selecting the club

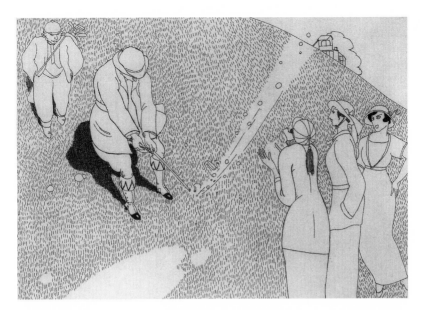

FIGURE 40. Charles Martin, illustration for "Le Golf," 1914, from *Sports et divertissements*

for her next shot as her male partner looks on. This revised illustration shows no direct connection to either Satie's music or his quirky text, but evokes in more universal terms the good life enjoyed by the upper class following the war.

The musical components of Satie's score further complicate the relationship between text and visual art. Adding a level to the illustration of the narrative, his compositions explicitly represent images of the text in sonic and graphic terms. In *Le Golf*, for example, the "trembling holes" are evoked by use of a descending chromatic scale; an ascending flourish based on unusual quartal harmonies and emphasized by a fortissimo dynamic marking provides a striking musical image of the breaking club. Satie meticulously coordinates these musical gestures to coincide with the corresponding bits of text, creating notation that provides a visual metaphor both for the shaking holes and the club breaking in the air.

Along with golf, ocean swimming became a major pastime for the French upper class in the first decades of the twentieth century. Perceived as a dangerous endeavor, it was initially attempted by only the most adventurous women. Satie's *Le Bain de mer*, which presents a brief dialogue between a man and woman, plays on this perception:

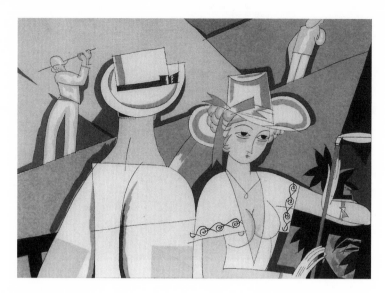

FIGURE 41. Charles Martin, illustration for "Le Golf," 1922, from *Sports et divertissements*

The ocean is wide, Madam.

In any case, it is deep enough.

Don't sit at the bottom.

It is very damp.

Here are some good old waves.

They are full of water.

You are all wet!

—Yes, sir.

Mimicking the ocean surf in his musical score, Satie creates a rolling bass line that extends across two octaves (G–g), rising and falling with wavelike regularity, and reinforces the ideogram with carefully placed crescendo and decrescendo markings. When he arrives at the word "deep," Satie shifts the pattern a semitone lower, to the axis of F-sharp, then falls deeply into the piano's lowest register just as the male in the text warns his female companion about sitting on the ocean's bottom. The right hand of the piano part contributes to the ideogram as well; the initial musical gesture, a motive comprising the notes C-sharp–B–E, is a miniature evocation of the same wave motion that is expanded in the left hand arpeggio, and the

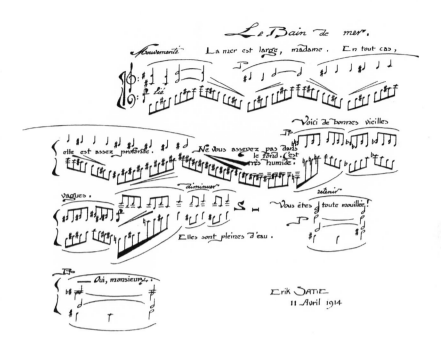

FIGURE 42. Erik Satie, "Le Bain de mer," 1914, from *Sports et divertissements*

melody that ensues is a long scalar ascent and descent in quarter notes, thus presenting the "wave" theme in augmentation, with adjacent pitches. Satie uses slurs, including one that is so exaggerated that it seems to extend off the page, to heighten this sense of motion.

As the piece continues, the text "Here are some good old waves" is punctuated by a climactic ascent in the bass, exaggerated by the heavy shading of the barred notation to suggest the crash of a major swell. The piece comes to an abrupt halt on a flamboyant rest, which is presented as a wave-shaped "S," before petering out with two almost motionless statements of the wave motif in the bass. This is finally reduced to a two-note cadential figure, which signals that the wave, depleted of its force, has at last hit the shore. Much as this notation reinforces the events of the scenario, Satie's music suggests an ocean swim with surprising clarity. The arpeggios simulate not only the motion but the sound of waves, with a crescendo at the crest of each rise and a diminuendo at each wake. The musical climax of the piece, keyed to the phrase "Here are some good old waves," corresponds to

FIGURE 43. Charles Martin, "Le Bain de mer," 1914, illustration from *Sports et divertissements*

the textual and notational high point of the composition, and the rests that follow create a startling articulation that approximates the moment of surprise—and possibly submersion—delivered by the pounding surf. The final gestures, calm and cadential, suggest the end of the excitement.

Just as Satie's composition clearly aims to evoke the events of the text in musical sound and graphic notation, Martin's original illustration depicts the scenario in straightforward terms. A man and woman stand in shallow water as a huge wave, which has already overwhelmed one man, builds behind them. Clearly frightened, the woman holds onto her companion as he smiles and appears to speak Satie's text into her ear, and as the surf is certain to overcome them the man's admonition—"Don't sit on the bottom"—belies his acute desire to fall into the water with his female friend. Martin's revised plate, however, has nothing to do with this story, but instead portrays a sleekly arched female figure in mid-dive. Having apparently come from nowhere, she is poised to enter not the water but the passing rowboat of a rather concerned-looking man. As in his later illustration for *Le Golf,* Martin here seems most concerned with conveying an overall sense of wit and contemporary style rather than the details of fashion or the essence of the vignette.

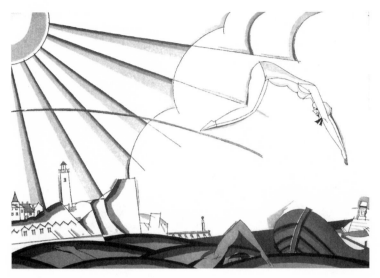

FIGURE 44. Charles Martin, "Le Bain de mer," 1922, illustration from *Sports et divertissements*

## THE VOGUE FOR DANCE

Among the diversions depicted in *Sports et divertissements*, social dancing holds pride of place, a position no doubt inspired by the Parisian dance craze that began just after the turn of the century. Fashionable women flocked to the dance floor in droves in these years; as *Vogue* reported in 1913, Paris was "dance-mad" in a way that recalled the arrival of the waltz in the city at the end of the eighteenth century, when "the Parsienne waltzed morning, noon, and night" in her high-waisted, corsetless "waltz" dress. In the early twentieth century, as we have seen, socialites donned Poiret's updated versions of those very designs; thus, in a very explicit way, dance and dress linked the city's new elites to their aristocratic ancestors.[36]

In *Sports et divertissements*, Satie casts a skeptical eye on this phenomenon by including among his twenty compositions three parodies of popular dances. In "Le Water-chute," the waltz is the focus of his humor. In the years around World War I this venerable dance was a vehicle for musical nostalgia in France (as epitomized in works such as Ravel's *Valses nobles et sentimentales*), as well as a locus for café-concert and cabaret humor, but its most popular incarnation was the *valse-chantée*, a sentimental song occupying the middle ground between these extremes. One of the best-known exponents of the genre was the music-hall star Paulette Darty, and

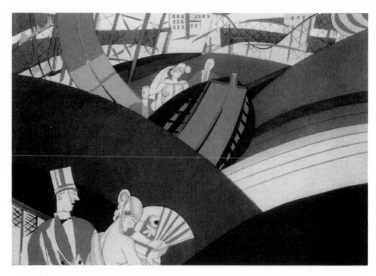

FIGURE 45a. Charles Martin, "Le Water-chute," 1922, illustration from *Sports et divertissements*

for this "Queen of the Slow Waltz" Satie composed one of his most popu-
lar and financially lucrative pieces, a sung waltz entitled "Je te veux." In "Le
Water-chute," references to the *valse-chantée* are evoked in a short waltz
that describes in musical terms the sensation of riding on one of the water
roller coasters new to popular Parisian amusement parks around 1910.
Using the familiar triple rhythms and sweeping melodic gestures of the
dance to create a sense of expectant pleasure as the car slowly ascends to the
ride's peak, Satie breaks abruptly from the pattern to mark the sense of
breathless pleasure at the moment of arrival, then represents the shocking
plunge with a long descending-scale pattern.

In "Le Pique-nique," the model is the cakewalk, the syncopated dance
commonly associated with American plantation culture.[37] Believed to be
related to the practice of allowing slaves in fancy dress to strut in front of
their owners in imitation of rich whites, the dance itself was based on a
European quadrille and was spread through the United States by black
entertainers who migrated to cities in the North following the Civil War.[38]
Imported to Paris around the turn of the century, the dance captivated the
city after John Philip Sousa's band performed cakewalk tunes at the Uni-
versal Exposition of 1900.[39] Satie's first interpretation of the dance fol-

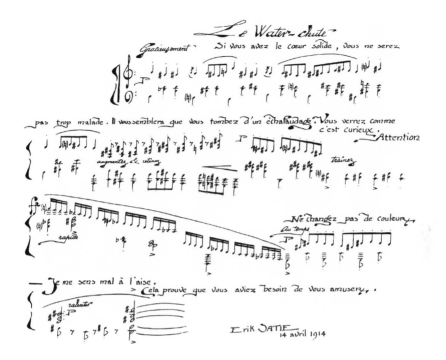

FIGURE 45b. Erik Satie, "Le Water-chute," 1914, from *Sports et divertissements*

lowed shortly thereafter, in the form of an "American intermezzo" entitled "La Diva de l'Empire," which he composed for Darty in 1904. As he worked on *Sports et divertissements* in 1913, however, the cakewalk was nostalgic, long displaced in the public imagination by more modern steps, and in "Le Pique-nique" he played on the sense of anachronism associated with the dance on the eve of the war, moderating the original syncopations and emphasizing instead a mildly rhythmic melodic line.

The most thoroughgoing of Satie's dance parodies occurs in "Le Tango (perpétuel)." Commenting ironically on the Parisian craze for the tango, which erupted around 1912, Satie suggests the tedium of the dance in the smirking aside, "perpetual," as well as in his performance indication—"moderately, and with great boredom"—and the repeat sign that appears at the end of the piece, suggesting that it be repeated ad infinitum.[40] His text likewise mocks the commonplace association of the dance with lascivious decadence:

The tango is the dance of the devil.

It is his favorite.

He dances it to cool down.

His wife, his daughters, and his servants cool themselves down that way.

To match the subversive tone of this text Satie creates a tame musical rendition of the dance, invoking its characteristic rhythmic pattern while playing on the tango's diabolical allusions by crafting the score around tritone relationships, thus repeatedly invoking the notorious and traditionally avoided *diabolus in musica.*

"Le Tango (perpétuel)" provides especially clear evidence of the connection between *Sports et divertissements* and the fashion press. The height of style in pre-war Paris, the tango infiltrated everyday life, inspiring new dress styles that allowed the freedom of motion essential to the dance and even motivating the creation of a new color—a burnt-orange hue named "tango." Emerging from the slums of Buenos Aires around 1870, the dance frankly expressed the sexual theme of male dominance and female submissiveness, and its erotic cachet was only enhanced in 1913 when the city's archbishop declared it "offensive to public morals" and forbade it entirely.[41] That summer the fashion for the tango evolved into "tangomania," leaving *Femina* to lament that it had become impossible to read a newspaper or leaf through a magazine "without seeing information about the technical aspects of the dance, its moral appearance, its worldly nature." The magazine, of course, contributed to the craze by touting the exotic dance of "famous gauchos, of shepherds guarding the flocks in South America, the 'cow-boys' of Brazil and Argentina," and by printing detailed charts of the steps.[42] Still, it warned that the "serious and life-threatening" obsession for the dance could lead to dangerous social practices, particularly if the "tangomaniac" became desperate enough to dance with anyone available—raising the possibility that employers and their servants might meet on the common ground of the dance floor.[43]

Martin's original illustration for Satie's "Le Tango (perpétuel)" suggests that, unlike the composer, he still viewed the dance with some enthusiasm in 1913. The tango's Argentine roots are clearly evoked in his imagery; the male dancer is swarthy, and his costume—which includes spurs, chaps, a cape, and a hat, as well as a gun on his belt—mark his identity. Two Argentine musicians, similarly attired, bend over their instruments, a guitar and another stringed instrument that may be a banjo. This group, which occupies the left half of the illustration, contrasts dramatically with the group at the right, which includes the female dancer and a group of onlookers.

# BEAU BRUMMELS *of the* BRUSH

A Dozen of the Gilded Youth of Paris, Taking
Their Brushes in Hand, Dub Themselves
Knights of the Bracelet, and Proceed to Paint
to the World the Admirable Futility of Art

*There must be some
guesswork in doing
one's own profile, yet
Marty has caught the
"Little Billie" in himself*

A RT has done
many strange
things in
Paris, but at
the present moment it
is indulging in a fan-
tasy stranger than usual.
The Salons, of world-
wide interest for so
many generations, have
ceased to please, and the
*vernissage,* once crowded
to suffocation, is no
longer fashionable, for
painters and sculptors
have turned their tal-
ents into the new chan-
nels of decoration and
the mysterious art of
personal adornment.

It is not so very long ago that for an artist,
one who had made a serious study of the very
foundations of art, to have stooped to dabble in
a thing so materialistic as the fashions, or to
have mixed the colors of his palette for a
scheme of interior decoration, would have been
considered a profanation of his talent. But to-
day, not so! Art has come down from its
heights and decided to carry off with it the
fascinating damsel Fashion to join in its gay
revels and even play for it the Muse.

#### EIGHT CHIEFS AND THEIR UNDERSTUDIES

This latest happy vagary by which artists
prove their power to raise all things to their
own level is due to a single group of young
men, Beau Brummels of art. This group of
artists is worthy of study collectively and in-
dividually. There are eight chiefs with as many
understudies, and the names of some of them,
at least, are familiar to America. There is
Bernard Boutet de Monvel, and his cousin,

*Odd, isn't it, that Marty, who sketched
this decoration for a Paquin hat-box,
should have learned his art from Cor-
non, who painted the solemn "Cain
and His Tribe in the Wilderness"?*

Pierre Brissaud; there are Georges Lepape,
George Barbier, and Jean Besnard; A. E.
Marty, Charles Martin, and Paul Iribe; and
there is Lucien Vogel, the impresario, so to
speak, of the group, the one who has caused the
others to materialize for the
benefit of the public.

These well-known names, together with a
number of those of lesser lights, carry a weight
equal to a whole army of Latin Quarter stu-
dents. They are young men of family who
have chosen art as their mode of elegance; they
are all Beaux Arts men, and for the most part
they have carried on their studies together, and
in the same classes. They *tutoient* one another,

and they have quar-
reled enough in their
*jeunesse dorée* to
make them fast friends
in later life.

Their professor was
Cormon, whose im-
mense canvas of "Cain
and His Tribe in the
Wilderness" occupies
a prominent place in
the Luxembourg gal-
lery. Strange that these modern exponents of
elegance and refinement should have received
their first impressions of art from one whose
reputation rests on his portrayal of primeval
man wearing but skins to cover his nakedness!

Each member of this group of Beau Brum-
mels has been accustomed in his work to the
frank criticism of the others, and the privilege
of saying exactly what they please is one they
all enjoy to the fullest. It is not astonishing,
with the same school and the same professors,
that the work of these men is somewhat similar,
though since they emerged from their artistic
swaddling clothes, and their Beaux Arts days
were over—they are not long over, however, for
thirty summers is about the age limit among
these men—they have all gone their own way
in art. It is rather, in fact, the certain dandy-
ism of dress and manner which is a constant
characteristic of the group that makes of them
a "school." Their hat brims are a wee bit
broader than the modish ones of the day, and
the hats are worn with a slight tilt, very slight,
but enough to give the impression of fastidious-
ness. Their coats are pinched in a little—just
a little—at the waist, their ties are spotless, and
their boots immaculate; a bracelet slipping
down over a wrist at an unexpected moment
betrays a love of luxury. The bracelet slipping
down at an unexpected moment might almost
be, indeed, the insignia of the group.

#### BEAU BRUMMEL SETS TO WORK

The great difference between these Beau
Brummels and their ancient namesake is that
while they are thoroughly imbued with the same
love of elegance and luxury, they are also hard
and vigorous workers. To be sure, they are
young men for the most part with very com-
fortable incomes; but to be elegant in Paris, to
belong to the Greyhound Club, to frequent the
polo tournaments, and, most of all, to retain

*The artist brings the native tango, booted, spurred, and with
hip armament, into play in a Parisian restaurant and opens
whatever mouths the ladies there have in delicious horror*

*It was, perhaps, on blue
Monday that Martin drew
this of himself and signed
it "his own best friend"*

FIGURE 46. "Beau Brummels of the Brush," from *Vogue,* 1914, reproducing
Charles Martin's illustration for "Le Tango (perpétuel)" from *Sports et
divertissements*

Elegantly dressed and enjoying champagne, they look on with distress as the woman bends to the lead of her dangerous partner. The link between the fashion press and *Sports et divertissements* is further confirmed by the fact that this same illustration was reproduced in the June 1914 issue of *Vogue* magazine, with a caption noting that Martin brought "the native tango, booted, spurred, and with hip armament, into play in a Paris restaurant," creating for the ladies present "a delicious horror."[44]

By the time of Martin's revisions, obsessive "tangomania" was a phenomenon of the past but the dance in stylized form remained popular. Martin's plate reflects this shift, presenting two sophisticated and decidedly non-exotic couples engaged in a highly refined version of the tango. The erotic overtones present in the original illustration are absent in the revision; postures erect, arms raised high, these dancers are marked by their detachment from one another rather than by a steamy embrace. Their body positions and blasé facial expressions suggest boredom rather than excitement, a reflection, perhaps, of the taming of the dance over time into a modest and less exciting pursuit. Furthering the sense of society chic, the Argentine musicians have been replaced by a jazz trio, consisting of a pianist, percussionist, and vocalist, which may well have performed tango music; by 1922, however, the heat of the dance had dissipated, and the truly stylish had moved on to newer steps.

## PUNS AND PLAY IN THE MUSICAL SCORE

Much as the fashion plates in the *Gazette du Bon Ton* followed Cubism's example in presenting a series of sophisticated puns based in visual art and its association with witty texts, so Satie's score for *Sports et divertissements* used the technique of musical quotation to create different types of music and word play. The simplest types of puns involve the play of music and text. A phrase from a popular song, folk tune, or military anthem is included in the score and is designed to be perceptible to the listener, who is expected to "read" the music in combination with Satie's text for a given piece. In "Le Reveil de la mariée," for example, Satie creates a moment of irony by quoting the musical phrase of the folk song "Frère Jacques" that matches the lyric "Are you sleeping?" after which he segues into a dissonant version of "Reveille" as his text refers to shouts ordering the bridal couple to get up.

The use of musical quotation is not always so simple. Satie's involvement of seemingly straightforward borrowings sometimes creates a double allusion, referring simultaneously to the tune quoted as well as to its already

existent quotation in art music. Claude Debussy's musical quotations, in particular, appear to have been on Satie's mind. In "Le Flirt," for example, Satie quotes the folk tune "Au clair de la lune," which Debussy used as the melodic underpinning for his early song "Pierrot" (1883). Debussy's borrowing involves a thoroughgoing repetition of the melody which seems designed to reinforce the long-standing connection of the *commedia dell'- arte* clown with the moon and its mystical powers. In Satie's composition the allusion to the tune is accomplished with only a fragment of the melody, and achieves a strikingly different effect. Cued up to the slangy phrase "I would like to be on the moon," the tiny bit of the melody he recalls is sufficient to suggest the tune in full, creating an obvious word association which reinforces in musical terms the trite conversation that constitutes the text of the piece. Flirting, Satie seems to suggest, is altogether banal.

The case for allusion to Debussy seems even more compelling in "Les Courses," where Satie quotes the "La Marseillaise." Debussy famously invokes the melody of the French national anthem at the climax of the final piece of his second book of Preludes, *Feux d'artifice*, using the tune not only as an earnest patriotic allusion but also as an integral compositional motif; Satie's quotation, in contrast, is ironic, and occurs just at the moment that his text announces the losers, rather than the winners, of the horse race that is the subject of his composition.[45] Satie thus achieves a dual end, gently mocking the heroic and patriotic allusions of the original song, and lightly parodying Debussy's more sincere use of the melody.

Debussy was not the only composer in Satie's sights as he composed *Sports et divertissements*. A group of subtle and previously unrecognized musical borrowings links the work to George Bizet's *Jeux d'enfants*, a suite of a dozen piano duets describing different children's games. A late work that won Bizet the acclaim he had long sought, the piece was beloved by the French public and became part of bourgeois culture; it was so popular that Bizet orchestrated five of its pieces to create the *Petite suite d'orchestre*. Its subjects as well as its widespread appeal made the work a natural target and a valuable resource for Satie as he set about composing his own set of pieces on the theme of sports and games, and the work may have held special attraction as he pursued a project involving illustrations, since it was originally published in 1871 with an elaborate engraved title page depicting its themes.

Both collections include pieces on the themes of swinging and on the games Puss in the Corner and Blind Man's Bluff, and specific musical correspondences reveal that in these instances Satie makes self-conscious

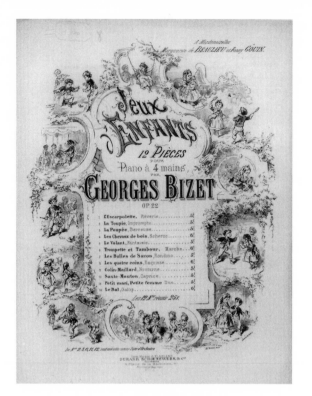

FIGURE 47. Georges Bizet, title page from *Jeux d'enfants*, 1871

reference to Bizet's work. In "La Balançoire," for example, he condenses and updates the material of Bizet's "L'Escarpolette." Both composers create a visual and musical analogue of swinging by using octave motion in the low register; while Bizet's piece begins with a series of arpeggiated octaves, Satie reduces this material to a two-octave pendulum. More importantly, Satie has derived his melody directly from Bizet: when Bizet's theme begins in earnest (measure 13), it takes the shape of a chromatically inflected scale ascending from the G below middle C and rising to the D a note above; Satie's melody begins on the same G and follows the same contour. While the first phrase of Bizet's melody outlines the G-major triad, however, Satie makes a joke by focusing his first phrase on the tritone above G, C-sharp. Similarly, the three other phrases of Satie's pieces are derived from Bizet, but are rearranged and reworked for an anti-tonal effect.

*Example 1a.* Bizet, "L'Escarpolette," mm. 13-15, seconda pars. Reprinted by permission of Durand S. A. / Theodore Presser Company.

## La Balançoire

*Example 1b.* Satie, "La Balançoire," opening. Reprinted by permission of the Department of Printing and Graphic Arts, The Houghton Library, Harvard University.

The connection between *Jeux d'enfants* and *Sports et divertissements* is even clearer in "Les Quatre coins," where Satie's text and music transfer the game of Hide and Seek to the animal world:

The four mice.

The cat.

The mice tease the cat.

The cat stretches.

It springs!

The cat is in the corner.

Satie's musical score is based on only five notes—one for each of the five animal characters. The central note, D, represents the cat, while the four mice are the two surrounding pairs of semitones (B-C, E-F). The entire piece develops as a game based on the rearrangement and recombination of

*Example 2a.* Bizet, "Quatre coins," mm. 82-84, prima pars. Reprinted by permission of Durand S. A. / Theodore Presser Company.

# Les Quatre-coins

*Example 2b.* Satie, "Les quatre coins." Reprinted by permission of the Department of Printing and Graphic Arts, The Houghton Library, Harvard University.

these tones, with a special emphasis on semitone motion. Only in the final and climactic gesture of the piece does Satie break from this game, adding the notes G and A to form a complete scale in the bass part, as the cat pounces on its prey.

Bizet's version of "Quatre coins" is also an exploration of a series of embellished semitones. The connection, however, extends far beyond this similarity. Bizet's piece, in fact, is the source for the four-note set (B-C, E-F) that Satie uses to represent his mice. Midway through Bizet's work, these four notes appear and are repeated to create a melody, which is emphasized by the marking *"espressivo."* This is not coincidental: working backward, it becomes clear that Satie based his music and text on this passage from Bizet, building a complete scenario from only a few notes.

### FASHIONABLE MUSIC AFTER *SPORTS ET DIVERTISSEMENTS*

Up until now, it has been believed that Vogel quickly followed up the commission for *Sports et divertissements*, requesting from Satie three songs to be published in the December 1914 issue of the *Gazette*. This would have been a remarkable rarity for the magazine, which, given its elitist and artistic bent, did not print music. In fact, the *Gazette* was not published at all in December 1914, due to the war, and no evidence found to date supports the existence of any such commission.[46] Satie completed his *Trois poèmes d'amour*, the compositions thought to have resulted from this transaction, on 2 December 1914, probably too late for them to have been included in the magazine had it been produced on schedule.[47] His numerous sketches and drafts for these extremely short songs (including thirteen versions of the final song alone) bear no suggestions of a responsibility to Vogel, nor to impending deadlines or payments received—exactly the sort of offhand references that are rife in the sketches for *Sports et divertissements*. Finally, there is no evidence that Vogel was simply forced to hold off publication until after the war; the *Trois poèmes* were not printed in the *Gazette* even after it went back to press in 1920.[48]

Vogel did, however, include two other compositions by Satie that year in magazines with a different tone and target audience. In October, he published the song "Danseuse," setting a text by Cocteau, as the second in a series of "sweet little airs to sing," in the middle-market women's magazine *L'Illustration des Modes*. Recalling the musical scores that proliferated in the nineteenth-century fashion press, the magazine published six short songs between October 1920 and June 1921. Exemplifying French tradition, the pieces included two chanson settings—the first of which was a

song from the era of the Directory celebrating the liberating changes in dress during those years—as well as two airs by Lully and one by Aubert. Satie's song was the only contemporary work included in the group.[49] Designed to amuse, edify, and entertain the female readership, the songs were accompanied by witty and charming illustrations done by top fashion illustrators. "Danseuse" appeared with illustrations by Martin, offering a glimpse of the collaboration on *Sports et divertissements* that would reach the public when the album emerged from the press a little over a year later.

At almost the same time, Vogel published Satie's *Premier menuet* in a very different journal, the high-minded artistic and literary review *Les Feuillets d'Art*, which professed a dedication to "finding in the taste of the moment all that is traditional and durable."[50] Positioned between poetry by Paul Valéry and reproductions of Renaissance art, Satie's composition took on a decided gravity; if "Dansuese" had been published in a context designed to suggest that it exemplified the best feminine French musical qualities in modern terms, the placement of the *Premier menuet* seems to have been intended to convey Satie's alignment with the most serious French modernists in art and literature.

In the realm of music, *Sports et divertissements* quietly assured Satie's place in the avant-garde. From Darius Milhaud, who viewed it as "one of the most characteristic works of the French school," to John Cage, who saw it as a prototype for modernism, the composition has inspired a wealth of commentary assigning it significance in the years since it appeared.[51] Only within the context of the world of art and fashion created by the *Gazette du Bon Ton*, however, can the full importance of *Sports et divertissements* to the development of musical modernism be gauged. Against the background of the magazine culture that inspired it, the musical album comes into sharp relief as a particular evocation of the sophisticated taste and lifestyle enjoyed by upper-class Parisians in the early twentieth century. In his preface for the album, Satie described it as a "work of fantasy." The "fantasy" behind the music, as we have seen, is fashion: it set *Sports et divertissements* in motion, gave it shape, and created a link between composition and couture that would continue to develop in stylishly artistic post-war Paris.

# 4

# GERMAINE BONGARD

There are profound fashions as well as frivolous ones.

JEAN COCTEAU

On an evening in late May 1916, a select group of Parisians gathered at fashion designer Germaine Bongard's boutique on the stylish rue de Penthièvre. Like her more famous brother, Paul Poiret, Bongard maintained a gallery on the ground floor of her atelier, and on view were modernist paintings by Picasso, Léger, Matisse, and Modigliani.[1] The evening's highlight, however, was a concert of the latest works by Erik Satie and Catalan composer Enrique Granados. The event was poignant: Granados and his wife had drowned a few months earlier, homeward bound after the successful premiere of his opera *Goyescas* at the Metropolitan Opera in New York. Unexpectedly invited by President Wilson to visit the White House following the performance, they had missed their scheduled sailing and were on the last leg of their delayed journey when a German torpedo hit their ship in the English Channel. Granados was picked up by a life raft, but seeing his wife flailing in the waves he jumped in to save her and the couple died together at sea.[2]

The evening at Bongard's salon was part memorial tribute to Granados and part celebration of living artists, with a printed program featuring designs by Matisse and Picasso, and performances of Satie's most recent works by the composer himself. For Satie, the evening marked a significant career juncture: bringing him into contact with the fashionable Parisian intelligentsia—from diplomat Paul Claudel to social gadfly Jean Cocteau— the concert chez Bongard established him as a darling of the creative set and laid the groundwork for his entrée into the city's loftiest artistic domains.

It also solidified his position in the center of the vibrant group of artists, poets, writers, and musicians who were working in the war years to recast modernism as an expressive mode that could accommodate fashionable avant-garde approaches as well as pro-French political sentiment.

Satie's involvements with members of the *Gazette du Bon Ton* circle, and in particular with Valentine Gross, had paved the way for his appearance at Bongard's studio. Not only had Gross brokered the commission for *Sports et divertissements,* the work that won Satie credibility in fashionable circles, she had also had presided over the first meeting between Satie and Cocteau, which took place at her apartment on the Isle St. Louis in October 1915. This occasion was especially significant to Cocteau because it included Gabriel Astruc, the influential producer and financier who since 1913 had overseen the Ballets Russes seasons.[3] For years Cocteau had been desperate to insinuate himself into the Russian entourage, but his efforts had been stymied: his orientalizing fantasy *Le Dieu bleu,* created in collaboration with Reynaldo Hahn for the 1912 season, had failed, and he quickly found himself excluded from the troupe's creative team, relegated to the backroom work of creating art and publicity materials for its productions. That same year, the exasperated Diaghilev served him with the artistic ultimatum "Astonish me!"—a command which Cocteau later claimed inspired his "break with spiritual frivolity."[4] Three years later, however, Cocteau had come no closer to meeting Diaghilev's demand, and the evening chez Gross represented what might be his last chance to make an impression, via Astruc, on the impresario. Discussion that night probably centered on yet another project that never came to fruition, the production of a French version of *A Midsummer Night's Dream* to be staged at the Médrano circus. While Astruc was interested, the project was cut short by the war, and by December Cocteau had left for the front, where he ministered to the wounded as a volunteer in the private ambulance corps of his flamboyant friend, Count Etienne de Beaumont.[5]

The following spring, while Cocteau was home on leave, he encountered Satie on a number of occasions. In all likelihood he heard the composer's music for the first time on April 18 of that year, when he went with Valentine Gross to the "Festival Erik Satie–Maurice Ravel" sponsored by the Société Lyre et Palette, a loosely organized collective of painters, writers, and musicians based in the newly trendy Montparnasse quarter of Paris. Like most of the Lyre et Palette events, this evening of "peinture et musique" was held at the apartment of the group's founder, the Swiss painter Emile Lejeune, who had come to Paris in 1910. Shortly after his arrival, he began to organize small concerts at the Académie Colarossi,

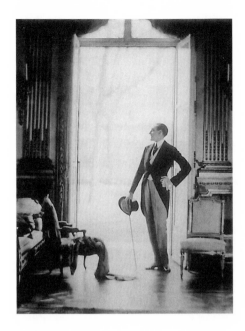

FIGURE 48. Adolphe de Meyer, photograph of Count Etienne de Beaumont

where he was studying, eventually adding art exhibitions to the events and ultimately moving them to his apartment, which was rechristened the "Salle Huyghens" for the street on which it was located.

The list of Lyre et Palette affiliates reads like a roster of modernism: Picasso, André Derain, Henri Matisse, Jean Metzinger, Juan Gris, Amedeo Modigliani, Manuel Oritz de Zarate, André Lhote, and Gino Severini all exhibited there, and Apollinaire, André Salmon, Max Jacob, Pierre Reverdy, Blaise Cendrars, and Cocteau himself read poetry. Reaching beyond the bohemian intellectual set, the Salle Huyghens events drew a high-society crowd; on one typical occasion in 1915, according to a newspaper report, rows of "splendid, shining limousines" idled their engines while their well-heeled owners found edification at a poetry reading inside.[6]

In the area of music, the Lyre et Palette Society was home base for Satie and the younger artists who had begun to gather around him. Known at the time as the "Nouveaux Jeunes," the group would later be labeled "Les Six" by newspaper critic Henri Collet; it included Georges Auric, Francis Poulenc, Arthur Honegger, Louis Durey, Germaine Tailleferre, and Darius Milhaud. Satie was the collective's elder statesman, and on the program of the Satie / Ravel concert in April 1916 were performances of his *Avant-dernières pensées*, a recently completed set of three pieces for piano, along with two new songs, "La Statue de bronze" and "Daphénéo," and, finally, one of his best-

known works, the piano duet *Trois morceaux en forme de poire*, composed in 1903. An important event for Satie, the concert was introduced by the young composer/critic Alexis Roland-Manuel, who gave a background lecture on Satie's life and compositional aesthetic, and raised the composer's visibility by establishing the first chronology of his works.[7] The concert also set the stage for the more famous "Instant Erik Satie," sponsored by the Lyre et Palette in November 1916 and held in conjunction with an exhibit in which works by Kisling, Oritz, Matisse, Picasso, and Modigliani were displayed alongside African masks and sculptures lent to the gallery by the dealer Paul Guillaume. At this event, Satie gave the premiere performance of the piano pieces entitled *Les Trois valses distinguées du précieux dégoûté*, and Cocteau and Cendrars each read a poem in the composer's honor—the wordplay-filled "Hommage à Erik Satie" from Cocteau, and from Cendrars, the punning "Le Music Kiss Me (*Le Musickissme*)."[8]

Satie's involvement with the Société Lyre et Palette was typical of the composer, who always insisted that he learned the most about music from painters rather than musicians. With the notable exception of Claude Debussy, who remained his close friend for almost thirty years, nearly all of his colleagues worked in areas outside of music. His Montmartre cohort at the turn of the century, an eclectic group that included Catalan painters Ramon Casas and Santiago Rusiñol, Basque artist Ignacio Zuloaga, and poet Contamine de Latour, sealed his association with the bohemian fringe, while his later involvements and collaborations with Picasso, Braque, André Derain, Francis Picabia, Marcel Duchamp, Tristan Tzara, Constantin Brancusi, André Breton, and Man Ray placed him in the center of the Parisian avant-garde.[9] Drawings and paintings done of Satie by his friends throughout his life—from Augustin Grass-Mick's fin-de-siècle depiction of the composer in the company of stars including Jane Avril, Georges Courteline, and Toulouse-Lautrec, to the portraits done in the 1920s by Picasso, Cocteau, and Picabia—attest to his wide-ranging involvements. A gifted calligrapher and draftsman himself, Satie considered "musical evolution" to be "always a hundred years behind visual evolution," and was an insider in these modernist circles.[10] Fernande Olivier, Picasso's companion during the artist's early days in Montmartre, recalled Satie as "the only person that I heard argue clearly and simply about Cubism,"[11] while Man Ray described him in plain terms as "the only musician who had eyes."[12]

Thus, from 1892, when his occultist drama *Le Fils des étoiles* was premiered at an exhibition of Symbolist painting, to the thwarted presentation of his "Furniture Music" at a showing of children's drawings in 1922, Satie gravitated toward the galleries that were home base for his artist col-

leagues.[13] These spaces served as the setting for the premieres and performances of many of his compositions, and functioned as workrooms where he could vet new pieces, hear jazz from the United States and the latest music from Europe, and interact with the artists, writers, and poets whose work he so profoundly admired. At Germaine Bongard's salon on that evening in May 1916, a fresh element—fashion—was added to the modernist mix, setting up a dynamic in which advanced art was invested with an aura of au courant sophistication and haute couture gained credibility as a viable mode of artistic expression.

## COUTURE AND CULTURE CHEZ BONGARD

Bongard was uniquely positioned to bring artists and fashionable socialites together in a way that suggested that avant-gardism could be stylish and amusing as well as relevant and radical. After working briefly for her brother as a designer of children's clothing, she struck out on her own, opening her first salon in 1911 and settling the following year in the rue de Penthièvre atelier. Almost completely unknown today, she was significant enough in 1912 to merit a full-page profile in *Vogue*.[14] Under the heading "A New Salon for Unique Fashions," the anonymous article provides a reader's tour of her rue de Penthièvre salon, which consisted of "several apartments in a large new hotel just off one of the main boulevards," furnished with "the usual artistic sense of the Poiret family." Located in the heart of the growing Parisian fashion district, just off the rue du Faubourg Saint Honoré, Bongard's shop, according to *Vogue*, included an expansive series of showrooms and fitting rooms decorated in an eclectic style that mixed old and new, fancy and plain; Louis XVI furniture sat next to rough-hewn wood tables, and traditional toile was hung alongside polka-dot and chintz wallpaper. These "quaint surroundings," the article suggested, perfectly reflected the taste of "this artist to her fingertips," whose clothes, hats, and lingerie were designed for women seeking "something different." Three photographs accompanying the article provide a sense of Bongard's individualistic style. While differing in detail, the ensembles depicted—a daytime dress, an evening gown with a wrap, and a suit inspired by military uniforms—were all classical designs tweaked with modernist sensibility, whether in the form of bright colors, unusual fabric, or whimsical embellishment. A separate photograph of Bongard's salon taken by Henri Manuel in 1912 suggests the influence of her brother's revival of the eighteenth-century Directoire style; the two models pictured appear in high-waisted, body-hugging dresses much in the Poiret vein, and even wear bonnets that

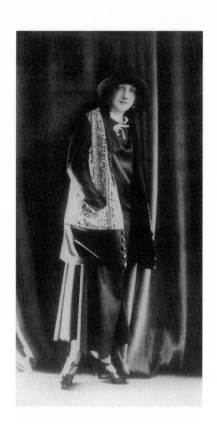

FIGURE 49. Henri Manuel, photograph
of Germaine Bongard, 1923

hark back to the Revolution, suggesting the importance of both simplicity
and French historicism in her designs.

In contrast to her brother, who catered primarily to wealthy society
women, Bongard was popular with a clientele that included "the most ele-
gant women of the artistic intelligentsia," ranging from Madame Henri
Matisse to the pianist Marcelle Meyer.[15] Meyer, in fact, wore a Bongard
dress when she posed for the celebrated portrait of Les Six done by Jacques-
Emile Blanche in 1922, thus providing one of the best records of the de-
signer's sophisticated later style. More generally, Bongard's affiliation with
the artistic avant-garde was marked by a fluid interchange in which paint-
ing and fashion were negotiable commodities: Juan Gris recalled swapping
one of his works for a Bongard creation in order to surprise his wife, while
Gino Severini remembered that in "a friendly exchange agreement with
Mme Bongard, we gave her paintings and she dressed our wives . . . [who]
were more elegant than they ever had been."[16]

# A NEW SALON FOR UNIQUE FASHIONS

## In Quaint Surroundings the Lover of "Something Different" May Satisfy Her Taste

THOUGH it is scarcely a year since Madame Bongard threw her salons open to the public, she is already regarded as an important factor in the world of fashion. The establishment of this new luminary; who, by the way, is a sister of the famous Paul Poiret, consists of several apartments in a large new hotel just off one of the main boulevards of Paris. Quaint, attractive rooms they are, furnished with the usual artistic sense of the Poiret family. So, of course, they form a most suitable setting for Madame Bongard's unique models.

### SALONS AS UNIQUE AS THE GOWNS

The main entrance is through a small, square hall with walls covered in a buff paper with large blue polka dots which, just at the top of the high, wooden wainscoting, is finished by a narrow stenciled frieze of red flowers with touches of black. The buff and blue of the paper are in charming contrast to the woodwork, which is painted a pronounced gray. A double doorway leads to a larger room with woodwork in vivid green and walls covered with flowered chintz. Wooden tables, odd flower stands, and curious old chiffoniers painted the same shade of green as the woodwork, furnish the quaint room, and the last touch of completeness is the wooden bird cage hung at the daintily curtained window.

On either side this room are other suites of salons and showrooms, where are exhibited the hats, gowns, and lingerie. The latter is a branch of the sartorial art in which Madame Bongard is particularly interested, and in which she has originated some interesting and practical designs. The main showroom on the right is hung with "toile de beurre," a buff background striped with dull red, which is printed especially for the house. The woodwork is gray, the furnishings, upholstered chairs and sofas of the Louis XVIth period, with some rare pieces of inlaid mahogany. White batiste curtains embroidered in chainstitch with a large central medallion hang at the windows. The over curtains and portières are of the same sheer material. The former are edged with a deep, pointed border of red linen, the latter are embroidered in red chainstitch. Out of this room open the fitting rooms, papered in red and white check toile.

### AN INEXHAUSTIBLE GENIUS

An artist to her finger tips is Madame Bongard. She designs all the creations of the house, and apparently her inspiration is inexhaustible, for after working over the hundred or more models which formed her collection for the autumn, she declared she only wished she had the time to design as many more. Yet so much of herself goes into each costume, and so attached to them does she become, that it is really a hardship for her to let them be taken, after they have come to her for final inspection, from her own apartments to the showrooms.

Madame Bongard really made her début last spring, but as a matter of fact, it is this opening which is her first important showing. From the models especially photographed in her salons for Vogue it will be seen that each is stamped with a certain indescribable charm which has always set the models of this family in a class apart.

### A TASTE FOR VIVID COLORS

The topmost photograph on this page shows a cleverly simple reception gown of cherry-colored chiffon with very narrow stripes of

(*Continued on page* 104)

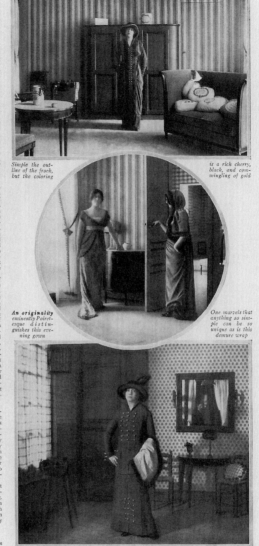

*Simple the outline of the frock, but the coloring*    *is a rich cherry, black, and commingling of gold*

*An originality eminently Poiret-esque distinguishes this evening gown*    *One marvels that anything so simple can be so unique as is this demure wrap*

*Every designer attempts an interpretation of the military costume—Madame Bongard's is in green velvet, gold braid, and brass buttons*

FIGURE 50. Profile of Germaine Bongard's fashion salon in *Vogue* (New York), 1912

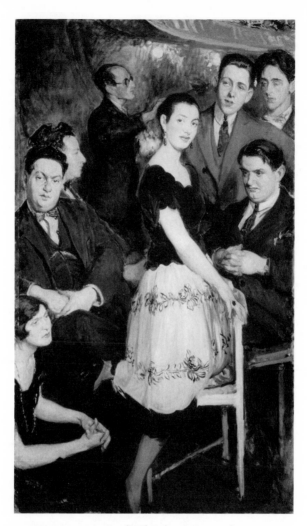

FIGURE 51. Jacques-Emile Blanche, *Portrait of Les Six,*
1922

Beyond simply outfitting artists' wives, however, Bongard was herself a
significant figure in the circle of Montparnasse modernists that coalesced
during the war. A painter and musician in her own right, she made her
mark by sponsoring a number of interdisciplinary events to benefit artists
in the gallery adjacent to her atelier, which became known as the Galerie
Thomas. In this endeavor she had the assistance of artist Amédée Ozenfant

(1886–1966), who is now recognized primarily for his collaboration with Charles Edouard Jeanneret (later known as Le Corbusier) in the development of the post-war movement known as Purism. Ozenfant was struggling to articulate a vision of post-Cubist art when he met Bongard, and together they organized a series of events in the Galerie Thomas designed to showcase the latest works of Picasso, Léger, Lhote, Matisse, Derain, Modigliani, Vlaminck, and other modernists in their group, many of whom were also involved with the Société Lyre et Palette. Three major shows at the Galerie Thomas were mounted between December 1915 and June 1916, and, as at the Salle Huyghens, poetry readings and musical performances were linked to each exhibition. An article published in the *Mercure de France* just after the opening of the second show—a large exhibition limited to black-and-white drawings, with works on view by all the artists listed above, plus Max Jacob, Kisling, Laboureur, Marie Laurencin, Severini, and Jacques Villon—attested to the rapprochement between fashion and painting achieved at these events.[17] The Bongard dress shop, the paper reported, had become "an artistic salon. An exhibition of paintings there has brought the elite of Parisian society running. . . . The art of couture benefits from this. The painter Matisse is in ecstasy before the pleats in a skirt, he suggests the right kind of neckline essential to complete the architecture of a dress."[18] Matisse was not the only guest in Bongard's studio to be captivated by couture; the art was hung so close to the workrooms that, according to at least one report, "the visitor, while looking at the paintings, might also glimpse, through an open dressing-room door, a seamstress pinning up the hem of a customer's skirt."[19] This proximity certainly reinforced the notion that couture was on an artistic par with painting, and brought the avant-garde into contact with the elite, not only in the tangible terms of the canvasses and clothes, but also in the form of the patrons for each, who mingled happily in Bongard's boutique.

Few artists were more taken with the connection between fashion and modernism than Ozenfant. In this "art," he claimed, France "most consistently affirms the suppleness of her genius"; and thus he felt that it would be "a true injustice not to include fashion—dresses, hats, etc.—among the plastic arts."[20] Recalling his years with Bongard in his memoirs, he reflected on the direct and profound influence that his experience of couture had on his aesthetic views: "Fashion," he wrote, "helped me to understand why some forms and colors survived for centuries while most die as soon as they are born. This experience encouraged my research on visual constants and psychological universals which would call me to Purism."[21]

So motivated and intrigued by fashion was Ozenfant that he opened his own Paris boutique, known as Amédée, where he sold dresses and accessories of his own design through the 1920s.

## *L'ELAN* AND THE CALL TO ORDER

In addition to serving as an exhibition space, Bongard's shop was the base of operations for Ozenfant's wartime magazine, *L'Elan,* ten issues of which appeared between April 1915 and December 1916. Produced on fine paper and handsomely illustrated—Severini called it "chic, well-presented, careful, and flawless"—the journal had the ambitious goal of furthering "propaganda for French art, French independence, in sum the true French spirit," and advocated a kind of stylish patriotism that accommodated both an unqualified support for the war effort and a strong defense of Parisian avant-gardism.[22] Indeed, this duality was encapsulated in the magazine's title, which conflated the essential optimism contained within popular French philosopher Henri Bergson's concept of the *élan vital* with wartime military connotations of the term to evoke what has been described as "an almost mystical" expression of "France's will to succeed, her military *je ne sais quoi,* an ancient Gallic spirit."[23]

More obviously, however, the word *élan* had an immediate resonance with modern fashion, signifying the particular panache of self-assured and specifically French style. This sensibility was showcased in the magazine's first cover, drawn by Ozenfant, which superimposes a woman's head onto a sketchy map of the French and Belgian battlefields. Crowned in laurel leaves and wearing a beaded necklace into which is embedded the word "France," she is clearly Marianne, the feminine emblem of the nation, an updated and patriotic model of the iconic nineteenth-century Parisienne. As her necklace unravels along the French front, her protection and domination of the territory is conveyed with clarity: she is the very incarnation of victory as well as style. Adding to the fashionability of the image was its clever caption, "Le front—le collier de la victoire," which matched a small pun on the word *front,* which can mean "forehead" as well as military "front" in the English sense, with a larger commentary on the "necklace of victory" that in due time would be unfurled by the French.

Given Ozenfant's involvement in the milieu of haute couture during the lifespan of *L'Elan,* his turn to fashion imagery to express a nationalist agenda seems natural. Moreover, in this regard he could look to an earlier, and specific, magazine model, namely, *Le Mot,* the journal founded in November 1914 by Cocteau and fashion illustrator Paul Iribe, who, as we have

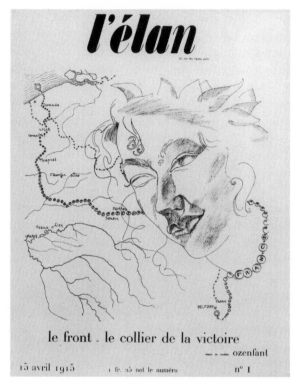

FIGURE 52. Amédée Ozenfant, "The Necklace of Victory," from *L'Elan*, 1915

seen, had made his name working as an illustrator for Poiret and for the *Gazette du Bon Ton.* Like *L'Elan, Le Mot* argued for a sensibility that was both patriotic and progressive, a "path of France" that was well mannered yet adventurous: "Between TASTE and VULGARITY, both unpleasant," the January 1915 issue of *Le Mot* proclaimed, "there remains an *élan* and a sense of proportion: THE TACT OF UNDERSTANDING JUST HOW FAR YOU CAN GO TOO FAR."[24] In addition to articulating perhaps the most apt definition of fashion ever conceived, *Le Mot*'s advocacy of a middle ground between conservatism and radicalism amounted to a call for a revived classicism, a meshing of advanced art and high style to create a new kind of modernism that was appealing yet challenging and anti-bourgeois.

Ozenfant pursued this idea during the life of *L'Elan,* developing the magazine from a journal designed to create a "connection between artists at the front and in Paris" into a showcase for cubist art and avant-garde

poetry, a self-described "avant-garde review of explorations of art and attitude."[25] Music was largely overlooked in the magazine, with one glaring exception: from the outset of *L'Elan*'s publication, Camille Saint-Saëns was vilified on its pages as the consummate example of a French artist corrupted by German values and aesthetics. Under the title "In the Shadow of the Laurel Wreath," for example, an article in the 15 May 1915 issue speculated archly on Saint-Saëns's recent acceptance into the French Society of Men of Letters, noting that "the hundreds of lines that our national musician devoted to Wagner" had garnered him the honor.[26] The article's point was driven home in the cartoon that accompanied it, in which a caricature of Saint-Saëns, ear cocked attentively, popped out of the Académie Française while a caption posed the question, "No Wagner on the horizon?" The following month, the magazine took him to task for what it characterized as his attempt to replace "La Marseillaise" with a new national anthem: "This indefatigable man is always truly young!" it sarcastically proclaimed. *L'Elan*'s final joke on the composer provided fodder for its last issue: Ozenfant, having sent Saint-Saëns a complimentary subscription to the magazine, received a handwritten note from the composer declining the favor and reproduced it as cover art.

By January 1916, the list of contributors to *L'Elan* had grown to include Apollinaire and Jacob as well as Derain, Lhote, Diego Rivera, and the Cubist circle: Picasso, Metzinger, Gleizes, and Severini, among others. That year, the magazine published Cubist works alongside figurative drawings and illustrations, thus positing that avant-gardism could embrace styles other than Cubism. In his first theoretical article, published in the final issue of *L'Elan* and entitled "Notes sur cubisme," Ozenfant articulated this stance, for the first time using the terms "purism" and "purist" to describe his neo-Platonic ideal.[27] "CUBISM IS A MOVEMENT OF PURISM," he declared in the essay, using uppercase script for emphasis. "Cubism has assured itself a place of true importance in the history of the plastic arts, because it has already partly realized its Purist aim of cleansing plastic language of extraneous terms, just as Mallarmé attempted to do for verbal language." At the same time, Ozenfant argued, Cubism had fallen into a state of crisis, because it was too elitist, too angular, too involved with scientific theories concerning the fourth dimension, and, above all, too decorative. As his biographer, Françoise Ducros, has noted, in this tract Ozenfant began to speculate on the evolution of art after Cubism, focusing on its "universal visual and psychological constants," which he perceived could lead to a cool, rational, and lucid style that negotiated the boundary between art and architecture.[28] Cubism and classicism, Ozenfant argued, were neither mutually exclusive nor even

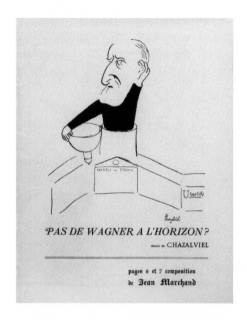

PAS DE WAGNER A L'HORIZON?
dessin de CHAZALVIEL

pages 6 et 7 composition
de Jean Marchand

FIGURE 53. Chazalviel, "No Wagner on the Horizon?" from *L'Elan*, 1915

incompatible, and in combination they pointed the way to a new and perfectly expressive modernist mode.

A critical moment in Ozenfant's development of his ideas about the future of art arrived in January 1918, when he met Jeanneret for the first time. By the end of that fevered year, they had arrived at the fundamental principles of the new movement they called Purism and had published a small book entitled *Après le cubisme* outlining their ideas. In short, they called for the elimination of the picturesque, decorative aspects of Cubism that had become prevalent after 1914, proposing instead an art based on principles of order, purity, and logic. While adopting the same everyday utilitarian items that animated Cubist canvasses—bottles, vases, guitars, and the like—as the main subject matter for Purist art, Ozenfant and Jeanneret argued that by refining these objects into a state of simplicity their essential classicism would be revealed and the link between classic and contemporary art would be laid bare.[29] By stripping away labels and language, they claimed, they would "cleanse" Cubism and illuminate the connections between modernist art and French tradition that extended in a line from Le Nain through Poussin and Ingres to Corot and Seurat. For Ozenfant, this was a matter of simply recognizing that "the present is our own moment of eternity."[30] Amounting to part of the larger post-war "call to order," his plea for a new classicizing art followed on the heels of the Armistice and

was introduced to the public in the first exhibition devoted to Purism, which was held at Bongard's Galerie Thomas between 22 December 1918 and 11 January 1919.[31]

## SATIE IN THE BONGARD CIRCLE

Against this backdrop, Satie's involvements with Bongard and the artists and writers linked to the Galerie Thomas come into focus. Like Ozenfant, Satie was engaged in an effort to expose the innate classicism of the mundane, and he had spent much of his mature career exploring the musical possibilities of the mix of high and low culture. Satie even personified the very idea of this mingling since from the late 1880s through the early 1900s he was equally at home in the city's elite music establishments and its popular entertainment venues, and was composing art music as well as waltzes and cabaret songs. Indeed, many if not most Parisians knew him only as a composer of popular tunes—as Roland-Manuel recalled, Satie was recognized in the city's "most important" music store as the creator of "some waltzes and a cakewalk," while in the suburb of Arcueil, where he had lived since 1898, his neighbors believed him to be only the composer of a few familiar songs and dances.[32] From the turn of the century onward, however, Satie's preoccupation with popular music was part of a larger project in which he explored ways that the melodies and harmonies of French entertainment music—including music-hall tunes, sentimental waltz melodies, operetta airs, and traditional French folk songs—could be integrated with the classicist traditions of French art music. Just as Ozenfant aimed to reveal the eternal beauty contained within the popularizing style of Cubism, so Satie strove to illuminate the ways in which the music of "everyday life" was linked to the high-art repertoire, and to reveal the ways in which "high" and "low" music could express the quintessentially French ideals of clarity, simplicity, and structural balance.

Satie's effort to reconcile these different kinds of music began as early as 1903, with the composition of *Trois morceaux en forme de poire*. In this work, which contrary to its title is a loosely connected set of seven (not three) piano duets, "classical" and popularizing idioms are in constant contact. Nearly all of the pieces in the set incorporate references to popular music works that Satie had composed at the fin-de-siècle, including segments of the incidental pieces *Danse* (1890), *Le Fils des étoiles* (1891), and *The Angora Ox* (ca. 1901), as well as the café-concert songs "Le Veuf" (1899), "Le Roi soleil de plomb" (ca. 1900), and "Impérial-Napoléon" (ca. 1901). It was not until 1911, however, when Maurice Ravel brought atten-

tion to Satie's works by performing the second *Sarabande* (1887), the Prelude to Act 1 of *Le Fils des étoiles* (1891), and the third *Gymnopédie* (1888) at a concert sponsored by the newly formed Société Musicale Indépendante, that Satie's exploration of the possibilities of a high/low musical mix gained real momentum.

Suddenly Satie, who had spent more than twenty years laboring in comparative obscurity, was in the public eye. Only weeks later, in March 1911, a review of the concert by Michel Calvocoressi appeared praising Satie as an important forerunner of Debussy and Ravel, and at a concert of the Cercle Musicale, Debussy conducted his own orchestral versions of two of Satie's *Gymnopédies* to rave reviews. The attention was sustained throughout the year, as articles about Satie appeared in a variety of publications. In March, a large spread on the composer appeared in the newly launched *Revue Musicale S.I.M* (published by the Société Musicale Indépendante), and included an overview by critic Jules Ecorcheville illustrated with Antoine de La Rochefoucauld's portrait of Satie, as well as the scores for a number of his works. In April, Calvocoressi published another article on Satie in the journal *Musica,* and in December he included Satie with a group of forward-looking composers ranging from Chopin to Debussy in an article in the London-based *Musical Times,* which was entitled "The Origin of To-Day's Musical Idiom."[33] At the same time that Satie was garnering this (mostly) positive critical attention, a number of his works were seeing print for the first time: in 1911 alone, Rouart-Lerolle published the *Sarabandes, Trois morceaux,* and the piano duet *En Habit de cheval.* Satie's exposure was further enhanced when he began to write articles for publication in the *Revue Musicale S.I.M.*—his first literary piece, the infamous "Memoirs of an Amnesiac," appeared in 1912—and by the end of that year a group of younger composers and critics took such inspiration from his example that they proposed he be honored as "Prince of Musicians." Demurring initially from this suggestion—"These asses are completely ignorant," he insisted—he thought twice and accepted, reasoning that "music needs a Prince" and agreeing that "she shall have one, by God."[34]

Satie's flurry of compositional activity between 1912 and 1916 attests to the creative stimulus this attention inspired. In these highly fruitful years, Satie turned his attention fully to the project of integrating high and low music that he had initiated with *Trois morceaux,* most importantly producing the piano works that are generally referred to as the "humoristic piano suites." The series began in 1912 with the *Préludes flasques (pour un chien)* and *Véritables préludes flasques (pour un chien),* and in 1913 there was a burst of creativity, with six sets of pieces: *Descriptions automatiques,*

*Embryons desséchés, Croquis et agaceries d'un gros bonhomme en bois, Chapitres tournés en tous sens, Vieux sequins et vieilles cuirasses,* and three groups of children's pieces, given the overall title *Enfantines*. The year 1914 brought three additional works, *Heures séculaires et instanta-nées* and *Trois valses distinguées du précieux dégoûté,* as well as the fashion-oriented album *Sports et divertissements,* and 1915 saw the last of these pieces, *Avant-dernières pensées.*

## TEXT, MUSIC, AND THE *TON DE BLAGUE*

While often considered to be insignificant, Satie's "humoristic suites" are in fact pathbreaking works that redraw the parameters of piano composition. The change is most immediately obvious in the unconventional appearance of the musical score: the pieces, with one exception, are written in notation without bar lines or key signatures, and all but two of the works are com-posed without time signatures. Most revolutionary of all, however, was Satie's inclusion of texts in these scores. From the origin of keyboard music down to Satie's day, words had appeared in piano scores in two basic guises: first, in titles, and second, in standardized instructions for the performer, such as "allegro," "largo," "legato," and so on. Satie expanded on both con-ventions, and in addition explored a variety of new possibilities, creating in-tegrated compositional complexes in which texts and music combined to generate expressive content that transcended its individual elements.

Satie had begun to experiment with the possibilities of using text in his compositions as early as the 1890s, when he was scratching out a living as a piano player in the Chat Noir and other Montmartre haunts; in these fin-de-siècle venues, language was developing as the centerpiece of a unique mode of ironic humor that was captured in contemporary parlance by the complex term *blague.*[35] A watchword of the bohemian counterculture—the refined Goncourt brothers rued it as the "new form of French wit, born in the artist's studios . . . raised amid the downfall of religion and society"— the *ton de blague* was widely assimilated and considered "Parisien par excellence."[36] By 1913, it was described as a mix of acute observation and playful teasing:

> *Blague* is a certain taste which is peculiar to Parisians, and still more to
> Parisians of our generation, to disparage, to mock, to render ludicrous
> everything that *hommes,* and above *all prud'hommes* are in the habit
> of respecting and caring for; but this raillery is characterized by the fact
> that he who takes it up does so more in play, for a love of paradox, than
> in conviction: he mocks himself with his own banter, *"il blague."*[37]

As an attitude and artistic stance, *blague* passed from the Montmartre studios housing bohemian students to the Montparnasse spots frequented by the twentieth-century avant-garde, including the Société Lyre et Palette and the Galerie Thomas. Across this transfer, Satie remained one of its definitive and unwavering exponents.

On the most immediate level, the *ton de blague* in Satie's piano works is conveyed in his enigmatic titles. Ranging from the absurd *Flabby Preludes (for a dog)* to the mystifying *Dryed-Out Embryos,* these headings are humorous because of their obfuscating language as well as their lack of functionality: disjunct from the music itself, the titles satirize the entire tradition of labeling musical compositions, either in neutrally descriptive terms, such as "Sonata," or more allusive language, such as Robert Schumann's *Papillons,* or Claude Debussy's *Jardins sous la pluie.* By introducing an element of ironic humor into this process, Satie deflated a central tenet of musical tradition.

The texts that Satie built into his compositions reflect a similar ironic sensibility. For one thing, the very presence of language in a piano composition may be seen as an invocation of the *ton de blague,* a large-scale mockery of the expressive relationship between text and music that was celebrated with special enthusiasm in the Romantic era, and, in particular, as a critique of the extensive narratives in late-nineteenth-century program music. Satie's texts are brief and fall into two (sometimes overlapping) categories. First, like keyboard composers for generations before him, Satie uses language to provide instructions to his performers, but unlike his antecedents he supplements the standard terminology with quirkier directives, advising the pianist to play, among other things, "like a nightingale with a toothache," "drunk," or "with the tip of your thought." These instructions shift the burden of interpretation to the performer, who must grapple with the language as well as the music in order to convey the expressive meaning of the piece. Satie's texts thus require the performer to participate in a kind of conspiratorial humor, establishing an intimate and unprecedented mode of communication between the composer and his interpreter.

The second type of text in the piano works of 1912–15 is more extensive, consisting of quasi-narrative and conversational commentary built into the compositional fabric. Defying categorization as either poetry or prose, these texts are astonishingly diverse and entertaining, covering everything from a wife's harangue of her husband in a department store to an erudite account of the activities of imaginary sea creatures. In form and structure, they are a mélange, juxtaposing snippets of spoken language

with narrative comments and personal asides. The language is cool and objective, the tone is one of reserved banality, and the overall effect is that of a recorded observation of daily activities. Satie captures the mundane quality of even the wildest imaginings and conversely invests the everyday with an aura of fantasy.

In musicological discussions, the "humoristic" piano works are typically grouped together indiscriminately and treated as insignificant curiosities. In fact, this body of work represents Satie's rather systematic exploration of the potential relationships of music and language. In the works of 1914 and 1915 Satie's growing involvement with the worlds of fashion and high society came to be a direct and perceptible influence on this aspect of his compositional aesthetic, seen most clearly in the explicitly fashion-oriented album *Sports et divertissements*, as discussed in chapter 3, but also evident in the three other works composed in those years—*Heures séculaires et instantanées* (June–July 1914); *Les Trois valses distinguées du précieux dégoûté* (21–23 July 1914); and *Avant-dernières pensées* (23 August–6 October 1915). It is not coincidental that each of these works had its premiere performance in a fashion-related venue: *Heures séculaires* at Poiret's Galerie Barbazanges (1917), *Les Trois valses* at the Société Lyre et Palette (1916), and *Avant-dernières pensées* at Germaine Bongard's Galerie Thomas (1916).

## THREE FASHION-CONSCIOUS WALTZES, WITH SUBTEXTS

In light of its specific fashion associations, *Les Trois valses* merits a closer look. Premiered at the November 1916 Lyre et Palette concert devoted to Satie, which took place in conjunction with the splashy exhibition of African art lent by art dealer Paul Guillaume, the composition has conventionally been explained as a swipe at Maurice Ravel, whose *Valses nobles et sentimentales* had captivated bourgeois Paris in 1911 and who was renowned as one of the city's most fastidious dandies. This seems unlikely; among other things, Satie's well-documented disdain for Ravel's music did not surface until after the war, and although by 1920 his stance against Ravel had hardened to the point where he described him to Milhaud as "a fool" with a "superior manner," his feelings even then were mixed.[38] "I love Ravel deeply," he wrote in 1919, "but his art leaves me cold, alas!"[39] Rather than relating to Ravel, Satie's *Valses* seem more likely to have been crafted as a commentary on fashion, music, and cultural tradition that would appeal to Satie's new, stylish, and cultivated audience.

For like *Sports et divertissements, Les Trois valses* is explicitly *about* fashion. Its titles amount in English to something like "Three Waltzes of a Precious Neuraesthenic," but the French words *précieux* and *dégoûté* have important resonances that defy translation. *Précieux* is the rare masculine form of the label applied to high-bred women of the *ancien régime*—known as "les précieuses"—who cultivated rarefied modes of speech and dress along with an ultra-refined style of living; *dégoûté* was used in the seventeenth century to describe a state of extreme boredom identified with the idle upper class.[40] The texts implicated into the body of Satie's three dances reinforce these Louis Quatorze references, describing different aspects of the self-involved dandy's preoccupation with his own appearance, from his waist ("Sa taille") and his pince-nez ("Son binocle") to his legs ("Ses jambes"). The topic of the first piece is the subject's narcissism: he "looks himself over," "puts his hands on his hips" with delight, wonders "who will dare say that he is not the most handsome," and predicts his conquest of the "pretty marquise." In "Son binocle," he fetishizes his pince-nez, cleaning it, recalling that it was a "nice souvenir" given to him by a beautiful woman, then becomes depressed as he recalls that he has lost its case. Finally, in "Ses jambes" his obsessive streak escalates as attention shifts to his legs, which "only dance special dances":

He is very proud of them . . .

They are nice, slim legs.

In the evening, they are dressed in black.

He wants to carry them under his arm.

They glide along, very sadly.

Here they are indignant, very angry.

Often, he kisses them and wraps them around his neck.

How good it is for them!

He emphatically refuses to buy leggings.

—Like a prison! he says.

Providing a strange counterpoint to these imaginative commentaries are epigraphs from classical texts, which preface each of the three waltzes. An excerpt from Jean de La Bruyère's *Les Caractères ou les moeurs du siècle* (1688) serves as an introduction for "Sa taille"; a line from Cicero's *De re publica* (ca. 54–51 B.C.) introduces "Son binocle"; and "Ses jambes" is preceded by an excerpt from Cato's *Agri Cultura* (ca. 200 B.C.). On the surface, this choice seems bizarre and even nonsensical, but Satie's logic comes into

focus when the work is viewed in light of his contemporaneous engagement with fashion and the modernist approaches of the circles at the Société Lyre et Palette and the Galerie Thomas.

Although they originate in radically different contexts, the three epigraphs are linked by their common involvement with Greek culture and matters of morality. La Bruyère's caustic account of court life in the age of Louis XIV, for example, is well known as a highly personal critique of the aristocratic society he observed firsthand from his post as tutor to the Duc de Bourbon; less frequently noted is the fact that the work made it past the king's censors only because it was presented as an appendix to La Bruyère's translation of the *Charakteres* of the Greek philosopher Theophrastus. Probably composed around 300 B.C., Theophrastus's work consists of thirty brief character sketches that delineate the main kinds of moral types found in the high echelons of ancient Greek society as they had been outlined in the studies of Aristotle, who was Theophrastus's teacher. La Bruyère's original *Caractères* updates this approach to *ancien régime* France and is widely considered to be the first work of social criticism in French literature.

Similarly, Cicero's seminal work, *De re publica* (from which derives the term "republic"), was an effort on the part of the famous Roman senator to make the moral ideas of the Greek philosophers accessible to his contemporaries; in essence it is his Latin re-telling of Plato, describing a harmonious universe where justice reigns and the aristocracy rules with fairness. Finally, the Roman Senator Cato's text on agriculture, which is among the oldest extant examples of Latin prose, is a practical manual for owning or managing a farm, a paean to the principles of simple living and hard work. Cato, known as "the Censor," adamantly opposed the luxury and wealth that he perceived would be the downfall of Rome, and argued that Greek language and philosophy, emanating from the decadent East, threatened values, a sentiment encapsulated in his famous dictum, "Carthage must be destroyed."

Satie's access to these historical texts was no doubt simplified since all three were reissued in new editions in France between 1910 and 1912.[41] Drawing from these sources, he chose his epigraphs carefully to create a series of references to classical scholarship while at the same time exercising his beloved *ton de blague*. Above all, the texts he selected seem to offer a self-referential, tongue-in-cheek critique of his own compositional aesthetic: the maxim taken from La Bruyère, for example, which asserts that "those who injure the reputation or position of others for the sake of a witticism deserve to be punished with ignominy," seems ironic in light of the very witty work that would follow, not to mention all of Satie's past compositional humor. Likewise, Satie's choice of an obscure line from Book IV

of Cicero's *De re publica,* drawn from a section of the treatise devoted to criticizing the Greek practice of exercising naked, seems to be a clear reference to Satie's early and successful *Gymnopédies* of 1888, which take their title from a dance done naked by adolescent boys. Finally, from Cato he selected a simple instruction issued to the paterfamilias: "The master's first duty, when he returns to the farm, should be to prostrate himself before the household gods; then, the same day, if he has time, he should make the rounds of his domain, so that he can see the state of his fields, the work that has been done, and that which remains to be completed." This appears to refer to the very act of composition itself; having come to the final piece in *Trois valses,* Satie was in a position to "prostrate himself" before the work and take stock of what he had done.

The texts woven into the fabric of *Les Trois valses,* then, create two distinct levels of commentary. The first, which is concerned with the mundane details of fashion and style, is conveyed in Satie's own quasi-narrative, which is fitted into the musical score; the second, which associates Satie's compositional approaches with classicist thought, is presented in the epigraphs that preface each of the three dances. Taken in total, these texts bring everyday concerns of appearance into contact with eternal questions of morality and beauty, and suggest their proximity in a lighthearted and humorous way. This was a connection and an approach to which the circle of artists and otherwise fashionable Parisians who gathered at the Société Lyre et Palette and at the Galerie Thomas would certainly have warmed.

## BACK TO THE BONGARD SALON

Following on the heels of the premiere of *Les Trois valses* at the Salle Huyghens, the Satie/Granados concert chez Bongard in May 1916 featured Satie's performance of his most recently composed set of piano pieces, entitled *Avant-dernières pensées,* as well as the premiere of *Trois mélodies* in its entirety (the third song, "Le Chapelier," having been finished only four days earlier) with Satie accompanying popular soprano Jane Bathori.[42] With pieces entitled "Idylle," "Aubade," and "Méditation," *Avant-dernières pensées* charts territory different from that of *Les Trois valses,* but likewise alludes to classical and mythological subjects. In addition, the dedication of the individual pieces to (respectively) Debussy, Dukas, and Roussel seems to have been designed to associate the work with a modern-leaning national musical tradition.

The audience-pleaser at this concert, however, was no doubt the new song set *Trois mélodies,* which included "La Statue de Bronze," "Daphénéo," and

"Le Chapelier." Songs had been Satie's livelihood during his café-concert and cabaret days at the turn of the century, but, remarkably, he had composed nothing in the genre between 1903 and 1914. That autumn, as France entered the first winter of the war, he returned to song with *Trois poèmes d'amour*, three extremely brief settings of his own "magic words"—the first and last song texts he composed—in a style evoking French medieval song. With *Trois mélodies*, he took a different approach, setting humorous texts he solicited from poets Léon-Paul Fargue and René Chalupt as well as from seventeen-year-old Mimi Godebska, daughter of Satie's friends Cipa and Ida Godebski. Ravel was also a friend of the Godebski family and composed *Ma mère l'oye* for Mimi and her brother in 1908; Mimi's aunt was the formidable socialite Misia (Godebska) Sert, who in 1915 was fast becoming one of Satie's main patrons. Satie met Chalupt through Roland-Manuel and promptly became friends with the Chalupt family; he dedicated "Son binocle" and "Ses jambes" from *Les Trois valses* to (respectively) René and his sister Linette, who was a piano student of Satie's friend and interpreter Ricardo Viñes. Though the origins of Satie's relationship with Fargue remain murky, the two probably met through Viñes and/or Ravel, who, like Fargue, were members of the artistic group that cohered beginning in 1902 and adopted the name "Les Apaches."[43]

Each of the entertaining songs in *Trois mélodies* features a distinctive musical style and approach. "La Grenouille," for example, tells the story of a bronze frog in a public park; his mouth cast open, he seems eternally poised to speak great thoughts, but can do no more than collect the change thrown his way and serve as a resting place for insects. The vampy march Satie uses to set this text gives way to a static ostinato figure as the frog's frustration and boredom are revealed; he yearns to be free but is unable to change his circumstances. "Daphénéo," cast as a dialogue between two children, Daphénéo and Chrysaline, is a tale of the confusion that ensues over two words that sound exactly the same in French: "un noisetier," a hazelnut tree, and "un oisetier," an imagined tree that yields weeping birds. Satie matches the deadpan inquisitiveness of the text by associating each child with a distinctive musical motive; by linking those motives through retrograde inversion he sets up a musical situation in which questions and answers sound as aural calls and responses.

While this musical trick may have been lost on audiences, the wit of Satie's approach in "Le Chapelier" would have been easy to discern. Chalupt's poem is a retelling of the Mad Hatter's tea party, the famous scene from Lewis Carroll's *Alice in Wonderland*. The Hatter's watch, clogged with butter, is running three days slow, and in order to remedy the

problem he drops it into his cup of tea. To create a musical rendition of this text, Satie turned to one of the techniques he had honed in the humoristic suites of 1912–15, borrowing a well-known tune as the basis for his new composition. In this case, he lifted the love-duet from Charles Gounod's popular five-act opera *Mireille*, a tune which itself is based on the Provençal folksong "O Magâli, ma bien-aimée." Satie's borrowing from Gounod, who in turn had borrowed from French tradition, thus creates a musical parallel to the looking-glass distortions of the Mad Hatter's milieu. While Satie reconstructs Gounoud's piece, changing the texture to emphasize the bass, regularizing the meter, and shifting in and out of references to the melody, the tune would have been instantly recognizable and the humor would have been obvious to the trendy crowd gathered at the Bongard atelier.

## FASHION AND MUSIC AT THE SALON D'ANTIN

Fashionable as the artistic "happenings" at the Galerie Thomas and the Salle Huyghens were, they were overshadowed in the summer of 1916 by a blockbuster series devoted to "Painting, Poetry, Music" known as the Salon d'Antin.[44] Sponsored by the review *SIC* (short for *Sons—Idées—Couleurs*), the program for the salon included an exhibition of avant-garde art, two literary matinees, and two musical matinees. The venue for all these events was Paul Poiret's couture salon on the rue Faubourg Saint-Honoré, but the exhibition took its name from the atelier's back-door address on the avenue d'Antin (now avenue Franklin-Roosevelt), most likely in an effort to make the show seem more official. Poiret's sponsorship of the exhibit, a significant effort on behalf of modernist art in the midst of the war, was later described by André Salmon as the stroke that "put an end to the many powerful forces hostile to modern art," thus opening the way for advanced modes of expression following the armistice.[45] And while a large number of paintings were on view for the first time during this show, the exhibition is famous for one in particular—Picasso's *Les Demoiselles d'Avignon*—which shocked and scandalized audiences at the opening even though it had been completed nine years earlier. Picasso's involvement in this exhibition, and his willingness to at last put the *Demoiselles* on view, was no doubt eased by his relationship at the time with one of Poiret's top models, the exotic Pâquerette.

The literary and musical events adjunct to this exhibition included readings by poets Max Jacob and Guillaume Apollinaire and concerts featuring works by Satie, Milhaud, Stravinsky, and Georges Auric. The first of these musical performances included Satie's *Gymnopédies* and *Sarabandes* for

GERMAINE BONGARD

piano, Stravinsky's *Three Pieces for String Quartet*, performed by Yvonne Astruc, Milhaud, Honegger, and Félix Delgrange, and works by Henri Cliquet, Roger de Fontenay, Milhaud, and Auric. Misia Sert was in the audience and the next day characterized the music in bluntly unflattering terms in a letter to Stravinsky:

> Well, then, yesterday afternoon I heard there was a concert at Poiret's art gallery, where they were playing Satie, then your quartets. You can imagine that I dropped everything and threw on my clothes to get there in time to hear some of it. When they got to you, my poor ears had been subjected to every possible nightmare—and my eyes, too. Why do you get mixed up in all this, dear Igor? What sense is there in this poor man's sauerkraut?"[46]

A "nightmare" for the eyes: surely Misia refers in the latter instance to the Cubist aesthetic of Picasso's monumental canvas. By the time of the Salon d'Antin, of course, Picasso had moved away from such an aggressively fractured approach, turning instead to more representational modes of expression and reprising the themes of his pre-Cubist paintings. His next major project, however, would allow him the opportunity to juxtapose Cubism and classicism to stunning effect: on August 24 Picasso agreed to join Cocteau and Satie in the creation of a new work for Diaghilev's Ballets Russes, which would be entitled *Parade*.

# 5

# VANITY FAIR

Fashions!—The Stage!—Society!—Sports!—The Fine Arts!
*DRESS AND VANITY FAIR* MASTHEAD, 1913

Cocteau and Satie set to work on *Parade* almost immediately after their encounter at the Bongard *fête* in the spring of 1916, launching a stormy partnership that would last for nearly seven years. The fruits of this collaboration were few in number but bold in intent: the duo proposed to demonstrate that modernist art could be entertaining, fashionable, and fun. Modernism à la Cocteau and Satie drew its materials from the ephemera of everyday life, including fashion, advertising, cinema, and popular song, and expressed itself in a slangy tone that was both colloquial and sophisticated. Casual yet cosmopolitan, this mix matched the heady mood that prevailed after World War I and appealed to high-society patrons as well as avant-garde provocateurs. By the close of the 1920s, it had become a dominant style in France and in the United States, and was recognized as a viable alternative to the more hermetic and abstract modernist works that emerged at the same time. Not to everyone's taste, however, fashionable modernism had its share of detractors, and they reacted with force on the occasion of its public debut, which arrived with the premiere of *Parade* at the Théâtre du Châtelet in May 1917.

Like the premiere of Igor Stravinsky's *Rite of Spring* or George Antheil's *Ballet mécanique*, *Parade*'s first performance has become the stuff of legend.[1] Given by the Ballets Russes at an invitation-only society benefit for war victims in May 1917, the ballet was the fourth and final work on a program that included two established crowd pleasers—the Romantic favorite *Les Sylphides* (1909) and Stravinsky's *Petrouchka* (1911)—along

117

with the more recent but highly conservative *Midnight Sun* (1915), with music by Nicolai Rimsky-Korsakov. As the closing number on the bill, *Parade* left the audience divided, with half of the patrons shaking their heads in amazement and the remainder shaking their fists in anger.[2] Those in the latter group protested that the work was lighthearted, silly, and banal, and thus offensive in light of the raging battles on the Eastern front; they derided its creators with the wartime epithet *sales boches,* or "dirty krauts." "If I had known it was going to be so silly," one man of this ilk reportedly remarked as he stalked out of the theater, "I would have brought the children."[3] Like many of the artists present at the premiere, however, Marcel Proust viewed the work's humor and wartime meaning more philosophically, writing to one of his friends after the performance that he found *Parade* "so moving . . . it puts the brakes on and gets moving again so marvelously. What concentration there is in all this, what nourishment for this age of famine."[4]

*Parade's* storyline helped to incite this wide range of reactions. A departure from the standard Ballets Russes fare of mythology and oriental spectacle, it was a detour into the mundane world of Parisian entertainment, deriving both its title and content from the performance sideshows known as *parades* that were typical at French carnival celebrations and outdoor fairs. The fairground setting was not new in Diaghilev's productions—*Petrouchka's* milieu was the Russian Shrovetide carnival—but while *Petrouchka* was historical fantasy, *Parade* was a more startlingly realistic representation of a practice familiar to Parisians for centuries. Cocteau's scenario, in which the advertising come-ons fail pathetically, brings to the fore the drama of this ordinary occurrence:

> The scenery represents houses in Paris on a Sunday. *Théâtre forain.* Three music-hall numbers serve as the *Parade.*
>
> Chinese Prestidigator
>
> Acrobats
>
> Little American Girl
>
> Three managers organize the publicity. They communicate in their terrible language that the crowd is taking the parade for the *spectacle intérieur,* and coarsely try to make them understand. No one enters.
>
> After the final number of the *parade,* the exhausted managers collapse atop one another.
>
> The Chinese, the acrobats, and the little girl come out of the empty theater. Seeing the manager's supreme effort and their failure, they try in turn to explain that the show takes place inside.[5]

While this seemingly simple libretto has inspired a variety of interpretations, it has been read most commonly as an allegory of artistic modernism and misunderstanding: in this view the ballet proposes that like the thwarted players in the commonplace *parade* creative artists also face an ignorant and hostile public, which is blind to their determination, talent, and originality. Valid as this interpretation of *Parade* as a parable of the avant-garde may be, however, it is clear that what initially impressed audiences was the ballet's meshing of modernist art and society chic. Indeed, the team collaborating on the work—which included Pablo Picasso and Léonide Massine in addition to Cocteau and Satie—was the very embodiment of the hybrid mix of bohemian artiness and high-society style that was essential to the emergence of fashionable modernism. While *Parade* was on the drawing board, Picasso in particular was enjoying dual prestige as a leader in avant-garde circles and a darling of adventurous connoisseurs. The ballet was his first commission for the theater, and the simple fact of his involvement with the Ballets Russes—an ensemble viewed as a bastion of the elitist tastes and Right Bank establishment traditions—raised eyebrows in Left Bank artistic circles, where it was seen both as a betrayal of avant-garde principles and as evidence of a new commercialism in his work. Picasso's personal circumstances during the preparation of the ballet reinforced this perception of his social ambitions: in early 1916 he moved from a small apartment in Montparnasse (which at the time was the de facto headquarters of experimental art) to the fashionable suburb of Montrouge, and as if to cement his new status, while working on *Parade* in Rome that year began a relationship with one of Diaghilev's ballerinas, Olga Koklova, whom he married in July 1918.

The Right Bank / Left Bank tensions playing out in Picasso's personal life resonated forcefully in his decors and costumes for *Parade*. On the side of tradition, his classicizing curtain set a reassuring tone for the ballet, portraying in monumental scale a lovely (if slightly skewed) *commedia dell'-arte* scene of acrobats, clowns, and other Italian players. Now famous as the *rideau rouge*, it was technically not a curtain but a painting; measuring more than 10 by 17 meters, it was (and remains) Picasso's largest canvas. Showcased at the opening of the ballet, it was seen for barely a minute and a half as the orchestra played Satie's gentle *Prélude,* which the composer described as "very restrained and solemn, and even rather dry, but short . . . slightly banal, falsely naïve—blah, in fact."[6] Then it rose, and the sensibility of the ballet changed dramatically. Picasso's set suggested a city consisting of several abruptly angled large buildings; it was as though he aimed to bring the Cubist aesthetic of his earlier paintings to three-dimensional forms. This

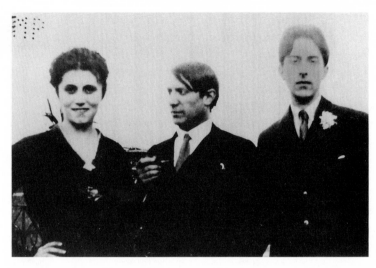

FIGURE 54. Olga Koklova, Pablo Picasso, and Jean Cocteau in Rome, 1917

was confirmed when the ballet's characters appeared on stage: two of the managers wore 10-foot-high constructions meant to make them look like walking collages—the French manager outfitted as a pipe-smoking Harlequin and the American as a New York skyscraper—while the third, costumed as a horse, was created by two dancers who wore a suit topped with a large head that was realized in multiple planes and fractured perspectives. These costumes and theatrical backdrops solidified the association of Cubism with fashionable society and prepared the way for the more general acculturation of Picasso's artistic style, which would occur through the 1920s.

*Parade*'s Cubism, however, was not the only element that gave the ballet a cachet of modernist chic: as Deborah Menaker Rothschild and Jeffrey Weiss have independently shown, its appeal to the beau monde stemmed just as much (if not more) from its use of music-hall acts as the basis for ballet.[7] Although the music-hall show was not a new entertainment in 1917—it had emerged in the mid–nineteenth century almost simultaneously in Paris and London—it was recognized in the early twentieth century as an expressly modern amusement. Fast paced and lavishly costumed, it was an irreverent, topical, and often risqué distillation of contemporary life, done in a manner completely consistent with contemporary sensibilities, and it appealed to patrons in a cross-section of social and economic classes. With an emphasis on variety (to the extent that the term "variety

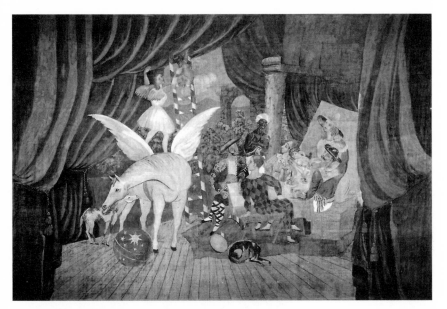

FIGURE 55. Pablo Picasso, curtain for *Parade*, 1917

theater" became a synonym for "music-hall"), it included a wide range of acts, which could involve "circus acrobatics, juggling, sports, magic, animal acts, comic sketches, cinema" as well as "a défilée of lavish costume and female flesh."[8] The vitality and resonance of this mix was especially powerful, as artists searched out new modes of expression on the eve of the war; the Italian Futurist provocateur F. T. Marinetti spoke for many when he celebrated the music-hall for having "no tradition, no masters, and no dogma," proclaiming it "the crucible in which the elements of an emergent new sensibility are seething."[9]

Just a few years later, Cocteau signaled his desire to reflect not only the music-hall's subjects and style but also its orientation toward modern life in *Parade*'s subtitle: *Ballet réaliste*. This intention was unmistakable on stage since the acrobats and the Chinese magician featured in the ballet would have been instantly recognizable to the audience as new versions of the characters that populated music-hall revues around town. Picasso sealed the association by closely modeling his costumes on those of music-hall performers, with the acrobats in blue and white tights and the conjurer in a boldly decorated suit of red, yellow, and black silk. The managers, too, were modeled on the stock figures from these entertainments—the master and mistress of ceremonies known as the *compère* and *commère*—and even

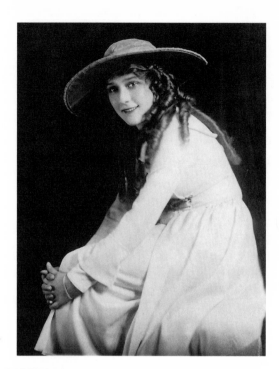

FIGURE 56. Mary Pickford
in 1921

Picasso's Cubist horse costume could be traced to the equine outfits worn
in music-hall shows by the famous Parisian clowns Footit and Chocolat, as
well as by the Fratellini brothers at the Cirque Médrano.[10]

Above all, however, *Parade*'s kinship with fashionable music-hall culture
was obvious in the Little American Girl. Hollywood supplied the models for
this character, in the form of two young starlets who ruled the silver screen
in its early days: Pearl White and Mary Pickford. White, who played the lead
in the popular movie series *The Perils of Pauline*, released in 1914–15, was
known for her cleverness and daring stunt work, while Pickford, dubbed
"America's Sweetheart," played the cute charmer in a string of films that
included *Poor Little Rich Girl* and *Rebecca of Sunnybrook Farm*, both
released in 1917. The costume for *Parade*'s Little American Girl, purchased
at the last minute off the rack of a Parisian sporting goods store, combined
allusions to Pickford's childish attire, which generally involved flouncy
dresses and a floppy hair bow, with the suggestion of White's "Pauline" uni-
form, which typically included a wide-collared middy sailor blouse.

These American stars came to *Parade* not only via the cinema, but also
via the Parisian music-hall, where imitators of Pickford and White per-

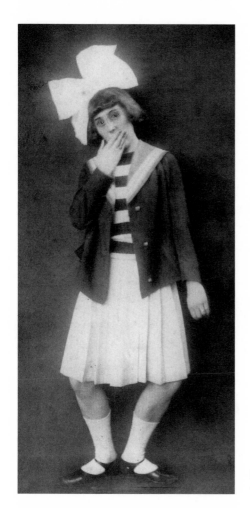

FIGURE 57. Lydia Sokolova as the
"Little American Girl" in *Parade*

formed under evocative names such as "Miss Rag Time" and "Miss Kathaya Florence, the Yankee Girl." Cocteau's "Girl," like her music-hall counterparts, performed a routine worthy of the screen heroines, riding a horse, jumping on a train, cranking up a model-T Ford, pedaling a bicycle, swimming, playing cowboys and Indians, snapping the shutter of a Kodak, dancing a ragtime, imitating Charlie Chaplin, getting seasick, almost sinking with the Titanic, and finally relaxing at the beach. The ballerina dancing the role was required to execute an unprecedented athletic routine that included numerous cartwheels, splits, and jumps, prompting one contemporary critic to note that there were "dozens of music-hall performers who

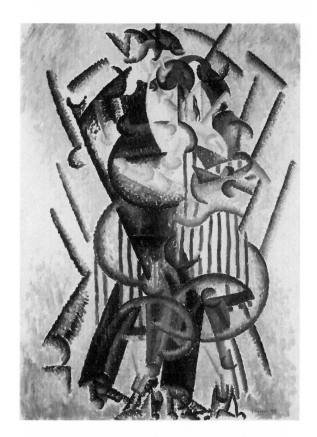

FIGURE 58. Gino Severini, *The Bear Dance at the Moulin Rouge*, 1917

can do this sort of thing better, because they are to the impudent manner born."[11]

In keeping with her Hollywood roots, the Little American Girl's showpiece was a ragtime dance, performed to music that seemed to come directly from the USA. In fact, Satie's catchy "Steamship Ragtime" did have an American core: it was a reworking of Irving Berlin and Ted Snyder's 1911 hit song, "That Mysterious Rag." One of that year's best sellers in the United States (topped by another Berlin dance tune, "Alexander's Ragtime Band"), "That Mysterious Rag" never made it to Broadway but was a centerpiece of the vaudeville skit "A Real Girl," which was performed at the annual Friar's Frolic, a springtime ritual of New York society. The song reached Paris in 1913 under the title "Mystérious Rag" and was one of the

highlights of the music-hall revue *Tais-toi, tu m'affolle*s (roughly, "Shut Up, You Bother Me"), which played at the Moulin Rouge through most of that year. In that revue, the popular dance team of Manzano and La Mora (an obvious pun on the French word *l'amour*) performed a step called the Grizzly Bear to the tune. Initially scandalous—Sophie Tucker was arrested in 1910 for her rendition of the dance—the Grizzly Bear was part of a craze for steps that coarsely mimicked animal motions, which included the Turkey Trot and the Bunny Hug. Manzano and La Mora's version, marked by a "swooping, swaying walk that culminated in a bear-like lurch and hug," was wildly popular, and among other things inspired an abstract portrait of the dance team in action by the Futurist artist Gino Severini. The French edition of the song, published by Edouard Salabert in 1913, featured a cover photo of the duo costumed for their act in American cowboy garb, and included a set of instructions supplied by "le Professeur Robert" outlining the steps.

By making "That Mysterious Rag" the foundation for his own "Steamship Ragtime," Satie swept up a variety of references and allusions that intensified the characterization of *Parade*'s Little American Girl and drew attention to the fact that she was an archetype of transatlantic style. Among other things, Berlin and Snyder's ragtime song is explicitly about the dance mania that prevailed in early-twentieth-century France and America, with a lyric describing the "sneaky, freaky, ever melodious" tune that would consume you "while awake or while you're a-slumbering":

> Did you hear it? Were you near it?
>
> If you weren't then you've yet to fear it;
>
> Once you've met it, you'll regret it
>
> Just because you never will forget it
>
> If you ever wake from your dreaming, a-scheming, eyes gleaming
>
> Then suddenly you take a screaming fit, that's it!
>
> That Mysterious Rag . . .

As much as these lyrics identify the Little American Girl with the latest dance fads, so too does the song's genre suggest her au courant style. The ragtime song was the height of fashion after about 1910, and was typically written for performance by female music-hall stars. On both sides of the Atlantic these celebrities were typically featured on the covers of sheet music arrangements of the tunes; while the French edition of "Mystérious Rag" included a photo of Manzano and La Mora, the American version reproduced a cameo photo of either the popular singer Carrie Lilie or the

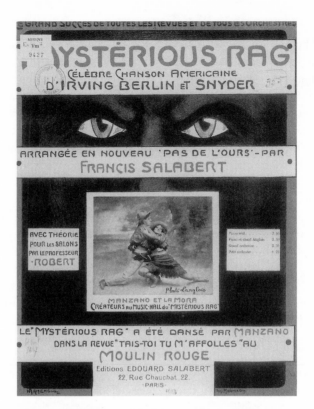

FIGURE 59. Manzano and La Mora on the cover of
Salabert's edition of the "celebrated American song,"
"Mystérious Rag," by Irving Berlin and Ted Snyder, 1913

multitalented Bonita, who was part of one of the most successful vaudeville
acts of the early century.

Exactly how or why Satie landed on "That Mysterious Rag" as his model
for the "Steamship Ragtime" remains a mystery itself. He never acknowl-
edged his use of the song, and no obvious connection links the tune or lyric
to the scenario enacted by the Little American Girl. Furthermore, there is
no evidence to suggest that Satie attended the Moulin Rouge show, or that
he met Berlin prior to a reported encounter in Paris in 1922.[12] What Satie
probably did know was the Salabert score of Berlin's piece, in at least one of
its four versions: it was published in 1913 as a piano solo, as a song with En-
glish text and piano accompaniment, and in versions for large and small
orchestra. Satie's adaptation, scored for large orchestral ensemble, is not a

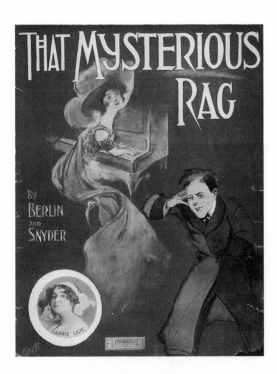

FIGURE 60. Carrie Lilie in a cameo photograph on the cover of "That Mysterious Rag," by Irving Berlin and Ted Snyder, 1911

simple borrowing from any of these arrangements, but is instead a thorough reworking of the model that alters melodies, harmonies, and overall structure while leaving the rhythms of the original song almost entirely intact. As is now well known, Satie reorganizes the original material, presenting it in reverse order, beginning with twenty-four bars that correspond to the original chorus, moving on to sixteen bars based on Berlin's verse, and ending with eight bars that paraphrase Berlin's introduction. In each of these sections, Satie also alters the original melodies, following a formula that turns rising passages into descending ones, stepwise patterns into skips, and repeated notes into distinct and different pitches.[13] In combination with his advanced harmonic scheme for the piece, these melodic changes obscure the original tune, masking the model so thoroughly that Satie's use of Berlin's music escaped notice until 1961—a remarkably late date given the widespread popularity of the original song.[14]

Satie's title—"Steamship Ragtime"—is simpler to explain. Derived from the scenario for the Little American Girl's turn on stage, it refers both to the general vogue for transatlantic steamship travel (which remained a novelty through the 1920s) and, more specifically, to the Titanic, whose

sinking the Girl escapes. Above all, however, the ship seems to serve as a marker of Americanism, as detailed in Cocteau's description:

> The Titanic—"Nearer My God to Thee"—elevators . . . steamship apparatus—The New York Herald—dynamos—airplanes . . . palatial cinemas—the sheriff's daughter—Walt Whitman . . . cowboys with leather and goat-skin chaps—the telegraph operator from Los Angeles who marries the detective in the end . . . gramophones . . . the Brooklyn Bridge—huge automobiles of enamel and nickel . . . Nick Carter . . . the Carolinas—my room on the seventeenth floor . . . posters . . . Charlie Chaplin.

This string of ideas, painting modern America as a clanky hub of endless sound, motivated the most radical innovation of *Parade*'s score, which was the inclusion of non-musical noises. Added by Cocteau, and ranging from whistles and sirens to the pecking of a typewriter and the firing of a gun, these sounds were intended to heighten the ballet's realism; as Cocteau jotted in a note on the final copy of Satie's manuscript, "the four-hand piano music of *Parade* is not a work in itself but is intended as a background designed to put the primary subject of sounds and scenic noises into relief."[15] Not surprisingly, Satie objected to having his music accorded such lesser status, and at his insistence nearly all of the sounds were suppressed in the performances of 1917.

*Parade*'s mix of influences from Cubist art and music-hall entertainment inspired its most important champion, the poet and critic Guillaume Apollinaire, to pen a now famous program note about the ballet. Published in the newspaper *L'Excelsior* during the week of the first performance, the essay introduced two new terms to the art lexicon: the phrase "l'esprit nouveau," which Apollinaire borrowed from military jargon to suggest a parallel between wartime camaraderie and *Parade*'s artistic teamwork, and the neologism "sur-réalisme," which he devised to describe the ballet's transcendence of nineteenth-century realism. [16] As both he and *Parade*'s creators surely recognized, exactly these qualities would make the ballet scandalous in some conservative quarters. Ever savvy, though, Cocteau chose to depict in *Parade* specific kinds of entertainment that enjoyed a particular vogue with members of fashionable society, who, shedding their stodginess during the war, had begun to frequent lowbrow haunts like the music-hall and circus. This practice of "slumming," as sociologist Pierre Bourdieu has noted, provided the social and intellectual elite with a way of distinguishing itself from bourgeois culture.[17] Such distancing notwithstanding, however, it was the same stylish crowd that remained at the core of the Ballets Russes' audience, and by presenting to them on the stage of the Opéra an "artistic" ver-

sion of the acts they enjoyed in shadier venues, Cocteau not only allowed everyday entertainment to "invade art with a capital A," but also validated their role as tastemakers. *Parade* thus marked a turning point for the Ballets Russes, heralding a new sensibility rooted in the sophistication of upper-class life. Just as Diaghilev's troupe had set the themes and tone for fashionable society before the war with Eastern exoticism, so now fashionable society was setting the themes and tone for the ballet.

In the same vein, *Parade* reinvigorated and reconfigured the fashionable life that had developed around the Ballets Russes prior to the war. Artists and patrons still mingled in well-appointed drawing rooms, but now a group of younger bluebloods, American expatriates, and celebrities from stage and screen joined the stalwarts. This reconstituted social coterie, dedicated to reasserting the primacy of French cultural values, perceived the arts as a pleasurable cause and embraced fashion, advertising, and popular song with an enthusiasm previously reserved for literature, painting, and musical composition. Their vision of French culture was defined accordingly: just as money, fashion, and art blurred the boundaries of class in the 1920s, the modernism embraced by post-war high society mooted the traditional categories of old and new.

## FRENCH MODERNISM IN THE AMERICAN PRESS

*Parade* had a short run in 1917: scandalous to the mainstream audience, it was panned by Parisian critics and quickly dropped from the repertory. Between its premiere and its revival in 1920, the ballet's most significant afterlife occurred on the pages of style and fashion magazines, where articles illustrated with drawings and photographs extolled its modernity and originality. Since many French journals had suspended publication during the war, some of the most fervent appreciations of *Parade* could be found in American magazines, and the foremost among these was *Vanity Fair*, the culture and arts magazine founded in 1913 by the legendary publisher Condé Nast.[18]

Intent on developing a magazine devoted to high style, in 1913 Nast had purchased the fashion journal *Dress* magazine along with rights to the title "Vanity Fair" and had married the two on a single masthead as *Dress and Vanity Fair*. Much as this composite title suggested, the new magazine, according to an early editorial, intended to cover in equal doses "the Paris mode" and "the myriad interests" of the "Vanity Fair," which had been described in John Bunyan's seventeenth-century tale *The Pilgrim's Progress* as a marketplace for "houses, lands, trades, places, honors, kingdoms, plea-

sures, and delights of all sorts." Designed to appeal to men and women alike, the journal aspired from the outset to cover developments not only in fashion but also in theater, literature, art, and the outdoors, as well as "the most interesting doings of the most interesting people," and aimed to establish a new brand of American sophistication. Music was understood to be an essential ingredient of this good life, and, accordingly, the magazine offered readers a guide to the most stylish composers and their works, as well as substantive reports on musical aesthetics and events in the United States and Europe. Claiming that "all that is of interest in the Drama, in the Opera, and Music, both at home and in Europe" would be covered in its pages, the editors assured readers that they would "not lack in authority in those things which go to make the smart world smart."[19] While other publications—notably William Randolph Hearst's *Harper's Bazaar*—also promoted music as a key part of a fashionable lifestyle, no other magazine pulled it off with the panache or intellectual depth that Nast sustained, and no one did it with greater confidence, authority, or humor.

Nast's bold agenda for *Vanity Fair* was shaped by fifteen years of experience and a string of successes in the publishing industry. His first feat was salvaging *Collier's Magazine* from almost certain financial ruin in the 1890s, an act he followed by his transformation of *Vogue,* which he purchased in 1909, from a stodgy chronicle of New York society events into the nation's premier fashion magazine. As plans for *Vanity Fair* were reaching fruition in the summer of 1913, Nast spelled out the elitist philosophy that fueled these achievements in an extraordinary article entitled "Class Publications," which appeared in the trade journal *The Merchants and Manufacturer's Journal.* A manifesto for magazine marketing, it merits quoting at length:

> Even if we grant for the sake of argument that "all men are created equal," as the Declaration of Independence so bravely sets forth, we must admit in the same breath that they overcome this equality with astonishing rapidity. Among the 90 million inhabitants of the United States, as a matter of fact, there is a lack of "equality"—a range and variety of man- and womankind—that simply staggers the imagination. . . . This vast population divides itself not only along the lines of wealth, education, and refinement, but classifies itself even more strongly along the lines of interest. . . . And a class publication is nothing more nor less than a publication that looks for its circulation only to those having in common a certain characteristic marked enough to group them into a class. That common characteristic may be almost anything: religion, a particular line of business, community of residence; common pursuit; or some common interest. When I say a class

publication "looks" to one of these classes for its circulation, I say it very mildly; as a matter of fact, the publisher, the editor, the advertising manager, and the circulation man must conspire not only to get all their readers from the one particular class to which the magazine is dedicated, *but rigorously to exclude all others*.[20]

For Nast, the only class worth catering to was the upper class, although he included in this target group those who aspired to high society as well as those firmly ensconced within it. As for culture, Nast firmly held to the conviction that the new American elite should look in only one direction for a model, namely, to France.

This transatlantic orientation was to some extent in Nast's blood. As his biographer Caroline Seebohm has documented, his mother was descended from a long line of French aristocrats, among whom the Chamberlain to Louis XI and the court painter to Louis XIV were only the most prominent; his first wife, Clarisse Coudert—described by one acquaintance as "slender, suave, and frighteningly chic"—boasted a family tree that included one of General Lafayette's most trusted confidants as well as numerous scions of French society.[21] While Nast himself never learned to speak the language, his view of sophisticated culture and taste was shaped from the outset by French values, and in his professional life he saw to it that his magazines were infused with the sensibility of Gallic style.

Not surprisingly, Nast's pro-French bias was especially sharp after the declaration of war in the summer of 1914, and it intensified as time passed and pressure for the United States to participate in the conflict mounted. In January 1916, *Vanity Fair* officially entered the polemical fray, publishing French author Marcel Prévost's article on "The United Sates and France," in which the author made the bold assertion that the two countries were bound together against Germany in a struggle of "right against might."[22] Six months later, the magazine made the issue personal by printing an article entitled "Dropping Bombs on the Boches," based on the diary entries of Bernard Boutet de Monvel, a conscripted illustrator who worked at both Vogel's *Gazette du Bon Ton* and Nast's *Vogue*. Boutet de Monvel's accounting of the "impressions and experiences of a French Aviator Bomber," illustrated with photographs from the front, emphasized the dangers of the newly invented air war and was especially poignant in light of his wartime history: after sustaining injuries at the Battle of the Marne, Boutet de Monvel had been assigned to relatively safe duty in the French transport service, but insisted on being trained as a bombardier and ultimately earned the Croix de Guerre for his bravery.[23] His extraordinary story of heroism set the stage for *Vanity Fair*'s most fervent discussion of America's rela-

tionship to France and the responsibilities it imposed, which was published in May 1917, only a month after the United States declared war on Germany. Written by senior statesman Joseph Hodges Choate, who served as Ambassador to Great Britain from 1899 to 1905, the essay was entitled "What We Owe to France: A Debt That Cannot be Measured in Terms of Money or Munitions," and its support of U.S. involvement in the war was unconditional.[24] "How much America owes to France, not only in gratitude, but in money, is hardly possible to measure," Choate wrote. "In the darkest days of our Revolution, when we were living hand to mouth, in the sorest need of everything that could possibly make our Revolution a success, France came to our rescue with a generosity that was actually without limits. . . . I think it is safe to say that without these aids we should have had to succumb and postpone for half a century at least our own independence." Even more importantly, he insisted, the French had from the start of the war in August 1914 been fighting on America's behalf, since Germany's "long-cherished and proclaimed" purpose was the "destruction of free governments everywhere, and dominion over the whole world, not only from the North Sea to the Persian Gulf, but throughout Europe and America."[25] It was only right, in Choate's estimation, that the United States should at last stand side by side with France, since the brave actions and sacrifices of French soldiers had kept the Germans at bay.

Tied to this political agenda, and perhaps even more important to Nast, was the magazine's program of promoting French art and culture. An article by the American painter Allen Tucker, published in the June 1917 issue under the title "Why France? And Why Is the Earth Flooded with Her Splendor?" was definitive in this regard, linking French dominance in the arts to the urgency of the American support in the allied war effort. In a veritable paean to French art, Tucker—who had gained notoriety as one of the organizers of the famous International Exhibition of Modern Art in 1913, which became known as the New York Armory Show—asserted that in spite of "the attack by evil on everything in the world that men live by," France, "the essential," had not changed:

> This is the nation that made the color of the windows in Chartres; that flung that row of kings across the front of Amiens, that sent the towers of Notre Dame rearing up to God. The French have been producing art from the time of the cave men, thirty thousand years ago, until this very day. All kinds of art, from the profundity of the "Master of Avignon" to the delicacies of Corot. Literature! Think of Molière and Verlaine! Heroes! Take the single case of the burghers of Calais. Science! Levoisier, Pascal, Descartes, Pasteur. Sculpture! From the man who made

the virgin on the cathedral of Notre Dame through Pilon, to our own day. Decoration! From the mosaics of Monreale to Puvis de Chavannes.

The true genius of France, Tucker thus maintained, was the nation's constant progress, its ability to have "bred men and women and educated them, and cultivated them, and developed them, so that France has always grown, has always been modern, has continually been in a state of Renaissance."[26]

This construction of French modernism as an inevitable outcome of race, tradition, and training was completely resonant with the aesthetic outlook of *Vanity Fair*'s editor, Frank Crowninshield. A veteran of the magazine industry and a champion of contemporary visual art, "Crowny" was one of the founders of the Museum of Modern Art (he served as secretary of the Founding Committee) and had a personal collection that included works by Georges Braque, André Dunoyer de Segonzac, and Marie Laurencin.[27] It was at his insistence that the magazine dropped the title "Dress" from its masthead, and under his direction that it shifted focus away from fashion to devote itself to chronicling the "progress and promise of American life," and to "looking at the stage, at the arts, at the world of letters, at sport . . . from the frankly cheerful angle of the optimist or . . . from the mock-cheerful angle of the satirist."[28] With Crowninshield at the helm, *Vanity Fair* became the site par excellence for magazine modernism. On the literary front, the magazine introduced American readers to (among others) P. G. Wodehouse, Robert Benchley, Dorothy Parker, Edna St. Vincent Millay, Walter Winchell, Colette, Aldous Huxley, E. E. Cummings, Clive Bell, and Edmund Wilson, and published work by contemporary authors Paul Morand, F. Scott Fitzgerald, Roger Fry, Carl Van Vechten, Alexander Woolcott, Wyndham Lewis, and Anita Loos. Photographs by Baron Adophe de Meyer and Edward Steichen were featured along with the work of George Hoyningen-Huene and Cecil Beaton. And above all, there was considerable coverage of French modernist art, in articles and reproductions; Constantin Brancusi, Henri Matisse, Aristide Maillol, André Derain, and Marie Laurencin were but a few of the artists represented on *Vanity Fair*'s pages.

## THE NAST / VOGEL ALLIANCE AND FRANCO-AMERICAN STYLE

The French magazine Nast admired most was the tony *Gazette du Bon Ton*, so it comes as no surprise to find that he leapt at the chance when the opportunity to collaborate with its publisher, Lucien Vogel, arose in 1915. The occasion was of one of the young century's greatest events, the World's Fair known as the Panama Pacific International Exposition, which was held in

San Francisco between March and December that year. One of the first major spectacles illuminated by electric light, the Exposition boasted attractions ranging from nightly fireworks and carnival rides to the special exhibition of the Liberty Bell, on loan from Philadelphia, and featured a specially constructed forty-three-story "Tower of Jewels" on which more than 100,000 glass gems dangled individually in order to shimmer and reflect light as the Pacific breezes moved them. The Exposition commemorated not only the completion of the Panama Canal on 1 January 1915, but also San Francisco's recovery after the earthquake and fire of 1906, and the 400th anniversary of the explorer Balboa's discovery of the Pacific Ocean. It was the fourth World's Fair to be held in the United States, following those held in Philadelphia (1876; celebrating the centenary of the signing of the Declaration of Independence); Chicago (1893; marking the 400th anniversary of the discovery of America); and Saint Louis (1904; to celebrate the Louisiana Purchase). While France had been a key participant in all these events, the San Francisco fair offered an extraordinary opportunity for the renewal and reaffirmation of the Franco-American alliance.[29] San Francisco, after all, styled itself as "the Paris of America" and aspired to match the French capital in its urban planning, architecture, and rich culture; although as one American critic remarked, "French restaurants and gay entertainments" were hardly a guarantee that this vision would be realized.[30]

In keeping with the tradition of the World's Fairs, a key attraction of the San Francisco Exposition was its presentation of arts and industries from around the globe. Over fifteen countries, covering territory from Australia to Sweden, and from China to Cuba, participated in the event, constructing special pavilions to house displays and performances showcasing their national cultures. The outbreak of war in Europe during the summer of 1914 prevented both Great Britain and Germany from participating, but the war did not deter the French, who instead seized the opportunity to demonstrate the nation's cultural resilience even in the face of military aggression.[31] Theirs was the largest and most ornate pavilion of the Exposition, an exact copy of the Palais de la Légion d'Honneur in Paris, and it housed a series of exhibits "of historic interest and incalculable value" highlighting French achievements in everything from architecture to zoology. France also dominated the Exposition's musical landscape; the centerpiece of the musical programming was a festival in June 1915 honoring composer Camille Saint-Saëns. For this occasion, the "great master, eighty-two years old," traveled to the United States to conduct the Exposition's orchestra and choir, which numbered over three hundred musicians hailing from different parts of the United States. Presiding over performances at

Festival Hall, which was rebuilt and nearly doubled in size for the Exposition, Saint-Saëns directed a series of programs consisting entirely of his own compositions, and even composed a special piece in commemoration of the occasion—a "symphonic episode" entitled "Hail California."

While the French pavilion included a number of exhibits highlighting innovations in technology and the *beaux-arts*, a surprisingly significant amount of space in the building was given over to what might be called the "luxury industries," or, as described in a souvenir program, "all fine and artistic things in the manufacture of which France leads the world."[32] The building's central *cour d'honneur*, for example, was bounded by rooms displaying silks from Lyon and novelties from the great Parisian department stores, while exhibits of perfume, jewelry, and interior decorations occupied most of the space on the approach to its rotunda. Above all, however, crowds thronged to the display of "French creations in fashion," where the stylish new designs of eleven respected Paris couturiers—Beer, Callot, Chéruit, Doeuillet, Doucet, Jenny, Jeanne Lanvin, Martial et Armand, Paquin, Premet, and Worth—were on view. (Missing was Paul Poiret, who shuttered his ateliers and began work as the chief tailor to the French armed forces when war broke out.) The clothes were presented not as individual items, but in three separate dioramas, each evoking a scene at a trendy French locale: a visitor to the exhibit could take in the ambience and typical fashions of the spa at Vichy, the racetrack at Longchamp, and the beach at the Côte d'Azur without ever leaving the pavilion. More than simply putting couture on display, these dioramas aimed to convey the importance of fashion as uniquely French, and more importantly, as one of the nation's signal contributions to global culture. This was a long-standing claim—the identification of fashion with French genius can be traced to the sixteenth century—but it took on new significance during the war, as France struggled to assert its cultural supremacy over the Germans.

Aiding in this effort were Nast and Vogel, who collaborated on a special issue of the *Gazette* to commemorate the French fashion displays. The publication appeared in two versions: the first, in French, was produced in Paris and appeared as part of the *Gazette*'s normal run, while the second, published in New York and printed in English, appeared as a unique offering under the title "The 1915 Mode as Shown by Paris."[33] Although published in different languages, both editions featured the same material, including *pochoir* plates by the *Gazette*'s illustrators and articles on fashion by its authors. While showcasing the latest Parisian looks, these publications reinforced the notion of a Franco-American alliance and emphasized the political significance of couture by including a preface by Paul Adam that

FIGURE 61. Exhibit of French fashion at the Industrial Arts Palace at the Panama Pacific International Exposition, featuring gowns by Madame Valerio and a setting modeled after the gardens of Versailles

minced no words on the issue. "Although a part of French soil is yet in the hands of the invader," he wrote, "Paris remains as ever the Paris of good taste and fashion":

> In spite of the events of the war, the spring Fashions of 1915 have come out in France this year, just as usual. . . . Good taste is on the throne of her judgment. Of all that civilization can create and cunningly invent, what better testimony may be had than that of Fashion. . . . Paris has innovated a warlike elegance, jovial, sportive, and easy, leaving every gesture free, whether to raise the unhappy wounded, or if need be, to handle a weapon.
>
> . . . Since the Latin races are fighting to uphold their tastes against Teutonic barbarity, was it not to be expected, and right, that Paris fashion should take the lead this spring, as in the past?[34]

The collaboration on the Panama Pacific project signaled the beginning of a professional arrangement between Nast and Vogel that would develop throughout the 1920s, resulting in a modernist transatlantic style based in a mix of French and American elements. Shortly after the Exhibition, Nast hired a number of Vogel's writers and illustrators to work at *Vanity Fair* and

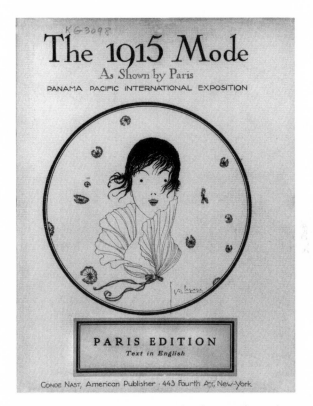

FIGURE 62. Georges Lepape, cover for the special French
and English edition of the *Gazette du Bon Ton*
commemorating the fashion displays at the Panama
Pacific International Exposition, 1915

*Vogue,* thus saving many of them from unemployment while the *Gazette*
suspended publication during the war; thereafter, the Vogel and Nast enter-
prises were virtually inseparable. When the *Gazette du Bon Ton* was revived
in 1920, it was published with Nast's financial backing, and the magazine's
masthead cited both Nast and Vogel as publishers. In addition, with mate-
rial and personnel borrowed from the *Gazette,* Nast began to publish a par-
allel American version of the magazine, which appeared in French under the
title *La Gazette du Bon Genre.* Billed as the "most expensive of all maga-
zines," Nast's *Gazette* promised to deliver "the very spirit and charm of
Paris" in its "unique and beautiful" pages.

No doubt due to its priceyness, the *Gazette du Bon Genre*'s appeal was
limited, and its primary clientele was a fashion-oriented crowd interested

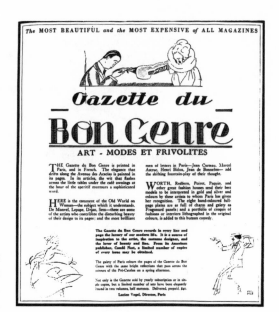

FIGURE 63. Advertisement for the *Gazette du Bon Genre*, from *Vanity Fair*, 1921

above all in the luxurious *pochoir* plates published in each issue. In *Vanity Fair*, by contrast, Nast had a forum for delivering his pro-French message to a considerably larger audience of American elites, and he embarked on this project immediately, making French culture a centerpiece of the magazine from its inaugural issue forward.

## FRENCH FASHION AND THE TANGO TEAS

In the first years of *Vanity Fair*'s circulation, Nast brought fashion to the fore in lengthy reports on "The Paris Mode," which he included in each issue.[35] Not simply a review of the latest styles, these articles were part practical reportage and part philosophical rumination, designed to promote the view of fashion as an essential aspect of French culture. By the time the magazine's second issue went to press in October 1913, the formula for this coverage was set. In an article entitled "The Triumph of French Traditions," the author—identified only as "Worth," thus insinuating that the piece was written by a member of the famous family of couturiers—asserted that the craft of French couture had at last been reestablished after many anomalous years of dominant orientalizing styles. In the author's view, it was a change for the better: "Not for many years have fashions been so full of detail, so full of workmanship," he announced with pride; "we have returned to our old love—strictly French fashions."[36]

In the next issue, *Vanity Fair* maintained this mix of fashion reporting and cultural commentary but landed on a livelier and more flexible frame for its coverage by linking news of the latest Parisian styles to updates on the city's ever-expanding mania for dancing. "The Dance Craze in Paris Creates New Types of Gowns," proclaimed the title of the first article in this vein, which was published in November 1913 and included illustrations and photographs documenting both the clothing and dance steps that were all the rage. The dance of the moment was the tango, and it was practiced in risqué afternoon gatherings known as Tango Teas, which were de rigueur for fashionable Parisians on the eve of the war. The erotic frisson of these occasions, during which respectable women were at liberty to dance with foreign strangers, required a provocative new kind of garment: "As everything in Paris is exemplified in, or leaves its mark on, clothes," *Vanity Fair's* critic remarked, "so Tango Teas have necessitated the creation of a new style of dress—one that could be worn afternoons and yet not be too warm for dancing. Thus we have the 'tango-visite,' or semi-evening gown, with short skirt and oh! So transparent a bodice . . . a whisper, or a breath, of tulle, or the finest, filmiest lace."[37] Loose enough to accommodate the sinuous steps of the dance yet suggestively revealing and body-hugging, the new tango gowns set the tone for a shift in fashion, away from tailored formality and toward coquettish delicacy. The styles illustrated in *Vanity Fair's* next article on the dance, published the following month and entitled "What You Shall Wear to the Tango Teas," exemplify this change, even including a "gown elaborately beaded with turquoises," which would clearly be seen to advantage when its wearer was engaged in the motions—and emotions—of the dance.

By December 1913, Tango Teas and the gowns they inspired had become so firmly identified with French style that, in searching for a way to validate the connection between Parisian tradition and the Argentine dance, *Vanity Fair* went so far as to suggest that by virtue of its "stately . . . slow and rhythmic movement" the tango was nothing more than an updated and exotic version of the quintessentially French minuet.[38] The dance, moreover, was affecting not only fashion but also fashionable lifestyles in the City of Light. In particular, the morning horseback rides in the Bois de Boulogne that had been a daily regimen for socialites since the 1890s were superseded by afternoons spent haunting the dark tango salons:

"An eternal tango" is how a witty American epitomizes the life of the French élégante of today—and very accurately, too. Does the Parisienne play bridge? No she tangoes! Does she promenade in the Bois? Oh no, she tangoes. Does she ride, drive, or pursue any of her accustomed pas-

*Dance gown of deep, shaped frills of fine lace edged with bison. These frills are held by bands of silver lace insertion embroidered in relief and posed upon a foundation of black satin. The bodice is of the silver lace insertion*

*This frock of all blue chiffon is quite sleeveless, and is held on the shoulders with jeweled straps of chiffon. The bodice is nothing more than an elongated girdle. Floating lengths of lavender chiffon fall from the left shoulder*

*An evening gown elaborately beaded in turquoises has but a very slight opening at the feet, and a short pointed train. Across the front, to form a little apron are shaped tulle frills, held in place by bands of the turquoises*

*A Cheruit dance frock of blue satin trimmed in rose satin. The fulness of the skirt is placed in small plaits, both in the front and at the back of the skirt. The sash, at the back, is of blue tulle*

*A changeable puce colored afternoon dress of taffeta. The silk is gathered over three ribbon bands to form three frills. Two of these are edged with bison fur. The bows, collar, and small revers are of matching panné velvet. The bodice is in waistcoat effect*

## WHAT YOU SHALL WEAR FOR THE TANGO TEAS

*The Argentine Tango is Like the Minuet, Stately in its Slow and Rhythmic Movement and it is for this Dance the Paris Dance Gowns are Designed.*

WHAT shall you wear for the Tango Teas? Let me whisper to you a secret, only to be revealed when it is found out, my dear, there is no Tango in America, or, at least, in New York. But it is quite different in Paris, and it is for Paris and the Tango that the French dance frocks are made.

*A white velours de laine coat and skirt with a sheer bodice which is suitable for Thé Dansant*

I never saw the Tango so well danced as at one of the cabarets in Paris, a unique place in the Montmartre, where one sees French, Americans, Russians, Spaniards and Argentines. There, dancing is purely personal, and they dance the Tango after the cabaret performances for true relaxation. I heard that Mr. Castle learned all of his fascinating steps from these men and women. Of course, the place is most Bohemian, for all of these people wear their stage costumes, reminding one of a fancy dress ball with the true Latin Quarter atmosphere.

Just after we arrived, some people came in evidently from having dined, for they were in dinner dress. French people are very energetic in their hunt for amusement, and unlimited in their capacity for enjoyment.

One of the girls had on a lovely white taffeta gown, the skirt was very narrow and lapped over so far in front that the opening did not show. At the bottom of the skirt was a three-inch border of blue, that seemed to be part of the material. When she stood her skirt was not over twenty inches wide at the feet. The tunic, which was short in front — not over eight inches from the waistline — stood out around the hips like a bit of crisp lettuce. It fell quite abruptly over the hips to the knees and longer at the back, where this panier went into a real pouch and was met by two sash ends that fell from the waistline to the bottom of the skirt. One sash end was of blue satin and one of a figured taffeta; these caught up the tunic at the back. The entire panier was veiled with thin brown silk net. Finishing the edge of this panier was a tiny box pleating of the net and a band of mink fur.

Under this gauzy and illusive panier was a semi-tight crushed girdle of figured taffeta, the figures being alternate bands of blue matching the blue at the bottom of the skirt, and soft pink roses. The panier was quite short in front and dropped to the knees at the side. The bodice had an illusive effect caused by the blue ribbon and figured taffeta being veiled with white tulle, edged with a band of rhinestones, and again veiled with a film of the brown net that fell to the waistline, where it was finished with a band of brown fur. Just at the bust, where you least expected a color or a definite line, was a soft five-inch blue satin ribbon, which finished in front in a loop and a pink rose. The sleeves were modest and pretty. They fitted the arm so as not to interfere with that important line of every woman's figure, the curve that runs from the under arm to the hips. How few women recognize this line and its importance.

I must tell you how pretty this girl's feet looked. Her slippers were blue silk and she wore blue silk stockings. The buckles on the slippers were rhinestones and turquoises, the blue stones matching the blue border of her gown. She had no ornament in her hair, but on her long white neck, which either nature or the artificer had produced — was a small string of graduated pearls, the most brilliant ones I ever saw. She was a blond.

(Continued on page 72)

*The skirt of this black velvet gown is open at the back over an insert of black lace.*

FIGURE 64. "What You Shall Wear for the Tango Teas," *Vanity Fair,* 1913

times? Indeed she does not; she tangoes. She tangoes afternoon, evening, and night until the wee sma' hours long past, she hies her home for a brief beauty sleep that she may be up and agoing again. . . . The beautiful Bois is forsaken save only by those who love it for itself. No one any longer goes there because it is fashionable. Truth to tell, the Parisienne is not naturally strenuous. She prefers soft cushions to the hard saddle, and, as the dance provides all the exercise she needs, on such occasions as she ventures forth it is to lounge in her limousine. The luxurious motor car with its costly fittings, silk cushions, and baskets of flowers, is now by no means a rarity on the Avenue des Champs-Elysées, and since the practical tailor suit but ill accords with the magnificence of this equipage, elaborate toilettes and languorous poses are adopted by its occupants. Paris is entering upon a period of luxury and elegance unequalled since . . . the eighteenth century.[39]

The elegant Parisienne was not alone in the tango salon; her American counterpart was likely to be dancing right alongside her. "Although many of the old nobility of France . . . claim that Americans have spoiled Paris," an article published in February 1914 explained, "it is difficult to imagine what Paris would do without its American colony."[40] Abandoning themselves to the dance, feminine "representatives of the land of the dollar" helped to transform what had been a pastime into an intellectual pursuit, queuing up at the Sorbonne and other bastions of French academe for lectures on the tango and its history delivered by celebrity scholars and social observers. More than simply filling the seats at these talks, the magazine reported, American women in need of tango gowns commanded the attention of top Parisian couturiers, who for the first time faced the realization that they needed to "put forth their best efforts not only for the American export trade but also for the Americans who live in the capital all year round."[41]

By early 1914, at just the moment that Satie was skewering the tango in *Sports et divertissements*, *Vanity Fair*'s critic Anne Rittenhouse could declare with confidence that "dress and the dance" were "inseparable . . . linked together in conversation, in the thoughts of women, and in the advertisements of the shops." If you intended to follow fashion, she insisted, "even from afar," it was essential to "go where dancing is to be seen," but this was a simple feat since dancing, "everywhere, and at all hours," was the "order of the day—and night."[42] It seems strange, then, to find that in spite of its focus on the social and cultural aspects of popular dancing, *Vanity Fair* devoted not one word in its articles to discussion of the music that lubricated the displays of fashion and dancing in tango salons until December 1914. The commentary that broke the silence was penned

by one Mrs. E. Roscoe Mathews, who remarked on the changes in Parisian life that had followed the Declaration of War and the mobilization of troops that took place that summer. Recalling that prior to the war "all Paris had taken up the Argentine rhythm with its appropriate genuflection," she noted that the city had, since the outbreak of the conflict, turned "rabidly American." "Everywhere, in the papers, the shops, the public squares were announcements of American teachers and dancers who declared that they would impart knowledge of the latest New York steps or give exhibitions of the most advanced and delirious forms of ragtime," she observed. "So quick had France been to follow our lead in all things that there was hardly a café which did not boast a band of Clef Club artists who played a sort of ragtime suggestive of a dim, shadowy Broadway."[43]

Mrs. Mathews's commentary brought to the fore the problem *Vanity Fair* would face from the outset in its reporting on contemporary music. Exactly what kinds of compositions would the magazine advocate to its stylish and culturally savvy readers—the popular tunes playing in the tango salons and other chic Parisian venues, or the more "serious" works of symphonists and art music composers? Could it do both? In short, when it came to music, the magazine seemed to be at a loss, with little to focus on in Nast's beloved France and even less in America that promised to appeal to its readers. In spite of the vow made in its inaugural editorial to cover "all that is of interest in . . . the opera and music, both at home and in Europe," *Vanity Fair* would flounder in this area, arriving at a set of topics and a brand of music that satisfied its mandate to be both au courant and stylishly French only after years of searching them out.

## MUSIC IN *VANITY FAIR*

*Vanity Fair*'s early commentators on music were preoccupied with fundamental and lingering questions about the past and future of musical composition in America—a topic that returned them, eventually, to the milieu of the Parisian dance salon. While the magazine devoted a few columns to the simple dissemination of musical information—critic Johnson Briscoe's preview of the New York opera season, published in the magazine's inaugural issue, was typical of this service—most of the substantive articles on music that appeared in the magazine up until 1917 grappled with the distressing fact that more than a century after the founding of their nation American composers had still not arrived at any sort of compelling or cohesive style.[44] The problem brought into relief the quintessentially American conflict between elitist and populist approaches: while some of the coun-

try's most celebrated composers, including John Knowles Paine, Arthur Hadley, and George Chadwick, had adopted European models and genres and continued to write symphonies, chamber music, and solo works in a late-Romantic style well into the twentieth century, others struggled to create a distinctive American music that uniquely reflected the national spirit and sensibility. This, they believed, required both new forms and a new musical language, and the source for both would be the fashionable world of popular dance. In short, they argued, ragtime would be the foundation of a truly modern and inherently American music.

*Vanity Fair* staked out its position on this controversy in April 1914, publishing an essay by Alys E. Bentley (described in an editorial note as the "head" of the "serious dance movement" in New York) that argued strenuously in favor of the ragtime-based approach. Syncopated music, in Bentley's view, had already captivated Americans; it was the only music powerful enough to "stir the pulses of our people so that they began listening, not only with their ears but with their hearts, and as it were, with their feet." Instead of responding to this "first sincere national desire for music observable in the masses," composers and academics had continued with the "mere blackboard teaching of music," making "little adjustment of this music instinct to the needs of a great nation like ours":

> There has been no inspiring connection between this nervous energy seeking for an emotional outlet and the higher planes of life and art. . . . By attending symphony concerts, [others have] educated themselves in music in a manner too often wholly intellectual and not spontaneous or natural. The result has been that most Americans have discovered, in ragtime, their first opportunity for basic musical expression . . . a true and natural expression of a primitive need for music expressed emotionally. They have realized the insufficiency of purely educational and intellectual music as a means of interpreting a natural art impulse.[45]

Much in the same vein, an essay by critic Charles Buchanan published in the March 1915 issue of *Vanity Fair* argued for an American music based on ragtime and other popular styles. "Can America produce great music?" he wondered in an article with the blunt title, "The Failure of American Composers". "Its artistic problem is unique; a dozen nationalities flung together under the dominion of a problematic thing called democracy. And yet the faintest echo of the large heave and tussle of modern America has found a place in music." American composers lacked "genius and melodic spontaneity," according to Buchanan, although these same qualities were plentiful in the "endless melodic kernels, the characteristically American rhythms that

are debauched and dissipated year after year in a welter of music hall frivolity." Instead of drawing on these native resources, he lamented, American composers continued to turn to Europe for models and methods, relying on "men who are alien, spiritually as well as geographically, to the American atmosphere and attitude of mind" for musical inspiration, and this could result only in the dead-end of imitation.[46]

*Vanity Fair's* readers had a taste of this European scene some months earlier, courtesy of the critic W. J. Henderson, whose essay on the continental modernists he dauntingly called the "new thought" composers was published in the magazine's January 1915 issue. The disparate group he gathered under this label included Ferruccio Busoni, Arnold Schoenberg, Alexander Zemlinsky, Jean Sibelius, and Erich Korngold, many of whom appeared, grim-faced, in photographs accompanying the article. Henderson characterized Schoenberg as both the group's leader and "a thinker of merciless logic," with "no respect for the sensuous charm of music," and he asserted that the "wreck of melodies and their crash of chords" emanating from the group as a whole had led the air to "throb with Kipling's ancient query, 'But is it art?'" Most bluntly, Henderson speculated that not one of these composers had felt "the fiercest draughts of tempestuous inspiration," but instead proposed that

> they crouch and huddle around their slim winter fires and croon their weird songs in the midst of flickering lights and eerie shadow. . . . Their music shivers and strains in alternate moods, but all is of the intense, meditative kind, the product of minds bent in upon themselves and seeking to create out of their own seed. Cerebral, analytic, coldly prepared and determined to astonish, this music is nonetheless an art. It seems unlikely to be lasting, but it is surely building a strong bridge across a chasm into new territory.[47]

With modernist Europeans ruled out, Carl Van Vechten stepped in to make an eloquent case for a new American art music based in vernacular sources. One of the most important commentators on music in the 1910s and 1920s, Van Vechten divided his time between Paris and New York, at first working for the *New York Times*, then publishing essays in a variety of periodicals, including *Vanity Fair*.[48] His reports on modernist composers were among the first serious assessments of new music to appear in print, and were collected in a series of books that notably included *Music After the Great War* (1915), *Music and Bad Manners* (1916), *Interpreters and Interpretations* (1917), and *Red* (1925). Concerned initially with Stravinsky, Schoenberg, and other Europeans, Van Vechten was by 1917 captivated by American popular song, jazz, and blues, and with the potential these

idioms held for concert music. In the April 1917 issue of *Vanity Fair*, he laid out his vision in an article entitled "The Great American Composer," which began with some negative speculation about the ultimate value of American music's highly acclaimed men:

> When some curious critic, a hundred years hence, searches through the available archives in an attempt to discover what was the state of American music at the beginning of the twentieth century do you fancy that he will take the trouble to exhume and dig into the ponderous scores of Henry Hadley, Arthur Foote . . . George Chadwick, Horatio W. Parker, and the rest of the recognizedly "important" composers of the present day? . . . A plethora of books and articles on the subject will cause him to wonder why so much bother was made about Edward MacDowell.

Instead, Van Vechten proposed, popular music, and especially ragtime tunes—he cited "Waiting for the Robert E. Lee," "Alexander's Ragtime Band," and "Hello Frisco"—would emerge as the "only music produced in America today which is worth the paper it is written on" because it represented an authentic and a genuinely contemporary mode of American expression. He addressed the question of European heritage with straightforward candor:

> If the American composers with (what they consider) more serious aims, instead of writing symphonies or other worn-out and exhausted forms which belong to another age of composition, would arrive to put into their music the rhythms and tunes that dominate the hearts of the people a new form would evolve which might prove to be the child of the Great American Composer we have all been waiting for so long and so anxiously. . . . If any composer . . . will allow his inspiration to run riot, it will not be necessary for him to quote or to pour his thought into the mould of the symphony, the string quartet, or any other defunct form to stir a modern audience. Percy Grainger, Igor Stravinsky, Erik Satie are all working along these lines, to express modernity in tone, allowing the forms to create themselves. . . . Alas! these men are not Americans![49]

## FASHIONABLE MODERNISM AND *VANITY FAIR*

Even as Van Vechten was putting the finishing touches on this essay, Satie and Cocteau were completing preparations for the premiere of *Parade*. *Vanity Fair*'s critics perceived in the ballet exactly the mix of popular sources and traditional framework that the magazine had been calling for from the outset, and its enthusiasm for the work and its creators was seem-

ingly unbounded. Scant months after the Paris premiere, in September 1917, the magazine published an article about the ballet by Cocteau himself that was part defense and part provocation, prefaced with an unsigned editorial reporting that Satie, "leader of the Futurist musicians," Picasso, "leader of the Cubist artists," and the "poet" Cocteau, had sparked a Parisian "fury" with the ballet.[50] Cocteau whetted American appetites with the claim that *Parade* had turned "half the artistic public of Paris against the other," primarily because of its lighthearted representation of everyday life, and he described the clapping and hooting, hissing and fistfights that the work set off in the audience.[51] "I have heard the cries of the bayonet charge in Flanders," he claimed dramatically, "but it was nothing compared to what happened that night at the Châtelet Theater." Photographs of the characters, including the two-man horse that reportedly had Parisians "still fighting furiously," rounded out the report.

Cocteau reserved comment on Satie's music for the end of his essay, praising his clear and natural orchestration, his "purest rhythms" and "frankest melodies." The absence of "slurring pedals, of all evidences of the melted and hazy" in the score, according to Cocteau, resulted in "the unfettering of the purest rhythms and frankest melodies." The essay's most trenchant remarks about music, however, concern the manner in which Satie used elements of dance and other popular styles to infuse the score with a modernist sensibility and "ambiguous charm." In *Parade*, Cocteau asserted, "two melodic planes are superimposed," and "without dissonance" Satie "seems to marry the racket of a cheap music-hall with the dreams of children, and the dreams and murmur of the ocean."[52]

In this article, Cocteau tested the ideas that would form the basis for the quirky manifesto on music he published in early 1918, entitled *Le Coq et l'arlequin*. A collection of aphorisms designed as a defense of *Parade*, this little book served above all to promote Satie, who Cocteau claimed was composing a "music of France for France," based in the idioms of "the music hall, the circus, [and] American Negro orchestras." The "Impressionist" style of Debussy and Ravel, according to Cocteau, was outdated; "enough of clouds, waves, aquariums, water-sprites, and perfumes of the night," he pleaded—and Stravinsky simply extended the Russian tradition of Musorgsky and Rimsky-Korsakov with more aggressive rhythms. In contrast, Satie's "music of the earth, everyday music," captured the very essence of modern life and introduced into modernist composition "the greatest audacity—simplicity." Satie, in Cocteau's memorable phrase, composed "music on which one walks."[53]

Beginning in March 1918, *Vanity Fair* expanded on these same themes in a series of essays that presented Cocteau and Satie as the avatars of French modernism and promoted their brand of *dernier cri* avant-gardism. Van Vechten's enthusiasm was obvious in the two articles he published in that issue of the magazine, which had titles describing the composer as both "Master of the Rigolo," and "A French Extremist in Modern Music." Painting Satie as an innovative visionary, Van Vechten credited him with using whole-tone scales in his compositions "before Debussy ever thought of doing so," and described his borrowings from popular music models as "one of the necessary links between the music of the past and the music of the future."[54] Satie and Cocteau quickly came to dominate *Vanity Fair's* pages: articles either by or about Satie appeared in consecutive issues of the magazine between September and January 1921, and the following year Satie was featured in eight out of the twelve issues.[55] The first two articles to appear in the magazine were by Satie himself, inaugurating a series by the composer described in a photo caption as a "satiric clown, [a] fantastic juggler." His ironic "Hymn in Praise of Critics," published in September 1921, was a tirade against critics rather than a hymn in their praise.[56] "A Lecture on The Six," which appeared the following month, formally introduced readers to Satie's circle with a handsome photograph of the stylishly attired group posed on the Eiffel Tower, solidifying the identification of these composers with Parisian chic.[57] A brief editorial note described Les Six as "young musicians embodying more or less the ideals of Erik Satie," but in his essay Satie called himself simply their "mascot." His bond with them, he wrote, was an adherence to the "New Spirit," the aesthetic ideal set out by Apollinaire around the time of *Parade*, which centered on the importance of surprise as a quality of modernist art. This "New Spirit," in Satie's view, was "the spirit of the time in which we live—a time fertile in surprises," defined by "a return to classic form, with an admixture of modern sensibility."[58] Two more of Satie's pre-concert commentaries followed: "A Learned Lecture on Music and Animals," in May 1922, and, in October that year, "La Musique et les enfants," which appeared entirely, and extraordinarily, in French.[59] *Vanity Fair* also solicited two new (and more conventional) articles from Satie, including an appreciation of Igor Stravinsky, published in February 1923, and a similar piece on Claude Debussy, which for reasons unknown remained unpublished.[60]

Running parallel to Satie's own commentaries was a series of articles by *Vanity Fair's* critics emphasizing the importance of Satie's popularizing aesthetic to the development of modernist music. In November 1921, for

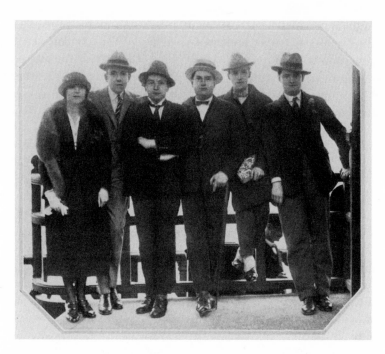

FIGURE 65. Les Six at the Eiffel Tower, from *Vanity Fair*, 1921

example, Paul Rosenfeld's article "The Musician as Parodist of Life" revisited the work of Les Six, which he described as marked by "gaily contemptuous irony and unpretentious charm." Like Van Vechten, Rosenfeld was an early and prolific commentator on modernist music in both Europe and the United States, but unlike his older colleague he was no fan of jazz or popular music: he declared bluntly that "jazz is not American music . . . [but] a striking indigenous product, a small, sounding folk-chaos" even as he acknowledged the importance of popular idioms as a catalyst for new music in the case of Les Six. "As much at home in the vaudeville house and movie cavern as the concert hall," he wrote, their music "speaks the vulgar tongue, is slangy, unpretentious, popular," incorporating "jazz, ragtime, military calls, the improvisations of Negro and South-American dance orchestras, and even . . . the canned, absurdly inhumanized expressions of the gramophones and automatic pianos." The Dadaist muse of Les Six, he informed readers, "swears blithely, wears breeches, thinks Freud horribly soft and 'so 1914,' and adores Jack Dempsey."[61]

In February 1922 another influential author (and the managing editor of *Vanity Fair* from 1920 to 1921), Edmund Wilson Jr., weighed in on the

issue. A literary critic by profession, Wilson addressed the innovations of modernist authors for publications including the *New Republic*, the *Dial*, and the *Bookman*; his first major book, *Axel's Castle*, was a study of Proust, Joyce, Yeats, and Gertrude Stein. His article on music and culture for *Vanity Fair*, entitled "The Aesthetic Upheaval in France," focused specifically on the influence of jazz and what he called the "Americanization" of French literature and art.[62] Lamenting the abandonment of traditional French values—"the ideals of perfection and form, of grace, and measure, and tranquility"—by the nation's younger artists, Wilson complained that they had instead turned to "the extravagances of America." This shift, Wilson asserted, was motivated by a reaction against nineteenth-century French art, which found its antithesis in American movies, dances, and music—no wonder, then, that avant-garde composers in France were presenting foxtrots, ragtimes, and Charlestons in the guise of high art. In essence, Wilson was turning the paradigm for modern art already established by *Vanity Fair* on its head, arguing that the most salient aspects of modernism, which the magazine had demonstrated to be most clearly evident in French music, had in fact originated in America and could only succeed there, where "our monstrosities are at least created by people who know no better."[63]

Cocteau, too, found a home on the pages of *Vanity Fair*, and was especially prominent in the magazine in the fall of 1922, when, in three closely spaced essays, he outlined his conception of a new dramatic genre, which he called "realistic theater." In September that year, his article "The Comic Spirit in Modern Art: A Note on the Profound Realism of Exaggeration and Caricature" was published with a reproduction of his line drawing of Satie and a caption describing Cocteau as the "spokesman" of the "younger generation in France."[64] This essay, which followed the appearance of several major works in which Cocteau played a leading creative role, including the idiosyncratic ballet *Les Mariés de la Tour Eiffel*, begins as an appreciation of Stravinsky, but unfolds as a defense of Cocteau's own aesthetic, which had been challenged in Wilson's earlier *Vanity Fair* article. Arguing that Stravinsky "transforms himself, changes his skin and emerges new in the sun," ultimately "overleaping the fashion," Cocteau likened himself to the Russian composer, claiming that as a result of efforts to avoid "modernism and all its grimaces," he had arrived at a new, realistic art based on caricature. "One must not confuse that which is intended to provoke laughter with that which provokes laughter by mistake," he warned readers.[65]

The next month, Cocteau's essay "The Public and the Artist" appeared in the magazine, illustrated with a reproduction of Marie Laurencin's portrait of him. The article, an English translation of selected portions of *Le*

*Coq et l'arlequin,* follows the format of the original work, presenting a series of aphorisms about art and music. Some of the choicest bits are included: "Art is science—in the flesh," Cocteau announces. "Genius, in art, consists in knowing how far we may go too far." Missing from the one-page presentation, however, are Cocteau's assertions that jazz and popular sources are the way forward to new music, a central idea in his original tract, and one that certainly would have resonated with *Vanity Fair*'s readers. Finally, in December 1922, his article "A New Dramatic Form: A Discussion of a Novel Type of Ballet Which Partakes Also of the Comedy and of the Revue," addressed the issue. This "new type of creation," he maintained, will owe "much to the example of the Greek tragedies, the pageants of the eighteenth century, the circus, the music-hall, the movies, and the boxing ring." Citing *Parade,* he noted especially the ballet's exemplary quality of "realism," which "consists in taking gestures from reality and then by making them unrecognizable to transform them into a dance." The dancers in this new art, he asserted, must also be acrobats, mimes, and actors; they are "the true martyrs of a new era."[66]

Taken in total, Cocteau's articles in 1922 set out his aesthetic program for an art grounded in everyday culture and sophisticated wit. This vision matched Satie's own ideal and through 1925 *Vanity Fair* promoted this model in articles by artists including Georges Auric, Tristan Tzara, Virgil Thomson, and Paul Morand.[67] To Morand fell the task of synthesizing and summarizing the exploits of Les Six, the "new paragons of French salon music," who were "sired" by Satie. As one of Cocteau's closest friends, Morand could undertake this assessment from a particularly auspicious vantage point. A career diplomat, he served as an aid to the Director of Political Affairs in France in 1916 while making a mark as a writer; his *Journal d'un attaché d'ambassade,* published in 1963 and based on his diaries from the war years, recounts in vivid terms his interactions with Cocteau and his circle, beginning with their first encounter in October 1916. As Morand recalled, on that occasion he found Cocteau immersed in his work on *Parade:*

> On his table were a pair of enormous tortoiseshell spectacles brought
> back from Germany by J. E. Blanche, some glass prisms, Cubist draw-
> ings, Allied flags. . . . Satie comes in, looking like Socrates; his face is
> made up of two half-moons; he scratches his little goatee between
> every two words. He doesn't speak about his genius; his great concern
> is to look mischievous. One recognizes the semifailure, the man who
> was dwarfed by Debussy and who suffers from it. . . . He seemed to me
> very jealous of Stravinsky.[68]

FIGURE 66. Marie
Laurencin, *Portrait of Jean
Cocteau,* 1921; reproduced
in *Vanity Fair,* 1922

From this point until Morand left Paris to take a post at the French Embassy
in Rome in mid-1917, he and Cocteau were a regular pair at social and artis-
tic events around the city. Morand's journal for late 1916, for example,
records their experience at a party at the home of Princess Eugène Murat,
which included Stravinsky, "very much the dandy, mustard-yellow
trousers, black jacket, blue shirt and blue collar, yellow shoes, clean-shaven,
slicked-down blond hair, bad teeth, myopic, thick lips," and Satie, "a faun,
little beard, cracked laugh."[69] Stravinsky played *Petrouchka* at the piano;
Milhaud performed Satie's *Morceaux en forme de poire.* A week later,
Morand and Cocteau spent an evening at the Cirque Médrano, a favorite
haunt of Les Six, and the following month Morand was with them all at the
Salle Huyghens for an evening of music and poetry.

Hardly an outside critic, then, Morand knew what he was talking about
when he painted this "young, imprudent" crowd as casually fashionable
and fun-loving in his article for *Vanity Fair.* Describing an evening of the
music of Les Six played "to the gay sound of the cocktail shaker," he could
cite Cocteau as their "poet, inspirer, and soul," the center of their "orga-
nized riot of sound," who has "laid the foundations for a new aesthetics

which . . . can now be said to hold the center stage." Much in keeping with the spirit of the 1920s, Morand noted, in the "studios, salons, and work-rooms filled with the tonic dissonances which we can discover in various forms of their music, the Six, between short drinks and long ones, destroy the formal technique of the old music and fix the rules of the new."[70] The cosmopolitan and transatlantic style of Les Six that Morand perceived as "new," as it turns out, would find its match in the work of another of his close friends—the fashion designer Coco Chanel—and he would be a key player in bringing the composers and the couturiere into contact.

# 6

# COCO CHANEL

Chanel is the woman with the most sense in Europe.

PABLO PICASSO

"Fashion must come up from the streets." So declared Coco Chanel, articulating a philosophy that would revolutionize style and change women's dress forever. In an age when ornate embellishment and rigorous body control still set couture clothing apart from lesser modes of dress, Chanel dared to propose a radical new look based on simplicity and body-conscious naturalism. Her functional designs, inspired by the humble sweaters, trousers, and other workaday garments of ordinary French men and women, were a powerful antidote to the widely held notion that couture was an art and the couturier an artistic genius. Instead, Chanel emphasized the craft of fashion, using precise tailoring and rare fabrics to translate everyday looks into elegant—if expensive—designs. Her competitor Paul Poiret groused that this amounted to nothing more than "deluxe poverty," but Chanel's popularizing aesthetic resonated with upper-class Parisian women in search of a fresh look after the war. Meshing the classical French values of restraint and elegance with a modern ideal of freedom and fun, her approach was precisely in tune with the idea of a liberated world where even women in society's loftiest echelons let loose and "took the métro, dined at restaurants, drank cocktails, played games, and showed their legs."[1]

Charismatic as well as creative, Chanel found herself by the 1920s in the exceptional position of both circulating in high society and dressing its leaders. As she traveled in this beau monde and encountered the most celebrated painters, writers, and musicians of the day, she discovered that many of them shared her belief that the "streets" would be the true source

for new modes of expression. Her involvements with artists were often complex and always multifaceted; she was patron to many, artistic partner to some, and the close intimate of a few. Tightly allied with the Ballets Russes, she built connections with Cocteau, Stravinsky, and Les Six, and played a vital role in forging and advancing an ideal of modernism based in simplicity and everyday elegance. From the influence of her ideas to the impact of her personal relationships, Chanel was an important advocate for the modern musical style that emerged in the 1920s, a force in defining the new sound Cocteau described as "music on which one walks."[2] "By a kind of miracle," he proclaimed, "she has worked in fashion according to rules that would seem to have value only for painters, musicians, and poets."[3]

The foundations of Chanel's aesthetic were laid early and shaped by dire circumstances.[4] Born to peasant parents in the Loire town of Saumur in 1883, she was just twelve years old when her mother died; abandoned by her father, she passed her youth as a ward of the Catholic orphanage in the remote village of Aubazine. Faced with the choice of either joining the novitiate or leaving the convent altogether when she reached the age of eighteen, she opted to move to the larger and livelier town of Moulins, where she attended boarding school, learned to sew, and worked as a lingerie salesgirl and tailor's assistant. Fashion was a secondary interest, however: at the time, Chanel's dream was to become a music-hall star, and in 1905 she got her chance, making her debut at the town's outdoor music pavilion, La Rotonde.[5] Working there as a *poseuse*—one of a dozen unpaid singers who filled in for the main star when she took a break—Chanel quickly developed a signature repertory and a regular following. Two songs in particular literally made her name: "Ko Ko Ri Ko," a tune first made popular by the renowned star Polaire in 1897; and "Qui qu'à vu Coco dans le Trocadero," a "canine complaint" recounting the adventures of a lost dog, which was composed by Elise Faure in 1889.[6] Not a year had passed when, encouraged by her success and armed with a new nickname, "Coco" set her sights on conquering music-hall stages in the more cosmopolitan town of Vichy.

One of the first European resorts, Vichy was a magnet for upscale visitors from England and the Continent. Known for its therapeutic thermal springs even in the first century A.D., the town's cachet skyrocketed in 1860 when Napoleon III came to take a cure, and after his stay the transformation from medical retreat to tourist resort commenced. Hotels, restaurants, and shops appeared, and entertainments designed to provide amusement between (or in lieu of) spa treatments rapidly developed. The spectacle of everyday life was a main attraction, and the town's public spaces—from its

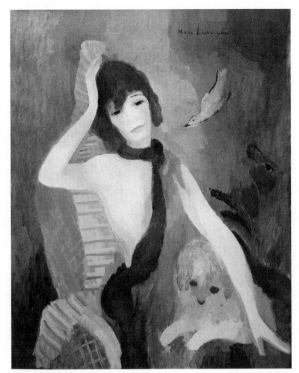

FIGURE 67. Marie Laurencin, *Portrait of Mademoiselle Chanel*, 1923

glamorous casino and elaborate open-air café to the iron latticework prom-
enade imported from the 1900 Exposition Universelle in Paris—showcased
visitors in a manner that invested activities at the resort with the aura of
theatrical display.[7] Musical performances, thought to be as restorative as
the Vichy waters, provided additional opportunities for exhibition; outdoor
band concerts, operetta productions, and music-hall shows played to audi-
ences day and night, and the town opened an opera house, an Art Nouveau
landmark seating nearly 1,500 patrons, in 1903.[8] Although music venues
were plentiful and opportunities for would-be stars abounded, Chanel was
turned away at every audition, and she abandoned the idea of a music-hall
career for good in 1908. She left Vichy that year with a wealthy lover
named Etienne Balsan and, more enduringly, with an affinity for the resort
lifestyle and its own brand of everyday performance that would shape the
course of her future.

At Royallieu, Balsan's chateau in the countryside near Compiègne, Chanel enjoyed a private version of Vichy's public pleasures. Days were spent riding horses and playing tennis, evenings were passed in diverting parties and pantomimes, and a steady stream of high-profile guests kept things lively.[9] Despite the casual tone at the chateau, female visitors followed the custom of dressing formally for sports: long skirts and high-necked blouses were the convention for tennis, while for horseback riding most donned an outfit called the *amazone*—a term invoking the sexually suspect warrior women of Greek mythology—which combined a full-length skirt, a tightly corseted jacket, and a high hat.[10] Chanel, with neither the appropriate clothes nor the resources to acquire them, instead improvised a wardrobe, wearing a man's short-sleeved shirt with jodhpurs that she had made to measure at a local tailor shop, and topping off the ensemble with a plain straw hat. This simple look, devised for sports and leisure at Royallieu and dictated by both taste and finances, became the cornerstone of the youthful style she developed over the next half century. As her friend Paul Morand remarked, Chanel "built her wardrobe in response to her needs, just the way Robinson Crusoe built his hut."[11]

The Chanel style first reached the public in 1910, when she opened a small hat shop in Balsan's apartment on the boulevard Malesherbes in central Paris. Eschewing the contemporary taste for elaborate millinery, which she found to be overloaded and absurd—"How could a brain function under all that?" she wondered—she instead sold small flat straw hats and boaters like those she created for herself and her friends at the chateau.[12] The actresses and other celebrities she befriended chez Balsan helped secure publicity for her designs: Lucienne Roger appeared in a Chanel hat on the cover of *Comoedia Illustré* in September 1910; Jeanne Dirys was depicted in a broad-rimmed Chanel model on the magazine's cover four months later in a lavish color illustration done by *Gazette du Bon Ton* artist Paul Iribe; and Gabrielle Dorziat wore Chanel millinery in the acclaimed play *Bel Ami* in 1912. In the wake of these endorsements Chanel's popularity soared, prompting her to move her business to a larger space on the rue Cambon, the street in the heart of the city's most prestigious shopping district that remains the site of her flagship boutique even today.[13] Financing for the venture came courtesy of a new lover, English aristocrat Arthur "Boy" Capel, a wealthy and well-educated Royallieu regular, who would remain the focus of Chanel's romantic attentions until his death in a car crash in 1919.[14] Complex and cut short in reality, the Chanel/Capel relationship lived on in literature, providing inspiration for Morand's first book, *Lewis et Irène*, which was published in 1924.[15]

In the summer of 1913 Capel and Chanel vacationed at Deauville, a fashionable resort on the Normandy coast. Transformed in the 1860s from a sleepy hamlet into an "elegant kingdom" by Napoleon III's half brother, the Duc de Morny, the town came complete with a glamorous racetrack and a world-class polo field.[16] Direct railway service linking Deauville to Paris made the seaside resort so easy for wealthy city-dwellers to reach that it became known colloquially as the capital city's 21st arrondissement, while its accessible location on the English Channel made it a favorite destination for British aristocrats and industrialists. This mix of upscale visitors gave Deauville a distinctive flavor, creating a demand for British sports including golf and tennis and producing a blend of cultures that had an effect on everything from food and drink to entertainment and dress. By 1913, just after the town opened both a grand seaside casino and the opulent Hotel Normandy (and connected them by underground passage), *Vogue* was promoting Deauville as the "summer capital of France" with the "shortest, gayest, and most exciting season at any of the fashionable resorts on the continent."[17]

Deauville's cachet, like Vichy's, depended on the sense of everyday theatricality peculiar to resort life; thus its attractions and events—from restaurants to the racetrack to the boardwalk along the shore—privileged display and put a premium on self-presentation. The opportunities to show off extensive wardrobes were plentiful: regular changes of dress were expected, as morning promenades gave way to afternoons passed at polo or the races. Elaborate evening-wear was the rule for nights spent dancing or gambling at the casino, and thanks to a cool climate fancy hats and fur wraps were seen even in high summer. Fashion leaders like American heiress Mrs. Whitney Vanderbilt set the tone for display; she appeared for a typical visit to the polo matches in an ensemble consisting of a white coat, "a knee-length, belted affair, above a white skirt cross-barred in navy blue," which she topped with "a voluminous mantle of navy blue," and accessorized with white pumps and "a small white hat with long loops of navy blue velvet on the left side."[18] Dress, as this description suggests, was taken seriously even when it came to sports and leisure activities, and since most women participated in these pursuits only as observers, practicality hardly mattered.

While reveling in Deauville's cosmopolitan atmosphere, Chanel perceived a significant opportunity to expand her business. Most women at the resort, she observed, were not dressed to enjoy the sandy beaches and tennis courts, but instead—like Mrs. Vanderbilt—seemed to be attired for an

old-fashioned promenade along the Champs-Elysées; as she memorably described the scene, "1914 was still 1900, and 1900 was still the Second Empire."[19] Chanel, however, noticed a group of younger women, much like her Royallieu set, who *did* play tennis and golf, and who even braved the surf to swim and sail. With them in mind, she extended the principle of simplification she had honed in her hat shop to clothing, proposing a system of dress founded on basic elements: full and comparatively short skirts, open collar blouses, simple sweaters, and loose belted jackets, all designed to allow activity while retaining a sense of sophistication.

These new looks came up from the streets—or, more accurately, from the shore: in Chanel's hands the sailor collar shirts, turtlenecks, and oversize sweaters worn by Deauville's fishermen were transformed into fashionable ensembles for upscale women whose most taxing labor was the pursuit of pleasure. Capturing both the sense of elitism and the spirit of freedom and fun that prevailed at Deauville, Chanel reinterpreted these familiar garments, producing them in unusual fabrics with refined tailoring, thus asserting that everyday influence could indeed be the basis for rarefied expression. Her borrowings from working wardrobes, moreover, even implied the possibility of democratization for fashion, suggesting that high style could be rooted in the practicality of the mundane (admittedly in its luxury version) rather than the preciosity of the exotic. Paradoxically, this intimation of classlessness, as fashion historian Anne Hollander has observed, made her designs all the more appealing to wealthy followers of fashion, and in a town as attuned to style as Deauville, such an audacious proposition certainly did not go unnoticed.[20] Encouraged by her clients and financed by Capel, Chanel opened a boutique in 1914 in the heart of the resort's shopping district, on the prestigious rue Gontaut-Biron, and sold hats as well as pullover and cardigan sweaters, relaxed skirts, and simple swimwear all of her own design. Despite the extravagant price tags she hung from these garments, Chanel quickly developed a clientele for fashion that, in *Vogue*'s words, "has everything to do with elegance but is based on elements alien to elegance—comfort, ease, and common sense."[21]

The resort lifestyle in Deauville not only inspired Chanel's breakthrough designs, it also fueled her success as a couturiere and established her as a social presence. The constant need for clothes and the premium placed on up-to-date style in the seaside resort kept her shop busy, while the fluid social scene accommodated a woman of even her undistinguished background. Like most resorts, Deauville was by definition a community of privileged transients, and its diversions—from promenades to sports to parties—provided a platform for an ever-changing array of personalities. In

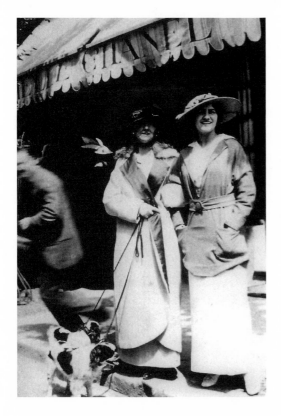

FIGURE 68. Chanel and her aunt, Adrienne, in front of the Deauville boutique, 1913

FIGURE 69. Sem, caricature of Chanel and Boy Capel, 1914

this environment Chanel's past became less relevant, and as both Capel's mistress and a popular clothing designer in her own right she made her way into the town's social set. When the fashionable caricaturist Sem immortalized her relationship with Capel in a cartoon depicting her, hat box dangling from her arm, in an embrace with her sportive lover, who was rendered as a centaur brandishing a polo mallet, her social status was secured.

## PRACTICALITY AND FASHIONABILITY IN THE WAR YEARS

Chanel's shop had been open for less than a year when war was declared in August 1914. With the mood in Paris grim and the battles on the eastern front gruesome, formality and ostentation in dress were considered *démodé,* and with many theaters shuttered and entertainments curtailed, there were few places in any case to wear fancy clothes. In addition, with taxis mostly serving as battlefield ambulances, walking, biking, and bus riding became the primary modes of transportation and clothing had to be practical; as *Vanity Fair* noted in May 1917, "the prospect of footing it home . . . owing to the lack of taxis—even the *métropolitain* stops now at ten o'clock . . . definitely settled the question of theater attire."[22] Emblematic of the dismal wartime situation was the transformation of the racetrack at Longchamp, once the site par excellence for sartorial display, into a cattle yard. "When will the parterres of Longchamp bloom again," lamented *Vogue,* "and when, oh when, will this dreary war be over? This is the question Parisians are asking themselves each day; and with the echoes of Verdun in our ears, the end seems very far away."[23]

As the war dragged on, French and international elites flocked to Deauville and other resorts in search of refuge. Chanel kept her shops open, and found that her designs sold well in those spots and in addition found favor in Paris, where plainness and practicality had supplanted opulent display. Her boutiques grew rapidly, and in 1915 she expanded her enterprise into southern France, opening a third shop in another resort town— Biarritz. Located on the Basque coast, this "all-year mecca of the fashionable world" was linked to Paris by a night express train, and it became an especially desirable destination during World War I because of its location: remote from the battlefields and close to neutral Spain, it offered relative safety as well as all of the amenities that had become customary at European resorts, from sparkling beaches and glamorous casinos to upscale hotels and a wealth of entertainments. [24] Sports and youthful pastimes were the order of the day year-round; "the season is continuous," *Vogue*

reported, "one dances, swims, plays tennis, and goes to the Casino in the evening; there are races in September and a horse show in the winter, and there is fox-hunting in the fall."[25] As for shopping, Chanel's atelier, a sumptuous boutique located in a villa facing the Biarritz casino, did a booming business. A full-scale *maison de couture*, selling a range of high-priced ensembles and accessories, the shop purveyed the elegant separates she had developed in Deauville as well as a new line of evening dresses she designed for resort nightlife. So successful was the venture that by the end of 1916 Chanel was secure enough to leave its operation in the hands of her sister Antoinette, and she left Biarritz for Paris that winter, returning to the capital city as a major force in fashion, the proprietor of three successful shops and the employer of three hundred workers.[26] "The First World War made me," she later remarked; " In 1919, I woke up famous."[27]

Fame accrued to Chanel thanks in part to the fashion press, which began to disseminate images of her designs to a widespread readership in France and the United States in 1916. *Harper's Bazaar* was the first to recognize her work, publishing an illustration of a simple, straight-cut dress from her Biarritz collection, with the caption "Chanel's Charming Chemises," in its March issue that year. Condé Nast's *Vogue* followed suit, printing a photo of a woman clad in a checked Chanel dress topped with a belted jacket in its February 1917 issue, and the next month the French magazine *Les Elégances parisiennes* picked up on Chanel's popularity, publishing illustrations of three of her ensembles, all with the ankle-revealing skirts and loose belted jackets that were emerging as the hallmarks of her everyday style.

The press recognized Chanel not only for her unconventional designs, but also for her use of an unconventional fabric—jersey. This stretchy knit cloth (named for largest of the Channel Islands, where it was worn traditionally by local fishermen) had long been considered unsuitable for haute couture because it was inexpensive, inelegant, difficult to stitch, and nearly impossible to embellish with embroidery, pearls, or other decoration. For Chanel, the choice of jersey represented more than a fabric innovation: by working with it she was able to further simplify her designs, moving the emphasis in dress away from ornament and toward architectural line, and thus allowing the structure of an item of clothing to displace the surface as the zone of emphasis. As philosopher Gilles Lipovetsky has noted, this desublimation of fashion found parallels in contemporaneous visual art: the simplification and purification characteristic of Chanel's designs mirrored Cubism and other abstract art, while her choice of an inexpensive everyday fabric as the basis for high fashion can be likened to the use of newsprint and other mundane objects in the collages and *papiers collés* of Picasso and

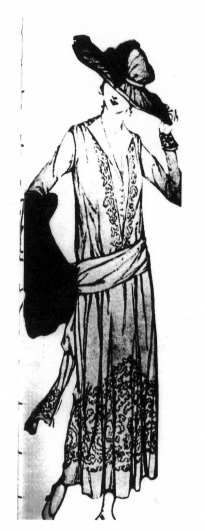

FIGURE 70. Illustration for "Chanel's Charming Chemises," from *Harper's Bazaar*, 1916

Georges Braque.[28] Machine-made and colored most frequently in muted beige and blue hues, jersey had the added advantage of being completely consistent with the practical and sober tone that prevailed during the war. With jersey, Chanel claimed, she "liberated the body, abandoned the waist, and created a new silhouette," thus heralding a new era. "One world was ending," she recalled, and "another was being born. I found myself there; an opportunity arose; I took it."[29]

Chanel prospered through the 1910s, but the 1920s witnessed her emergence as a fashion powerhouse on both sides of the Atlantic. In this decade her designs came to be viewed as emblematic of social change and shifts in attitude that portended greater freedoms for women following the war—a category that covered everything from smoking cigarettes and drinking cocktails in public to driving cars and piloting airplanes. Captured most notoriously in Victor Margueritte's scandalous novel *La Garçonne*, in which the nineteen-year-old protagonist elects to have a child out of wedlock and becomes entangled in a lesbian affair, these challenges to male prerogatives were manifested in fashion most obviously in a taste for androgyny.[30] "The female silhouette has become flat," noted contemporary fashion commentator René Bizet in 1925, summing up what had become known as the *garçonne* look:

> Today, an adolescent makes a better model than the Venus de Milo. Boys and girls can exchange their clothes. No more difficult coiffures—hair is short. No more trains or wraps: skirts are short and straight.[31]

Chanel's system of dressing in casual separates conformed perfectly to the new ideal, which prized youth and its attendant qualities of slenderness, physical fitness, energy, and enthusiasm. As Alison Lurie has observed, the women "did not look like men, but rather like children":

> . . . like the little girls they had been . . . and (to a lesser extent) the little boys they had played with . . . whereas a hundred years earlier the ideal woman had been a good and innocent little girl, she was now a daring, even a naughty tomboy. The "flapper" of the 1920s was high-spirited, flirtatious, and often reckless in her search for fun and thrills. And though she might have the figure of an adolescent boy, her face was that of a small child: round and soft, with a turned-up nose, saucer eyes, and a pouting "bee-stung mouth." Her bobbed hair curled about her head like a child's, or clung to it like a baby's.[32]

Chanel's cardigan sweaters, collared shirts, and simple skirts captured just this sensibility of appropriated childishness, winning acclaim for conveying the "secret of eternal youth." In addition, they promoted a larger image for which Chanel herself was the icon: boyishly small and slim, she was a perfect model for her own androgynous designs, and in 1917 she completed the look by cutting her hair into a short bob—setting off a true fad for the hairdo.[33] In 1921 she went a step further, introducing a decidedly nonfeminine signature scent, the still popular Chanel No. 5. Not the first fash-

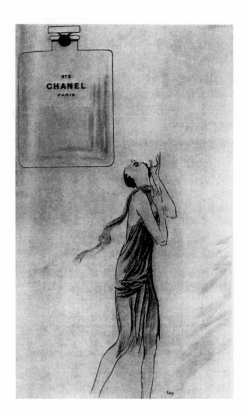

FIGURE 71. Sem, advertisment
for Chanel No. 5, 1921

ion designer to expand from clothes to perfume—as we have seen, Poiret
had introduced his "Rosine" line in 1911—Chanel was the first to name a
perfume after herself, and she made waves with the essence, which broke
entirely with convention. Concocted by chemist Ernest Beaux, the scent
was created not from the natural flower oils that had been the basis for per-
fume from its inception in the eighteenth century, but instead from a mix
of over eighty synthetic aldehydes, producing a smell so fresh and unusual
that some contemporary critics resorted to describing it in terms custom-
arily associated with avant-garde visual art, calling it "abstract."[34] The
Chanel perfume bottle reinforced this connection: a sleek, transparent cube
that revealed the liquid within, it was marked only with a clean white label
bearing the name "Chanel No. 5" in black lettering.[35]

Chanel's most enduring innovation of the decade, however, was the "lit-
tle black dress." A long-sleeved sheath of black crêpe de chine, this garment
introduced the radical concept that clothing should be uniform rather than
idiosyncratically unique—an idea that was antithetical to haute couture's

FIGURE 72. Gabrielle Chanel, the
"Ford signed Chanel," from
*Vogue* (New York), 1926

long-standing investment in the notion of one-of-a-kind dressmaking. In lieu of distinctive design or embellishment, Chanel proposed standardization and repetition to the extent that not even the color would set one iteration of a design apart from the next. Registering this "assembly-line" approach, *Vogue* likened the dress to the latest developments in the industrial world, describing it as a "Ford signed Chanel."[36] Most importantly, the little black dress offered another route to simplicity in fashion: undecorated and architectural, it was an intense expression of the emphasis on line and structure in dressmaking that had been Chanel's focus from the outset of her career. Its simplifying power was felt not only on the broad plane of fashion, but also in individual closets; with a little black dress in her wardrobe, a woman need never worry about having appropriate attire for any occasion.

The multiple facets of Chanel's originality were captured in a single concept: "chic." The fashion codeword for modern elegance, the term was introduced in France in the late eighteenth century, and by the end of the

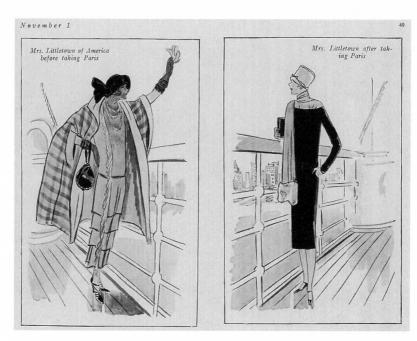

FIGURE 73. Illustrations from "Before and After Taking Paris," from *Vogue* (New York), 1924

nineteenth century, as Lisa Tiersten has demonstrated, had come to signify an "artistry of the self" founded on individuality, authenticity, and good taste.[37] By the time Sem published his little manifesto on "True and False Chic" in 1914, a range of additional meanings had accreted to the term: "youthful, ingenuous grace," "harmonious and discrete simplicity," and "charm" were all invoked in his tract, along with the notion that "chic" was an integral part of "French tradition."[38] These conceptions carried forward into the 1920s, and by 1924 *Vogue* was sifting through the term's various connotations in a regular column that promised a "Guide to Chic" for everyone from debutantes to "stout older women." The magazine attempted a further explication that year in an article entitled "Before and After Taking Paris," in which "Mrs. Littletown of America" discovers "the difference between French chic and the homegrown product." The high point of the fictional American's shopping adventure is a trip to the Chanel boutique, during which she comes to understand French style:

> Simplicity. That was the first thing. A good dress, well designed, beautifully cut, with a single idea in its construction and only such trimming as gave it character . . . as a rule, the simpler it was, the better. Simplic-

ity of line, perfection of accessories . . . and those who were superlatively chic had taken another step, adding a bit of personal detail.[39]

When it came to chic, simplicity—of the sort that "always has been and always will be expensive"—was fundamental, and Chanel was iconic.[40] Throughout the 1920s her stripped-down style, inspired by resort life and characterized by youthful simplicity and sophisticated elegance, found devotees and imitators in America as well as in France. Equally at home on Fifth Avenue and the Place Vendôme, Chanel chic was the basis for a timeless transatlantic style and the foundation for what remains one of the world's most powerful fashion empires.

### WITH STRAVINSKY

Chanel's post-war fashion triumphs were paralleled by her social conquests. An A-list clientele and sheer force of personality proved to be all she needed to establish herself in most stylish Parisian circles, but a friendship with the dazzling socialite and Diaghilev patron Misia Sert assured her entrée into the less easily penetrated world of art and, in particular, into the Ballets Russes clique.[41] A decade older than Chanel, Misia had artistic connections by birth—her mother was the daughter of a famous cellist, her father a well-known sculptor—and she had studied piano seriously enough to create expectations that she would pursue a concert career. Instead, she married, enhancing her connections to the Parisian intellectual and artistic elite in the process. Her husband (the first of three) was Thadée Natanson, founder and editor of the innovative Symbolist journal *La Revue Blanche*, a magazine whose contributors included the greatest French writers of the day—from Apollinaire to Zola—as well as an array of international literary figures, most of whom were published in France for the first time in the journal. Music criticism was provided by Debussy, writing under the now famous pseudonym Monsieur Croche, and reproductions of original artwork by Vuillard, Bonnard, Manet, Monet, Corot, Pissarro, Renoir, Puvis de Chavannes, Félix Vallotton, and others appeared regularly in the magazine.[42]

The marriage to Natanson ended in 1904, and within a year Misia had married again, this time to wealthy newspaper magnate Alfred Edwards, whose fortune she lavished not only on clothing and jewels but also on commissions for artworks and musical compositions. Divorced again in 1908, she began a long affair with the Catalan painter José-Maria Sert, a wealthy and extravagant eccentric whom she married only in 1920—in a ceremony that Proust, who was one of the wedding guests, memorably described as "having the august beauty of marvelously useless things."[43] In 1908 the

couple attended the premiere performance of Musorgsky's *Boris Godunov* at the Paris Opéra, and thereafter Sert and Misia were among the most influential patrons of Diaghilev's enterprises.

Chanel came later to the Ballets Russes, but she was in the audience for the preview performance of *The Rite of Spring* in 1913, the guest of modern dancer Elise Jouhandeau—then as now better known by her stage name, Caryathis.[44] It was in the Russian troupe's milieu that Chanel and Misia seem to have met; introduced at a party given by actress Cécile Sorel in celebration of *Parade's* premiere in 1917, they became fast friends. In the summer of 1920, the Serts invited Chanel to accompany them on their honeymoon to Venice as a diversion from her grief over Boy Capel's death, and during the voyage they introduced her to Diaghilev. The Russian impresario was struggling to resuscitate the Ballets Russes both aesthetically and financially in the wake of the war: not only had ballet audiences and public taste changed dramatically between 1914 and 1919, but his financial network, which consisted in large part of the French and Russian aristocracy, had collapsed.[45] With a view to a dramatic comeback, he was seeking financing for a planned Paris revival of *The Rite of Spring*, which would use the original sets, costumes, and score while introducing choreography by his new lead dancer, Léonide Massine. Misia and Sert did not come to the rescue as Diaghilev perhaps hoped they would; instead, it was Chanel who offered to underwrite the reprise.

The most reliable account of Chanel's largesse in this matter comes via Boris Kochno, who was Diaghilev's secretary from 1920 until the impresario's death in 1929.[46] Kochno recalled that following their encounter in Venice Chanel visited Diaghilev at the Hotel Continental in Paris, leaving him with a check in the amount of 200,000 French francs to cover costs of *The Rite's* production but stipulating that the gift remain anonymous—a promise that Diaghilev quickly broke, as Chanel no doubt expected he would.[47] In a stroke, she thus both gained entrée to the uppermost echelons of Diaghilev's enterprise and defined herself as a ballet patron to be reckoned with. An intimate of the Russian clique from this point forward, it would be only a matter of time before she joined Diaghilev's inner circle of dancers, painters, and librettists as a collaborating artist.

The considerable social and professional benefits of an association with the Ballets Russes were not the only factors motivating Chanel's generosity: by the time she wrote the check to Diaghilev, she was in the midst of an affair with his star composer, Igor Stravinsky. Hard evidence of this relationship is scarce: no letters or other documents are known to relate its details, and somewhat unusually, given their shared appetite for publicity,

neither the composer nor the couturiere spoke much about it. Chanel, however, finally went on record in 1946, during her self-imposed exile in Switzerland, discussing the affair with Morand, who published the interview thirty years later, after both Chanel and Stravinsky had died.[48] Even today, this recorded conversation provides the fullest—if completely one-sided—account of their relationship.

In her reminiscences to Morand, Chanel recalled a "young and timid" Stravinsky (in fact, one year older than she) who claimed he had told his wife about their affair. "She knows I love you," he reportedly assured Chanel. "Who else could I tell about such an important thing?" In Chanel's account, the high drama included a scene in which Misia and Sert interrogated Stravinsky about his intentions in their apartment overlooking the Seine, while the composer, "in the next room, wringing his hands," was desperate to know if Chanel would marry him. Thinking the situation "idiotic" and the Serts "crazy," Chanel asked that Stravinsky "come back and be friends," a phrase that seems to have encompassed more than just his companionable instruction on the music of Wagner and Beethoven, since when Stravinsky left for Spain with the Ballets Russes in February 1921 he asked her to come along. Chanel agreed to the rendezvous but broke her promise, instead initiating a new affair with the Russian Grand Duke Dmitri Pavlovich and heading for Monte Carlo with him in her recently acquired "little blue Rolls." According to Chanel, when Misia got wind of this new entanglement she meddled in, telegraphing Stravinsky in Spain with the catty message, "Chanel is a shopgirl who prefers Grand Dukes to artists," after which Chanel received a telegraph from Diaghilev with the ominous warning, "Don't come, [Stravinsky] wants to kill you."

Amidst Chanel's memories of these intrigues, the most telling feature of her version of events is her analysis of the way in which the affair affected the two lovers, leaving her unscathed but profoundly shaping Stravinsky's character. "This adventure, which I laugh about today," she told Morand, "changed Igor's life. . . . It transformed him from a self-effacing and timid man . . . into a strong and monocled man, from the conquered to the conqueror."[49] For his part, Stravinsky never went on record about the affair.[50] Instead, Chanel's claims about the relationship were rebutted primarily by his widow Vera and his amanuensis Robert Craft, beginning in 1978 with the publication of *Stravinsky in Pictures and Documents*, their collaborative "album of vignettes."[51] Disavowing Chanel's account of the relationship as simply "the bragging of her late-in-life memory of it," Vera and Craft asserted that "no one who knew Stravinsky" would ever have believed that he "considered divorcing in order to marry Chanel, or that he

would invite her to accompany him . . . to Spain"— their reason being that he had moved on, and was by that time having an affair with the Russian cabaret singer Zhenya Nikiytina, best known by her stage name, Katinka.[52] But the affair with Katinka seems to have been largely without emotional ties, while the relationship with Chanel had meaning; Chanel's biographers describe the composer as "very smitten" and "passionately in love with her," while even Stravinsky scholar Richard Taruskin sums up the affair as "a liaison that apparently meant a great deal more to Stravinsky than it did to Chanel, who was collecting White Russians at the time."[53] We can hardly expect a dispassionate accounting of events from Vera Stravinsky, of course, since she began her own liaison with the composer after meeting him at a dinner in Montmartre in February 1921—probably just as he was pleading with Chanel to accompany him to Spain.[54] And this invitation is one of the few matters in Chanel's recounting for which there is corroboration, in this case from Stravinsky's friend, the conductor Ernest Ansermet. At the end of March he wrote with some concern to the composer, making specific reference to Chanel's addresses on the rue Cambon and in the Paris suburb of Garches. "I hope your stay in Spain will have gone well," he began:

> But what's going on? Have you made peace with the Serts? And with yourself? I keep turning this question over. What are they doing at Garches, and on the rue Cambon? I've talked the whole thing over with [Charles-Ferdinand] Ramuz, since a telegram from you raised the question. He was quite upset by it all, but doesn't see it quite as I do. Not people's feelings. But the consequences . . . Now dearest Igor, courage. I'm with you with all my heart in your pain.[55]

By the time of Ansermet's letter the Chanel/Stravinsky affair was clearly at an ebb, and may have been over. Its beginning is easier to pinpoint, since it surely falls close to the date on which Stravinsky, his wife Catherine Nossenko, and their two children took up residence in Chanel's rambling Art Nouveau estate, Bel Respiro, in the exclusive Paris suburb of Garches. This was a *fait accompli* by September 1920.

How had the Stravinskys landed at Chanel's doorstep? Having spent the war years in Switzerland, they, like many Russians, found themselves stateless and stranded in Europe after the October Revolution. For Stravinsky, a return to St. Petersburg was unthinkable, and housing in Rome, where he had hoped to settle, proved impossible, so at the suggestion of Misia and Sert, the family rented a cottage for the summer of 1920 in the Breton fishing village of Carantec.[56] Calm, picturesque, and remote, the town was idyllic but offered little in the way of professional promise or

social stimulation, and Stravinsky was in need of both. The search for lodging in Paris began almost immediately.

As he contemplated a return to France, Stravinsky must have taken stock of the toll that the Swiss exile had taken on his career, for unlike Chanel he had not prospered greatly during the war years. Actively working throughout the period, he had pursued two seemingly distinct creative impulses, on the one hand composing music inspired by Russian folk traditions—the set of songs known as *Pribaoutki;* the pantomime entitled *Renard,* or *The Tale about the Fox, the Cock, the Cat, and the Ram;* and the ballet *Svadebka,* now best known as *Les Noces*—and on the other, composing instrumental works that drew to some extent on popular music idioms, including *Three Pieces for String Quartet, Ragtime for Eight Instruments, L'Histoire du soldat, Piano-Rag-Music,* and two sets of easy pieces for piano four hands. This impressive catalog, however, was not enough to keep Stravinsky fully in the public eye, especially in Paris. In the French capital, his last significant premiere—the opening of *The Nightingale* at the Opéra in May 1914—had faded to vague memory, and his ballet *Fireworks* had been eclipsed by Satie's *Parade* during Diaghilev's one wartime season three years later. In addition, he was strapped for cash; his royalties evaporated almost immediately when war broke out, since there were few performances of his earlier works and his publishers—Jurgenson in Russia and Russicher Musik Verlag in Berlin—were both barely functional as the conflict wore on.[57] Diaghilev's plan to take the Ballets Russes on a sixteen-city American tour in the spring of 1916, with culminating gala performances at the New York Metropolitan Opera, must have seemed potentially (and redemptively) lucrative to Stravinsky, particularly since *Petrouchka* and *The Firebird* were among the most highly touted of the ballets programmed on the trip. Surely in light of this he expected compensation above and beyond the 16,000 Swiss franc retainer that Diaghilev had promised for the year.[58] In the end, however, the tour was a financial disaster, ushering in what Lynn Garafola has called the "most desperate chapter" in the history of the Ballets Russes.[59] It generated little additional revenue for Stravinsky but did create some positive publicity, helping above all to build his profile as an international musical celebrity—an image that no doubt enhanced his attractiveness as far as Chanel was concerned.

## STRAVINSKY IN FASHION

Even before the Ballets Russes tour Stravinsky had made his debut in the American style and fashion press. Careful readers of *Vanity Fair* would

have noticed critic W. J. Henderson's mention of him as a composer of "weird things yet unknown here" in an article on modernist music published in the January 1915 issue of the magazine, and they would have begun to see more frequent references to his works as the arrival of Diaghilev's troupe approached.[60] Nearly every article about the Ballets Russes that appeared in *Vanity Fair* during this period mentioned Stravinsky if only in passing; typical was a December 1915 piece by the Russian Ballet's hired publicist, Edward Bernays (who signed the article with the name-scrambling pseudonym Aybern Edwards), announcing their "long-heralded appearance" as "one of the artistic sensations of the winter" and promising orchestral performances of Stravinsky's works.[61] Taking stock of the tour after it ended, the avid Ballets Russes follower Baron Adolphe de Meyer lingered a bit more on Stravinsky's contribution. Tracing the history of Diaghilev's effort to create a synthesis of "Russia's most stimulating arts—music painting, acting, singing, dancing," he singled out Stravinsky as the organization's musical linchpin, asserting that he stood "in the very front rank of modern musicians."[62] *Vanity Fair*'s readers already had a striking image they could associate with this commentary, thanks to a reproduction of the Cubist-style portrait of Stravinsky done by "painter and rythmatist" Paulet Thévenas, which appeared in the August 1916 issue of the magazine.[63] Published alongside the artist's depictions of Jean Cocteau and aristocratic arts patrons Anna de Noailles and Edith de Beaumont, the Stravinsky portrait not only offered a likeness of the composer but also firmly associated him with the newest currents in visual art and the most sophisticated Parisian circles.

Even *Vogue*, which normally limited its coverage of musical issues to overviews of opera and orchestra programs, took note of Stravinsky. In January 1916—more than a year before the name Chanel first appeared in the magazine—its somewhat erratically published "Music Notes" column included a one-paragraph commentary about "this futurist of the strings," whose *Three Pieces for String Quartet* had just been performed by the Flonzaley Quartet in New York's Aeolian Hall. "The name Igor Stravinsky," the anonymous author began, "seems to stand for the last word in modernism":

> His *Scherzo Symphonique* [sic] was played at the popular Ziloti concerts in Petrograd in 1908, and his name became almost a household word throughout Russia. . . . The Russian Ballet presented his *Oiseau de feu* and *Petrouchka*, thus making him famous throughout Europe. Chamber music in its subtlest possibilities of tone is a delight for Stravinsky, and while he seemingly disregards accepted laws of composition there is a distinct musical design behind his mists of impressionism. [64]

# PAULET THEVENAS, PAINTER AND RYTHMATIST

*Whose Cult Proclaims a Relation Between Sculpture, Painting and Dancing*

### By Marie Louise Van Saanen

THAT a painter should be a dancer is not strange in these days when everybody dances. But Paulet Thévenas, the Paris painter, is spoken of as a "Rhythmician," in the serious way that another might be called a Swedenborgian or a Theosophist. The word expresses, in the case of himself and his very serious followers, a practice based on a definite theory. To put it as simply as possible, the Rhythmicians believe that there is a necessary relation between music, or rather dance music, and sculpture and painting, and that all are very necessary to each other.

It was some time before the Great War that some of the friends of Jacques Delcroze started the systematic cultivation of the Gymnastique Rhythmique, in a big room of an old house opposite the Luxembourg Gardens. Thévenas was soon recognized as the leader of the "movement," and being a Swiss—he comes from Geneva and so is a neutral—has been able to give his attention to it, which would not have been the case if he had had to go to the front like most of his associates.

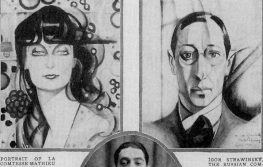

PORTRAIT OF LA COMTESSE MATHIEU DE NOAILLES

IGOR STRAWINSKY, THE RUSSIAN COMPOSER

PAUL THEVENAS
And some examples of his style in portraiture

When asked once what was the symbol of his vision, as an artist, he answered "Crystal!" The word is illuminating. It expresses clarity, harmony of form, precision, concentration, mass, mystery of design and brightness. All these things his admirers find in the painter's work.

Thévenas works in water colors, because in that medium he finds, rather than in oils, the transparency and precision for which he seeks. There is a great variety in his portraits, showing that his procedure in each case has been influenced by the physical and intellectual qualities of his subject. The qualities to be found in his portraits of the Comtesse de Noailles and of Igor Stravinski are also to be discovered in his landscapes; its own radiant life. His drawings of figures rendering the dance, as realized by the Gymnastique Rhythmique, are spirited studies of free movement, but free movement showing a consciousness of the exact relation between musical notes and controlled muscular obedience.

SHELLEY said that most wretched poets "learned in suffering what they taught in song." Thévenas believes that an artist should try to express in paint what he has learned in dancing, and, conversely, try to express in dancing what he has learned in painting. To him dancing must have an actually spiritual or intellectual side; must express precise thought and governed imagination. He finds fault with much of the dancing of the theater, because it is lacking in this respect. He has converted the Paris Opera authorities to his views, for he has been allowed to form a class for the instruction of members of the Ballet, to improve the relations between the dancers and the orchestra. Thus he is the first to apply the Delcroze methods to the operatic stage.

IT is only in the matter of the views on the subject of the relation of dancing to painting that Thévenas consents to wear a label. As far as this is concerned he is a Rhythmatist. As a painter he refuses to admit that he belongs to any "school," or follows any master.

COMTESSE E. DE BEAUMONT

JEAN COCTEAU, THE FUTURIST POET

FIGURE 74. Article on Paul Thévenas, with portrait of Igor Stravinsky, from *Vanity Fair*, 1916

Three months later, just as Diaghilev's troupe was heading for its final performances in New York City, prominent theater critic Clayton Hamilton weighed in with an article declaring ballet to be "The Greatest of the Three Arts of Russia"—the others being literature and music. Asserting that Diaghilev had "realized the dream of Richard Wagner" by creating a true synthesis of the arts, he proclaimed that Stravinsky had met the "Wagnerian challenge" by devising a true musical "imagining" for the ballet. Although the message of this art was "semi-Asiatic," he noted, its method was "more than semi-European": the material, he claimed, was "barbaric, but the craftsmanship, if anything, is super-civilized."[65] Thus the American critic, perhaps hoping to soften U.S. audiences to the sound of *The Rite*, revived a strain of commentary about Stravinsky's musical style, which, as we have seen in chapter 3, originated in early French critiques designed to reconcile the raw aspects of the composer's musical language with his attractiveness to rarefied audiences.

Stravinsky's positive American press had a limited impact in Europe, where the composer returned to the spotlight only in December 1919, following the concert premiere of *The Song of the Nightingale* in Geneva. This re-entry was harsh; audience reaction included whistles and catcalls, newspaper and journal critics pilloried the score, and the periodical *La Semaine Littéraire* even published a cartoon depicting Stravinsky throwing a harmony book at a nightingale that stood singing at his feet.[66] The fully staged ballet, with sets, costumes, and curtain by Henri Matisse and choreography by Massine, had a better reception when it premiered at the Opéra two months later, despite (or perhaps due to) decors that amounted to little more than what one commentator called "snob-funereal export chinoiserie."[67] Stravinsky's score was singled out for praise by serious music critics; Louis Laloy, for one, perceived in the music the "solidity of a symphony," and commented on its "condensed, concentrated" quality.[68] Still, the ballet had only a few performances and had to be revived again in 1925, with fresh choreography by Diaghilev's new star, George Balanchine.[69]

## PULCINELLA AND FANCY DRESS FUN

On the heels of these disappointments, Stravinsky was putting the finishing touches on the work that would assure his comeback with stylish Parisian audiences and reestablish his position as the arbiter of musical chic—namely, *Pulcinella*. The composer joined this project when it was already well underway; called in after Manuel de Falla withdrew in the fall of 1919, he was enticed no doubt by both the promise of a healthy paycheck

from Diaghilev and the prospect of collaborating for the first time with Picasso, who was designing costumes and decors for the work. Married and living in the upscale suburb of Montrouge, Picasso "dressed like a well-to-do businessman, in a well-cut suit with a bow tie, white pocket handkerchief and gold watch chain," and circulated in just the rarefied social circles Stravinsky was eager to re-enter.[70] The composer's own contribution to *Pulcinella*, as he stated in an interview printed on the front page of *Comoedia* on the day of the ballet's premiere, would offer audiences a "new kind of music, simple music" with a focus on the "quality of sound." As he reassured readers, however, the overall effect would not be jarring, since "the ear becomes bit by bit sensitive to those effects which are at first shocking."[71]

With a scenario based in the traditions of the *commedia dell'arte*, *Pulcinella* was an affectionate and even nostalgic engagement with the art and music of eighteenth-century Italy. The work began to take shape when Stravinsky joined Diaghilev, Picasso, and Cocteau in Rome in early 1917 as they completed preparations for *Parade*.[72] Diaghilev, stymied by the war and reluctant to continue to plumb Russian sources in light of his disgust with the deteriorating political situation in his native country, saw the potential in developing new works based on Italian themes: he perceived the ways that Italian subjects could form the basis for a marriage of Latin past to avant-garde present, renewing classical tradition and reinforcing a popular political agenda which elevated non-Germanic culture. From libraries and private archives in Italy he amassed the musical and literary manuscripts that would form the basis for the new ballet.[73] Scores attributed at the time to composer Giambattista Pergolesi (but since established as the work of his lesser-known contemporaries) would be the ballet's centerpiece, and Diaghilev charged Stravinsky with weaving them into a workable whole.[74]

While the printed program for the ballet frankly described *Pulcinella* as having "music by Pergolesi, arranged and orchestrated by Igor Stravinsky," the work was heralded by music critics (on the whole) as a breakthrough for the Russian composer, who almost immediately was credited with devising a largely original score.[75] "M. Stravinsky has never shown more talent than in *Pulcinella*," critic and composer Reynaldo Hahn raved, "nor a more certain taste for audacity."[76] Audiences, too, adored the ballet, and for the high-society patrons that Diaghilev so assiduously courted, one of its greatest attractions was no doubt its recognizable affinity with their own pleasurable pursuits: unlike *Petrouchka*, which was based on *commedia* themes but set in the unidentified Russian past, *Pulcinella* suggested contemporary diversions—and specifically those of the Venetian carnival,

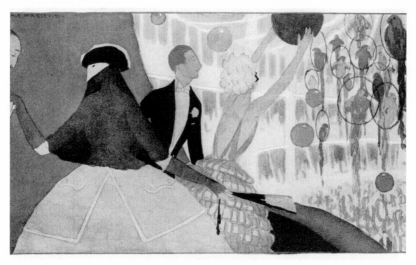

FIGURE 75. André Marty, "The Opera Ball," from *Vogue* (New York), 1921

which captured the imagination of *le tout Paris* like clockwork every February. Indeed, the ballet's connection to the annual carnival celebration was noted by critic Paul Souday, who likened Stravinsky's very treatment of Pergolesi to its characteristic masking and costuming:

> The funny thing about the affair is precisely having [Pergolesi] so modernized by dressing him up in so audacious a mask. We disguise ourselves, at a carnival, in the person of old times; why not sometimes clothe the old masters in modern costumes? It is the same procedure, and this little work of M. Stravinsky is exactly a masquerade, and one of the most witty.[77]

A pilgrimage to Venice to celebrate the pre-Lenten carnival festivities had long been a seasonal ritual for members of the Parisian upper class. Before World War I, the *Gazette du Bon Ton* and other elite magazines covered the events in breathless reports from Italy, while for those who preferred to stay closer to home, invitations could be had for a seemingly endless round of carnival-themed parties in Parisian ballrooms and gardens. For one such *fête* "in the best taste," the garden of the hostess in the 7th arrondissement was transformed into "the Venice of Tiepolo and the Orient, with all of its fantasy of rich tapestries and shocking colors," and entertainment was provided by socialites acting out the roles of Pierrot, Harlequin, and Columbine.[78] In the twenties, as travel became simpler, Carnival became an even more important touchstone for those in high society, a rea-

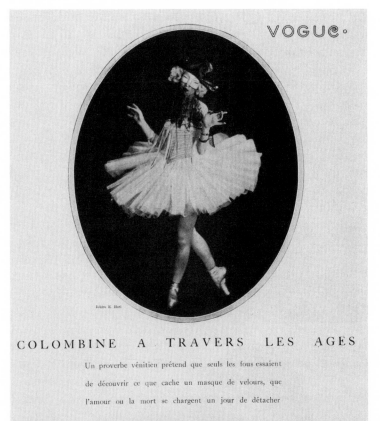

FIGURE 76. "Colombine à travers les âges," from *Vogue* (Paris), 1922

son for a mid-winter voyage and an excuse for a celebratory attitude that could linger long after the February festivities had ended and Lent had begun. As French *Vogue* noted, it all hinged on the "Nietzchean ideal" of living dangerously, of "condensing into each minute a maximum of effort, conquest, analysis, possession, genius, and suffering in order to more fully

taste the pleasure" that precedes privation.[79] Outfitted in elaborate costumes based on the stock characters of the *commedia* as well as the traditional dominoes and masks associated with carnival, socialites could enjoy both the pleasures of fancy dress and the perquisites of anonymity at parties year round. So intense was the fascination with the subject that each February *Vogue* produced an issue devoted to the theme of carnival, and in 1922 the magazine went so far as to devote a liberally illustrated four-page article to the seemingly pedantic topic of "Colombine Across the Ages."[80]

*Pulcinella* tapped exactly this vein, transferring the fancy dress fun of the carnival season to the ballet stage. Indeed, Picasso initially intended to costume the dancers in contemporary dress, with the women wearing the full-skirted gowns and feather headdresses that were popular in Paris during the winter of 1920, and his access to the latest designs would have been eased by his wife Olga, who was at the time one of Chanel's top clients.[81] The idea was quashed by Diaghilev, who had a more historicizing vision of the work, but Picasso's sketches attest to his first, modern dress impulse.[82] If not present on the ballet stage, women attired in such outfits were certainly be found at the now legendary party that followed the premiere, which was hosted by Prince Firouz of Persia and held at a house on the outskirts of Paris owned by an ex-convict. As Jean Hugo remembered it, everyone "drank champagne copiously" and Stravinsky "got drunk and went up to the balcony and the bedrooms, grabbed all the pillows, bolsters, and feather-beds and hurled them from the balcony down into the great hall. We all had a pillow fight, and the party ended at three in the morning."[83] Back in the high life, Stravinsky had reclaimed his position at the center of the Ballets Russes clan and in the process reestablished himself as the musical darling of Paris society.

## CHEZ CHANEL

In the flush of this success, perhaps even at this party, Stravinsky and Chanel met.[84] Following the *fête*, however, Stravinsky quickly returned to Carantec, from whence he reported passing several unhappy and isolated months among "conventional little Frenchmen who can't afford Deauville."[85] House-hunting with his wife in Paris that summer, he probably encountered Chanel at Misia and Sert's wedding on August 2, and sometime between that date and early fall the couturiere offered him use of her villa in Garches. By 22 September the Stravinsky entourage, which included his immediate family as well as the family of his brother-in-law and assorted childcare and household staff, was definitely ensconced there, as a postcard

from the composer to Ansermet bears that date along with Chanel's address. In the clipped message he wrote to his old friend, Stravinsky excused his brevity, remarking that his "nerves" were "in poor condition"—a thinly veiled reference, perhaps, to the tense romantic situation already developing inside the Chanel villa.[86]

Shaky nerves and emotional complexities notwithstanding, Stravinsky was remarkably productive during his time at Garches. The conditions were certainly favorable: Chanel intended Bel Respiro to be her retreat in the wake of Boy Capel's death and spared no expense in the design and decoration of the house and its extensive gardens. Moreover, after years of exile Stravinsky must have been delighted to return to the full cultural and intellectual life of Paris—and relieved to find his family diverted by the city's many offerings.[87] Within two days of posting the card to Ansermet, he finished the *Concertino for String Quartet*, which had been commissioned by the Flonzaley Quartet, and returned to work on *Les Noces*, which had been the source of considerable creative frustration throughout the war. The score for that ballet came into focus at Bel Respiro, as Stravinsky arrived finally at an orchestration for four pianos and percussion, which he believed would be "at the same time perfectly homogeneous, perfectly impersonal, and perfectly mechanical."[88]

With news in the fall of 1920 that Chanel would fund the revival of *The Rite of Spring* Stravinsky began to review proofs of the score, looking not only to the new production but also to the possibility that his publisher Russicher Musik Verlag might at last issue a final version of the work.[89] He and Massine had already begun to discuss new choreography for the ballet in the summer, and had agreed on a more abstract approach in which the dance would follow the structure of the score rather than the details of its rhythmic or metric design, as had been the case in Nijinsky's original conception.[90] "Massine does not follow the music note for note or measure by measure," Stravinsky reported in an interview with critic Michel Georges-Michel, which was published in *Comoedia* on the eve of the premiere; "he has invented a new kind of dance."[91] More objective and urbane than the original, they believed, their new *Rite* would be more in tune with the cosmopolitan sensibilities of post-war Paris. Massine's choreography, now lost, was apparently up to date enough to include a shimmy, but the sound of the ballet was the same; one of the children in the house at the time recalled that the villa was filled with "the echoes of the piano" playing "music so powerful that it scared us."[92]

While the substance of the score did not change, Stravinsky embarked on a campaign to recontextualize it, aiming to align the ballet with the aes-

thetic values emerging in post-war France. In particular, as Taruskin has demonstrated, he showcased its "simplification of texture, static vamping harmonies, and repetitive ostinato-driven forms," recasting the features originally perceived as hallmarks of *The Rite*'s primitivism as elements of a more contemporary style.[93] At precisely this moment in 1920, Stravinsky also disavowed his earlier claim that the ballet had been inspired by a dream-vision in which he saw the final sacrificial dance, maintaining instead that a musical theme came to him first, catalyzing the composition of "an architectonic and not an anecdotal work."[94] Divorced from the choreography that had made it shocking and explosive in the first place, *The Rite* could accommodate a range of new expressive meanings consistent with notions of post-war fashionability. Indeed, the ballet's cachet carried forward from the 1913 premiere right up to the revival thanks in part to the fact that it had entered the collective consciousness as a *scandale* without having been much seen or heard: following a few staged performances in Paris and London in 1913, there were concert versions in Moscow and St. Petersburg in February 1914, then, famously, at the Salle Pleyel in Paris in May that year. Afterward, *The Rite* more or less disappeared from the landscape.[95] Renowned yet unknown, it produced just the kind of buzz that attracted the elite audience Diaghilev aimed to recapture, and paired with a revival of *Parade* in this Ballets Russes season, it took on a new and decidedly modernist cast.

The opening night of the revised *Rite* must have been a golden moment in the Chanel/Stravinsky relationship. Presented at the still glamorous Théâtre des Champs-Elysées—the site of the original premiere—the new *Rite* was heralded instantly as a classic.[96] Among the critics most favorable to the production was British musicologist Edwin Evans, editor of the music journal *The Dominant* and a regular contributor to the *Pall Mall Gazette*, *The Musical Times*, and—more surprisingly—*Vogue*.[97] A longstanding intimate of the Ballets Russes, Evans was described by one rival as someone who "expounds the gospel according to Stravinsky from many pulpits," and was so much a part of Diaghilev's clique that Picasso sketched his portrait in 1919, depicting him in a line-drawing much like the renditions of Stravinsky, Satie, and Cocteau he completed in the same period.[98]

Shortly after the performance of the *Rite*, Evans visited Stravinsky at Chanel's villa, taking along with him Ansermet, the painter André Derain, who had just created the costumes and decors for the Ballets Russes production of *La Boutique fantasque*, and "one or two other kindred spirits."[99] Stravinsky played new works for them at the piano—the *Concertino*, the opening section of *Les Noces*, the whole of *Renard*, and "his last completed

composition," *Symphonies d'instruments à vent à la mémoire de Claude Debussy*. Evans reported on these works in an article for the journal *Musical America*, announcing unequivocally that *The Rite* was destined to "be generally recognized as the greatest musical achievement of the decade that produced it." Audiences, he suggested, had simply needed time to catch up with Stravinsky's advanced ideas; finally, seven years after its conception, they were capable of hearing the music with "the right kind of attention."[100] Commenting on the more recent works—for after all, as he pointed out, Stravinsky had not "come to a standstill"—he observed that the composer was in the midst of a "contrapuntal evolution." "He is less and less preoccupied with chords," Evans maintained, "and more and more engrossed with the movement of parts." This, in Evans's assessment, amounted to a new conception of counterpoint, which qualified Stravinsky as "the Bach of today"—or at least, as the article's title proclaimed, as a "contrapuntal titan."[101] A photograph of the bespectacled composer that appeared alongside the article referred to him simply as a "magician in counterpoint."

Surely Evans was inspired to make these comments about counterpoint after hearing the work that preoccupied Stravinsky above all while he was chez Chanel, namely, *Symphonies d'instruments à vent*. Widely recognized as the composer's masterpiece of the 1920s, this composition began to take shape in April 1920, when Henry Prunières, editor of the new journal *La Revue Musicale*, asked Stravinsky to contribute a piece for publication in a special commemorative supplement in memory of Claude Debussy, who had died in 1918. In response, Stravinsky provided a chorale scored for piano, which appeared under the title *Fragment des symphonies d'instruments à vent pour Claude Debussy* alongside *tombeaux* in memoriam of Debussy composed by Bartók, Dukas, de Falla, Goossens, Malipiero, Ravel, Roussel, Satie, and Schmitt. [102] Stravinsky's piece stood in marked contrast to some of the more florid contributions in the collection; visually austere and musically sparse and simple, it was described by one contemporary commentator as "strong and brutal," lacking "nuance" as well as time or key signatures. "These pages," the critic continued," offer some interesting problems in musical esthetics."[103]

In Carantec during the summer of 1920 Stravinsky addressed some of those "problems" as he built a larger work around the chorale, leaving the original composition itself as the final segment of the piece.[104] He completed a short score in late July, then at Garches devoted himself to working out the orchestration, completing *Symphonies* as a whole on 30 November 1920.[105] This twelve-minute piece, far more than the historicizing pastiche of eighteenth-century Italian tunes that he created for *Pulcinella*, augured

# IGOR STRAVINSKY: CONTRAPUNTAL TITAN

Described as "Bach of To-day" by English Writer—Plays New
Works for Group of Intimates—Musical Opinion Rallies to
"Sacre du Printemps," Revived in Paris—Score Will Be
Recognized as Greatest Achievement of Decade, Is Pre-
diction—Contrapuntal Evolution More Pronounced—Use
of Instrumental Timbres—Color Polyphony in Painting

## By EDWIN EVANS

LONDON, Jan. 20, 1921.

Edwin Evans

ABOUT three weeks ago I spent a day with Stravinsky at the villa he is occupying
a little way out of Paris. With us were Ernest Ansermet, the conductor, Derain,
the painter, and one or two other kindred spirits, and naturally we heard some of
the composer's latest works. He played us the piano version
of the Concertino which, somewhere about the same date, or
a little earlier, was being hissed in New York. We also
heard the opening section of "La Noce Villageoise," the whole
of "Renard," and his last completed composition, "Symphonies
d'instruments à vent à la mémoire de Claude Debussy."
Within a few days previously I had also heard two perform-
ances of "Le Sacre du Printemps," the revival of which was
the occasion of my visit to Paris. I had also assisted at a
concert given by the group of composers known as "Les Six,"
and enjoyed a quiet hour's conversation with Maurice Ravel,
who not long before had paid an interesting visit to Vienna,
and was full of musical news from that city, where the camp
of modern music is now burning as brightly as in Paris and London. Before leaving
London I had read E. J. Dent's impressions of musical Berlin, which he found some
decades behind the times, so far as contemporary musical thought is concerned, and
on my return I read of the greeting that had rewarded those admirable players, the
Flonzaley Quartet, at the first performance of the Concertino. On the mental impres-
sion made by these contrasts, I make no comment. The mere statement of their
succession is enough.

Igor Stravinsky, Famous Russian Composer, Whose Latest Work Reveals His Devel-
opment as Magician in Counterpoint

### Paris's Changing Attitude

The attitude of Paris toward the
"Sacre du Printemps" has developed ex-
actly as one would have forecasted from
historical precedent. It will be remem-
bered that in 1913 the work was received
in the same way as New York received
the Concertino. The following season
it was performed by Pierre Monteux at
his "Concerts Populaires." He had, of
course, the advantage of a more special-
ized audience. Among those who went
to the Ballet there must have been many
for whom music was a necessary but not
very important adjunct to the stage per-
formance, and when they found that the
unfamiliar sounds encroached so much
upon their attention they were predis-
posed to resent it. Others came to see
and be seen by the best Paris society.
Those who went afterwards to the con-
cert performances must be presumed to
have been attracted by the music, or at
least by curiosity concerning it. These
performances were very successful, and
the effect of them upon the public has
persisted. When the ballet audience
gathered again to hear the same work
in December, its predisposition was the
other way, and the music was heard with
the right kind of attention. Except at
one point of the performance, all opposi-
tion had vanished, and as the music at this
particular point is relatively unaggres-
sive, whereas Massine's choreography
is somewhat provocative, I do not think
I am wrong in assigning to the latter
the audible signs of disapproval, which
were not very pronounced, and such as
they were, were quickly silenced. That

is the position after seven years. Seven
years hence, I am convinced, this work
will be generally recognized as the great-
est musical achievement of the decade
which produced it. Year by year musi-
cal opinion is rallying to it. Only the
other day a Paris musician, whose at-
tainments entitle him to be heard, de-
clared that it towered over the music
of its period in the same manner as the
"Matthew" Passion and the Ninth Sym-
phony towered over theirs.

### Thinks in Counterpoint

Meanwhile Stravinsky has not been at
a standstill. The tendency towards a
contrapuntal evolution which was visible
in "Petrouchka" and even before, has
become more pronounced. He is less
and less preoccupied with chords, and
more and more engrossed in the move-
ment of parts. Of course his conception
of counterpoint is not that of the six-
teenth century, nor is it limited to the
resources of the scale. His employment
of instrumental timbres is essentially
contrapuntal. When, for instance, he
associates for a brief moment in
"Pulcinella" the double-bass and the
trombone, it is not that he wants to
mix these two sounds into a blended tim-
bre, which would correspond with har-
monic method. He takes a soft and
fatty penetrable sound, and sets against
it a hard penetrating one, and if they are
of unequal intensity, they possess in an-
other way equal strength, for both are
extremely characteristic, and character
is strength. But their respective charac-
ters differ so widely that their identities

are in no danger of being sacrificed.
They exist as independently of each other
as any two parts in a piece of counter-
point. Stravinsky treats rhythm the
same way. But it is a little premature
to analyze processes of this kind, and it
has moreover the special disadvantage
of conveying an impression that the com-
poser is working to a theory, which is not
the case. That is one of the dangers be-
setting any writer like myself in the en-
deavor to clear up some of the intricacies
of modern music. If I analyze a Brahms
symphony it will not occur to anybody
that the technical reasons I give were
Brahms's reason for writing it. If I do
the same with a Stravinsky work there
will always be some malignant person
who will say that Stravinsky wrote it to
prove the theories advanced in explana-
tion of it.

This contrapuntal tendency is by no
means limited to Stravinsky. It per-
meates the work of nearly all the com-
posers who have the distinction of meet-
ing with the disapproval of reactionary
audiences. It is not even limited to mu-
sic. It animates modern painting. You
will meet with it in the theater. As an
instance I would quote a setting which
Lovat Fraser, who designed that of the
"Beggar's Opera," has recently made for
a little ballet which Mme. Karsavina is
presenting at the Coliseum. Its colors
stand out sharply, one from another, and
do not sacrifice a fraction of their iden-
tity. They form a counterpoint to each

other where artists of the other ten-
dency would have sought to make har-
monies. And the advantages gained by
this process are the same. In a scene
designed for harmony the individual
patches of color offer the eye an uncer-
tain outline. Between a costume and
the background in front of which its
wearer is moving, one receives the opti-
cal impression of a narrow zone of
neutral blur, which results from the ten-
dency of harmonized colors to fuse one
into the other. But the free employ-
ment of opposites, that is to say, the
opposition of complementaries, has, if
the artist has sufficient skill and taste,
the effect of a colored polyphony in
which the parts move with as much free-
dom as in musical counterpoint.

I have a special purpose in mentioning
these things at the moment. I recently
committed myself to the statement that
Stravinsky was identifying himself more
and more as a successor to Bach, that he
was in fact becoming the Bach of to-day,
and it came to my knowledge afterwards
that this was regarded as one of the
things which a journalist will say be-
cause he thinks they sound clever. I
do not think that I am given to saying
things with that view, but if I am, I
take the opportunity of asserting that
this is not one of them. In impulse and
incentive there is quite a remarkable af-
finity between Bach and Stravinsky, and
I feel that it will become more apparent
as time goes on.

PHILHARMONIC ORCHESTRA
WALTER HENRY ROTHWELL—CONDUCTOR
WM. CLARK JR.—FOUNDER

Season   LOS ANGELES, CALIFORNIA   1920-21
100 MEN              42 CONCERTS
Spring Tour. Five Weeks—Western States.

Schumann Heink

Exclusive Management
HAENSEL & JONES
Aeolian Hall   New York

STEINWAY PIANO USED

JOHN McCORMACK

MANAGEMENT
CHARLES L. WAGNER
D. F. McSweeney
Associate Manager
511 Fifth Ave., New York

FIGURE 77. Profile of Igor Stravinsky, from *Musical America*, 1921

the new compositional style that would prevail in Stravinsky's works over the next decade, reflecting a deepening of his alignment with aesthetic ideals of simplicity, clarity, and elegance—the very qualities that would be cited as hallmarks of his new classicism.

## NEOCLASSICISM AND THE GARCHES COMPOSITIONS

*Symphonies* was assigned special significance among Stravinsky's works from the outset. Standing at the crossroads of the composer's pre-war Russianism and his post-war European sensibility, it defies easy categorization, and over time has been the subject of extensive and often contradictory analyses.[106] The title has stimulated discussion in its own right, thanks to Stravinsky's choice of the plural "symphonies," which simultaneously invokes the term's classical meaning—"to sound together"—as well as its more familiar usage as a reference to the symphonic genre.[107] A particularly probing line of analytical inquiry has explored the work as a "paradigm of discontinuity," in which musical interruption and interpolation are raised to the status of a principle in the composition's design.[108] This structural aspect of *Symphonies* has been interpreted by some analysts as a pre-figuration of the experiments with musical time and continuity that came to fruition in the 1950s; in this view, *Symphonies* is a piece of radical abstraction and Stravinsky a prominent figure in the early history of high modernism.[109] An alternative reading, proposed more recently by Taruskin, rests on his illumination of the work's roots in the traditional Russian Orthodox office for the dead, called the *panikhida*. This connection is compelling; the piece, after all, originated as a memorial for Debussy, and Stravinsky himself described the *Symphonies* as "an austere ritual which is unfolded in terms of short litanies."[110] Moreover, as Taruskin has demonstrated, the work follows the formal structure of the Russian service in general terms while more specifically alluding to the melodic, harmonic, and performance practice conventions of the ritual.[111] In short, if *Symphonies* looked to music's future in its conceptions of time and organization, so too did it look to music's roots in the remote Slavic past.

For audiences in the early 1920s, however, neither the modernist "moment form" of the future nor the Russian overtones of the past were likely the most compelling features of *Symphonies*; instead, listeners were no doubt captivated by the work's spare, urbane, and utterly contemporary style, for which no label then existed. Those attending the London Symphony's world premiere of the piece in Queen's Hall on 10 June 1921 were not amused. Basking in an all-Russian program that included works by

Rimsky-Korsakov and Scriabin, they gave *Symphonies* an icy reception; as the critic Ernest Newman—who himself described the work as a "hideous and meaningless collection of noises"—recalled, they "could not keep from laughing at the music. . . . At the end there was more hissing than I have ever heard in an English concert-room."[112] For his part, Stravinsky blamed conductor Serge Koussevitsky for the negative response, claiming that "the score of my music was not well crafted, and I myself did not know it as my own work." The audience, Stravinsky exclaimed, "did not hiss enough. . . . They should have been much angrier."[113]

Across the channel in Paris only a little more than a year after the London premiere, however, *Symphonies* met with a strikingly different response. In a context more conducive to contemporary fashionability than classical correctness, the work was performed at the Théâtre des Champs-Elysées in a concert organized by Jean Wiéner, a jazz pianist who in 1921 had made waves by inaugurating what he called "Concerts salades," in which current art music was mixed with jazz and popular song.[114] As if to showcase Stravinsky's one-man capacity for crossing these boundaries, *Symphonies* made its Paris debut in an unusual Wiéner program devoted exclusively to the composer, which included performances of the *Concerto for String Quartet*, *Piano-Rag-Music*, and concert versions of *Mavra* and *Pulcinella*. A dazzling success, the concert on 22 December 1922 holds the distinction of inspiring the first use of the term *néoclassique* to describe Stravinsky's work: in his review of the performance critic Boris de Schloezer used the word to herald Stravinsky's move toward a "denuded stripped-down, style" and announced the composer as the "most anti-Wagnerian of musicians."[115] *Symphonies*, Schloezer proclaimed, was the epitome of this new approach.

In landing on the word *neoclassic* to describe Stravinsky's music, Schloezer engaged a term that was complex, politically charged, and variously employed across a range of disciplines in the early part of the twentieth century.[116] In the field of music alone, usage at the time ranged from an extreme at which the term pejoratively signified outmoded German instrumental music (particularly the works of Mahler and Brahms) to one where it positively described contemporary fascinations with French music of the seventeenth and eighteenth centuries. At the time of Schloezer's review, as Scott Messing has demonstrated, the dizzying array of meanings attached to the term was just shaking out, and *neoclassicism* was emerging as a useful label to describe music that encompassed four general traits: simplicity, objectivity, youthfulness, and cultural elitism.[117] Surely Schloezer's association of the term with *Symphonies*, where the first two of these qualities are

carefully honed, played a role in solidifying the definition that has been ascribed to it ever since.

Key to the identification of *Symphonies* with neoclassicism are its instrumentation and orchestration, both of which were finalized while the composer was living at Chanel's villa. Sketches dating from as early as 1917 show that Stravinsky initially considered scoring the piece for an ensemble including harmonium or string quartet, but at Bel Respiro he settled on an acerbic and highly unconventional twenty-three-piece wind ensemble consisting only of flutes, oboes, clarinets, bassoons, horns, trumpets trombones, and a tuba.[118] The "objective cry of wind instruments," Stravinsky later explained, would "render the musical architecture more evident."[119]

Schloezer zeroed in on precisely this notion of "architecture" in *Symphonies*, thus engaging what art historian Kenneth Silver has characterized as the "constructive" metaphor—based in the reality of post-war reconstruction—that was a "crucial aspect of all Parisian artistic discourse" in the 1920s.[120] Praising Stravinsky's composition for its twinned features of structural simplicity and cool objectivity, he described this "genial" work as

> a system of sounds which follow one another and group themselves according to purely musical affinities; the thought of the artist places itself only in the musical plan without ever setting foot in the domain of psychology. Emotions, feelings, desires, aspirations—this is the terrain from which he has pushed the work. The art of Stravinsky is nevertheless strongly expressive; he moves us profoundly and his perception is never formularized. . . . This art does not pursue feeling or emotion, but it attains grace infallibly by its force and by its perfection. Stravinsky reestablishes the ancient classical, pre-Beethovenian tradition.[121]

By liberating sound from sentiment, Schloezer thus proposed, Stravinsky gave full reign to the inherent expressive potential of musical form. And in *Symphonies*, that form is exposed thanks not only to the work's economical textures and taut instrumentation but also by virtue of its very design. In short, the "discontinuity" since cited by analysts as central to the composition gives rise to what has been called "mosaic" or "montage" form, in which discrete and sharply defined sections of music are juxtaposed without transitions or other connective tissue. Absent such mediation, the essence of the composition's structure—its architecture—is made transparent, a quality Stravinsky highlighted in his later description of *Symphonies* as "an arrangement of tonal masses . . . sculptured in marble . . . to be regarded objectively by the ear."[122]

If *Symphonies* marks Stravinsky's exploration of a stripped-down and form-oriented aesthetic, the piano album *Les Cinq doigts*, completed at Bel

Respiro in February 1921, pushes the notion of simplification to further limits.[123] The only work the composer created from start to finish while living in Garches, the eight short piano pieces of this set were characterized by Craft as being "of such extreme simplicity that it seems as if [Stravinsky] were trying to rediscover in them both his own roots and the elements of composition."[124] Often overlooked, the work has been rightly described as an "insignificant opus, but a big milestone."[125]

While his own young children may have been on Stravinsky's mind as he composed *Les Cinq doigts*, it is much more than a series of five-finger pedagogical exercises of the sort that were a commonplace of the literature for beginning piano students. In fact, the composition brings to the fore the one characteristic of nascent neoclassicism that is least evident in *Symphonies*, namely, youthfulness.[126] This is expressed not as much through technical simplicity or a lack of expressive artifice—qualities often associated with children's music, which indeed characterize the work—but rather through an engagement with popular music, which was then as now inherently associated with youth culture.[127] By combining the rudimentary techniques and lack of affect characteristic of children's music with fresh and vigorous idioms of popular music—what Chanel might have called music from the streets—Stravinsky arrived at a cosmopolitan style in which simplicity and surprise rule the day.

## YOUTH AND/AS CLASSICISM

Stravinsky's most important influence in this endeavor was undoubtedly Erik Satie, with whom he remained on friendly terms from the time of their meeting in June 1911 until the older composer's death in 1925.[128] Theirs was a mutual admiration; Stravinsky described Satie as "the oddest person I ever met, but the most rare and consistently witty," while for his part Satie judged Stravinsky to be "one of the most remarkable geniuses who has ever existed in music."[129] Just after their first encounter, Satie entered a phase of unprecedented productivity that lasted just over three years, during which he composed most of the piano pieces for which he is now best recognized, including the so-called "humoristic piano suites" and *Sports et divertissements*. Stravinsky no doubt heard many of these works at the time; he recalled that "in those early years [Satie] played many of his compositions for me at the piano," thus raising the likelihood that he was aware of the older composer's explorations of new musical aesthetics.[130]

Satie's consuming project, as we have seen, was his development of a style in which popular music idioms typical of the cabarets, café-concerts,

and music-halls he frequented as both performer and passerby were accommodated into composition. This conflation of high and low, marked by a humor dependent on parody and pun, was well suited to the naïveté and simplicity generally associated with children's music; indeed, as Satie scholar Alan Gillmor has noted, nearly all of Satie's piano compositions seem in some way to reflect "the mysterious world of the child."[131] In the fall of 1913, however, Satie composed the only group of works that he explicitly identified with children, the simple piano pieces published the following year under the umbrella title *Enfantines*.[132] Based on a series of five-finger scales that traverse the white notes of the keyboard, these pieces may have furnished Stravinsky with an important compositional model: like *Enfantines*, *Les Cinq doigts* is based on conventional five-finger formats (although venturing beyond white-note diatonicism) and the pieces in both collections are extremely brief, largely diatonic, and marked by an austere two-part texture.[133]

Beyond these surface similarities, the pieces in Stravinsky's collection suggest the possibility of two more intriguing and meaningful links to Satie. First, as Taruskin has revealed, the third piece in *Les Cinq doigts* (Allegretto) is an "unadvertised arrangement" of the traditional Russian folk dance known as *Kamarinskaya*. The tune, a staple at weddings and other festive occasions, first found its way into Western repertoires via Domenico Cimarosa's opera buffa *Le Astuzie femminili*, composed in 1794, which ends with a "Ballet russo" based on the dance. It reappears in Beethoven's "Twelve Variations on a Russian Dance from Wranitsky's Das Waldmädchen," WoO71, and in 1848 was made famous in Europe, to the extent that it became a cliché of Russian nationalism, after it appeared as the main tune in Glinka's *Fantaisie pittoresque*.[134] Stravinsky's choice of this well-known melody as the basis for his own little composition is illuminated in Taruskin's analysis, in which he demonstrates that the tiny "Allegretto," with its embedded folk music, marks precisely the moment at which Stravinsky returns to diatonicism—and thus the composer, with delicious irony, lights on an iconic yet utterly Westernized Russian tune as the basis for his reconnection with a more purely European compositional idiom. Surely this clever maneuver recalls Satie's appropriation of tunes popularized in Bizet's similarly iconic *Jeux d'enfants* as the basis for pieces in *Sports et divertissments*, as discussed in chapter 3.

A second link to Satie arrives in the final piece in Stravinsky's collection, entitled "Pesante," which is a tango.[135] The popular Argentine dance, as we have also seen in chapter 3, inspired Satie's witty "Le Tango (perpétuel)" in *Sports et divertissements*, and likewise in *Les Cinq doigts* the characteristic

tango rhythms provide the foundation for a piece that seems to be a humorous take founded on the meshing of rudimentary (and presumably childlike) keyboard technique with sophisticated humor. Stravinsky's consistently pungent harmonies—which begin in the second measure with the juxtaposition of the tonic (C) and a diminished triad on the leading tone—as well as his slow and heavy tempo, suggest a similar parody, designed to subvert the more sensuous languor and sexual connotations conventionally associated with the dance.

*Les Cinq doigts* was not the first Stravinsky opus to reflect Satie's influence; Stravinsky described *Three Easy Pieces*, completed in late 1914, as his "three music-hall pieces," thus making a connection to the popular music milieu that was the basis for much of Satie's work. The score itself implicates a visual pun typical of Satie, compressing music written for piano duet—a four-hand ensemble, generally requiring four musical staves—onto three staves. Most explicitly linking himself to the older composer, Stravinsky dedicated his waltz in the set to Satie, explaining that it was a "souvenir of a visit with him in Paris," and noting that it was "intended to portray something of his *esprit*."[136] Under the influence of that spirit, Stravinsky—with a whimsy more characteristic of Satie—later even called this his "ice-cream wagon waltz."[137]

The choice of a waltz to honor Satie was apt, since (as noted in chapter 4) the composer scored one of his first popular successes with the "sung waltz" *Je te veux*, and between 1912 and 1914 composed half a dozen pieces in the genre. Among these works, the collection of three waltzes entitled *Les Trois valses distinguées du précieux dégoûté*, completed in the summer of 1914 (discussed in chapter 4) seems to have been an especially important model for Stravinsky: the waltz of his *Three Easy Pieces*, composed only a few months later, bears a particular similarity to the first dance in Satie's set, entitled "Sa Taille." The relationship is seen most easily in the opening melody of Stravinsky's piece, which alludes clearly to the first significant tune in Satie's waltz by echoing its melodic contour, tracing an arc from E to A and back again. Other features common to the two pieces include a tonal focus around C-major, a rhythmic pattern that consists of four eighth-notes followed by a quarter-note, and a chromatic emphasis on the F/F-sharp minor second. More generally, Satie's sense of playfulness emerges in Stravinsky's insistence on repeated notes, particularly in the trio of his waltz, and in the hand-crossing gestures that pervade the piece. Perhaps most amusing is the fact that the tune Stravinsky adapts in his opening coincides in Satie's score with the textual annotation, "Then he

*Example 3a.* Stravinsky, Waltz from *Trois pièces faciles*. Reprinted by permission of Chester Music.

Puis, il s'adresse un compliment tout rempli de mesure.
(Then, he bestows on himself a restrained compliment.)

*Example 3b.* Satie, "Sa Taille." Reprinted by permission of Editions Salabert.

bestows on himself a restrained compliment"; Stravinsky, again in a mode more typical of Satie, thus makes a little inside joke.

Other details in *Three Easy Pieces* also suggest Satie's example. In the "March," for instance, Stravinsky follows Satie by quoting a folksong— identified as the Irish tune "The Blacksmith and His Son," about which little is known beyond the fact that the composer owned a printed collection of songs that included the tune.[138] Indeed, Stravinsky's piece, a jaunty march that begins with open fourths evoking horn calls and goes on to present a series of fanfare patterns marked by clangy dissonances, may well incorporate elements of the Irish tune; Taruskin points to the repercussive opening figure and the descending scale pattern that are common to both. As he also notes, however, there is little actual quotation, just fragmented bits and pieces of melody that pop up through Stravinsky's piece.[139] The melodic gestures Stravinsky uses, in fact, are such commonplaces of military music that the identification of an actual source tune seems less important than simply recognizing that Stravinsky purposefully composed the piece around the most mundane kinds of military references—from brassy fanfares to mobilizing scales to plodding bass patterns. For an audience that

would not likely have been acquainted with the particular Irish tune in question, let alone any lyrics it carried, these more generic qualities would have made the piece instantly recognizable as an ironic musical commentary on the grim events unfolding in the contemporary world as World War I raged on. Just this kind of nonspecific allusion, dependent on the use of fragments of melodies appropriated from everyday sources, was a long-standing hallmark of Satie's style and seems to be yet another example of his influence.

Stravinsky's engagement with popular dance intensified through the war years and reached a peak in 1919 with *Piano-Rag-Music*. Scored for solo piano, this work is modeled explicitly on the Brazilian *maxixe*, another dance that captivated Paris before the war.[140] Stravinsky no doubt heard (and probably danced) the *maxixe* as he made the rounds of trendy Parisian nightspots with his friends, and he played his new composition in the fall of 1919 for a number of them, including Diaghilev, Massine, Picasso, Auric, and Poulenc, at a soirée hosted by Jean Hugo and his wife Valentine Gross.[141] Fashionable well into the twenties, the dance in 1919 provided inspiration not just for *Piano-Rag-Music* but also for Darius Milhaud's "spectacle-ballet" *Le Boeuf sur le toit*, which opens with the borrowed *maxixe* tune, "Sao Paulo Future," which had been recorded by the Brazilian Marcelo Tupinambá in 1914.[142] So popular was Milhaud's work with high-society audiences that it spawned an eponymous nightclub in 1921, which, as we have seen, was the favorite watering hole for all of stylish Paris in the twenties. Music there was provided by none other than Jean Wiéner, who often performed at the piano with his partner Clément Doucet.[143]

Seen in the context of these works, all marked by an engagement with popular music à la Satie, the seemingly inconsequential *Les Cinq doigts* comes into focus as something much more than "children's music." Indeed, in an unassuming fashion, the work suggests Stravinsky's own pared-down version of a new style rooted in the sounds and ideals of the contemporary world, tinged with an irony based on objectivity. It was by virtue of Satie's example, and Stravinsky's embrace of the idea, that such a style, dependent not on mining the past but instead on celebrating the everyday present, could be accommodated into the emergent idea of neoclassicism in the early 1920s.

## NEOCLASSIC/CHIC

In Chanel's milieu at Garches, then, Stravinsky completed two important works that helped to establish the meaning of the term "neoclassicism" in

musical circles. *Symphonies,* with its architectural approach and "cellular" systematization, presents one face of this new style; *Les Cinq doigts,* with its anti-academic and youthful mix of popularizing models and childlike affect, presents another.[144] Overarching both trends is a sensibility in which simplicity, precision, and up-to-date savvy are the prized values, and at bottom is the notion that this amalgamation of values would distinguish French music from its European—and specifically its German—counterparts. Thus was constituted the cultural elitism that Messing has identified as the fourth basic marker of neoclassicism.

Stravinsky's culturally inflected classicism was in keeping with a broader reductionist impulse that took hold in France following the war, in which "simplicity" became a kind of shorthand for anything that was abstract, concise, and clear. The recognition that such simplicity need not be hermetic or abstract but could accommodate fun and even frivolity added to its appeal, and the idea gained momentum in sophisticated Parisian circles with the premiere of *Parade* in 1917. The following year it attained something of a codification with the publication of Cocteau's little manifesto, *Le Coq et l'arlequin,* which promoted Satie's "little classical path" and his "clear, simple, and luminous" style.[145]

While Cocteau focused on Satie to the exclusion of Stravinsky in *Le Coq,* other critics were quick to connect Stravinsky with the emergent ideal of simplicity as his new works appeared in the early 1920s.[146] Ernest Ansermet, for one, noted in 1922 that the composer was "simplifying his style more and more, reducing it to the most common, direct, and frank elements, recalling the most exceptional forms without losing any of the new-found freshness in his manner of expression."[147] Schloezer, as we have seen, was already praising Stravinsky's "stripped-down style" in February 1923, and in separate commentary published later that year he accommodated that quality into what he described as a "new classic style, otherwise called objective."[148] That same year Nadia Boulanger, teaching harmony at the new Franco-American music school in Fontainebleau, weighed in on Stravinsky, noting his "precise, simple, and classic lines," which she claimed asserted "authority without artifice."[149]

Purity, clarity, simplicity, precision: these were exactly the terms invoked to describe fashion of the early 1920s. Typical was American *Vogue's* proclamation that in Paris, "simplicity is favored" to the extent that "the preference of the truly smart woman is not to be seen at all rather than to appear conspicuous."[150] "French ideas were never more simple," was the caption of a *Harper's Bazaar* spread in 1924; the accompanying illustrations showed tight-fitting cloche hats and streamlined clothing.[151] French *Vogue* echoed

the sentiment in a two-page spread demonstrating the difference between fashions of 1904 and those of 1924. In contrast to the complexities of the old style—which signaled the "state of mind" of a "fragile woman who was a stranger to practical realities," the new look, the magazine declared, was captured in "two words: simplicity, comfort." The silhouette was natural, following the body, and it was left unornamented: a single strand of pearls, practical shoes, and a small hat were the only accessories advised.[152] Women, according to *Harper's Bazaar* in 1921, had "at last adopted the easy-fitting, comfortable, graceful straight-lined model" which expressed "modern freedom and modern frankness."[153] An editorial published in *Vogue* even tied these fashion trends to more substantial aspects of life, positing under the headline "The Natural, Simplicity, and the World" that "good education and simplicity go hand in hand," and the magazine counseled readers to follow the rules common to both.[154]

Used widely to describe the fashions of the day, the terms "simple," "precise," and "pure" were applied with special frequency to Chanel's designs, and in her case were further identified with youth and energy. Her "youthful sports costumes," *Vogue* proclaimed in 1925, were "the perfect expression of the Parisienne's preference for the simple line that carries elegance in its wake."[155] "From the point of view of good taste, simplicity, subtlety, and wearability," another article asserted, Chanel was "without peer."[156] "Simple, youthful lines," exclaimed another commentary, "Chanel has a feeling for the type of clothes that the woman of today likes best."[157] In the 1920s her simplification of style, based on "retaining a simple line without decoration," came to be recognized as emblematic of the age.

Simplicity, while perhaps the most basic of the characteristics that new music and new fashion shared in the early 1920s, was not their only common thread. As we have seen, an emphasis on repetition was equally evident in Chanel's "little black dress" and Stravinsky's musical structures, while the privileging of architecture over ornamentation was as fundamental to her jersey separates as to his mosaic form. Even more apparent is the fact that in their work both Chanel and Stravinsky engaged with the vernacular world—or in Chanel's words, "the streets." The idea that elements of everyday culture could be the foundation for sophisticated style informed Chanel's decision to create upscale interpretations of workaday garments, much as it informed Stravinsky's decision to appropriate popular tunes and rhythms for his compositions.

This mix of simplicity and streetwise savvy was identified as "neoclassicism" in music, but in fashion this term was considered to be both outdated and problematic. In matters of dress, as Anne Hollander has demonstrated,

"neoclassic" had other connotations, most literally suggesting the draped garments that emulated original Greek and Roman attire, and more colloquially referring to the gauzy and tubular "Directoire" dresses inspired by a fascination with antiquity and worn by the "Merveilleuses" at the turn of the nineteenth century. Closer to Chanel's time, the term "neoclassic" had been used to describe the long, high-waisted tunic dresses popularized by Poiret as a revival of this style, which by the 1920s were considered to be extremely out of date.[158] Reluctant to invoke any of these associations, the fashion establishment settled instead on the more neutral term "chic" to convey the same qualities of simplicity, precision, and purity.

As we have seen, in the early 1920s the meaning of "neoclassic" in music and "chic" in fashion stabilized respectively around the work of Stravinsky and Chanel. That this process occurred during the time of their liaison is felicitous and perhaps coincidental, but it seems more likely to be tied to their shared engagement with a broader culture of style that prevailed in elite Parisian circles after the war. Bringing an idealized classical past into contact with aspects of contemporary life, this culture encouraged intersecting modernisms for which Chanel and Stravinsky were especially visible, articulate, and passionate advocates.

## AFTER STRAVINSKY, COCTEAU

Shortly after *Les Cinq doigts* was completed in February 1921, the Chanel–Stravinsky affair came to an end. A flurry of entanglements followed: as Vera and Craft pointed out, the composer took up with the cabaret performer Katinka, then with Vera herself; meanwhile, Chanel become involved with the Grand Duke Dmitri, then with poet Pierre Reverdy, and eventually, with the Duke of Windsor. Instead of meeting Chanel during the Ballets Russes' tour of Spain in the spring of 1921, Stravinsky spent time looking for a house suitable for his family in the south, settling them first in a small cottage in Anglet, then more permanently in Biarritz, at the villa called Les Rochers. "We have left Garches for good," he wrote definitively to his editor Otto Kling on 21 May.[159] Stravinsky had not, however, left Paris for good; as part of an arrangement with the Pleyel piano company, he had use of an apartment in the city, and there is no doubt that his path crossed Chanel's there as well as in Biarritz, where her couture shop was arguably the most fashionable in town. In the early 1920s, Chanel even helped to finance a restaurant—the Château Basque—run by Stravinsky's brother-in-law, which was located in the same building as her Biarritz atelier.[160] Chanel cherished to her death an icon Stravinsky gave her before he

left Garches, but perhaps their liaison remains best characterized by Cocteau's less romanticizing cartoon, captioned "Stravinsky chez Coco Chanel" and dated 1930, which depicts Stravinsky standing behind a piano in a room decorated with a Picasso harlequin painting; music comes from the deranged-looking composer's ear along with the words "Bel Respiro— Ha!"

In the wake of the Stravinsky affair Chanel ventured for the first time into the world of the theater, creating costumes for Jean Cocteau's adaptation of *Antigone*. Written while Cocteau vacationed in the south of France with his lover Raymond Radiguet, the adaptation of *Antigone* was part of a remarkable body of work Cocteau completed in the fall of 1922, which also included the novels *Le Grand Ecart* and *Thomas l'Imposteur*, and the poetic series *Plain-Chant*. Under the sway of what has since been called the "myth of the Mediterranean"—the sense of proximity to antiquity that similarly prompted Matisse, Bonnard, Picasso, and Picabia to explore classical themes while they spent time on the Riviera—he took the matter of ancient Greece literally, aiming to create a "modern reduction" of *Antigone* that would "freshen, sharpen, and comb" Sophocles.[161] Although he likened this "contraction" to a "pencil drawing based on the painting of a master," or a "photograph of the Acropolis taken from an airplane," Cocteau, as his biographer Francis Steegmuller points out, did not stray far from the original text, following Sophocles often speech by speech. Cocteau's reductive approach was no doubt influenced by his earlier brush with *Antigone* at the Comédie-Française. "It was incredibly boring," he wrote his friend Jacques Maritain of the production, "the age of the actress playing Antigone made her walk to her tomb all too natural, and consequently anything but touching. Old men—quite obviously chorus-boys in white beards—sang unintelligible words to music by Saint-Saëns. That was a true *scandale*."[162]

Cocteau's *Antigone* would be a more up-to-date model, a "new dress on an old Greek tragedy," and his choice of venue set the tone: the play would be mounted at the Théâtre de l'Atelier, the most fashionable experimental theater in Paris, located in Montmartre and run by the actor Charles Dullin.[163] For the sets, Cocteau enlisted Picasso, who took inspiration from images he saw on Greek vases and created a "vast blue seaside sky, white Doric columns, and huge round shields."[164] For incidental music, he turned to Honegger, who produced a score for oboe and harp that Cocteau described as "hard and modest."[165] And for costumes, his choice was Chanel, "because she is the greatest couturiere of our age, and it is impossible to imagine the daughters of Oedipus poorly dressed."[166]

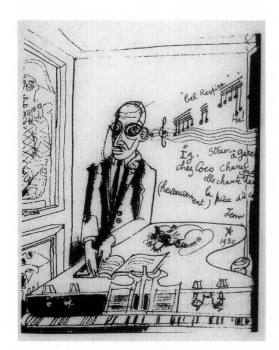

FIGURE 78. Jean Cocteau, "Stravinsky at Chanel's House," 1930

The play opened on 20 December 1922 on a bill with *La Volupté de l'honneur* by Pirandello. Dullin filled the role of Creon, the Greek dancer Genica Atanasiou played Antigone, and Cocteau spoke the part of the chorus, which was projected over loudspeakers that were hidden under masks designed by Picasso. By all accounts a success, the production gained further cachet when André Breton and his Surrealist followers disrupted a performance, leading to their eviction from the theater.[167] The numerous reviews included commentaries by Ezra Pound and André Gide, but the most extensive coverage was printed in Condé Nast's *Vogue* and *Vanity Fair*, where Chanel—not Picasso, Cocteau, or any of the actors—was the showcased artist.

A two-page spread that appeared in the February 1923 issue of American and French *Vogue* proclaimed in a headline that "Chanel Goes Greek While Remaining Chanel," and included photographs of Atanasiou, hair closely cropped and eyebrows sharply plucked, in costume, along with a series of drawings depicting the performance done by *Gazette du Bon Ton* illustrator Georges Lepape. Chanel was praised for her faithfulness to authentic Greek dress; Antigone's "heavy white wool robe, ornamented with brown wool in places," read one caption, "is exactly the robe we see on

FIGURE 79. Vladimir Rehbinder,
photograph of Genica Atanasiou in
*Antigone,* costumed by Chanel, from
*Vanity Fair,* 1923

Delphic vases; it is a beautiful recreation of something archaic that has been
intelligently illuminated."[168] A different photo included in the piece, shot
by Man Ray, showed Antigone in a full length coat of raw wool Chanel had
designed, which was decorated with Greek vase motifs in maroon and
black. In addition, the production seems to have given Chanel her first
opportunity to design jewelry, in the form of a studded headband for
Creon, thus launching what would be henceforward an essential and lucra-
tive aspect of her business.[169]

Cocteau claimed the headline in *Vanity Fair*'s version of the same arti-
cle, which appeared in May 1923. "A French Poet Rewrites Sophocles for
the Modern Stage," announced the title, but the illustrations were all
Chanel, right down to the caption "Chanel à la grèque" under which was a
notice that "the great French dressmaker" had given the "impression of
ancient clothing which has survived the centuries."[170] For the couturiere,
*Antigone* was a milestone, signaling her arrival in the world of avant-garde
art as a participant and not just a patron. The collaboration with Cocteau
and Picasso enhanced her social and artistic status as well as her profes-
sional profile, differentiating her from contemporary rivals and positioning

her to take on larger and more visible artistic projects. The opportunity came within two years.

### RESORT STYLE REDUX: *LE TRAIN BLEU*

In 1924 Chanel went from backing Diaghilev's productions to dressing his ballets. The "opérette dansé" that marked her entrée was *Le Train bleu*, with scenario by Cocteau, curtain and programs by Picasso, decors by the Cubist sculptor Henri Laurens, music by Darius Milhaud, choreography by Vaslav Nijinsky's sister, Bronislava Nijinska—and costumes by Chanel. The 1924 *saison russe* began in January in Monte Carlo, with premieres of *Les Biches,* with music by Poulenc, and *Les Fâcheux,* with music by Auric, but *Le Train bleu* took shape later and had its premiere at the Théâtre des Champs-Elysées on 24 June. Elevating the pastimes of upscale Parisians to the domain of art, it was part of a series of works that expressed what Lynn Garafola has called "lifestyle modernism," associated with Cocteau and his "art of the sophisticated commonplace."[171] Born with *Parade,* this artistic approach had informed *Le Boeuf sur le toit* as well as the collaborative entertainment *Les Mariés de la Tour Eiffel,* a pantomime parody of a Parisian wedding mounted by Cocteau and Les Six (minus Louis Durey) in 1921. With *Le Train bleu,* the lens of lifestyle modernism was trained on fashion itself; the ballet's title invoked the opulent "blue train" that whisked the smart set from Paris to the resort beaches of the Riviera, which, having made its maiden voyage only the year before, was the epitome of chic in 1924. The sportive theme was likewise timely, as Paris was host to the Olympic Games that summer and events were getting underway just as the premiere approached.[172] *Vogue's* commentary about the ballet captured this au courant sensibility:

> In *Le Train bleu* we found ourselves *en plein dix-neuf cent vingt quatre.* To begin with, the Picasso curtain: it is terrific. The scene (by Laurens) and the dresses (by Chanel) are perfect. The Russian Ballet is no longer Russian: the cool, quiet, utterly distinguished colours of this ballet are as French as it is possible to be. . . . At the end we feel we have had an experience that is new.[173]

The ballet's appeal to *Vogue's* upscale (and social-climbing) readers should come as no surprise. Cocteau's slight scenario recounts the antics of a group of upscale holiday-makers already decamped from the train to the shore. In its ten brief scenes, the stylishly up-to-the-minute ballet spoofs their athleticism as well as their romantic intrigues. All of the characters had real-life models: the bathing beauty nicknamed La Perlouse and her

FIGURE 80. Lydia Sokolova and
Anton Dolin in *Le Train bleu*,
costumed by Chanel, 1924

boyfriend Beau Gosse, or "handsome kid," were resort clichés, while the female tennis champion and her boyfriend, a golfer, would have been recognizable to contemporary audiences as takes on the popular tennis champion Suzanne Lenglen and the links-loving Prince of Wales. Pleasure-minded "chicks" and "gigolos," based on the louche types that could be found lingering at every stylish Riviera hotel at the time, made up the corps de ballet.

The contemporary tone of *Le Train bleu* was conveyed immediately in Picasso's drop curtain, and reinforced in the angular beach backdrops by Laurens. The curtain, depicting two monumental women running hand in hand on a beach, their white tunics falling away at the shoulders, had originated as a small painting in 1922; it was enlarged at Diaghilev's request by his scene painter, Prince Alexander Schervashidze, for use in the production.[174] Laurens, who had never before executed a stage decor, created angular striped cabanas, abstracted versions of the changing cabins found along the Riviera beaches. And Chanel's costumes were versions of the fashions she had pioneered at Deauville and Biarritz. Her tennis togs came complete with the headbands that had become Lenglen's signature, her British-style golfing ensembles consisted of plus fours, striped sweaters, and coordinating knee socks, and her two-piece bathing suits, which harked

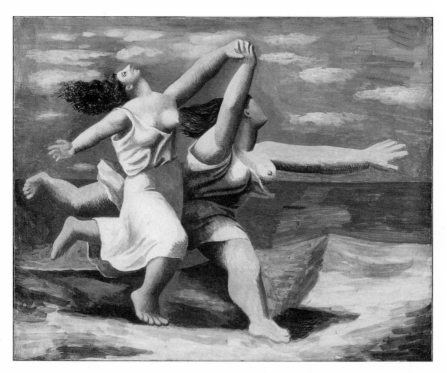

FIGURE 81. Pablo Picasso, *Deux femmes courant sur la plage,* 1922

back to her own Deauville swims, were realized in deep russet-and-wine-colored jersey. Accessories were as important as the clothes: imitation pearls, rubber bathing caps and slippers, wristwatches, and Kodak cameras prevailed. Everyone was tan, and sunglasses were so essential that they were written into the script.

Much as the street—or more properly, the beach—met the stage in the decors and costumes for *Le Train bleu,* so too did high and low culture meet in the work's choreography. Bronislava Nijinska, who had replaced Massine as Diaghilev's primary choreographer in 1922, viewed the ballet as an opportunity to explore the compatibility of contemporary entertainment and serious dance.[175] The ballet's sportive themes provided a key point of contact between high and low, validating a rapprochement of acrobatic technique and classical vocabulary; as *Vogue* noted, Nijinska's choreography gave "the impression of health-giving exercises."[176] Relying on burlesque physical comedy more typical of the popular revues than the ballet, the dancers proceeded through a series of humorous skits; in the early

scenes, for example, the main characters lock each other in the beach cabanas, and the choreography for Beau Gosse includes a frenzy of hand-stands, summersaults, and a legendary "fish dive," in which he executes a double pirouette followed by a cartwheel and a hands-first dive into the arms of the Golfer. Social dancing of the period, which was rife at Riviera resorts and thus topically appropriate, was also incorporated into the ballet, and contemporary cinema played a role, as Nijinska included a segment of slowed dance to approximate the slow motion of movies at the point in the scenario where an airplane—still a rarity in 1924—flies overhead.[177]

Milhaud matched this choreographic mélange with music that mirrored its popularizing sensibilities. Charged by Diaghilev with creating a "danced operetta," in under two weeks he devised a score that was, in his words, "gay, frivolous, and frothy in the manner of Offenbach."[178] At work in Feb-ruary 1924, he noted in his diary that the ballet was "quite a folly. . . . It is Paris, vulgar, dirty, and sentimental, with many polkas, gallops, [and] waltzes . . . not one syncopation. . . . I would like a music of laziness, non-chalant, very 'Monsieur who whistles softly under his breath while strolling with his hands in his pockets and winking his eye.'"[179] In fact, the score is slight and full of jaunty tunes fully in keeping with the scenario. Some of the numbers were even dictated by Cocteau—including the "dance around the cabanas in scene 5, the sports duet based on musical couplets in scene 6, and the *valse dansée* in scene 7. This last number had a direct source in the popular sphere, where the exaggerated adagio was a staple of professional dancers.[180] Milhaud's most ambitious effort to create a con-nection between popular music idioms and "high art" forms occurs in the ballet's final ensemble number, a "choir of chicks and gigolos," in which a simple music-hall-style tune becomes the subject for a four-voice fugue.

In its review of *Le Train bleu, Vogue* waxed enthusiastic about the music: "The conventions [of Milhaud's score] are those of musical comedy, open-ing chorus, inevitable waltz . . . but it is all sophisticated into beauty. It is a holiday translated into an operetta, then retranslated into ballet."[181] In the same vein, audiences responded to the "subtle, simple, ironic, and smiling" musical portrayal of the Riviera holiday, while the critic for *Musical Amer-ica* found it charming "in its insouciance and light sophistication."[182] Some in the musical establishment, however, were less friendly. Typifying this view was Charles Tenroc, who, reviewing the work in *Le Courrier Musical,* objected to Milhaud's experiment in the "genre Folies Bergère," noting that it proved only the composer's facility with "monotonous vulgarity." "Di-verting" and "harmless," according to Tenroc, the work garnered the ap-

proval of the "well-fed" audience but left him unsatisfied and concerned about the future of French music:

> I'm afraid that our young talents waste their best years. They produce with a disconcerting fertility, but tiny eggs, without consistency. Their music has the quality of music produced on command. . . . Pressed to deliver their merchandise on time, they compose more like machines in order to go faster. And, because on the other hand it is essential at any cost to do something new to satisfy the intermediary and maintain the musical stock exchange, they will do anything.[183]

Tenroc and like-minded critics notwithstanding, the idea that street style could be the basis for new and serious art, whether in the realm of music or haute couture, was unstoppable in the 1920s. In search of the social information necessary to sustain creativity, the artistic gaze had shifted from the salon to the street, bringing everyday culture into contact with elitist tradition. Chanel was in the vanguard of this change, and the slangy chic that became her trademark set an example for artists across a range of fields. The result was an alternative strand of modernism, in which a popularizing style and a sensibility of refined youthfulness overruled abstraction and intellectualized decadence. Seen in this context, new music of the period—including Stravinsky's neoclassicism and Milhaud's lifestyle modernism—comes into focus, and its characterization as an "art of the everyday" is exposed as an unfinished view. Like Chanel's cashmere cardigans, this was an art that went down to "the streets," but the materials found there were filtered through an elite sensibility and reconstructed for a socially privileged audience. As we shall see in the following chapter, the linkage of composition and haute couture narrowed further still as the negotiation of the boundaries between private and public art continued throughout the decade—with fashion as a centerpiece.

# 7

# VOGUE

Our books, our clothes, our life, as well as our music, grow
each year more syncopated.
*VOGUE*, 1925

In May 1924, fashion was the focus at the Théâtre de la Cigale, a slum-mingly chic Montmartre music hall. Count Etienne de Beaumont had commandeered the venue for a series he billed as the "Soirée de Paris," and he promised "choreographic and dramatic shows" with new works by some of the most sought-after artists of the day, including Satie, Milhaud, Picasso, Braque, Derain, and Cocteau.[1] In lieu of an offering by one of those well-known modernists, however, the series opened with a surprise: a brief ballet entitled *Trois pages dansées,* for which Beaumont himself had de-vised the choreography and much of the scenario. Not only did this work have high style credibility—costumes were by couturiere Jeanne Lanvin and scenery was by *Gazette du Bon Ton* illustrator Valentine Hugo—but Beaumont's story line came straight from the fashion world: the ballet brought covers of *Vogue* magazine to life, "as if the journal had fallen from the hands of a dreaming reader and fashion figures were freed from their paper bondage" to dance "a tarantella or a passepied."[2] In a stroke, Beau-mont's "Soirées" signaled fashion's full-fledged arrival in the domain of artistic modernism, and from the beginning *Vogue*'s place at the center of the enterprise was established. As the opening number on the first evening of the series, *Trois pages dansées* not only celebrated the magazine's status as the world's most important revue of dress and design, it also announced *Vogue* as a force of Franco-American culture. Naturally enough, *Vogue* covered the production on its pages, acclaiming Beaumont as the "Maece-nas of Paris" and including an illustration depicting the ballet's opening

scene. In an unusual if not unprecedented manner, the magazine thus promoted and critiqued the very work it had inspired.

Such challenges to convention were nothing new for *Vogue*. French in name but American by birth, the magazine was founded in New York City in 1892 as a "dignified authentic journal of society, fashion, and the ceremonial side of life," but was transformed into the glamorous style journal we know today when Condé Nast took the helm as publisher in 1909.[3] Nast's Francophilia found a natural outlet in *Vogue*, where the main fare was Parisian couture and its French and American devotees, and under his direction the magazine used fashion to foster a new ideal of transatlantic style. The formula was simple: American readers relied on *Vogue* for information about the latest trends in the French capital, and more importantly depended on the magazine for advice on how best to adapt Parisian looks and ideas to suit distinctly American tastes. By 1920, French women clamored for an edition in their own language, and on 15 June that year the first issue of French *Vogue* appeared on newsstands, exclaiming in its opening editorial "On parle français!"[4] Billing itself as both a "mirror of everything that was the best and most secure in Parisian taste" and a guide to "the best of American style," the new magazine promised to be "the most perfect, the most modern, the most elegant fashion journal that the French reader will have the joy of leafing through, of reading, of contemplating."[5]

With the introduction of its French version, *Vogue* became the first periodical to have not just export copies but distinct and separate editions, containing different material, printed in different languages, and produced in local plants.[6] A dual presence in Paris and New York inclined the magazine to promote an idealized vision of transatlantic elegance, at the epicenter of which was situated haute couture and its high-society clientele. Fashion, however, was only one facet of *Vogue*'s Franco-American cultural program; contemporary art and music were its other cornerstones. Among composers, Satie and Les Six emerged as exemplary of *Vogue*'s ideal, and Stravinsky—who, as we have seen, attracted the magazine's notice as early as 1916—continued to feature on its pages through the following decade. All appear frequently in *Vogue*, mentioned in music reviews as well as in coverage of the parties, costume balls, and other pleasures cultivated by Parisian elites in the 1920s, where they were more often than not invited guests rather than performers. In *Vogue*'s view, they occupied a central place in the reconfigured social order following World War I, and the magazine treated them accordingly. By showcasing them as animators of fashionable society, *Vogue* played a critical role in redefining the relationship between artists and their upper-class supporters, and helped to rearticulate

*(Below) To the music of that celebrated Viennese composer of the Second Empire, Strauss, the ballet, "Le Beau Danube," danced its pretty way before a Constantin Guys reproduction*

*The spectacle in which Vogue participated began with the coming to life of the two girls on the magazine cover. They quarreled over a four-leaf clover and danced delightfully*

## THE MAECENAS OF PARIS ENTERTAINS

IT is fortunate for the world that patrons of art still exist. Commercial enterprises may weed from artistic writings ridiculous visions and immature attempts, but their intervention, useful though it be, can only go half way. At the side of the writer must be his friends—and between them must be a sympathetic and understanding friendship.

What understanding there is, then, in the use of funds that have launched the "Soirée de Paris" of Comte Etienne de Beaumont! This gentleman is indeed a Maecenas; he watches over young hopefuls in artistic fields. It was such a

*Editor's Note—In one of the series of entertainments that make the Paris season gay, Vogue was invited by Comte Etienne de Beaumont to collaborate with him in a very chic spectacle— and the result was three pages which came to life and danced*

man who sponsored Chateaubriand a hundred years ago, making it possible for him to give of his best.

Helpful though the actions of M. de Beaumont are to artists, they must be considered from another point of view as well—the social. If M. de Beaumont has called his theatrical enterprise "Soirée de Paris," it is because he wished to stress its social aspect. Just as the ball of M. de Beaumont was eminently Parisian, exquisite, full of originality and artistry, so the "Soirée de Paris" is a performance to be appreciated by connoisseurs of art and society.

© Walery

FIGURE 82. "The Maecenas of Paris Entertains," from *Vogue* (New York), 1924

the boundary between public art and private entertainment. From its vantage point at the height of haute couture, the magazine proposed that new music was not a mirror of high style but a stimulus to it; *Vogue*'s chosen composers were thus both avatars of modernism and unlikely arbiters of fashionability.

One of *Vogue*'s top competitors in France was the *Gazette du Bon Ton,* which as we have seen returned to newsstands in January 1920 after its wartime hiatus. Still distinguished by its signature *pochoir* plates, the *Gazette* in its new guise had a more intellectual tone and an intensified interest in modernist art; the March 1920 issue, for example, featured a glowing commentary on the work of Jean Metzinger, whose paintings and theoretical studies helped to define Cubism before the war, and it included Jean Cocteau's debut piece for the magazine—an essay on his recently deceased collaborator, the artist Guy-Pierre Fauconnet.[7] This change of focus was due in no small measure to the influence of a powerful new investor who held a controlling interest in the magazine, namely, Condé Nast.[8] Beyond making adjustments to the journal's content, Nast's stake in the *Gazette du Bon Ton* prompted him to test the market for the magazine in the United States, where (as noted in chapter 5) he simply republished it, in French but with American advertisements, under the title *Gazette du Bon Genre.*[9] The magazine was a flop, falling out of circulation by the end of 1922, and by 1925 the *Gazette du Bon Ton* itself had ceased publication, doomed in part by Nast's decision to shift talent from the *Gazette* to French *Vogue.* In short order, he had convinced Lucien Vogel and his wife, Cosette, to join the editorial staff in the new magazine's Paris office, engaged the writers Francis de Miomandre and Paul Géraldy as regular contributors, and secured the services of the *Gazette*'s "Beau Brummel" artists— Georges Lepape, Eduardo Benito, André Marty, Paul Iribe, Pierre Brissaud, and Charles Martin—to create covers and illustrations for *Vogue.* Although these artworks were only rarely presented as elaborate *pochoirs,* they conveyed the stylistic sensibilities of the *Gazette*'s plates and added a clearly French stamp to the magazine, while allowing *Vogue* to be sold at a far more accessible price.[10]

Lower cost, however, was only one key to *Vogue*'s success. In contrast to the *Gazette du Bon Ton,* which retained an overwhelmingly French orientation, *Vogue* promoted a brand of high style that leavened French fashion with a dose of "American ways and American wants"—a mix that appealed to women in both countries, especially in light of "the dearest bond" that had linked them during the war. The premise of a shared, fashion-based transatlantic culture was evident on almost every page of each issue, for although the magazine's two editions were independent productions they contained many of the same editorials, articles, illustrations, and photographs. For French readers, *Vogue* promised that it would offer an "adaptation, not a translation" of its American edition, allowing French women to

"take to heart" information about American art and dress, while never neglecting "French ideals."[11] Readers in the United States, on the other hand, benefited from both the sharpened focus on Parisian couture made possible by the installation of a full staff at French *Vogue*, and from the magazine's exclusive, state-of-the-art photo studio, where nearly all the fashion shoots for American *Vogue* took place.[12] Even when they diverged, the Paris and New York editions emphasized the ways in which their geographically separated readers were alike: photographs of New Yorkers at the horse races in Saratoga were paired with images of Parisians at the Longchamp racetrack; pictures of socialites relaxing at the French resorts of Deauville and Dinard ran alongside photos of Americans lounging on the beaches of Newport and Southampton. Sunny Monte Carlo found its twin in Palm Beach, St. Mortiz had its equivalent in Lake Placid, and, of course, Paris met its match in New York City.

In short, French and American interests and values mingled in *Vogue's* two editions, combining to create a new paradigm for sophisticated style that went beyond matters of dress. By July 1921, the magazine was advertising its desire to be a "mirror of the highest society . . . a brilliant critic of artistic, musical, theatrical, and literary events . . . the arbiter of sophisticated behavior and the supreme authority in the matter of bon ton."[13] Thus positioning itself as a cultural entity, *Vogue* opened another perspective from which the shared good taste of French and American women could be assessed: just as a female New Yorker needed to know about the latest plays, performances, and personalities in Paris, the magazine asserted, so too did her French counterpart require information about the amusements and affairs of the most stylish Americans. By reporting on fashion, the arts, and high society on both sides of the Atlantic, *Vogue* made it not just possible, but in fact de rigueur, for women to be up-to-date with developments in both countries, and posited the existence of a single, international, and fashion-oriented society, for which it served as both reporter and creator.

The magazine's stated ambition—to be the "Baedecker of the woman's world"—stimulated a variety of pathbreaking initiatives that went far beyond the printed page. Among the most natural of these outgrowths was *Vogue's* sponsorship of a series of benefit fashion shows in the United States, including the glamorous "Fête de la Mode d'Eté," held at New York's Commodore Hotel in June 1920, where American socialites modeled the latest Paris looks to raise money for the "American Committee for Devastated France."[14] The magazine also established a variety of services, engaging consultants who would respond to direct inquiries from readers, offering advice on etiquette, entertaining, shopping, schools, and travel. But most radically,

*Vogue* opened an "Information Bureau" in Paris to accommodate its readers; nestled in the "rich and elegant" neighborhood between the Opéra and the Church of the Madeleine, this office was advertised as a comfortable place to "write, telephone, rest between shopping adventures, and chat with friends." [15] With a staff that stood ready to act as a "devoted and well-informed Parisian companion," *Vogue*'s bureau promised insider access to the city's best jewelry shops and couture salons, as well as guidance on everything from acquiring a fashionable dog to furnishing a summer residence. As for entertainment, these experts were armed with information on "what is worthwhile at the theaters; what is the art show of the day; when the next important auction will be on," and ready with details about the "gilded restaurants where American jazz is popular."[16] In sum, the Paris office created a way for readers to put the magazine's advice directly into practice, easing the transition from reading about fashion and style to actually living a fashionable lifestyle. Like the great Parisian department stores it promoted, *Vogue* proposed and sustained a female-oriented culture that emanated from the idea and ideals of dress but stretched out into multiple domains.

*Vogue* magazine was thus the centerpiece of a multifaceted enterprise, which as a whole proved to be a surprisingly positive force in France. Even in 1920, as the first Paris edition of the publication went to press, the city struggled to recover from events of 1918 that capped the long war—including air raids and artillery attacks that claimed nearly six hundred civilian lives, food rationing, heat and hot water shortages, and a deadly influenza epidemic. In addition, the economic crisis that began during the war intensified after the Armistice, as German war reparations never materialized and the franc declined a remarkable 80 percent against the gold standard before its de facto stabilization in 1926.[17] In the midst of these crises, *Vogue* was a booster for France, a champion of both Parisian haute couture and the country's nascent tourism industry. The magazine landed on an especially effective formula for linking these two pleasures, organizing its issues around themes that corresponded to the seasonal peregrinations of the international elite to various resorts in France and nearby countries.[18] Focusing in turn on fashions for winter vacations on the Riviera or at Biarritz, sports holidays at Saint-Moritz, and swimwear for summers at Deauville, *Vogue* made resort life and haute couture inseparable, redefining the very idea of an elegant lifestyle and making it clear that a woman who wished to be au courant needed to frequent the right spots, carrying in tow a wardrobe tailor-made for her destination. Benefiting more than the financial markets, *Vogue*'s pro-French agenda hit a psychological nerve, reinforcing the notion

that no matter how difficult the conditions, luxury and refinement would remain the national hallmarks. Perhaps most importantly, with its transatlantic presence, *Vogue* deepened the allure of France for Americans at a time when the dollar soared against the franc, drawing U.S. resources to the French luxury industries at a critical juncture.

## FASHION, THE ARTS, AND THE CULTURE OF CUBISM

Much as *Vogue* posited that its readers in France and America shared an affinity for the finest in fashion and travel, the magazine promoted the notion that they shared a taste for the best of the arts. In its articles and illustrations as well as its services and offices, *Vogue* strengthened its role as a tastemaker by providing information about—as well as access to—the latest cultural offerings. Painting, sculpture, and interior design became important points of contact as the magazine covered the visual arts in both its French and American editions, reporting on current exhibitions and trends in brief informational columns as well as in more substantial articles. This was one area where *Vogue*'s two editions often differed, each focusing on local events in order to guide readers to select museums and galleries in their respective cities. Yet, in keeping with the magazine's cultural agenda, even these features emphasized transatlantic ties: typical were French *Vogue*'s piece about "American Painters of Women" exhibiting in Paris, and American *Vogue*'s review of the New York shows of Parisian painters Marie Laurencin and Irène Lagut, which ran under the title "Ultra-Modern French Art in New York."[19]

One artistic style, however, quickly emerged as a model of the Franco-American mix *Vogue* sought to promote, and it had the benefit of linking easily to the world of dress: in the magazine's hierarchy of modernist art Cubism was the pinnacle of fashion, a style that transferred easily from the canvas to the couture salon. The magazine made the connection as early as 1913 in an article entitled "Dress Plagiarisms from the Art World," taking note of "one of the newest movements among artists . . . in [whose] wake follow the artists of dress." Cubist approaches were absorbed in fashion, according to the magazine, in a variety of ways: in fabric, such as Poiret's silk sprinkled with "square-cut confetti"; in new colors, such as "a new wonderful shade of warm yellow, called mandarin"; and in new clothing shapes, including everything from a "simple form of draping" to a "broken silhouette."[20] As fashion historian Richard Martin has observed, it was in this last domain of form that Cubism was perceived to have had the clearest influence on dress, exemplified in the shift away from the volume and amplitude

of Belle Epoque gowns toward more flattened structures, and in the new composition of clothing through a process of layering light fabric—which was likened by some critics to collage and *papier collé* techniques. As we have seen, Cubism's implication of vernacular references likewise found an application in haute couture—notably in Chanel's sportswear of the war years—while its notions of indeterminate and non-representational shape were echoed in her most famous garment, the "little black dress."[21]

Indeed, *Vogue*'s identification of Cubist painting with cutting-edge couture intensified in the early 1920s, when Cubism itself was on the wane but Chanel's designs were ascendant. The magazine reflected on haute couture's continuing attraction to this brand of modernism in an article published in its French edition of January 1921; "after the complete failure of Cubism in art," the author proposed, it was "amusing to study its decorative possibilities in women's fashion." The Cubist impulse in dress, according to the article, was driven by a general need "to return to lines, after years of impressionism and imprecision." The author spiked this discussion with an idea to which *Vogue*'s readers surely warmed, positing that Cubism was a transatlantic style, a blend of (French) classicism's linearity and the American "taste for the mechanical and vast iron horizons": New York City skyscrapers, the Brooklyn Bridge, and Greek sculpture all contributed to this expression of everyday "exuberance and excess."[22] "Essentially modern" as it was, Cubism thus fit neatly into the vision of Franco-American culture that *Vogue* was invested in promoting, and it remained a prominent topic in the magazine's coverage of culture through the 1920s, the subject of numerous illustrated articles devoted to the "great chic to be found in modernistic art," and the style most often showcased on its covers.[23]

## MUSIC IN *VOGUE*

If Cubism was *Vogue*'s Franco-American artistic style par excellence, jazz was its quintessential transatlantic music. Exemplary of the magazine's view was an article entitled "America Sends the Spices of Life to Europe," which situated jazz as only the latest in a long series of U.S. exports that included everything from tobacco and military aid to movies and cocktails. The homeland of Debussy, Fauré, and other composers of "the most refined music," the author noted, had extended a warm welcome to "those who blow saxophones, trombones, or jazz-flutes with an undeniable but deafening verve."[24]

*Vogue* celebrated this new sound with particular enthusiasm, since arrival of jazz at last gave Nast's flagship fashion magazine a style-oriented

focal point for its coverage of music. Right into the 1920s, the magazine's commentaries on music were anything but glamorous, typically relegated to the magazine's back matter and limited to an occasional informational column entitled "Music Notes," in which anonymous authors provided news and reviews of concerts and recitals in New York and its environs.[25] More substantive articles on musical topics did appear from time to time—showcasing stars from the Metropolitan Opera, covering major concert events, and even reporting on so seemingly specialized a topic as music education at Harvard and other major American universities—and as we have seen, the Ballets Russes and Igor Stravinsky garnered coverage, particularly during the time of the Russian troupe's U.S. tour in 1916. With the launch of its French edition in 1920, however, *Vogue*'s coverage of music began to acquire a sharper focus as, in keeping with its new cultural agenda, the magazine began to highlight links between French and American musical traditions and institutions. Key to this initiative was French *Vogue*'s intermittent column on the Paris music scene, which often appeared under the somewhat misleading title "L'Opéra et L'opérette." The feature covered select performances and personalities, but also delved into substantive issues that allowed the Franco-American agenda to be advanced. Prime among news items in the 1 May 1921 issue, for example, was a detailed report on the founding of a music conservatory for American students in the great château at Fontainebleau, the historical summer residence and hunting lodge of French kings, located about 60 kilometers southeast of Paris. *Vogue* noted with pride that while American musicians had traditionally traveled to Germany to pursue their studies, France would be their new destination: the New York–based "Société des Amis Américains des Musiciens de France" would send a select group to live at the château, where they would work one-on-one with French "composers, singers, virtuosos, acoustic specialists, [and] conductors," all of whom would visit Fontainebleau to expose their "personal technique, their ideas, the ways in which they practice their art, how they translate their ideas . . . all that the soul of a musician contains." Support for the Conservatory, the article observed, was widespread, and included a subvention of a hundred thousand francs from the French government as well as funding from the high-society philanthropists who were regular contributors to the Ecole des Hautes Etudes Musicales, under whose aegis the Franco-American School was founded.[26]

In the same column, *Vogue* reported on the Paris musical season—a topic of some interest, since only in May 1921 did the city's major venues return to a full run of performances following the war. The magazine noted that

Wagner was a significant presence, with *Siegfried* at the Opéra and *Tristan und Isolde* at the Théâtre des Champs-Elysées: in *Vogue*'s view, it was a surprise to see so many of the city's elites elegantly dressed and absorbing such "essentially German" music with the battles still such a recent memory. On the other hand, the author reported, there was modern French music to be heard in Paris, and in particular, music in a style that had been introduced the previous year with *Le Boeuf sur le toit*. *Vogue*'s critic—identified in a manner customary at the magazine only by the initials "J.R.F."—described this "farce" as the missing piece between the *commedia dell'arte* and modern cinema, and reported that it had sparked a series of similar efforts by Cocteau and his circle, including Georges Auric and Arthur Honegger, who were judged to be "very different talents" engaged in creating "a kind of naïve music, an imitative harmony which has pleased many enemies of the modern movement." The appeal of their compositions, *Vogue*'s critic suggested, stemmed from their "pure technique (followed and understood by few people)" and from their ability to create music that was innovative and expressive of contemporary life while offering "exactly what so many of us have searched for in music: a direct connection with their state of mind, joy or distress, realized with as much force as Wagner!" In the opinion of "J.R.F.," Wagner's operas might be playing across Paris but their day had passed: true expressive power was now to be found in the music-hall-inspired, jazz-inflected music of Satie and Les Six.[27]

Thus did *Vogue* begin to align itself explicitly with Cocteau, echoing almost exactly the sentiments expressed in *Le Coq et l'arlequin*, and signaling an embrace of the popularizing aesthetic the book advocated. Nast's *Vanity Fair*, as we have seen, had taken the lead in promoting *Le Coq*'s brand of modernism to American readers, publishing an article by Cocteau that previewed its contents as early as September 1917, featuring Satie and his circle in a series of articles that ran through the early 1920s, and even printing an English translation of selected portions of *Le Coq* in the fall of 1922.[28] While *Vanity Fair* made these composers the center of its culture-oriented sphere, *Vogue* established them as part of the fashionable Parisian elite, and accordingly, in its coverage often linked them directly to the haute monde and its pleasures. Satie, in fact, surfaced unexpectedly in the very first issue of French *Vogue*, earning a mention in a column devoted to wardrobes, summer theater productions, and interior decoration; he was, after all, the inventor of "furniture music":

Furniture music? It is music that must be played between the acts of a theatrical or musical spectacle, and which contributes, like the sets, the curtains, or the furniture of the hall in creating an atmosphere. The

musical motifs are repeated without stop and it is useless, says Erik Satie, to listen to them: one lives in their ambiance without paying them any attention. It's up to you to find a way to hear this *musique d'ameublement* and to devise an opinion on the topic. But that has nothing to do with the furniture we're so taken with this season. It's just an opportunity to make and hear music, the passion of the moment. . . . After the dance, which has diminished in intensity, let us throw ourselves with abandon into musical concerts; at the least because they are social reunions.[29]

## *VOGUE'S* MODERNIST INSIDER, JEANNE ROBERT FOSTER

This is unconventional criticism, and it comes from an unexpected critic: the mysterious "J.R.F." is in fact the American Jeanne Robert Foster (1879–1970), best known today as the author of earthy poetry inspired by the Adirondack region where she was born. Foster, however, had a much wider range as a writer, as well as an eclectic background that brought fashion and the fine arts consistently into contact—all of which helped land her on the pages of *Vogue* in the early 1920s. Up until now, her role at the magazine has gone unnoticed (even by her biographers), but as the magazine's most imaginative and unwavering champion of modernist art she merits a closer look.[30] Her commentaries and articles set the tone that became definitive of *Vogue's* cultural coverage, in which new art was situated firmly within the sphere of fashionability, and her allegiance was clearly with the brand of modernism associated with Satie, Les Six, and Cocteau. Well ensconced in the milieu of these and other contemporary artists, she enjoyed advantages not available to more ordinary critics, and she conveyed this insider access in her reports.

By all accounts an astonishing beauty, Foster made her first fashion connections just after the turn of the century, when she was one of the most sought-after models in New York City, famous as the "Harrison Fisher Girl"—the counterpart and competitor to Charles Dana Gibson's "Gibson Girl." While posing for a variety of artists and photographers, and seeing herself featured on the cover of the *Ladies Home Journal* and a number of other magazines, she worked as an assistant to the fashion editor at the Hearst Newspaper Corporation; in this position she had the first look at the latest Paris fashions each week as they arrived by steamship in New York. When a family illness forced her to leave New York for Boston in 1905, she took courses at Harvard, studying literature with Charles Townsend Copeland and philosophy with William James, and embarked on a career in journalism, writing feature articles and reviews for the *Boston-American*

and other East Coast papers.[31] Her article on the dancer Ruth St. Denis, published in the *Boston-American* in 1909, reveals an already ardent devotion to modernist art; dismissing another critic's negative review as "the result of his own ignorance," Foster defended St. Denis's avant-garde style, asserting that it was appropriate, since "as a nation changes so must its dance."[32]

Later that year Foster joined the staff of the *American Monthly Review of Reviews*, the progressive and issues-driven periodical edited by Albert Shaw.[33] The thirty-year-old Foster quickly became the de facto literary editor and art critic for the *Review*, and found herself at the center of controversy in 1913 when she reviewed the New York Armory Show for the magazine. As other critics recoiled and responded negatively to the wide array of contemporary European and American art on display, she expanded on the themes of change and national identity in art, pushing her readers to "appreciate and encourage the art that is of the present":

> By our loyalty to living art we measure the ration of our artistic
> progress as a nation. We must continue to look upon the "young
> vision" in matters of art with indulgence. . . . Every generation has a
> rhythm of its own and the succeeding generations will break up this
> rhythm and form another as surely as age follows age.[34]

Foster's commentaries on the Armory Show helped to establish her reputation as a critic, and more importantly the show provided her with a glimpse of the man who would assure her entrée into the modernist circles from whence much of the art on exhibit emanated: namely, John Quinn, a prominent New York lawyer and one of the world's foremost collectors of contemporary art, who had financed and facilitated the exhibition. A champion and friend of Constantin Brancusi, Henri Matisse, Pablo Picasso, and many other contemporary artists, Quinn was also on close terms with writers Ezra Pound, T. S. Eliot, and James Joyce.[35] He met Foster for the first time in 1918, when their mutual friend John Butler Yeats (the father of poet William Butler Yeats) fell seriously ill, and thus began a love affair that lasted until Quinn's death in 1924.

Foster traveled to Europe on Quinn's behalf in 1920 and 1921 looking for art to add to his collection; she and Quinn managed a rendezvous in Paris in the summer of 1921, and together they visited the city's dealers in the spring of 1923. In the course of these extended trips, Foster met nearly all the artists Quinn cultivated, and developed a special friendship with the writer and connoisseur Henri-Pierre Roché, who acted as Quinn's representative in Paris. Best known today for his novel *Jules et Jim* and the François Truffaut film it inspired, Roché was an intimate of many avant-

garde artists, to whom he introduced Foster; the many souvenirs of her friendships include a photograph taken by Picasso, which shows her lunching with Roché and Olga Picasso, as well as two portraits of her done by André Derain. Even in these rarefied circumstances, fashion was never far from her mind; typical is her diary entry for 3 August 1921, which notes simply: "Bought another Picasso, dress, sweater."[36]

Among Roché's closest friends was Erik Satie. They met in 1914, when both were involved in Jean Cocteau's planned production of an all-French version of *A Midsummer Night's Dream* at the Médrano Circus, and remained devoted to one another until Satie's death eleven years later.[37] Roché, who lived in New York from late 1916 through the end of 1918, was the prime instigator of efforts to organize an American tour for Satie, which never came to fruition but nonetheless provided a boost for the composer. In addition, on his return to Paris in 1919 Roché brought Satie into artistic circles he might otherwise not have explored, introducing him in particular to Constantin Brancusi. The friendship that ensued between sculptor and composer provided inspiration for both artists as well as worldly sustenance for Satie, who often ate extravagantly at the Romanian sculptor's table.[38]

It is hardly surprising, then, to find Roché bringing Satie into contact with Quinn and Foster during their Paris visits. The composer's correspondence with Roché attests to a planned but cancelled meeting with the couple as early as 29 July 1921, and photos show Satie, Brancusi, and Roché on the golf course (probably at St. Cloud) with the American duo during the summer of 1923.[39] Between those dates, Foster had published a glowing appraisal of Brancusi in *Vanity Fair*, introducing readers to "the man and the formal perfection of his carvings," and presenting him as a personality—"singularly handsome, a man of great personal distinction" as well as a great innovator. Illustrated with a photo of the artist and close-ups of some of his key sculptures, including "The Kiss," the piece situates him amid fellow modernists, with the assertion that "among strong men like Picasso and Derain and Matisse in painting and Erik Satie in music, Brancusi stands preeminent."[40]

Typical of *Vanity Fair*'s arts coverage, this was a fairly straightforward review, but in *Vogue* a different approach was in order. With a background in fashion and access to modernist artists, Foster was poised to provide just what Nast needed in this magazine, and from June 1920 through August 1923—coincident with her trips to France—her articles on the latest trends in Parisian art, culture, and social life ran in both of *Vogue*'s editions, always attributed only to "J.R.F." Foster contributed the already discussed

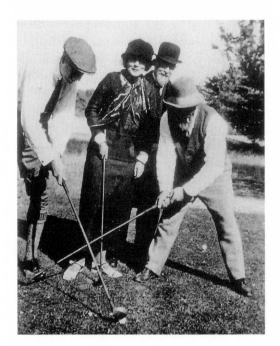

FIGURE 83. John Quinn, photograph of Jeanne Robert Foster on the golf course at St. Cloud with Henri-Pierre Roché, Erik Satie, and Constantin Brancusi, 1923

articles on Cubism's influence on fashion and on the French taste for American jazz, offering readers an insider's glimpse of the overlapping worlds of art and fashion. That her first piece, in French *Vogue*'s inaugural issue, included a witty reference to Satie and his "furniture music" is testament not only to the esteem with which the composer was held in stylish circles, but also to his friendship with Foster at the time, and her discernment as a tastemaker. A key player in Nast's effort to promote transatlantic modernism, "J.R.F." emerges as an important advocate for this agenda as well as an effective and idiosyncratic spokesperson for the cause of art and music as expressions of fashion.

## PRIVATE MUSIC / PUBLIC ART

Satie's "Furniture Music" had its premiere in early 1920 at one of the most fashionable places in town—Poiret's Galerie Barbazanges. Two other events that year, both organized by Cocteau and financed by Beaumont, secured his place. The first, the now legendary "Spectacle-Concert" presented that February at the Comédie des Champs-Elysées, featured the premiere of *Le Boeuf sur le toit*, as well as public premieres of Satie's *Trois petites pièces*

*montées*, Georges Auric's "foxtrot" *Adieu, New York!* and Poulenc's setting of three Cocteau poems, collected under the title *Cocardes*. The second, a "Festival Erik Satie," took place at the Salle Erard in June and was an all-Satie program that began with a lecture by Cocteau and featured a number of premieres, including the first performance of the *Premier menuet* and *Nocturnes*—both played by Ricardo Viñes—as well as the *Chapitres tournés en tous sens* and a version of *Parade* for piano duet played by Satie and Germaine Tailleferre. Also on the bill was the "symphonic drama" *Socrate*, commissioned by the Princesse de Polignac in 1916 and performed for the first time in Satie's expanded version for voice and small orchestra on this occasion. The Princesse attended along with many other socialites who supported the event as "dames protectorices"; as the critic Pierre Leroi reported for the *Courrier Musical*, there was "considerable affluence," with a "long line of deluxe cars" parked outside the theater.[41]

In July, Satie gained even more credibility in stylish circles when he collaborated with the dancer Elise Jouhandeau (née Toulemon), better known as Caryathis, on a "fantasie serieuse" entitled *La Belle excentrique*. A highly touted adept of Jacques Dalcroze and his eurythmic school, "Carya" was also a presence in Parisian social and cultural circles, counting Chanel among her close friends and actor-producer Charles Dullin (whose Montmartre theater, as we have seen, produced Cocteau's *Antigone*) among her lovers. For her first major post-war performance, Satie composed what he described as a "très Parisien" tour through three decades of dance entertainment in the city. Scored for a small music-hall-style orchestra, the suite included three dance movements—the "Franco-Lunar March," subtitled "1900: Marche pour une grande cocotte"; the "Waltz of the Mysterious Kiss in the Eye," or "1910: Elégance du cirque"; and a "High Society Can Can," described as "1920: Cancan moderne"—all linked by a "Grand Ritournelle," which was a recycled version of his 1905 cabaret song "Legende californienne."

The costume Caryathis would wear to convey this history of dance was a matter of some concern, and Satie was involved in its selection; the "Belle Excentrique," he insisted in a letter to the dancer, must above all look like "a parisienne of Paris."[42] As Jouhandeau later recalled, the composer had precise ideas about just how "eccentric" her outfit should be, and he accompanied her on a round of visits to the city's top couturiers and artists. At Poiret's, she remembered, Satie dismissed the designs with the comment, "Ah no! No odalisques!"; at Marie Laurencin's, where the artist had designed a very stylish costume with a horse's mane, he insisted, "No! I'd rather see you as a zebra!"[43] Also rejected were designs by Jean Hugo, Kees Van Dongen, and Poiret's sister Nicole Groult. In the end, Caryathis wore

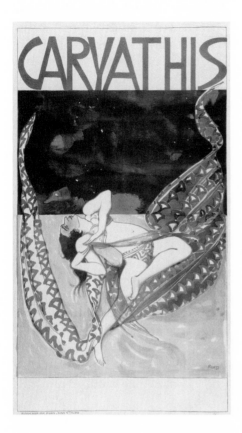

FIGURE 84. Léon Bakst, poster of Caryathis as "La Belle Excentrique," 1920

a provocative outfit designed by Cocteau, which combined "a black velvet top with long sleeves" that exposed her midsection with a long, full skirt made of "a multitude of tulle pleats in all the colors of the world" that opened to reveal jeweled underwear in the shape of a heart; a long feather rose from the train of the skirt and extended above her head, and she wore a mask designed by Groult, with flattened and exaggerated feminine features.[44] The inspiration for the costume, Jean Hugo recalled, was the stage dress of the internationally renowned music-hall performer Gaby Deslys, famous for her risqué performances before the war.[45] The design created for Caryathis, however, went far beyond the glitzy showgirl style Deslys made popular, and much like Satie's score used the material of everyday entertainment as the basis for expressive modernist art. Even Léon Bakst was captivated by her look, creating an advertising poster that depicted her attired as "La Belle Excentrique," seminude and surrounded by flowing green fabric.

*La Belle excentrique* was composed expressly for Caryathis's public per-formance at the Théâtre du Colisée, a venue best known at the time for its projection of Charlie Chaplin films. The work was introduced as part of an eclectic one-woman program that included Auric's *Paris-Sport* (for which the costume was designed by Natalia Goncharova), Poulenc's *Le Jongleur,* and Ravel's *Rapsodie espagnole;* according to one observer, Caryathis came across as "a species of bizarre genius" who "acted, mimed, and danced with science and observation."[46] The show was a success, and following its pre-miere *La Belle excentrique* moved to a different kind of venue, where the boundaries between public and private art were less precisely articulated—namely, Paul Poiret's garden, where in 1919 he established a club known as the Oasis. Described by *Vogue* as "the most amusing, the most beautiful place in Paris," this spot alternated between operating as a commercial establishment open to all—"the demi-monde, the men of letters, the old youth, journalism and the boulevard"—and shutting down for private events, including elaborate theme parties much in the vein of his earlier "1002nd Night" *fête.* The public evenings mimicked the private soirées, each organized around a theme; one of the most notable of these affairs was the party inspired by Emile Zola's 1873 novel *The Gut of Paris*—a story of life in the city's central marketplace, Les Halles—for which patrons were invited to come dressed as meats and vegetables.[47]

Poiret's Oasis flourished as one of the city's top "bar-dancings"—the term invented by the French to convey the American flavor of dance clubs dominated by jazz bands—but in June 1921, seeking to create a more artis-tic presence on his property, the couturier transformed the space into an outdoor theater.[48] In its inaugural season, the Oasis featured a series of plays by the popular humorists Paul Reboux and Charles Muller, including an opening-night presentation of their parody of Debussy's *Pelléas et Mélisande,* which was entitled *Idrofile et Filgrane,* and as a special attraction presented a reprise of Caryathis's performance as *La Belle excentrique,* with Satie himself conducting the music-hall-style orchestra.[49]

Such fare was good fodder for French *Vogue,* allowing the magazine to mix its reports of Poiret's private soirées and public productions with com-mentary on his latest dress designs. In the July 1921 issue, Jeanne Robert Foster took special note of the shift from "bar-dancing" to "théâtre lumineux" in the couturier's garden, crediting the "magician" Poiret with having created a "a theater like no other . . . the tour de force of a real artist."[50] Poiret had worked miracles, she reported, building the theater in

FIGURE 85. André Marty, "A L'Oasis," from *Modes et manières d'aujourd'hui,*
1919

the space of three weeks, distinguishing it with a design that included col-
orful floral armchairs, a pneumatic stage, an inflatable roof, and, in lieu of a
curtain, a trellis "like those at the Trianon" that opened and closed at its cen-
ter. The article's headline, reading "A la Manière du XVIIIme," made clever
reference to the series of parodies that had made Reboux and Muller
famous—each of which had a title beginning with the phrase "in the man-
ner of"—while alluding at the same time to Poiret's lingering penchant for
*ancien régime* excess. This attraction was evident in his couture collections
even after the war; in 1920, for example, while Chanel and other designers
showed dresses that were streamlined and simple, Poiret's designs were
characterized in *Vogue* as "an orgy" full of "abundance, fantasy, and splen-
did fabrics."[51] In addition, in his new role as theater director, Poiret invited
comparisons to the aristocratic organizers of the *fêtes* organized for Louis
XIV; this was especially easy since the main fare at the Oasis included farces
and divertissements explicitly reminiscent of those popularized in the grand
siècle. Further emphasizing the connection between present and past, Poiret
mounted an exhibition of eighteenth-century paintings in his Galerie Bar-
bazanges, and saw to it that theater patrons were steered inside during inter-
mission by a footman dressed and wigged in the style of the *ancien régime*.[52]

Dressed in Poiret's designs, the most stylish women in Paris came to his performances; one of Eduardo Benito's illustrations of the Oasis even depicted the Princesse Lucien Murat in a "superb red dress, complete with voluminous hips"—a twentieth-century take on the hip-extending pannier style worn by fashionable women during the eighteenth century.

Yet it was not the Oasis, where Poiret's historicizing taste held sway, but instead the thoroughly modern bar Le Boeuf sur le toit that came to dominate *Vogue*'s pages in the 1920s. The Boeuf inverted the traditional salon dynamic: in lieu of a system in which wealthy patrons opened their homes to invited artists and intellectuals, it proposed the cachet of an open social setting animated by artists and intellectuals, to which elite society gravitated. Located on the rue Boissy d'Anglas, in the chic neighborhood near *Vogue*'s Paris office, the restaurant/bar opened in January 1922 and quickly became one of the most exclusive nightspots in Paris.[53] A real-life incarnation of the "Nothing-Doing Bar" that had been the subject of the Cocteau/Milhaud ballet, Le Boeuf was known for its eclectic clientele, and recognized by one of the era's most compelling chroniclers as a spot where "high society mixed with painters and actors, businessmen with writers . . . one knew everyone, or got to know them."[54] The haunt of Cocteau and Les Six, it was frequented by the newly constituted *tout Paris*—with regulars such as writers Raymond Radiguet and André Gide, poets Blaise Cendrars and Max Jacob, artists André Derain, Brancusi, and Picasso, society figures Etienne de Beaumont and Misia Sert, and, of course, couturiers Chanel, Lanvin, and Poiret—and quickly become the focus of considerable media attention.

Although the history of Le Boeuf—both bar and ballet—is by now well known, the nightclub's emergence as a meeting ground for the haute monde and modernist artists merits further consideration here in light of the role that the fashion press played in fostering the mix. The ballet earned a coveted spot in the *Gazette du Bon Ton*, where it was depicted in a *pochoir* illustration by Eduardo Benito in 1920, but the bar got its fullest coverage in *Vogue*, which first took account of Le Boeuf's cosmopolitan crowd in June 1923, in the article recounting a night on the town with the fictional character Palmyre that was cited at the opening of chapter 1.[55] One of "six young Parisiennes" created to exemplify the magazine's ideals, Palmyre in this vignette mingles with Satie and his crowd, passing a significant part of the evening at Le Boeuf, "where one suffers serious physical deformities thanks to disjointed popular dances"— although an illustration, to the contrary, shows a calm scene with a few elegant dancers and a smiling Jean Cocteau seated at a corner table.[56] An article contributed by the magazine's

occasional critic Jean LaPorte, published a few months later and billed as a guide to "The Nocturnal and Elegant Life of Paris," surveyed the city's top nightspots, the places "where one lived from midnight to six in the morning." Among these establishments, LaPorte noted, it was necessary to "make a special place" for the "magic" Boeuf, "which for two years had been "one of the most seductive places in Paris around midnight," despite of the fact that "you will never find a film star there, and it's almost always impossible to dance." According to LaPorte, it was the city's "most interesting nightclub, with a clientele of young writers, musicians, and painters . . . an open circle that gathers not because of snobbism, but because of shared taste." Inspired by "the touching poet" Jean Cocteau, "with the Group of Six at his side," the club was a sure success in LaPorte's view; "under such an aegis, guided by such patronage," its "glory" would endure along with that of its creators."[57]

The fashions at Le Boeuf, LaPorte observed, reflected the club's diverse clientele; a man in an "impeccable suit" sat next to a "young painter from Montparnasse in a velvet sweater with a floppy tie," and women were elegantly attired. It was music, however, that defined and distinguished Le Boeuf: "the jazz is always first-rate," *Vogue* reported, with "Vence [*sic*], a demon on the saxophone . . . [and] a black chanteuse with a voice like a locomotive's whistle, singing 'Do It Again' in an unforgettable manner." An illustration that ran with the article, depicting a black saxophone player playing along with a drummer in the dark and crowded bar, provided an additional reference to Vance Lowry—the great saxophone and banjo player who had made a name during the war as a member of London's Ciro Club Coon Orchestra.[58] As for the song "Do It Again," it was a top hit for George Gershwin and Buddy DeSylva in 1922, featured in the show *French Doll*, where it was performed by Irene Bordoni. *Vogue's* observations, along with those of the period's most colorful chronicler, Maurice Sachs—who recalled hearing American tunes including "Ain't She Sweet," "Black Bottom," "Breezin' Along with the Breeze," "The Man I Love," and "Sometimes I'm Happy" at the Boeuf—make it clear that the American influence in the club was far more authentic than that conveyed by the ballet, which Cocteau freely admitted was "an American farce, written by a Parisian who has never been to America."[59]

Nightclubs went in and out of fashion quickly in Paris, but the Boeuf had staying power. Even as late as May 1925, *Vogue* was describing the club to its American readers as "one of those tiny Paris haunts that within four narrow walls confine two worlds":

tionnel faisaient frissonner un public de viveurs courbés sous une puissante évocation de la Russie légendaire.

Aujourd'hui Cora Madou, a pris place sur le haut tabouret de bar et lance ses chansons baroques et si personnelles par-dessus les épaules endiamantées et les plastrons blancs. Artiste curieuse que l'Amérique ne tardera pas à réclamer.

L'élégance la plus raffinée est de rigueur chez Fysher; le smoking détonne; la petite robe aussi. Il y faut cravate blanche ou triple collier de perles. Au caveau de Camille Desmoulins au contraire, l'assistance est plus mélangée. Dans ce décor qui exalte les fastes révolutionnaires et où l'on s'attend toujours à voir surgir des sans-culottes, la pique à la main, il paraît moins choquant d'apercevoir des cols mous et des vestons. On y entendait l'année dernière la belle artiste Efremova, la célèbre chanteuse russe, transfuge de la "Chauve-Souris", dont la voix nuancée modulait des chants paysans et romantiques avec une rare originalité et qui savait évoquer puissamment "la tribu prophétique aux prunelles ardentes."...!

Bien d'autres cabarets connaissent des vogues momentanées et sont adoptés pendant une semaine où une saison par un groupe de noctambules : avec la vitesse d'un feu de paille, la nouvelle se propage, des échos de journaux y font allusion, on les cite dans les potins des cinq à sept, en bavardant au bois ou dans les salons d'essayage. Vite l'on y accourt : il faut être vu le soir même à la place où hier la duchesse de G... s'est assise: il faut entendre le jazzo-flûte vanté par Jacques de M...; Dieu ! que ce serait grave d'avoir été distancé ! Comment ! il y a un chanteur florentin chez R...? Ne parle-t-on pas également d'un gondolier qui sait tous les airs de la lagune et transporte le public de C..., à Venise par la magie de ses "canzone"...

Il est évident que ce ne sont pas là éléments suffisants pour assurer un public fidèle. Un endroit chic comme le "Daunou" ne possède aucune attraction à grand fracas. Il s'est imposé ainsi qu'une force élégante; il n'est pas d'ailleurs seulement voué à la vie nocturne. L'après-midi de ravissantes fidèles y viennent faire leurs dévotions au dieu de la danse ; et leur religion est telle qu'elles y retournent le soir et jusqu'aux heures les plus tardives. Au contraire, "Rector" qui a emprunté son nom à la célèbre maison londonienne et qui s'est installé aux "Acacias", d'antan, a recours à de somptueux éléments étrangers pour attirer un public choisi. Sa réussite est égale. On y jouit d'un semblant de jardin assez imprévu qui rappelle les arbres de zinc de l'ancien Moulin-Rouge.

Il faut faire une place tout à fait spéciale au "Bœuf sur le toit". Depuis

*Le "Bœuf sur le toit" est peut-être la "boîte" de nuit la plus intéressante, parce qu'ayant une clientèle très fermée de jeunes littérateurs, de jeunes musiciens, de jeunes peintres. Le jazz y est toujours d'une belle qualité, ainsi que l'atmosphère ambiante*

FIGURE 86. Illustration of "Le Boeuf sur le toit," featuring Vance Lowry, from *Vogue* (Paris), 1923

There are the young bloods at the bar who act as if they owned the place. If they deign to speak to someone sitting at the tables in the outer wilderness, they do it with condescension. Does not Jean Cocteau count himself as one of them, and Tristan Tzara. . . . The bar is hung with photographs by Man Ray of some of these celebrities. Dear, fat Doucet delights us at the piano, and the little tables are crowded with a public as remarkable in its own way as the young intellectuals at the bar.[60]

The Boeuf's particular mix—French high intellectualism and *beaux-arts* avant-gardism combined with American music and cocktails—added up to a stylish and inherently transatlantic expression of modernism, matching

exactly the program *Vogue* had sought to promote from the outset. The club's music exemplified *Vogue*'s ideal combination of Franco-American values, as did its main animators—Satie and Les Six—who upheld French tradition by virtue of their classical and conservatory training, yet composed works informed by the idioms of American jazz and popular music. By bringing these two musical spheres into contact, Le Boeuf reinforced the chic of a brand of modernism in which French traditions were invigorated by American musical idioms, and in addition boosted the social status of these composers, elevating them from the position of artists/performers to a rank equivalent to that of other patrons and party-goers. In part due to this leveling, Satie and Les Six found themselves poised for more direct involvements with the haute monde, not simply as supported artists but as collaborators and friends.

## THE GRANDE SEMAINE AND PARISIAN MUSICAL LIFE

Le Boeuf sur le toit offered year-round diversion for trendy Parisians, but each spring its habitués were largely otherwise occupied, engaged in the round of balls, parties, performances, and charity events known as the *pleine saison*. Built around a "great week" or "Grande Semaine" in late May, this was the period when fashionable society returned to the city, home for a brief stay between post-Christmas travels to Monte Carlo or St. Moritz and summer vacations on the Riviera or the Normandy Coast, and its extravagant events garnered *Vogue*'s full attention. From the beginning of May to the end of June, Parisian high society displayed itself in a round of spectacles held in the city's public theaters, private mansions, and outdoor parks, all of which provided extraordinary opportunities for the intersection of modernist music and haute couture. In settings ranging from intimate soirées to public galas, the same composers that *Vogue* situated at the center of its social universe occupied center stage as the season unfolded.

The traditional Parisian social calendar, defined by fixed dates for specific events and activities, was disrupted by the war, and began to resume regularity only in May 1921. "Paris is becoming Paris again," French *Vogue* exclaimed in an editorial that month, as the haute monde was recuperating "the traditional dates for the return to the South, for evening and daytime receptions . . . its natural habits."[61] This return to normalcy was launched with a series of four balls held at the Théâtre des Champs-Elysées on the four Fridays of May, which were thus known as "Les Bals des 4 Vendredis de Mai." Benefiting a group of charities that aided war victims in the hard-hit city of Rheims, the balls had the support of politicians, including French

president Alexandre Millerand and the U.S. ambassador, as well as high society. The events were overseen by an "Executive Committee" consisting almost entirely of socialites, which was chaired by the American Nina Crosby—who, upon her marriage to Melchior de Polignac, the director of the Rheims-based Pommery Champagne company and the nephew of the Princesse de Polignac, had assumed the title of Marquise. Good works and high fashion mixed at the balls: an article in the May issue of *Vogue* featured a photo of the organizing committee gathered around a table at the home of the Marquise, and previewed in a quartet of illustrations the gowns that she and other trendsetting women were expected to wear to the events, including dresses by Chanel, Paquin, Lanvin, and Poiret.

Each of the "Quatre Vendredi" balls was identified with a particular color scheme: the "Black and White Ball" inaugurated the series, followed by "Sunset," "Moonlight," and "Rainbow" balls.[62] While these themes, according to the advertisement, were intended to describe the lighting that would be in effect at each event, *Vogue*'s coverage makes it clear that many female ball-goers adopted them as suggestions for costumes and had their couturiers design lavish ensembles accordingly. A photograph published in the June issue, for example, shows actress Cécile Sorel at the "Sunset" ball in a voluminous gown designed by Callot Soeurs which was meant to look like a rosebud closing at day's end; a similar snapshot captures the Baronne Fouquier at the "Rainbow" ball in a gold lamé sheath by Worth trimmed with gold lace and "sumptuous fringes made of pearls in all the colors of the rainbow."[63] A full-scale costume ball, the Grand Prix Ball at the Opéra, was another highlight of the "Grande Semaine." A long-standing tradition in Paris, at which costumes and masks were de rigueur, the "opera ball" had its roots in the masquerading associated with Venetian Carnival, but by the late nineteenth century had become a social institution as well as a showplace for the city's elites.[64] The Opera Ball of 1921 aimed to revive the sensibilities of hedonism and ostentation that had characterized those earlier events, while simultaneously functioning as yet another benefit for war victims.[65] Organized by the Princess Lucien Murat and designed by Poiret, who decorated the Palais Garnier for the occasion in bold swathes of red and purple, "the ball was magnificent, successful in every way," according to *Vogue*, while the crowd was "enormous" and the costumes "gorgeous."[66] The music only added to the ambiance; as one partygoer reported, the "jazz heard throughout the theater" enveloped the revelers with the "most pleasant rhythms possible."[67]

Even amid events of such opulence, however, the highlight of this first *pleine saison* was the return of the Ballets Russes to the Théâtre de la

FIGURE 87. Vladimir Rehbinder, photograph of Cécile Sorel costumed by Callot Soeurs for the "Sunset" Ball, from *Vogue* (Paris), 1921

Gaîté-Lyrique for its most expansive program since the start of the war. As *Vogue* noted, Diaghilev's troupe was more than an artistic phenomenon, having become "like college life and the Great War itself, a definite bond in social intercourse," and the Ballets' performances were absorbed into the social routine as one of the season's most important amusements—eagerly anticipated, regularly attended, and attentively evaluated.[68] "With what joy did we await the return of the Ballets Russes after the war!" Jeanne Robert Foster exclaimed in her article about the troupe's 1921 Paris run. "Once again we have not been deceived."[69] In the shortened season that year, the dancers offered audiences two works not previously seen in Paris, each tinged with a particular and fresh exoticism: the Spanish-inspired *Cuadro flamenco*, with music by Manuel de Falla and sets and costumes by Picasso, which according to Foster conveyed a "strong perfume of its homeland"; and *Chout*, with music by Sergei Prokofiev and sets and costumes by Michel Larionov, which provided an example of more angular Russian modernism than previously seen in Diaghilev's productions.[70] Photographs of Diaghilev's star dancer Lydia Lopokova, and of Maria Dalbaicín, who was part of the ensemble of gypsy dancers specially engaged for the

production of *Cuadro flamenco,* rounded out the magazine's coverage. For once, there was no mention of Stravinsky, most likely because no new works by the composer were offered in this abbreviated season; nonetheless his presence and star power were acknowledged in Paris, as the run of performances at the Gaîté-Lyrique ended with a "Stravinsky Festival"— for which ticket prices were doubled.[71]

## THE BEAUMONT BALLS

For its American readers, *Vogue* recounted the remainder of events that made up the *pleine saison,* which included a *fête* at the golf club in the Paris suburb of St. Cloud, dinners at fine restaurants in the Bois de Boulogne, the Derby at the Chantilly racetrack, and the races at Longchamp. Amid its breathless reports, the magazine made special mention of a "fête de nuit" hosted by the Count Etienne de Beaumont and his wife Edith, which was held in the expansive gardens of their mansion in the heart of the fashionable 7th arrondissement. "Never was there a lovelier evening," *Vogue* enthused of this gathering. "Never was a more charming company assembled, nor more charming surprises planned"; in addition to a display of fireworks, a special dance was performed by two of the guests, and the dresses were so elaborate that they veered on being costumes.[72] *Vogue* lavished attention on this party, printing a full-page photographic portrait of the Countess de Beaumont with a caption that placed her "at the head of modern artistic movements" and credited her with "bringing French and international society together for musical fêtes of the highest interest." The Count, in turn, was praised for "uniting a sense of tradition with a comprehension of efforts in contemporary art."[73] Even before this party, the Beaumonts were well known for their lavish style of entertaining and adventurous taste, having earned considerable notoriety in 1918 by hosting a soirée—some maintain the first in France—where American jazz was performed. At their mansion on the rue Masseran, "dinners and balls . . . followed each other without ceasing"; swept up by these events, *Vogue* declared (at the risk of alienating some of the Beaumonts's competitors) that "no one can have more taste than the Count and Countess."[74]

At the top of the social heap, the Beaumonts were poised to expand their parties and presence in a way that would unify the disparate impulses of this first postwar *pleine saison*—the desires for dancing, fancy dress, and the chance to participate in as well as observe spectacular entertainments—with their own taste for modernist art and music. Their format would be the ball, and in 1922, they hosted the first in what would be a string of such

FIGURE 88. Photograph of Edith de Beaumont, from *Vogue* (Paris), 1921

events that lasted until 1949. Each of the Beaumont Balls was built around a specific theme, and invitees were expected to attend in elaborate costume. As a frequent guest, the Prince Jean-Louis de Faucigny-Lucinge, recalled, the choice of a theme for these affairs was carefully made; it "required and permitted at the same time the collaboration of the most dazzling talents of the age," including visual artists, musicians, and couturiers, the latter of whom "deployed their talents to create costumes as beautiful as they were unexpected."[75] As *Vogue* noted, the Beaumonts devoted themselves to "elevating the light and eminently Parisian event known as the ball into something more artistic":

> One must go to the Beaumont ball to understand how a man of taste can transform a simple society event into an event of particularly Parisian beauty. Just as there is international art and provincial art, so too there is an art, a beauty, that is Parisian. One must have a social sense that few possess in order to distinguish the elements of Parisianism, and M. de Beaumont possesses them, aristocratically and intelligently.[76]

The first of the Beaumont *fêtes* was the "Bal des Jeux," and it set a high standard in all respects. Invited to dress as toys or games, guests came attired in splendid and inventive costumes, many of which were designed

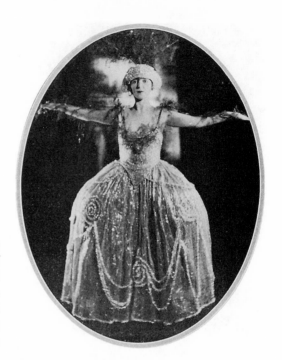

FIGURE 89. Vladimir Rehbinder, photograph of Princess Soutzo costumed by Chéruit as a Christmas tree for the Beaumont Bal des Jeux, from *Vogue* (Paris), 1922

especially for the party by the city's top fashion designers. French *Vogue*, which covered the ball in a two-page spread in its April 1922 issue, showcased some of the most original interpretations of the themes in an illustrated article that included photographs of Princess Soutzo, one of the evening's standouts, who came dressed as a Christmas tree in an ensemble that combined an ornate green gauze crinoline gown decorated with gold with a headdress made of evergreen branches; and the Countess Polotzoff and the Baronne de Rothschild, who appeared together in full-skirted gold dresses and turbans to which were attached delicate glass spheres designed to mimic soap bubbles. The Count and Countess de Beaumont were attired as "the play of shadow and light," she in a glittering silver gown and a massive conical hat, he entirely in black, as a "Pierrot noir."[77]

Perhaps the most celebrated costume of the evening, however, was worn by Satie's friend Valentine Hugo, who came dressed as a merry-go-round, in a gown she designed herself. The dress was a work of art; having begun with a simple frock in the shape of a lampshade, her husband Jean Hugo recalled, Valentine added "cardboard cutouts in the shape of a horse, a cow, a sled, a bicycle, a pig, and a mermaid; a red velvet bodice with gold fringe that opened on a mussel made of pastry playing the organ; and a Chinese

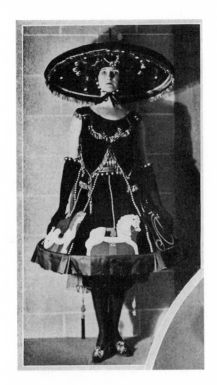

FIGURE 90. Vladimir Rehbinder, photograph of Valentine Hugo costumed as a merry-go-round for the Beaumont Bal des Jeux, from *Vogue* (Paris), 1922

hat ornamented with glass balls."[78] Amid the extremely elegant and delicately wrought couture confections worn by many of the party guests, Hugo's homemade ensemble must have seemed vernacular and edgy—and in this regard was emblematic of a new and overtly modernist dimension the Beaumonts would bring to Parisian social life. This sense must only have been enhanced as she made her entrance to the party escorted by her husband, outfitted as a billiard table, along with "Radiguet, dressed as a shooting gallery, and Jean Godebski costumed as a house of cards." As Jean Hugo recalled the occasion, others presented themselves as "a chess game, Dominoes, the game of Colin-Maillard, the guignol," while "Auric, Milhaud, and Poulenc came as football players, and Arthur Meyer was dressed in newspapers."[79] There was, in addition, at least one special (and highly professional) dance performance at this ball, for *Vogue*'s coverage includes a photograph of Léonide Massine and his wife dancing a polka, dressed in costumes "inspired by Gavarni."[80]

The entrances made by party guests, like those described by Hugo, were a centerpiece of the Beaumont Balls, a self-conscious link to a tradition that

had reached a high point in France with the royal masked balls of the *ancien régime*. On those grand eighteenth-century occasions, a variety of masquerades and choreographed dances known as *"entrées"* were interspersed amid the social dancing that constituted the evening's main fare. Courtiers and professionals sang, danced, and mimed through these performances; for one especially magnificent spectacle in February 1700 the Dauphin played the role of a "great lord surrounded by the animals of his menagerie and various attendants" in a divertissement that included two professional acrobats dressed as monkeys, two vocalists disguised as parrots and a theorobo player attired as a tiger. Typical of these masquerades, the performance loosely followed a simple narrative, in which the lord fell asleep, was awakened by a butterfly, and eventually picked up his sword and chased all the animals out of the room.[81]

The Beaumont balls echoed the opulence and audaciousness of such *ancien régime* masquerades, while updating their content to reflect twentieth-century sensibilities. The Bal des Jeux portended things to come, but included only a limited theatrical element, as costumed guests "entered" before the collected crowd in pairs or groups but apparently did not present dramatic performances. The following year, however, the Beaumonts came much closer to realizing their vision of a ball that joined contemporary art to French tradition—and they made the link to this past explicit, originally giving the event the title "Bal de l'Antiquité sous Louis XIV," and eventually settling on the simpler "Bal Baroque." The event was the singular focus of French *Vogue*'s July 1923 issue, where it was described in the magazine's opening editorial as being "without contest the grand event of the season," and covered in a nine-page spread on the "Grande Semaine" that included numerous photographs and illustrations. The costumes, the magazine reported, were "of a dazzling richness not seen in some time," and "evoked the fêtes of the grand siècle, like the dazzling fireworks, entirely white, displayed in the garden of flowering parterres." A remarkable twenty-seven *entrées*, all designed to stun with their elaborate costumes and clever wit, were played out "in front of a banquet table simulated in the marvelous décor done by [José-Maria] Sert," at the foot of which sat the Countess de Beaumont with several guests. *Vogue* made particular note of one performance, a spoof on Salomé's dance that ended with "Saint John's head—representing a face well known to all—being delivered to the Countess on a platter.[82]

Such were the preparations for this elaborate *fête* that the Count de Beaumont drafted a scenario outlining the entire evening. The setting, he wrote, was the "world of the imaginary":

FIGURE 91. Dorys, photograph of the "Alsatian Entrée," from *Vogue* (Paris), 1923

. . . of the novel, of fairy stories or allegories in the 16th, 17th, or 18th centuries. The idea is of a magnificently served supper of cardboard dishes, during which the shows are put on. The supper guests are the first entrée. This should be interpreted as follows: for the women, in tones of gold with white wigs and masks and for the men, in tones of brown and gold, with golden wigs and drapery over their suits. The following entrées, which the guests will perform as they wish, should be colorful. As they take place, the guests will gather in groups before the tables and sit on cushions. The fête will end with a few fireworks before supper. Obviously, the costumes will be designed with the greatest fantasy, in the simplest materials.[83]

The social importance of the Bal Baroque may be gauged by the fact that *Vogue* chronicled the rehearsals and preparations as well as the final event on the evening of 30 May, in a "diary" written by none other than Jeanne Robert Foster. Her account begins on 28 May, when "magnificent cars are parked in two lines along the little rue Duroc" as rehearsals for the *entrées* take place at the Beaumont mansion:

A light rain covers the garden and terraces. In spite of this the electricians work, mounting their lanterns. The grand salon is open on all sides by its four doors, onto the small salons where there are rehearsals. On one side, the entrée of "The Four Seasons," on another, that of the

Princess [Lucien] Murat, "Les Médecins de Molière. . . . Everywhere, people are rehearsing without noticing their neighbors, women in beautiful town dresses, some in sports clothes, because they've just come back from golf.

And at the center of the grand salon we find Erik Satie:

. . . at the piano for the poem of Mrs. Fellowes; M. Bertin, the charming comedian, is rehearsing with Princess Murat, singing the music that will accompany her entrée. M. et Mme de Beaumont are giving orders, going from left to right.

In this hive of activity, Vogue reported, all was serious, without "coquetterie"; nothing but "the great evening" occupied the "thoughts and desires" of those gathered.[84]

The performance Satie was rehearsing with Daisy Fellowes—niece of the Princesse de Polignac, wife of Winston Churchill's cousin Reginald Fellowes, and widely recognized as one of the most stylish women in Paris—was to be the evening's highlight. Fellowes, along with Olga Picasso, Massine, and the Count and Countess de Beaumont had been enlisted to participate in the *entrée* called "La Statue retrouvée," for which Beaumont had arranged a spectacular reunion of the team that had created *Parade*, commissioning music by Satie, scenario by Cocteau, costumes by Picasso, and choreography by Massine. In addition to advocating modernist art, the Beaumonts were champions of eighteenth-century French music, having among other things presented Wanda Landowska performing on the harpsichord and piano in a recital of works by Handel, Haydn, Bach, Mozart, Daquin, Scarlatti, and Couperin at their home in 1920.[85] Since the Bal Baroque in part celebrated the inauguration of the newly restored eighteenth-century organ in their music room, Satie composed a work showcasing the instrument; as he wrote to the Countess de Beaumont in December 1922, "The organ isn't necessarily religious and funereal, good old instrument that it is. Just remember the gilt-painted merry-go-round."[86] His five-movement work for the instrument, with trumpets added at the end, matched Massine's choreography and a scenario by Cocteau, which is now lost. This slight divertissement, set in the eighteenth century and based on a rococo theme, concerns the discovery of a statue by two women. Simple and direct, it begins with a march, after which follow two "searches" that were probably acted out by the two female protagonists moving in opposite directions. The statue's discovery is announced by a trumpet blast, and the work closes with a brief theme labeled "retreat"; scored in three voices, for organ plus trumpet, the music suggests that the statue came to life when it was found. The score is economical, lasting

under four minutes, but its sections were no doubt repeated as necessary to match the action of the *entrée*.

Although it went unremarked by *Vogue*, Satie participated in a second *entrée* at the Bal Baroque: for a performance by another beautiful young Parisian socialite, Mme René Jacquemire, he composed a five-song set on texts by Léon-Paul Fargue, entitled *Ludions*. Fargue, it may be recalled, was an old friend of Satie's, the author of the text set by the composer as the song "La Statue de bronze," which was premiered at one of the soirées held at Germaine Bongard's salon in the spring of 1916. The songs for the Beaumont party were short and bordered on being silly; the set takes its title from a kind of toy popular at the time, in which small objects (often a miniature diver) were suspended in water so that they would bob up and down. The song group includes a "Rat's Tune," written in 1886 by the ten-year-old Fargue for his pet white rat, a song called "Spleen," in which a seemingly nostalgic poet shifts tone and longs for a "cute but worthless blond in this cabaret of nothingness which is our life," and "The American Frog," where, predictably enough, animal sounds are the basis for wordplay and musical jokes. Mme Jacquemire, by all accounts a gifted soprano (and pianist), had special connections to the world of fashion; the only daughter of couturiere Jeanne Lanvin, she was the inspiration for the *robe de style*, a full-skirted, girlish dress that became the signature garment for Lanvin, as well as for the iconic image of a mother and daughter that graced the Lanvin perfume bottles. The Bal Baroque marked a coming-out of sorts for her, since even though she still circulated in society under her married name, she had divorced René Jacquemire—the grandson of former French Prime Minister Georges Clemenceau—the previous December. She would marry again in April 1923, becoming the wife of the Count Jean de Polignac—another of the Princesse's nephews.[87]

On the evening of the ball, diarist Jeanne Robert Foster reported "radiant weather," and evoking the Beaumonts' *ancien régime* theme, observed that "seduced by the *fête royale* that will be given this evening . . . the sky itself lit up." She went on to provide a glimpse of the evening's events:

> The entrées start off in the garden, following a salute to the Countess de Beaumont, seated at the foot of the grand salon in a décor magisterially conceived by J. M. Sert. . . . It is difficult to see and follow each entrée, the crowd is such that it's necessary to pull oneself up onto the chairs to try to discern, among the movements of the figures in the entrées, this or that person from Mount Olympus, others from the tragedies of Racine, exotic dancers, Molière's *Médecins* etc. . . . The luxury of the costumes surpasses anything we've seen for a long time.[88]

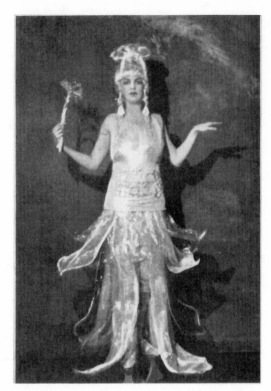

FIGURE 92. Vladimir
Rehbinder, photograph
of the Marquise de
Polignac costumed for
the Beaumont Bal Louis
XIV, from *Vogue*
(Paris), 1923

The evening as a whole, according to Foster, recalled "the youthful imagi-
nation created in the celebrated fêtes of Louis XIV"; more than a "souvenir
of the avant-garde," she observed, the party instead revived and revitalized
the traditions of the grand siècle.[89] Just as the Beaumonts had intended, the
ball forged a link between the glories of the French past and the excitement
and luxurious pleasures of contemporary Paris—all the while encouraging
the revelers gathered in their gardens to associate themselves in a seamless
line with the aristocrats and other elites of the *ancien régime*.

### STRAVINSKY AND THE BALLETS RUSSES IN THE GRANDE SEMAINE

Along with the Beaumont *fêtes*, the Paris performances of the Ballets
Russes remained a keystone of the spring social season in 1922. Having
been relegated to the less prestigious Théâtre de la Gaîté-Lyrique the pre-
vious year, Diaghilev's troupe returned to the Opéra in May with three
works new to the city—the one-act divertissement *Le Mariage de la Belle*

*au Bois dormant* (also known as *Le Mariage d'Aurore*), the opera-buffa *Mavra*, and the pantomime *Le Renard*. *Vogue* covered the performances in its July issue, publishing a full page of photographs from the productions as well as a portrait of Nijinska attired in a traditional tutu and an elaborate crown under a headline announcing "The Ballets Russes Pull Off Handsome Triumphs." The magazine endorsed the performances enthusiastically: "The old ballets enchanted and stunned us once again," *Vogue* exclaimed. "The new ballets are typically original and most fertile."[90] The Ballets Russes desperately needed this boost from *Vogue,* for the troupe was in the midst of a crisis, having just finished a disastrous and nearly bankrupting run in London during the winter of 1921. Narrowly scraping out of the situation there, Diaghilev seems to have calibrated the Paris program with the specific goal of appealing to the post-war audience in the city, which included both a large number of aristocratic Russians who had flocked to Paris in the wake of the Revolution and the Parisian social elites who had taken them up as a cause. In combination, it was a group naturally inclined to embrace art and entertainment that reflected aspects of Russian heritage, and this is precisely the vein Diaghilev tapped as he offered his Paris audience a diverse trio of new works—in three genres, representing the arts of three eras, and reflecting three distinctive Russian traditions.

This 1922 season marked a critical juncture for the Ballets Russes, and scholars have accordingly considered it from a number of important perspectives: among the most persuasive discussions are Lynn Garafola's demonstration of the ways in which this season marked a critical shift in Diaghilev's relationship with the marketplace, and Richard Taruskin's revelation of the ways in which it heralded a new Russo-European ideology for Diaghilev, Stravinsky, and the troupe as a whole.[91] Equally worth contemplating, however, is the manner in which the works performed in the 1922 *saison russe* reflected an awareness of the world of Parisian fashion and a desire to connect to its followers. As we shall see, in addition to capitalizing on the fad for all things Russian that persisted in the city in the years just after the war, these three works were tied specifically to particular pleasures that captivated the upper class and other devotees of high style, and were aligned with these pursuits in a manner that seems unlikely to have been coincidental.

The Ballets Russes' crisis of 1922 was precipitated by what one reviewer called "a gorgeous calamity"—namely, the massive failure of Diaghilev's ambitious production of *The Sleeping Princess* at London's Alhambra Theater the previous November.[92] A revival of Tchaikovsky's *Sleeping Beauty* as it had been created by French choreographer Marius Petipa for St.

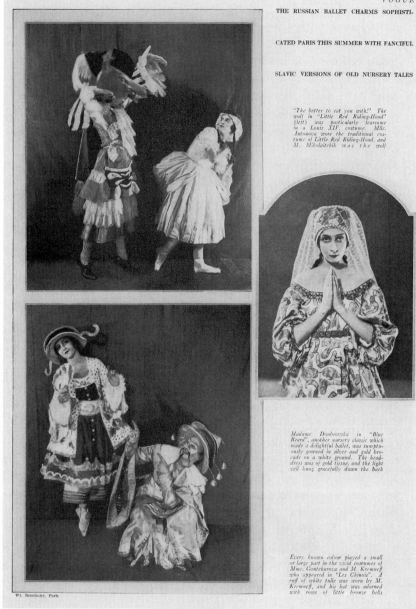

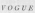

*"The better to eat you with!" The wolf in "Little Red Riding-Hood" (left) was particularly fearsome in a Louis XIV. costume. Mlle. Antonova wore the traditional costume of Little Red Riding-Hood, and M. Mikolaitchik was the wolf*

*Madame Dombrovska in "Blue Beard", another nursery classic which made a delightful ballet, was sumptuously gowned in silver and gold brocade on a white ground. The headdress was of gold tissue, and the light veil hung gracefully down the back*

*Every known colour played a small or large part in the vivid costumes of Mme. Gontcharova and M. Kremneff who appeared in "Les Chinois". A ruff of white tulle was worn by M. Kremneff, and his hat was adorned with rows of little bronze bells*

W. Benoinder, Paris

FIGURE 93. Photographs from the 1922 Ballets Russes productions, from *Vogue* (New York), 1922

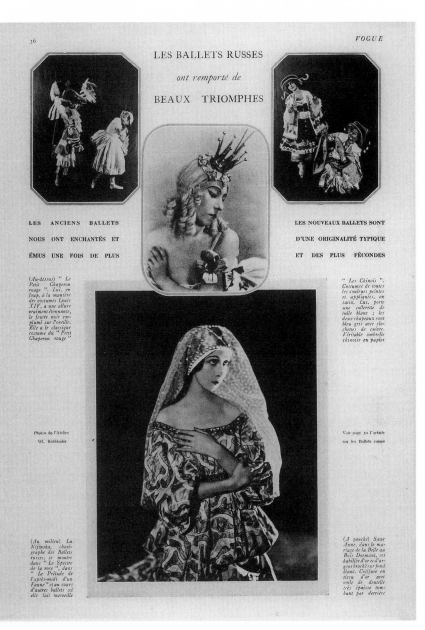

FIGURE 94. Photographs from the 1922 Ballets Russes productions, from *Vogue* (Paris), 1922

Petersburg's Maryinsky Theater in 1890, this slightly reworked and re-named ballet attracted audiences but was so expensive to produce that it never broke even; in the end, the situation was so bad that Diaghilev had to leave the costumes and sets with London financier Oswald Stoll, who had backed the production. The decision to bring Tchaikovsky's ballet back to the stage in the first place was a departure for Diaghilev, who had not previously been inclined to the wholesale resuscitation of older works; it marked the arrival of the style that Garafola has termed "retrospective classicism" in the repertoire of the Ballets Russes, and introduced a new approach character-ized by a rediscovery of the eighteenth century and "the glories of the French classical past" that persisted in the troupe's productions through *Apollon musagète* in 1928.[93] As a herald of this new line in the Ballets Russes' repertoire, *The Sleeping Princess* (as Diaghilev renamed the origi-nal *Sleeping Beauty* for the London performances) was a brilliant stroke. The story itself reeks of the *ancien régime*; published by French Academi-cian Charles Perrault in 1697 as part of the collection of his "Mother Goose" stories, *Sleeping Beauty* was an adaptation of an earlier folk tale, honed and refined by Perrault to suit the sensibilities of the most stylish artistic and political salons of his day.[94] In the transfer from Perrault to Petipa and Tchaikovsky, moreover, the story's eighteenth-century French ele-ments intensified; according to the wishes of Maryinsky theater director Ivan Vsevolozhsky, the costumes and decors of the 1890 production explic-itly evoked the court of Louis XIV, the choreography was modeled on eighteenth-century practice, and the highly stylized musical score even included a massive sarabande which, as Taruskin has observed, might as well have come from the old *ballet du cour*.[95] So compelling was the connection to the grand siècle that in 1923 the work, in its abbreviated version but sup-plemented with processionals and vocal interludes appropriate to the royal setting, was the centerpiece for a fundraiser at the chateau of Versailles, where it was performed for a glittering audience of politicians and high-society figures in the great Hall of Mirrors.

More than just an homage to the French past, however, *The Sleeping Princess* summoned up a specific tradition in Russian music—one in which European and aristocratic values, rather than "primitivism" à la *The Rite of Spring,* held sway. For Stravinsky, on the verge of applying for French cit-izenship and fresh from his brush with eighteenth-century Italy in *Pul-cinella,* the appeal of this Russo-European lineage was personal as well as artistic, and he associated himself profoundly with the production of *The Sleeping Princess* even though his main contribution was the orchestration

of two numbers missing from the second act of the original score.[96] Championing the ballet's connection of French and Russian elements, he described it in a letter he published in the *London Times* shortly before the premiere as "the most authentic expression of that period in our Russian life which we call the 'Petersburg' period"; two weeks later, in an interview with the same newspaper, he praised Tchaikovsky as an "immense talent" whose "knowledge of folk and old French music" had freed him from having to "enter into archeological investigations in order to reproduce the epoch of Louis XIV."[97] No doubt these Franco-Russian associations were not the only factors that fueled the composer's enthusiasm for the project: Vera Sudeykina—who was on the verge of leaving her husband for Stravinsky at the time—played the role of the Queen in the London production, where she made "a breathtaking entrance wearing a huge headdress of ostrich feathers."[98]

A nineteenth-century ballet extravaganza built on *ancien régime* themes, with lavish costumes and a musical score that laid bare the connections between the European upper class and its Russian counterpart—surely Diaghilev expected that *The Sleeping Princess* would hold a strong appeal for upscale Parisians and their émigré friends, who dressed in modern versions of eighteenth-century gowns for evenings at Poiret's Oasis and costumed themselves to dance in divertissements that recalled the Sun King's court at the Beaumont Bal Baroque. Had the full production mounted in London ever reached the Opéra in Paris, audiences would have been treated to a spectacle on a rarely achieved level, in which fashion was a driving force; by all accounts, Bakst's abundant and luxurious costumes were the ballet's centerpiece. In London, these ensembles were one of the production's most highly touted features, and although the "three hundred dresses" he created for the ballet were derided in the British press during the run at the Alhambra—Raymond Mortimer complained that the ballet was "all clothes," while W. J. Turner compared the costumes to "bank holiday dresses on Hampstead Heath"—it is easy to imagine that they would have inspired a completely different reaction in the world's fashion and style capital.[99] Instead, Paris audiences saw a truncated, one-act version of the original production, with costumes and scenery by Benois and Goncharova replacing the impounded originals. *Vogue*'s critic Jean LaPorte, for one, lamented the loss of Bakst's "marvelous costumes," judging the replacements as "highly interesting" but incapable of conveying the "orgy of colors" achieved by the "celebrated designer of *Schéhérazade*."[100] From its costumes to its content, then, Diaghilev's *Sleeping Princess* was precisely in

tune with the desire to recuperate the glories of the grand siècle, and in this regard reflected one of the greatest fashion trends of early 1920s Paris.

## MAVRA AND THE "RUSSIANIZATION" OF PARIS

While *The Sleeping Princess* connected the Ballets Russes to Parisian fascinations with the grand siècle, *Mavra* offered an interpretation of Russian popular entertainments that provided diversion for the city's upper classes after the war. The medium in this case was not dance but opera-buffa—arguably, the "serious" art that had been the progenitor of the cabaret and music-hall entertainments—and, like *The Sleeping Princess*, the work showcased the interconnected histories of Russian and European art. *Mavra*'s libretto, devised by Diaghilev's young new secretary Boris Kochno, was an ideal choice in both respects. Based on Alexsandr Pushkin's 1830 verse tale *A House in Kolomna*, it was drawn directly from the oeuvre of the writer commonly credited both with having created a modern Russian literary language by combining European and Russian traditions, and with animating an expressly Russo-European musical style by authoring both *Evgeny Onegin* and *Boris Godunov*. Stravinsky's personal attraction to the author is evident in his earliest works, including the song "Storm Cloud" (1902) and the suite for mezzo-soprano and orchestra entitled "Faun and Shepherdess" (1907), which are both settings of Pushkin texts.[101] Thus, as he and Diaghilev explored options for the 1922 Ballets Russes season, *A House in Kolomna* emerged as a work well suited to the advancement of their Franco-Russian agenda and—with only a few characters, a rudimentary plot revolving around mistaken identity, and farcical elements that veiled a more substantive commentary on social structures—ripe for setting as an opera-buffa.

As Taruskin has discovered, however, *Mavra*'s most striking quality was not its opera-buffa update of Pushkin, Glinka, and Tchaikovsky (the threesome to whom Stravinsky dedicated the work), but rather its relationship to the Russian cabaret culture that thrived in post-war Paris, and in particular its ties to Nicholai Baliyev's sophisticated émigré variety show, known as the "Théâtre de la Chauve-Souris à Moscou," or "The Bat Theater of Moscow." This hugely successful show, which played at the Théâtre Fémina on the Champs-Elysées beginning in December 1920, featured a series of songs, dances, and short plays all connected to Russian and Gypsy traditions. So fashionable was the production that even after it left Paris for New York in 1922 artists associated with the Chauve-Souris were highlighted regularly on *Vogue*'s pages: in August that year, for example, the singer

Dora Stroeva, who was in the United States with Baliyev, was singled out in an article on Parisian nightlife for her ability to create a "powerful evocation of legendary Russia," while the "celebrated Russian singer" working under the name "Efremova," was acclaimed for performing "peasant tunes and romantic songs with a rare originality."[102] Indeed, the success of the Chauve-Souris and Russian nightclubs in general was the natural outcome of the more general taste for all things Russian in post-war Paris, a cachet based in exoticism and aristocratic chic that endured through the 1920s. Among its many reports on this thriving culture, *Vogue* detailed the ambiance in two of the city's most popular Russian clubs—the Caveau Caucasien and the Kasbeck—where the walls were "hung with oriental carpets, divan-seats line the room, the lights are dim, and they are often lowered, leaving only a strange glow that comes from under a glass on the tables . . . giving a strange, eerie effect." The musical fare, the magazine advised, was worth the price of admission, since "one will surely hear the *Volga Boat Song*," along with tunes proving that "the Russians and the Negroes have joined forces . . . a bizarre mixture of Russian mysticism and Negro simplicity, appealing strongly to the taste of Paris."[103]

As this report suggests, titled and bejeweled Russians captivated Paris in the 1920s much as they had before the war, and for a number of years Slavic style was once again the rage. Leading the new charge was Chanel, who, as we have seen, had personal reasons for indulging a Russian fantasy—including her affair with Stravinsky and the liaison with the Tsar's nephew, Grand Duke Dmitri Pavlovich, which followed on its heels. In the midst of these romantic entanglements, Chanel entered what her biographer Edmonde Charles-Roux calls a "Russian phase," establishing an embroidery workshop (directed by Grand Duke Dmitri's sister, Duchess Marie) to create embellishments for her simply cut dresses, using more ornate fabrics in bolder colors, and adding fur coats to her collections. Perhaps Chanel's boldest experiment in this vein was her introduction of the long belted and embroidered peasant blouse known as the *roubachka*, which, *Vogue* reported, quickly became "the uniform of Parisiennes."[104] The Russian influence went beyond the designs to the presentation of new fashions; "pretty émigrés, all impoverished and uprooted" according to Charles-Roux, took jobs at Chanel's atelier, where the salesgirls and the mannequins spoke Russian to one another."[105] Among this group, in fact, was Igor Stravinsky's niece, Irina Belyakin, who at the age of nineteen adopted the name Ira Belline and became one of Chanel's regular models.[106] Some émigrés, like those in Chanel's atelier, were highlighted in a *Vogue* article whose headline proclaimed that "The Russian Aristocracy Finds

Refuge in Work," but more often the magazine reported on charity events mounted on their behalf.[107] An article published in February 1922, for example, noted that charity balls for Russian refugees had become regular events in the city, since "the Russian nobility has, of course, been financially ruined by the Revolution, and the social world of Paris makes every effort to lend assistance so that, for the evening at least, they return to their accustomed places."[108]

The Chauve-Souris show reflected and capitalized on this "Russianization" of Paris, emerging as one of the city's most popular nighttime diversions before moving on to play in London and New York. Stravinsky was one of its adherents, and on a particularly auspicious evening in February 1921 he and Diaghilev joined Baliyev's set designer Sergey Sudeykin and his wife, Vera—who had designed costumes for some of the Chauve-Souris productions—in the audience. The foursome dined afterward at a restaurant in Montmartre; this was Stravinsky's first meeting with his future companion and eventual wife. Another love interest from the Chauve-Souris orbit, however, emerged first; Stravinsky (as we have seen) had a brief romantic liaison with the dancer Zhenya Nikitina in the winter of 1921, after breaking with Chanel and before becoming involved with Vera. As Taruskin has shown, so taken with Katinka at the time was the composer that he ingeniously incorporated the polka melody that was her signature tune at the Chauve-Souris into his *Suite No. 2 for Small Orchestra*, which he seems to have created expressly for use in a Chauve-Souris production. Even more intriguing is his subsequent use of the same polka melody in the overture to *Mavra*, since as Taruskin has noted, this suggests that the very idea for the opera-buffa may have "originated within the orbit of the Chauve-Souris."[109] Perhaps most importantly, this borrowing lends weight to the notion that with *Mavra* Stravinsky explored the idea of collapsing the space between popular entertainment and the art of the Ballets Russes, bringing the cabaret show to the Opéra stage—a notion made all the more compelling given that many in the ballet audience were also frequenters of Baliyev's theater.

While only a few in Stravinsky's (and Katinka's) inner circle may have been attuned to the specific musical allusions, *Mavra*'s more general kinship with variety-show entertainments must have been obvious to most members of the audience who gathered at the Opéra to see the production in the spring of 1922. The thin plot itself could have been lifted from a cabaret show; a tale of love and disguise, it involves a mother, her daughter Parasha, and the daughter's lover—a soldier who enters the household dressed as a female cook, only to be discovered by the mother as he is shav-

ing in the kitchen. In addition, the work's dramatic and musical structures were well in keeping with the variety-show format; Kochno structured his libretto as a series of individual numbers showcasing specific characters or groups, with each surrounded by dialogue, and Stravinsky's score consisted almost entirely of parodies, spoofs, and musical borrowings.

*Mavra*'s premiere seems to have been engineered to make these suggested connections between popular entertainment and modernist art obvious to a selected audience that was likely to absorb and embrace them. The performance, part of a chic evening devoted to "Russian Music after The Five," took place at the height of the *pleine saison* in the ballroom of the luxurious Hotel Continental, near the Tuileries Gardens. Invited guests from the cream of Parisian society, in the midst of the spring round of balls and parties, gathered for a sumptuous buffet and the latest Stravinsky–Diaghilev premiere—with the added cachet of having the composer at the piano for the performance. The program, divided into two parts, was designed to illuminate *Mavra*'s pro-Russian orientation as well as its variety-show humor: the opera was preceded by a performance of familiar songs and arias by Glinka and Tchaikovsky, and even included the Act III quartet from *A Life for the Tsar*, the storyline of which concerns a peasant who heroically sacrifices his life for the sake of the Romanov dynasty. Against this backdrop, *Mavra*'s send-ups of all the same song types—from the Mother's parody of a Glinka-style cavatina to an exaggerated version of the romance in "Mavra's" aria (sung by the soldier in his drag alter-ego as he is discovered by the Mother)—would have been obvious. No wonder, as Kochno recalled, the elite group assembled for this private *fête* found *Mavra* charming.[110]

## MAGAZINE CULTURE AND *MAVRA*'S "PASTICHE" PROBLEM

The broader critical response that attended the work's public unveiling several days later at the Opéra, however, was less enthusiastic, despite the fact that the work was sandwiched between performances of *Petrouchka* and *The Rite of Spring* in an all-Stravinsky opening-night program.[111] The many elements that should have appealed to critics and audiences alike did not: Bronislava Nijinska's choreography was panned, and sets and costumes by Russian avant-garde artist Léopold Survage were judged by many as inappropriately small for the Opéra stage and otherwise unremarkable (Stravinsky later referred derisively to the entire ensemble of decors as "Galeries Lafayette cubism").[112] Many publications, including *Le Courrier Musical*, didn't even bother with a review, but critics who did assess the work were

harsh; Charles Tenroc, for example, writing in *Comoedia*, dismissed *Mavra* as part of a season given to "recondite nonsense" that reflected the "demise of the Ballets Russes," a "slide into internationalism" that left the group appealing only to "the idle who are eager to frequent spots where they can show off their evening attire."[113] Scathing critiques likewise came from Adolphe Julien, who called *Mavra* "the most uncomical of comic operas," and Emile Vuillermoz, who lamented Stravinsky's "backward march in the time machine."[114] Even the composer's friend Boris de Schloezer, a Russian émigré and hitherto staunch Stravinsky partisan, questioned the composer's recycling of the same Russian sources that had been used to "a greater or lesser effect on nearly all Russian composers." Lamenting the turn away from a "Negro-Russian" style that Stravinsky had been cultivating from *The Rite of Spring* onward, Schloezer bluntly proclaimed *Mavra* a failure:

> The general impression is that of a pastiche, a sort of musical amusement whose principal fault is that it is not amusing enough. But that was certainly not Stravinsky's intention. He wants to pump new blood into old forms, he wants to renew those forms, so as to create a new comic opera style. In that case the subject was too puny, too frail: it crumbles to dust. . . . The two styles—Italo-Russian and black American—never succeed in meshing but only impede one another.[115]

Schloezer's views about *Mavra*'s shortcomings have over the years become well known, but it has gone unnoticed that they were echoed by *Vogue*'s critic Jean LaPorte. In a surprising review—in fact, the first negative assessment of Diaghilev's troupe to run in the magazine—LaPorte raised the same issues of reinvention and pastiche:

> We perceived the musician's mental efforts not to simply follow his own nature, a willful search, a need to renew himself, to change, a fever of efforts and new inspirations. Is it not curious, even for someone not well versed in the subject, to put these names together: Tchaikovsky and Stravinsky? To put it in the context of French music, it would be like combining Ambrose Thomas and Ravel. Hearing *Mavra*, the chaotic inspiration of this pairing of names didn't fail to grow. Its duets at the third or sixth, its bravura arias which seem like constant parodies (*à la manière de*) but which according to the composer are not, produce a disarray in the mind which is attentive and eager to taste everything that a favorite musician has done. Pastiche can be a form of art for a few minutes. It is perhaps amusing for several measures to take a popular theme . . . and emphasize its baseness through heavy and punishing orchestration. This is an easy game for a great musician, but to have the courage to spend three quarters of an hour manipulating the same

tunes . . . Is it really necessary? Does it offer something new? We don't want to see in *Mavra* anything more than the game of a great musician. It seems to us impossible to imagine what there would be in this approach that Stravinsky could renew.[116]

Striking in both of these critiques is the identification of *Mavra*'s mix of styles as "pastiche." The term, from the Italian *pasticcio*, originally described a pie made of different ingredients; in music, it was from the seventeenth century onward the label applied to operas that were a "hodge-podge" of pieces from various sources and composers. By the time of *Mavra*, it was regularly used to connote works across a variety of genres that depended on the assimilation of incongruous materials, and in addition had come to derisively imply musical borrowing and imitation. With the critiques of *Mavra*, these various meanings were stabilized around Stravinsky, and "pastiche" in music became a shorthand for his reliance on borrowed style in lieu of original substance. Not simply connecting the composer to a long-standing musical tradition, the allegations of pastiche also linked Stravinsky to Picasso, since the term had been vehemently invoked by critics to describe the show he mounted at the gallery of his new dealer, Paul Rosenberg, in 1919, at which he exhibited a mix of Cubist and classicizing works.[117] This was a critical moment in the history of modernism, for the identification of Stravinsky and Picasso as *pasticheurs* signaled a rupture in the arts that has subsequently played out in a variety of practical and theoretical arenas, with key conflicts including debates over high and low art, formalism versus artistic freedom, and ultimately, the definition of modernism and postmodernism.[118]

On a perhaps less rarefied plane, but of special significance for this study, the invocation of pastiche in the critique of *Mavra* seems suggestive of fashion's interrelationship with modernist art, and with Stravinsky's work in the 1920s in particular. Not only did fashion itself depend on a constant mixing of disparate elements and the invocation of historical references as a locus for novelty—a trait equally evident in Poiret's eighteenth-century revivals and Chanel's Russian embroideries—but fashion magazines such as *Vogue* were the embodiment of pastiche, constructed of a non-narrative mélange of diverse materials: a typical issue might include (in no particular order) articles, photographs, illustrations, advice, letters, and reports on social life as well as advertising. Even the individual fashion magazine layouts in these publications were pastiches, almost always mixing text, illustration, and photography in a single feature, and often combining features on a single page. In short, pastiche was both a fashion constant and its signature method, a means of grounding the latest trends in a matrix of tra-

dition and a fundamental way of establishing the look as well as the substance of modern style.

LaPorte, as we have seen, did not draw such positive connections, but the fashionable set that surrounded him would have been more attuned to *Mavra*'s resonances with the pastiche-based art that could be found in Parisian cabarets and nightclubs, as well as in the brand of modernist art that Cocteau, Satie, and Les Six had been promoting since *Parade*. For Cocteau, a pinnacle of pastiche had been reached in the summer of 1921, with the premiere of the "spectacle-ballet" *Les Mariées de la Tour Eiffel*, which featured nine short compositions by five members of Les Six. Described by Cocteau as "a secret marriage between ancient tragedy and the end-of-the-year revue, the chorus, the music-hall number," the work made pastiche its artistic cornerstone as well as its style.[119] The following year, in the same manner, *Mavra* borrowed directly and liberally from popular Parisian entertainment, taking material from the Chauve-Souris to the stage of the Opéra; less obviously, it followed *Pulcinella*, which had likewise been based on the diversions of elite society—in that case, as we have seen, the masked balls and garden parties that animated the social season from Carnival through the summer months. Considered against this backdrop, *Mavra* comes into relief as neither failure nor misfire, but rather as the natural and logical step in Stravinsky's post-war alignment with the aesthetics of fashionable Paris. A synthesis of his own past and present, it was a musical and profoundly personal statement made at a critical juncture in his life and career. Small wonder that he characterized *Mavra* before the premiere as "the best thing I've done," or that he was devastated by the criticisms leveled against the work in its wake, going so far as to paste one especially cruel review—by Vuillermoz—into his autograph score.[120]

Given its pastiche elements, it is also not surprising to find either that *Mavra*'s cause was taken up in the style press, or that its strongest advocates included the French modernists who gathered around Satie. The defense, mounted primarily in *Vanity Fair*, began in September 1922 with Cocteau's article "The Comic Spirit in Modern Art." "The critics and the Parisian public," he wrote, "having grown accustomed to *L'Oiseau de feu*, received *Petruchka* very badly when it first appeared; then, when they had got accustomed to *Petruchka* they hissed *Le Sacre du printemps*. Today they are sulky about *Mavra*." And with *Mavra*, Cocteau asserted, Stravinsky had taken the dramatic step of aligning himself with Satie and his circle. "Think of it!" he exclaimed:

> Stravinsky bringing the homage of his supreme contribution to the endeavors of Satie and our young musicians. Stravinsky the traitor.

Stravinsky the deserter. It would never occur to any of them to think: Stravinsky the Fountain of Jouvenence. . . . . This downpour of drivel, of lava and ashes, is, however, a good thing for a work. Thus the critics think to destroy it but they only cover it up, they protect it and preserve it, and a long time afterward an excavation brings the marble to light, intact.[121]

The following month, Satie's article entitled "La Musique et les enfants"—a transcription of a lecture he had given prior to a concert, reproduced in *Vanity Fair* in the original French with the idiosyncratic ellipses, italics, and capitalizations of Satie's manuscript copy—was published with a photograph of Oda Slobodskaja, the young Russian singer who played the role of Parasha at *Mavra*'s premiere. The photo, which must have seemed somewhat out of place to those not attuned to efforts to identify Stravinsky with Satie via this work, bore a caption that described Slobodskaja as a "remarkable Russian soprano from the Imperial Opera at Petrograd, who has just scored a brilliant success in Paris in the leading role of Stravinsky's new opera *Mavra*."[122] Should readers have had further doubts about the work, they would have found a fuller explanation in the next month's issue of the magazine, in which Tristan Tzara discoursed on "News of the Seven Arts of Europe," beginning with a précis of *Mavra*'s plot and an appreciation of Stravinsky's music, which he characterized as "young, alert, tragic, and also comic."[123] And from Tzara they would have learned that the latest fashions seen at the work's premiere included a dress created and worn by the painter Sonia Delaunay-Terck, which was a "robe à poème"; "on the panels of her red gown," Tzara reported, she had embroidered several of his own verses.[124]

By December 1922, Cocteau had absorbed *Mavra* into his own program for creating "A New Dramatic Form," described in the article's subtitle as a "novel type of ballet which partakes also of the character of the comedy and of the revue."[125] Acclaiming Stravinsky as "the greatest musician of the century" in the opening paragraph, Cocteau went on to give a history of his own works, including *Parade, Le Boeuf sur le toit*, and *Les Mariés de la Tour Eiffel*, implying by association that *Mavra* aimed in the same way to match "the power of the performances of the Middle Ages, of Antiquity, of China, of American vaudeville sketches and eccentric 'turns.' "[126] Stravinsky, according to this reading, had aligned himself with the program Cocteau had been advocating all along, and had finally come into the fold. Satie's own eloquent and impassioned article about Stravinsky, published in the February 1923 issue of the magazine, added weight to these assertions. In his simple and direct assessment of his younger colleague, Satie provided a brief biog-

raphy peppered with personal recollections, along with a list of works that began with the Symphony of 1907 and ended with *Mavra*, "which the Russian Ballet has just presented at the Opéra." "I love and admire Stravinsky," Satie proclaimed, "because I perceive that he is a liberator. More than anyone else he has freed the musical thought of today—which was sadly in need of development."[127]

## RENARD AND THE RIVIERA

The third work premiered in Paris during the 1922 Ballets Russes season was a "merry performance with singing and music" now best known by its French title, *Le Renard*. While *The Sleeping Princess* traced its roots to the Russo-European ballet tradition and *Mavra* had ties to both opera-buffa and post-war Russian cabaret culture, *Renard*—a pantomime scored for a small ensemble of four male vocalists, four mimes, and a group of sixteen instrumentalists—took as its model the Russian minstrel show. As Taruskin has demonstrated, however, Stravinsky's was no simple borrowing. Instead, the composer combined two separate Russian traditions to create a newly imagined version of the traditional entertainment: for its content, he turned to the body of Russian folktales known as *skazki*, and for its presentation, he recalled the tradition of the Russian folk showmen known as *skomorokhi*. *Renard*'s text, an allegorical story of "the Fox, the Cock, the Cat, and the Ram," is one of the most familiar tales in the Russian repertory; in its simplest form it recounts the thwarted seduction of the Cock by the Fox. As for the performance tradition, the *skomorohki* were known to have performed at fairs, festivals, weddings, and other public events as early as the twelfth century, often appearing in masks and animal costumes, and frequently including songs and interpolated tunes in their shows.[128] By bringing these two traditions into contact, Stravinsky developed a theatrical presentation of the *skazki*, in a manner evoking the practices of the *skomorokhi*: the folktale was acted out, by costumed mimes, with musical elements.[129] For Parisian audiences in the 1920s, the historical significance of this pairing may not have been evident, but the work would have resonated with their own experiences; obvious points of reference would have been the masquerades and divertissements that enlivened the private parties they frequented, as well as the sketches and skits performed at cabarets and variety shows across the city.

Beyond these associations, *Renard* was joined to the Parisian upper class via its link to one of the city's most powerful socialites—the Princesse de Polignac. Unlike *The Sleeping Princess* and *Mavra*, which were composed

just in time for the 1922 Ballets Russes season, *Renard* was an older work; Stravinky's earliest sketches for the project date from early 1915, and in 1916 he committed to completing the work as a commission for the Princesse, guaranteeing her control over performances of the work for five years—including control over its premiere.[130] When the *Sleeping Princess* was reduced to a single act from a full ballet, however, she generously relinquished the rights to the premiere, allowing the work to debut at the Opéra, filling the space left in the Ballets Russes' bill. Her largesse went beyond this gesture; she also covered the debts accrued by Diaghilev's troupe during the 1922 season, and, most importantly, she worked her family connections in an effort to assure that the Ballets Russes would never again face circumstances so dire as those they confronted in the winter of 1921.

The Polignac family, as we have seen, made many good marriages, but none compared to the match the Princesse's nephew Pierre struck with Princess Charlotte, the eldest daughter in Monaco's royal Grimaldi family, in 1920. As Prince Pierre of Monaco, he was a devoted patron of the arts, among other things founding the Monaco Lecture Society in 1924 and supporting the development of a contemporary art museum. When his aunt approached him in late 1922 with the proposal that he help to establish the Riviera principality as home base for the Russian troupe, his agreement was assured. Under the arrangement that was subsequently negotiated, the Ballets made Monte Carlo its headquarters from that season forward until Diaghilev's death in 1929, traveling to Paris, London, and other destinations as necessary. As Garafola has shown, the contracts that made this a permanent arrangement provided a significant subsidy for the troupe: over 1.4 million French francs were guaranteed to the company in 1924, for example, including funds for travel and new works.[131] Ensconced in luxe, supported by the Société des Bains de Mer—the group that controlled the casino—and guaranteed a subvention from the principality, Diaghilev's troupe became a central attraction for the international elites who gravitated to the Côte d'Azur.[132]

The Ballets Russes first performed in Monaco in 1911, and returned to the area regularly thereafter, contributing to the considerable Russian presence along the Riviera.[133] As Mary Blume has noted in her history of the region, the Russian colonies dated to the beginnings of tourism in the area in the early nineteenth century and by the 1920s were "an essential part of the cosmopolitan society that made the Côte d'Azur distinctive."[134] In the spring of 1923, as the Ballets Russes recovered from its tumultuous London and Paris seasons, the group settled into its new residency, presenting a varied program at the Monte Carlo Opera House. Somewhat dis-

engaged from the productions, however, Stravinsky was throughout this run putting the final touches on the sole new work that the Ballets would produce that summer in Paris: *Les Noces*.

Stravinsky had begun to work on this project in 1914; the following April, critic Vladimir Derzhanovsky announced the forthcoming "new and specifically Russian type of spectacle," which would combine elements of opera and ballet to convey the essence of a Russian peasant wedding, a representation of "folk festivities."[135] As the work finally came to fruition nearly a decade later, Nijinska devised the choreography and Natalia Goncharova produced costumes and set designs of "the utmost simplicity" and uniformity; the women wore brown pinafores and white blouses, the men were dressed in brown pants and white shirts. In the end, as Drue Fergison has observed, the three artists achieved a "compelling unity of musical, choreographic, and visual elements," creating a look that, "with its sculptural and architectural massings, stylized movements from the vocabulary of Russian folk dance, and uniform brown and white costumes inspired by Russian peasant dress, underscored the communal, ritualistic, austere, and mechanistic aspects of both libretto and score."[136] Stravinsky's score, with music for an austere ensemble of four pianos and percussion (a constellation, as we have seen, arrived at during his stay chez Chanel) and texts drawn from Russian popular literature, set the tone for the work; Nijinska recalled being moved profoundly when she first heard the music, and maintained that she took her inspiration for the choreography from the chant-like melodies, repetition, fragmentation, and evocations of everyday life present in the score.[137]

The Princesse de Polignac hosted the private premiere of *Les Noces* at her Paris salon on 11 June 1923; unusually, the entire company was in attendance, and the audience would have included many of the same elites and aristocrats who were making the rounds of the *pleine saison*—fresh from the 30 May Beaumont Bal Baroque. Serge Lifar, who was present, recalled the evening as a magical occasion:

> Stravinsky was conducting. Round Diaghilev were Nijinska, all our leading artists, and the whole musical world of Paris. I sat on the floor, absorbing the music and rhythms, and floating away, as it were, into the inner world of the ballet. The powerful sounds enthralled me, swept me on, thrilled me with their mystery, their timelessness and illimitable space, their wild Russian upsurge . . . the Princesse de Polignac embraces Stravinsky, and loads us all with attentions. We, Diaghilev, Stravinsky, the leading actors, the corps de ballet, all are overwhelmed with a happiness that brings us close to each other.[138]

A larger audience of high-society figures assembled the following night at the Théâtre de la Gaîté-Lyrique for the *répétition générale,* and Jeanne Robert Foster covered the event for *Vogue.* In her report on "La Grande semaine de Paris," she included special notice of the "Gala Diaghilev," a benefit for Russian charities at which women in the audience wore "a profusion of diamonds and pearls on their décolletage," and diamonds in their hairdos:

> Imagine: the Marquise de Ludres is to the right, high up in one of the first boxes, the Countess de Beaumont sits in a box across the way . . . a little further on, it's Gabrielle Chanel, all in white, glistening with pearls . . . Mme Sert, the Grand-Duchess Marie, the Countess de Chevigné, and then, and then . . . as at the Opéra, this evening it's le Tout Paris and le "Tout Etranger."

Not limiting her commentary to the clothes and coiffures of the assembled ladies, Foster assessed the ballet, which, she reported to readers, under the guise of a "most classical form (likened by some to a modern Bach) presented us with an unexpectedly simple décor, an obstinate black and white." As for Stravinsky's music, even given the theater's less than ideal acoustics, it was "astonishing":

> Is it snobbism on my part? Did I truly comprehend the beauty of the dissonances created by an orchestra deprived of strings? My God, yes, I understood: I won't say that it will not be necessary to return again to hear these sounds of a penetrating modernism, but already their impact is strong, captivating. In order to carry them away and to savor their memory . . . I left before the performance of the final ballet. "Maginficent": Superb!" . . . I heard these exclamations right and left as I made my way through the crowd gathered in the hallways during the intermissions.[139]

In the same issue, *Vogue* published a review of *Les Noces,* complete with photographs and illustrations by Beau Brummel artist André Marty, under a heading that declared simply "Stravinsky's Noces Is a Tremendous Success." "Once again," the anonymous reviewer (probably Foster) began, "the magician Stravinsky has paraded in front of our eyes his fairy wand and revealed to us a new phase of his talent":

> The style of this multiform genius is to never be satisfied with one of his creations, it is to possess a brain perpetually in the throes of excitement and faculties of enthusiasm that make him modify almost every hour the look that he casts over the sonorous world. . . . Wouldn't many musicians, after the unanimous success of *Petrouchka,* [continue down that path]? Stravinsky, one year later, revealed *Le Sacre,* that

sound world, moving like a world in gestation, and placed on the stage of the Champs-Elysées rhythmic thrusts of shoulders and torsos of those primitive dancers. And then came *Le Rossignol*, and then *Renard* and then *Mavra*, all absolutely opposite manners of being and feeling. Today, it's *Les Noces*, and with Gontcharova's clear décor and choreography by Nijinska, one can hear the most clear and clairvoyant kind of music. The suppression of the orchestra, strings, woodwinds, brass: only percussion instruments: four pianos and an army of drums, tambours, glockenspiel, triangles, crotales. Voices above this: men's voices, women's voices. Return to the very essence of the musical cell, dissociated completely from sonorous effects: the brevity of an original theme, such as a primitive ancestor might have invented, an ardor that manifests itself by an explosion of a combination of sonority, and yet, no sentimental effect . . . but straight lines, a synthesis of melodies forgotten over centuries of culture. In the end, what is the most stunning tour de force, above all when one dreams of the subject of ballet, is the suppression of rhythm, as it is conceived in schools or in our ears, trained by school. As a consequence, internal rhythm exists in every musical moment and is translated, beyond any question of strong time and weak time, by the simple friction of vocal sounds against the waves of piano and percussion. Stravinsky's triumph is unforgettable. For those of us who have followed the Ballets Russes since their arrival in Paris in 1908, we have never seen such a happy ardor and not only in the expensive seats, where one could always expect a self-satisfied snobbism, but in the cheap seats, which erupted, where one could hear hands beating in time with applause as well as shouting. The Ballets Russes season of 1923 must thus be considered among the most glorious; perhaps we shall say that it was the most glorious of all.[140]

For *Vogue*, the disappointments of the 1922 Ballets Russes season were eradicated with *Les Noces*. The work succeeded where—despite Diaghilev's best efforts—*The Sleeping Princess, Mavra,* and *Renard* could not, mirroring the stripped down simplicity that defined haute couture and high style—the same shift epitomized by Chanel's absolute dominance of fashion and Poiret's marginalization from it, which began in earnest in 1923. In this regard, the performances of *Les Noces* marked a critical point in the development of a modernist aesthetic that depended on interactions of art and fashion, a moment of deep correspondence that did not simply reinforce or reflect existing affinities but created new possibilities and illuminated previously unforeseen connections in both spheres.

The Ballets Russes followed this success with an ambitious Monte Carlo season in the spring of 1924, which Diaghilev billed as a "Grand French Festival." There was no work by Stravinsky on the bill; instead, the programs

# LES NOCES
## DE STRAVINSKY ONT
## REMPORTÉ
## UN FORMIDABLE
## SUCCÈS

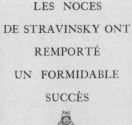

Photos Abbe

*Les costumes dessinés par Mme Gontcharova pour " Les Noces " de Stravinsky s'accordent de la plus étonnante façon à la musique*

*La fiancée avec sa chemisette de toile blanche, sa longue et simple robe de serge noire et ses cheveux sans fin, était Mlle Tchernicheva*

UNE fois de plus le magicien Stravinsky a promené devant nos yeux sa baguette féerique et nous a révélé une nouvelle phase de son talent. Le propre de ce génie multiforme c'est de ne jamais se complaire dans une de ses créations, c'est de posséder un cerveau perpétuellement en ébullition et des facultés d'enthousiasme qui lui font modifier presque à chaque heure le regard qu'il jette sur le monde sonore. Il y a assez de derviches-tourneurs dans la musique, il y a assez de bouddhas se contemplant éperdument en littérature pour que nous n'accompagnions pas de paroles admiratives et enthousiastes les incessants renouvellements de celui qui débuta dans l'art par le feu d'artifice de " L'Oiseau de Feu ".

Y aurait-il eu beaucoup de musiciens, après le succès unanime de Petrouchka, qui ne se seraient laissé griser par l'encens brûlé devant eux par mille thuriféraires ? Stravinsky, l'an d'après, révèle le " Sacre du printemps ", cette pâte sonore, mouvante comme un monde en gestation, et jette sur la scène des Champs-Élysées les houles rythmiques d'épaules et de torses de ses primitifs danseurs. Et puis, ce furent " le Rossignol ", et puis „ le Renard " et puis " Mavra ", toutes manières d'être et de sentir absolument opposées.

Aujourd'hui c'est " Noces ", et dans un décor clarifié de Mme Gontcharova, sur une chorégraphie de la Nijinska, se font entendre les musiques les plus pures et les plus clairvoyantes. Suppression de l'orchestre, des cordes, des bois, des cuivres : simplement les instruments de percussion : quatre pianos et une armée de timbales, de tambours, de glockens-piel, de tambours de basque,

*La Nijinska a conçu pour la chorégraphie de " Noces " des groupements et cascades de têtes d'un réalisme inoubliable*

de triangles, de crotales. Des voix en dessus : voix d'hommes, voix de femmes. Retour à l'essence même de ce qui constitue la cellule musicale, dissociation complète des effets sonores ; la brièveté d'un thème original, tel qu'un ancêtre primitif eût pu le concevoir, une ardeur qui ne se manifeste que par l'explosion d'un rapprochement de sonorité, et encore, nul effet sentimental produit par l'alanguissement d'une courbe chantante, mais des lignes droites, synthèse des mélodies oubliées pendant des siècles de culture. Enfin, ce qui est peut-être le plus étonnant tour de force, surtout lorsqu'on songe qu'il s'agit d'un ballet, suppression du rythme, tel qu'il est conçu dans les écoles ou par nos oreilles imprégnées d'enseignements d'école. Par conséquent, rythme interne existant dans chaque moment musical et qui se traduit, en dehors de toute question de temps fort et de temps faible, par le simple frottement des sonorités vocales contre les ondes des pianos et des percussions.

Le sujet est une noce ou plutôt ce n'est pas

*Une des plus émouvantes scènes du ballet est l'Adieu de la fiancée à ses amies et le drame symbolique des cheveux nattés, attributs virginaux*

une noce, c'est toutes les noces, comme elles doivent exister chez les êtres simples : les adieux de la fiancée à ses amies, du fiancé à ses amis, le repas rituel, les danses, la joie crépitante des assistants, enfin l'entrée des jeunes époux dans la chambre nuptiale, sous le foudroiement des crotales giglant leurs dernières fusées sonores. Le triomphe de Stravinsky fut inoubliable. Pour nous qui avons suivi les Ballets russes depuis leur apparition à Paris, en 1908, nous n'avons jamais vu telle ardeur heureuse et non seulement aux places chères, où l'on peut toujours supposer le bienfaisant snobisme, mais parmi les places populaires, pleines à éclater, où l'on ne distinguait d'en bas que des mains frappant en cadence pour applaudir, que des bouches ouvertes pour acclamer.

La saison des Ballets russes de 1923 doit donc être placée parmi les plus glorieuses ; peut-être même devrions-nous dire qu'elle fut la plus glorieuse de toutes. En effet, la troupe de Diaghilev vient de se compléter d'un grand nombre de jeunes danseurs moscovites. Elle possède une cohésion qu'elle n'avait certainement pas ces dernières années. Il y manque sans doute l'inoubliable figure d'un Nijinski, d'un Miassine, d'une Karsavina, mais peut-être justement parce qu'il n'y est plus d'étoile dominatrice, ces jeunes hommes, ces jeunes femmes déploient un zèle inaccoutumé, une activité joyeuse ; et le bondissement aérien des corps, la souplesse sinueuse des reins, l'agitation des pieds, le remuement des bras souples, s'emmêlent avec une ingéniosité et une verve que nous n'avions plus accoutumé de rencontrer dans les Ballets Russes.

La preuve de ce que nous avançons c'est que

(Suite page 62)

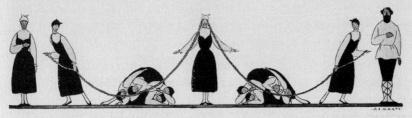

ALMASY

FIGURE 95. "Stravinsky's *Le Noces* Registers as a Terrific Success," from *Vogue* (Paris), 1923

showcased Satie and Les Six, featuring new ballets by Poulenc and Auric (Milhaud's *Le Train bleu*, as we have seen, was reserved for the summer season in Paris), as well as revivals of operas by Charles Gounod—*La Colombe, Philémon et Baucis, L'Education manqué*, and *Le Médecin malgré lui*—with new recitatives by (respectively) Poulenc, Auric, Milhaud, and Satie. All of the elements of fashion were in place: the Gounod operas, while composed in the mid-nineteenth century, harked back for their subjects to the *ancien régime*, and notably to Molière, who was also the source for Auric's *Les Fâcheux*, while Poulenc's *Les Biches* was an erotically charged divertissement set in a contemporary drawing room and featuring modern-dress costumes by Marie Laurencin. And yet, the works fell flat: Satie fled the scene, memorably characterizing the productions as "subtle, suburban, and subconscious." *Vogue* paid them no attention at all. Not the culmination of the fashionable modernism that has been the subject of this study, as is sometimes asserted, the 1924 Ballets Russes season in Monte Carlo instead marked the beginning of its wane. In June, it was Etienne de Beaumont's *Soirée de Paris* series at the Cigale Theater that drew fashionable crowds and *Vogue*'s attention, not least because the magazine itself had become subject matter for the ballet. In the end, however, the Cigale productions marked the passing of fashion's intense association with modernist music: Stravinsky was moving in new directions, premiering his *Concerto for Piano and Winds* at the Opéra on 22 May; Satie was aligning himself with the more radical factions of the avant-garde, about to enter into a collaboration with Francis Picabia on the experimental ballet *Relâche* and its filmed "Entr'acte." Within a year, by time of the great Art Déco exhibition in Paris during the summer of 1925, fashion and modernist music had parted ways, and the chic shunned the musical events planned for the exhibit, electing instead to hear the more impromptu performances of jazz and dance music taking place in the various fashion pavilions arrayed along the Seine and down the Champs de Mars. It was the end of a remarkable alliance.

# Notes

1. "Palmyre reçoit sa famille." The name Palmyre alludes to Madame Palmyre, one of the most important early *couturières* in France, who was active during the Second Empire.

2. This connection has never been systematically explored. Two classic studies that survey the history of the press in France include discussion of periodicals, but devote limited attention to either the women's press or the music press; see Hatin, *Histoire politique et littéraire de la presse en France*; and Bellanger et al., *Histoire générale de la presse française*. The few studies that focus on musical coverage in the periodical press include Miller, "The Mirror of Ages Past"; and Koza, "Music and References to Music in *Godey's Lady's Book*."

3. *Le Mercure Galant* grew out of *Le Mercure Français*, which was founded in 1611 and is widely considered to be the first French periodical publication. After appearing under a number of titles, it remained in circulation as the *Mercure de France* from 1724 to 1965 (see Vincent, *Anthologie des nouvelles du Mercure Galant*; and Moureau, *Le Mercure Galant*). Fashion coverage in the *Mercure Galant* is considered in DeJean, *The Essence of Style*, 63–69.

4. Hatin, *Histoire politique et littéraire de la presse en France*, 1:382–84. The range of topics covered in the publication is suggested by the term *galant*, which has its root in the fourteenth-century verb *galer*, or "to amuse oneself" (see Rey et al., *Dictionnaire historique de la langue française*, s.v. galant).

5. The weekly *Gazette de France*, considered to be the first news magazine, was founded in 1631 and reported on current events in France and Europe; the *Journal des Savants*, founded in 1665, published information about European literature and the arts and sciences, as well as works by leading figures, including epigrammist Jean-Baptiste Rousseau and mathematician Bernard Le Bovier de Fontenelle (see Bellanger et al., *Histoire générale de la presse française*, 1:85–95, 126–37).

6. See Robert, "La musique à travers *Le Mercure Galant*."

7. Two chansons per week were printed according to the terms of a contract agreed to by Donneau de Visé and Thomas Corneille, who was the government official responsible for overseeing the magazine's royal privilege (see Moureau, *Le Mercure Galant de Dufresny,* 41–49, and Annex 3: "Bibliographie des chansons et vaudevilles du *Mercure,*" 104–13).

8. The musical works published in the *Mercure Galant* included over twenty pieces believed to have been Dufresny's compositions, the most famous of which was the vaudeville entitled "Lendemain" (see Moureau, *Le Mercure Galant de Dufresny,* 45–46).

9. See Bellanger et al., *Histoire générale de la presse française,* 1:96–99, 119–21.

10. Gaudriault, *La Gravure de la mode féminine en France,* 24.

11. Jean Bérain (ca. 1637–1711), designer to Louis XIV, created the illustrations, which were engraved by Jean Le Pautre (1618–82). On Bérain, see Tollini, *Scene Design at the Court of Louis XIV.*

12. For an overview of these publications, see Gaudriault, *La Gravure de la mode féminine en France,* 34–42.

13. See Bellanger et al., *Histoire générale de la presse française,* 1:319; also Delpierre, *Dress in France in the Eighteenth Century,* 144.

14. Quoted in Roche, *The Culture of Clothing,* 473.

15. Gelbart, *Feminine and Opposition Journalism in Old Regime France,* 165.

16. In its forty-one-year lifespan, the magazine printed over 3,600 illustrations by well-known artists, including J. Horace Vernet (see Gaudriault, *La Gravure de la mode féminine en France,* 45).

17. Images of women making music were popular across the visual arts during this era; among the most famous examples is Maurice-Quentin de La Tour's portrait of the Marquise de Pompadour, painted in 1755, which depicts the Marquise, attired in a fashionable *robe à la française,* studying a musical score.

18. In 1816 Paris had only two lithography shops, but by 1847 this number had grown to over thirty (see Farwell and Solomon-Godeau, *The Image of Desire,* 2).

19. Gaudriault, *La Gravure de la mode féminine en France,* 50–51.

20. *Le Conseiller des Dames,* for example, published texts by Victor Hugo and Honoré de Balzac alongside its sumptuous fashion plates and chronicles of Parisian entertainments (see Sullerot, *La Presse féminine,* 29).

21. Significant segments of the censorship laws were reimposed in 1835; relaxed again in 1848, they were restored nearly fully with the establishment of the Second Republic in 1852. On this history, see Goldstein, *Political Censorship of the Arts and the Press in 19th Century Europe.*

22. Gaudriault, *La Gravure de la mode féminine en France,* 64–65.

23. *La Mode* remained in circulation from 1829 to 1862; Balzac's *Traité de la vie élégante* appeared in the magazine between October and November 1830.

24. The Goncourts are quoted in Steele, *Paris Fashion*, 100. For Baudelaire's essay, see his "The Painter of Modern Life."

25. Mallarmé, *Oeuvres complètes*, 705–847; see also Lecercle, *Mallarmé et la mode*.

26. For a discussion of the wardrobe merchants, see Perrot, *Fashioning the Bourgeoisie*, 36–52.

27. Less happily, this sector of the market expanded due to the constant lowering of manufacturing costs, a shift made possible in part by the exploitation of seamstresses and other fashion-trade workers (see Lipovetsky, *The Empire of Fashion*, 57).

28. On the department store, see Tiersten, *Marianne in the Market*; and Miller, *The Bon Marché*.

29. Jules Janin in *Revue et gazette musicale*, 26 February 1837, quoted in Johnson, *Listening in Paris*, 264.

30. For a detailed discussion of the issues related to the "women at the piano" theme, see Eyerman, "The Composition of Femininity"; see also Eyerman, "Playing the Market."

31. See Neuls-Bates, *Women in Music*, 179.

32. James Huneker, "The Eternal Feminine," *Overtones* (New York: Scribner's, 1904), 291–93; quoted in Neuls-Bates, *Women in Music*, 182.

33. *Le Journal de Musique* remained in circulation from 1764 to 1768, while *Le Journal de Musique, Historique, Théorique et Pratique* lasted only through its inaugural year, 1770.

34. These included Rameau's *Nouvelles réflexions sur la demonstration du principe de l'harmonie* (1752) and Jean-Benjamin de Laborde's *Essai sur la musique des anciens* (1770). On music theory in France during the eighteenth century, see Christensen, *Rameau and Musical Thought in the Enlightenment*; Cowart, *French Musical Thought*; and Verba, *Music and the French Enlightenment*.

35. For a study of Fétis and the *Revue Musicale*, see Bloom, "François-Joseph Fétis and the *Revue Musicale*; see also Bloom's summary article, "A Review of Fétis's *Revue Musicale*." The new title was adopted in 1835 following a merger of the magazine with music publisher Maurice Schlesinger's *La Gazette Musicale de Paris*.

36. Ellis, *Music Criticism in Nineteenth-Century France*, 2.

37. For a general study of the music press in this period, see Goubault, *La Critique musicale dans la presse française*.

38. Ibid., 76.

39. On *Mir Iskusstva* and the contemporary periodical press, see Acocella, "The Reception of Diaghilev's Ballets Russes," 239–50.

40. Garafola, *Diaghilev's Ballets Russes*, 273–99.

41. The supplement was published from 1908 to 1914, 1919 to 1921, and, under the new name *Le Théâtre et Comeodia Illustré*, from 1929 to 1936.

42. Garafola, *Diaghilev's Ballets Russes*, 260–61.

43. *L'Art d'Etre Jolie,* launched at the turn of the century, was one of the first fashion magazines to use photography and to use portraits of contemporary society beauties, who would have been recognized by most readers.

44. Vanina, "La Mode actuelle au Théâtre et à la Ville," *Comoedia Illustré,* 1 June 1909, 319.

45. Quoted in Steegmuller, *Cocteau,* 75.

46. Brunhoff, *Collection des plus beaux numéros de Comoedia Illustré.*

47. Victor Debray, "La Saison russe au Châtelet," *Le Courrier Musical,* 1 June 1909, 401; Debray, "La Saison russe," *Le Courrier Musical,* 18 June 1909, 415.

48. "En dinant," *Le Courrier Musical,* 15 June 1913, v–viii.

## CHAPTER 2

1. Gabriel Mourey, "Les Robes de Bakst," *La Gazette du Bon Ton,* June 1913, 165.

2. "The Bakst-Paquin Combination," *Vogue* (New York), 15 June 1912, 29.

3. Coleman, *The Opulent Era,* 33.

4. On such labels, see Musée de la Mode et du Costume, *Paul Poiret et Nicole Groult,* 242–43; see also Troy, *Couture Culture,* 24–28.

5. On Worth (1826–95), see Marly, *Worth;* and Saunders, *The Age of Worth.*

6. White, *Poiret,* 14.

7. On Doucet (1853–1929), see Chapon, *Mystère et splendeurs de Jacques Doucet.*

8. Poiret, *King of Fashion,* 40.

9. Coleman, *The Opulent Era,* 152.

10. Poiret, *King of Fashion,* 31.

11. Poiret designed a coat for Réjane's appearance in the play *Zaza* in 1898; for the fifty-six-year-old Bernhardt's lead role as Napoleon's adolescent son in Maurice Rostand's play *L'Aiglon,* he dressed the actress in men's military garb. *L'Aiglon* in particular brought attention to Poiret, as it was performed at the 1900 Exposition Universelle (see Musée de la Mode et du Costume, *Paul Poiret et Nicole Groult,* 177).

12. Quoted in White, *Poiret,* 22.

13. Proust, *Remembrance of Things Past,* vol. 1, *Swann's Way,* 151.

14. Boucher, *Histoire du costume en occident des origines à nos jours,* 373.

15. Quoted in White, *Poiret,* 41.

16. Quoted in Madame F., "An Interview with Monsieur Worth," *Vogue* (New York), 1 March 1912, 25.

17. For an appraisal of the Merveilleuses in historical context, see Musée Carnavalet, *Au temps des merveilleuses.*

18. Quoted in Anne Rittenhouse, "The Prophet of Simplicity," *Vogue* (New York), 1 November 1913, 43.

19. "Poiret on the Philosophy of Dress," *Vogue* (New York), 15 October 1913, 41.

20. Poiret, *King of Fashion*, 93.

21. Quoted in White, *Poiret*, 23.

22. This change was geographically limited, initially affecting only women living in northern parts of the country, and it was slow; women did not gain the right to vote in national elections in France until 1945.

23. International feminist congresses met subsequently in Paris in 1892, 1896, and 1900; the early woman's movement included such organizations as the National Council of French Women (CNFF), founded in 1900, and the French Union for Women's Suffrage (UFSF), founded in 1909. On the history of the feminist movement in France, see Fraser and Bartky, *Revaluing French Feminism*.

24. This change was possible due to the implementation of the so-called Sée law, named for the Republican legislator Camille Sée, which opened state-sponsored secondary schools to women (see Mosconi, *Femmes et savoir*; and Clark, *The Education of French Schoolgirls*).

25. Wollen, *Raiding the Icebox*, 5.

26. Poiret cleared his name in the proceedings, but the suit did serious damage to his business and reputation. This affair is detailed in Silver, *Esprit de Corps*, 167–82.

27. Poiret, quoted in Cydalise, "La Culotte et la femme," *Madame & Monsieur*, 10 March 1911, 1466.

28. White, *Poiret*, 14–15.

29. See Wollen, *Raiding the Icebox*, 2–4.

30. Larzul, *Les Traductions françaises des Mille et une nuits*, 33.

31. Cornu, "L'Art de la robe," *Art et Décoration*, April 1911, 112.

32. See *Art et Décoration* 29, April 1911, 105; see also figures 36 and 38, this volume.

33. Quoted in White, *Poiret*, 52–53.

34. On the founding of the Martine atelier, see Poiret, *King of Fashion*, 161–66.

35. White, *Poiret*, 118.

36. Duncan, *My Life*, 261.

37. Quoted in White, *Poiret*, 132.

38. An exploration of the theatrical aspects of Poiret's work may be found in Troy, *Couture Culture*, 80ff.

39. "Vogue Summarizes the Mode," *Vogue* (New York), 1 November 1913, 35.

40. Lepape and Defert, *The Art of Georges Lepape*, 54.

41. Lucie Delarue-Mardrus, *Femina*, 1 August 1911; quoted in Musée de la Mode et du Costume, *Paul Poiret et Nicole Groult*, 242–43.

42. Wollen, *Raiding the Icebox*, 2.

43. Poiret, *King of Fashion*, 201–2.

44. Ibid., 202.

45. Ibid.

46. On *Les Festes de Bacchus,* including the complete text, see Canova-Green, *Benserade,* 54–89.

47. Iribe, *Les Robes de Paul Poiret racontées par Paul Iribe.* This work launched Iribe's career, in Apollinaire's words, as "the prince of fashion design" (see Guillaume Apollinaire, "Current Events: At La Belle Edition," *Les Arts à Paris,* 15 July 1918; quoted in *Apollinaire on Art,* 468).

48. In the typical *pochoir* process the original drawing is transferred to a wood block; the engraver cuts the block in order to leave the contours of the image in relief. This image, once inked, serves as the basis for a series of stencils, which are cut for each area of color. The paint colors of the original artwork are analyzed and reproduced as exactly as possible, with a match of pigment and density, and the new paints are applied by hand to the black-and-white outlines (see Griffiths, *Prints and Printmaking,* 148). *Pochoir* had been revived by the Art Nouveau movement, in part because late-nineteenth-century printmakers became interested in similar Japanese techniques for stenciling on cloth. In Art Nouveau interior design, *pochoirs* were especially favored for the creation of large-scale wall murals.

49. Iribe emphasized these qualities by presenting his models in vivid color while rendering the minimalized backgrounds—reduced to walls, windows, and occasional pieces of furniture—in black and white.

50. Lepape, *Les Choses de Paul Poiret vues par Georges Lepape.*

51. Lepape and Defert, *The Art of Georges Lepape,* 67.

## CHAPTER 3

1. Robert Burnand, "Gazettes de Modes," *Art et Industrie,* April 1926, 46.

2. Lepape and Defert, *The Art of Georges Lepape,* 69.

3. Chase and Chase, *Always in Vogue,* 110.

4. Henry Bidou, "Le Bon ton," *Gazette du Bon Ton,* November 1912, 1–4.

5. Henri Bidou, "Au lecteur," *Gazette du Bon Ton,* Specimen copy, 1912, n.p.

6. The expression originated as "le bon ton" in 1751 and shifted to "de bon ton" in the early 1820s but consistently connoted "good manners in a given situation" (see Rey et al., *Dictionnaire historique de la langue française,* s.v. ton).

7. Robert Burnand, "Gazettes de Modes," *Art et Industrie,* April 1926, 47.

8. Georges Lepape, quoted in Lepape and Defert, *The Art of Georges Lepape,* 72.

9. Henri Bidou, "Le Bon ton," *Gazette du Bon Ton,* November 1912, 1. Bidou's exposure to the works of these artists most likely came via another fashion publication, the groundbreaking eighteenth-century book *La Gallerie des modes,* which included engravings of fine art images that highlighted fashion (see Roche, *The Culture of Clothing,* 15).

10. René Blum, "Le Goût au Théâtre," *Gazette du Bon Ton,* January 1912, 22.

11. Quoted in Steegmuller, *Cocteau,* 72.

12. Beaton, *The Glass of Fashion,* 108.

13. Acocella, "The Reception of Diaghilev's Ballets Russes," 232.

14. Blum commented favorably on the design of the Théâtre des Champs-Elysées, likening it to "a second grand opera" (see Lise-Léon Blum, "Le Goût au Théâtre," *Gazette du Bon Ton,* March 1913, 214). On the perception of the architecture as "Germanic," see Abram, *Le Théâtre des Champs-Elysées.*

15. Lise-Léon Blum, "Le Goût au Théâtre," *Gazette du Bon Ton,* June 1913, 246.

16. Lise-Léon Blum, "Le Goût au Théâtre," *Gazette du Bon Ton,* July 1914, 253.

17. Ibid.

18. Jean-Louis Vaudoyer, "Les dernières oeuvres de Mme Karsavina," *Gazette du Bon Ton,* July 1914, 237.

19. "Beau Brummels of the Brush," *Vogue* (New York), 15 June 1914, 35.

20. On Cormon (1845–1924), a student of Alexandre Cabanel, see Mainardi, *The End of the Salon,* 93–94; see also Nochlin, *Realism,* 250 n. 9.

21. "Beau Brummels of the Brush," *Vogue* (New York), 15 June 1914, 37.

22. Henri Bidou, "Au lecteur," *Gazette du Bon Ton,* Specimen copy, 1912, n.p.

23. The relationship of Cubism to Art Deco is considered in Crow, *Modern Art in the Common Culture,* 32–37.

24. Kirk Varnedoe, "Words," 39.

25. Picasso created illustrations for the magazine *Frou-Frou* and the newspaper *Gil Blas* around the turn of the century, while Duchamp provided drawings for *Le Rire.* On this phase of Picasso's career, see Daix, "Quand Picasso dessinait pour la presse 'parisienne'"; on Duchamp, see Tomkins, *Duchamp,* 26.

26. Templier, *Erik Satie,* 55–57.

27. Quoted in ibid., 32.

28. Satie, *Satie Seen through His Letters,* 27–28.

29. Gross's involvement is documented in her correspondence with Satie. In a letter of 26 February 1914, the composer reports that he has seen Vogel and "he told me what you [Gross] had done." Gross later annotated this letter, indicating that it "proved by friendly intervention with Vogel, that he commissioned the music for *Sports et divertissements*" (see Satie, *Correspondance presque complète,* 199, 861–62).

30. *Femina,* 1 April 1913, 179.

31. Martin provided little commentary about his art or artistic views, and neither a monograph nor a catalogue raisonnée documents his work. Two small books provide select details regarding his life and work (see Valotaire, *Charles Martin;* and Dulac, *Charles Martin*). Articles covering his work include George Barbier, "Charles Martin," *La Renaissance de l'art français et des industries de*

*luxe*, 1927, 194–98; Barbier, "Maître ES–Jeux et divertissements," *Art et Industrie*, May 1926; Marcel Astruc and Michel Dufet, "Les Décorations de A. Groult et Charles Martin," *Les Feuillets d'Art*, December 1925–January 1926; and Léon Moussinac, "Charles Martin," *Art et Décoration*, January 1923, 4–32.

32. Léon Moussinac, "Charles Martin," *Art et Décoration*, January 1923, 4.

33. George Barbier, "Charles Martin," *La Renaissance de l'art français et des industries de luxe*, 1927, 195.

34. Both of these designs were made famous in photographs by Edward Steichen, which were published in the April 1911 issue of the magazine *Art et Décoration*.

35. "Le Golf," *Femina*, 15 May 1913, 267; "La coupe Femina," *Femina*, May 1921, 36.

36. "Vogue Summarizes the Mode," *Vogue*, 1 November 1913, 37.

37. The dance originated as a parody in which slave couples strutted and kicked in mockery of their masters at plantation gatherings; a cake was awarded to the best performers. For a summary, see Berlin, *Ragtime*, 104.

38. Archer-Straw, *Negrophilia*, 43–44.

39. Sousa's band performed on the Esplanade des Invalides from 6 May to 4 July, 1900, drawing enormous crowds. The concerts featured transcriptions of classical compositions, fantasies based on American music, and Sousa's marches, as well as syncopated dance music. For the programs and Sousa's memoir of the time, see Sousa, *Marching Along*.

40. Included in Satie's sketches for the piece, the comment "perpétuél" was apparently part of his original conception.

41. The decree is quoted in Wehmeyer, *Erik Satie*, 92.

42. André de Fouquières, "Les danses nouvelles: Le Tango," *Femina*, 15 January 1913, 288.

43. Jean-Marie Franc-Nohain [Maurice Etienne Legrand], "Tangomanie," *Femina*, 1 July 1913, 376.

44. "Beau Brummels of the Brush," *Vogue* (New York), 15 June 1914, 35.

45. Debussy's use of *La Marseillaise* as a structural and compositional device is illuminated in Lewin, *Musical Form and Transformation*, 97–159.

46. This commission is first reported in Steegmuller, *Cocteau*, 135. Discussing Valentine Gross's relationship with Satie, he notes that Gross "had been able, during the winter of 1914–15, to have him commissioned to write three songs to be published in the *Gazette du Bon Ton*. For these he received three thousand francs . . . the largest sum of money he had ever seen." Steegmuller cites no source for this information, and it appears to have been the result of confusion: documents in Valentine Gross's correspondence attest to the fact that Vogel paid Satie three thousand francs for *Sports et divertissements*, not for *Trois poèmes d'amour* (see Satie, *Correspondance presque complète*, 861). Recent Satie scholarship has carried forward the inaccurate report that the *Trois poèmes* were published in the December 1914 issue of the *Gazette*; see, for example, Orledge, *Satie the Composer*, 309; and Whiting, *Satie the Bohemian*, 422.

47. The *Gazette* suspended publication after the Summer 1914 issue, which appeared in July; publication resumed with a special Summer issue in 1915, devoted to the coverage of French couture at the Panama-Pacific Exhibition in San Francisco, and then ceased again until January 1920.

48. *Trois poèmes d'amour* was published by Salabert in 1916 and premiered in April that year by Henri Fabert, with Satie at the piano.

49. The other works published were also illustrated; they included the chansons "La Sans-Gêne" (October 1920, 8–9) and "Misère" (27 January 1921, 262–63 ); "Le Fard" (13 January 1921, 228–29), and "Trouble de Coeur" (May 1921, 535–36) by Lully; and "La Vie champêtre," by Aubert (2 June 1921, 607–9). Illustrations were by *Gazette du Bon Ton* regulars André Marty and Maggie Salzedo. *Danseuse* was published by Salabert in 1921, without illustration, as the last of Satie's *Quatre petites mélodies*.

50. Satie's score appears in *Les Feuillets d'Art* 2, no. 1 (September 1921): 51.

51. Milhaud, *Etudes*, 42.

CHAPTER 4

1. Another sister, Nicole Groult, was also a fashion designer, and was married to the artist André Groult (see Musée de la Mode et du Costume, *Paul Poiret et Nicole Groult*, 32–39).

2. For a perspective on Granados by an early-twentieth-century French critic, see Collet, *Albeniz et Granados*; see also Hess, *Enrique Granados*; and Clark, *Enrique Granados*.

3. On Astruc, see Garafola, *Diaghilev's Ballets Russes*, 277–79.

4. See Steegmuller, *Cocteau*, 82–83.

5. On the *Midsummer Night's Dream* project, see Mattis, "Theater as Circus."

6. "Vernissage cubiste," *Cri de Paris*, quoted in Klüver and Martin, *Kiki's Paris*, 222 n. 4.

7. See Roland-Manuel, *Erik Satie*. This concert, according to Cocteau, led to the ballet *Parade*, for having heard a performance of Satie's *Trois morceaux en forme de poire* he was inspired to seek out the composer as a collaborator (see Steegmuller, *Cocteau*, 146). The date of the concert is mistakenly given by Cocteau as April 1915.

8. This evening is recalled in Severini, *The Life of a Painter*, 490.

9. Casas (1866–1932) and Zuloaga (1870–1945) were at the core of the group gathered around Rusiñol (1871–1931). Casas founded the Els Quatre Gats Café in Barcelona, which was the meeting place from 1897 to 1903 for the group of modernist Catalan artists that included Picasso. Prior to founding the café, Casas lived in Montmartre with Miguel Utrillo. On the relationship of the café to the Montmartre cabarets, see Cate, "Fumism and Other Aspects of Parisian Modernism in Picasso's Early Drawings."

10. Quoted in Satie, *Ecrits*, 158.

11. Quoted in Satie, *L'Ymagier d'Erik Satie*, 65.

12. Quoted in Satie, *Ecrits*, 240. Perhaps the most famous of their interactions was Satie's spontaneous collaboration with Man Ray in the creation of the artist's first French ready-made art object, the iron studded with tacks titled *Cadeau* (1921) (see Ray, *Self Portrait*, 115).

13. The première of *Le Fils des étoiles* was held at the fashionable Durand-Ruel gallery in conjunction with the first so-called Salon Rose + Croix, which included an art exhibition as well as performances of music and drama expressive of the Rosicrucian ideology. Featured artists included the minor Symbolist painters Carlos Schwabe and André Séon. Satie's works featured prominently at the Salon, since from 1890–91 he was "official composer" to the French Rosicrucians, having been so appointed by the sect's leader, "Sâr" Joseph Péladan. An ardent Wagnerian, Péladan promoted a musical aesthetic grounded in leitmotif technique and chromatic harmonies, a taste which Satie obliged only briefly and half-heartedly before breaking with the sect in 1892. On this period in Satie's career, see Gowers, "Satie's Rose-Croix Music." The premier of *Musique d'ameublement* took place in June 1922 at the Galerie Barbazanges, adjacent to Poiret's atelier, in connection with poetry readings and a display of children's art.

14. "A New Salon for Unique Fashions," *Vogue* (New York), 1 October 1912, 47.

15. Musée de la Mode, *Paul Poiret at Nicole Groult*, 31.

16. Severini, *The Life of a Painter*, 161–62.

17. The shows at the Galerie Thomas were mounted in December 1915, 15 March–15 April 1916, and 29 May–15 June 1916 (see Musée Antoine Lécuyer, *Amédée Ozenfant*, 28 n. 23).

18. *Le Mercure de France*, 16 March 1916, 382; quoted in ibid., 20.

19. Arvid Fougstedt, "De allra modernaste Parisutställningarna," *Svenska Dagbladet* (Stockholm), 11 February 1917, 4; quoted in Klüver, *Kiki's Paris*, 76.

20. Atrabile [Amédée Ozenfant], "Expositions," *L'Elan*, 1 January 1916, 18.

21. Ozenfant, *Mémoires*, 94.

22. Severini, *The Life of a Painter*, 160.

23. Discussed in Silver, *Esprit de Corps*, 52.

24. Cocteau, *Le Mot*, January 1915.

25. *L'Elan*, January 1916, 3.

26. Oscar, "A l'Ombre du Laurier," *L'Elan*, 15 May 1915, 3.

27. Amédée Ozenfant, "Notes sur cubisme," *L'Elan*, December 1915, n.p.

28. Ozenfant, *Mémoires*, 94; quoted in Ducros, "Amédée Ozenfant, 'Purist Brother,'" 73.

29. For a more detailed discussion, see Varnedoe, *A Fine Disregard*, 154–55.

30. Ozenfant, *Mémoires*, 54.

31. According to Ducros, the catalog published in *Bulletin Thomas* 1 (15 November 1918) reports that Ozenfant showed twenty works, none of them dated except for two nudes from 1910 and a drawing from 1914 (see Ducros, "Amédée Ozenfant, 'Purist Brother,'" 98 n. 25).

32. Roland-Manuel, *Erik Satie*.

33. Jules Ecorcheville, "Erik Satie," *Revue musicale S.I.M.*, 15 March 1911, 29–40; Michel Calvocoressi, "M. Erik Satie," *Musica*, April 1911, 65–66; Michel Calvocoressi "The Origin of To-day's Musical Idiom," *Musical Times*, 1 December 1911, 776–77.

34. Satie to Roland-Manuel, 3 July 1912, in Satie, *Correspondance presque complète*, 170.

35. As originally defined, *blague* referred simply to a pouch used to carry tobacco, but by the first decade of the nineteenth century the term had passed with new meanings into argot (see Rey et al., *Dictionnaire historique de la langue française*, s.v. blague).

36. Quoted in Weiss, *The Popular Culture of Modern Art*, 120.

37. F. Sarcey, quoted in Du Bled, *La Société française du XVIe siècle au XXe siècle*, 258. For further discussion of the term, see Weiss, *The Popular Culture of Modern Art*, 120. Sarcey was the literary and drama critic for the newspaper *Le Temps*.

38. Satie, *Correspondance presque complète*, 420.

39. Satie, *Satie Seen through His Letters*, 89.

40. Rey et al., *Dictionnaire historique de la langue française*, s.vv. précieux, goût.

41. La Bruyère, *Oeuvres*; Cicero, *De la république*; Cato, *De L'agriculture*, in Jeanroy and Puech, *Histoire de la literature latine*.

42. On Bathori, see Laurent and Tainsy, "Jane Bathori et le Théâtre du Vieux-Colombier."

43. On musical issues related to the Apaches group, see Pasler, "Stravinsky and the Apaches."

44. While the exact dates of these events have been the subject of some debate, it has recently become clear that the span of activities extended from 16–31 July 1916.

45. Quoted in White, *Poiret*, 139.

46. Quoted in Gold and Fitzdale, *Misia*, 174.

CHAPTER 5

1. See, e.g., Cooper, *Picasso Theater*; Steegmuller, *Cocteau*, 145–82; Rothschild, *Picasso's Parade*, 42–47; and Weiss, *The Popular Culture of Modern Art*, 167–92.

2. For a description of the audience reaction, see Guilleminault, *La France de la Madelon*, 209–23.

3. Quoted in Steegmuller, *Cocteau*, 186–87.

4. Marcel Proust, letter of 18 May 1917, quoted in Orledge, *Satie the Composer*, 212.

5. Jean Cocteau, *Théâtre* I (Paris 1957), quoted in Silver, *Esprit de Corps*, 117.

6. Satie, letter to Valentine Gross, 2 Decmber 1916, in Satie, *Correspondance presque complète*, 267.

7. See Rothschild, *Picasso's Parade;* and Weiss, *The Popular Culture of Modern Art.*

8. Weiss, *The Popular Culture of Modern Art,* 5.

9. F. T. Marinetti, "The Variety Theater, 1913," in Apollonio, *Futurist Manifestos,* 126.

10. For a comprehensive discussion of these costumes, see Rothschild, *Picasso's Parade,* 101–208.

11. Ernest Newman, *The Observer* (23 November 1919), quoted in Rothschild, *Picasso's Parade,* 95.

12. The Berlin/Satie meeting in 1922 is reported in Crosby, *Footlights and Highlights,* 186.

13. For a comparison of Satie's "Steamship Ragtime" and Berlin's "That Mysterious Rag," see Perloff, *Art and the Everyday,* 134–40.

14. The borrowing was first noted by Joseph Machlis. See his *Introduction to Contemporary Music,* 215.

15. "Le piano à quatre mains de *Parade* ne présente pas l'oeuvre exacte mais le fond musical destine à mettre en relief un premier plan de batterie et de bruits scéniques" (quoted in Rothschild, *Picasso's Parade,* 88).

16. Guillaume Apollinaire, "Parade et L'Esprit nouveau," *L'Excelsior,* 11 May 1917, 5; reprinted in Apollinaire, *Apollinaire on Art,* 452–53.

17. Bourdieu, *Distinction,* 18–34.

18. The standard biography is Seebohm, *The Man Who Was Vogue.*

19. "In Vanity Fair," *Vanity Fair,* January 1914, 13.

20. Quoted in Seebohm, *The Man Who Was Vogue,* 80.

21. On Nast's family, see ibid., 20–21; on Clarisse Coudert, see ibid., 51–67.

22. Marcel Prévost, "The United States and France," *Vanity Fair,* January 1916, 29–30.

23. Bernard Boutet de Monvel, "Dropping Bombs on the Boches," *Vanity Fair,* July 1916, 37.

24. Joseph Choate, "What We Owe to France: A Debt that Cannot be Measured in Terms of Money or Munitions," *Vanity Fair,* May 1917, 43.

25. Ibid.

26. Allen Tucker, "Why France? And Why is the Earth Flooded With Her Splendor?" *Vanity Fair,* June 1917, 69.

27. Crowninshield was publisher of *The Bookman* beginning in 1895 and became assistant editor of *Metropolitan Magazine* in 1900. He served as assistant editor of *Munsey's Magazine* before joining *The Century Illustrated Monthly Magazine* as art editor in 1910. In 1912 he published a small etiquette book entitled *Manners for the Metropolis,* and he began work at *Vanity Fair* in 1914 (see Seebohm, *The Man Who Was Vogue,* 103–21).

28. [Frank Crowninshield], "In Vanity Fair," *Vanity Fair,* March 1914, 15.

29. On the history of the World's Fair as a cultural event, see Benedict, *The Anthropology of World's Fairs,* 1–65.

30. On this history, see Ewald and Clute, *San Francisco Invites the World.*

31. On the French participation in the exposition, see Sandoz, *Rapport générale de la Section française*.

32. *The Blue Book*, 64.

33. This special issue of the *Gazette* was published as vol. 2, no. 8/9.

34. Paul Adam, "La Coutume de Paris," *Gazette du Bon Ton*, 15 June 1915, 8; English version in *The 1915 Mode as Shown by Paris*, 6–8.

35. "In Vanity Fair," *Vanity Fair*, September 1913, 3.

36. Worth, "The Triumph of French Traditions: France Fights Successfully Against Foreign Influence to Maintain its Fashion Supremacy," *Vanity Fair*, October 1913, 29.

37. "The Dance Craze in Paris Creates New Types of Gowns: A Changed Aesthetic Taste Approves of Vague Lines and a Complicated Combination of Fabrics," *Vanity Fair*, November 1913, 59.

38. "What You Shall Wear for the Tango Teas," *Vanity Fair*, December 1913, 65–66.

39. "With the Thé Dansant and Drama, Paris is Gay," *Vanity Fair*, January 1914, 62.

40. "Americans Contribute to the Gaiety of Paris," *Vanity Fair*, February 1914, 61.

41. Ibid.

42. Anne Rittenhouse, "Society Dances in the Costumes of To-Morrow," *Vanity Fair*, February 1914, 57.

43. Mrs. Roscoe E. Mathews, "What Shall We Dance This Winter?" *Vanity Fair*, December 1914, 57.

44. Johnson Briscoe, "Many New Singers, and Operas Three: A Glance at the Coming Season's Musical Offerings," *Vanity Fair*, September 1913, 49.

45. Alys E. Bentley, "Some Higher Aspects of the Dance Movement," *Vanity Fair*, April 1914, 19–21.

46. Charles Buchanan, The Failure of American Composers," *Vanity Fair*, March 1915, 49.

47. W. J. Henderson, "The New Thought Composers," *Vanity Fair*, January 1915, 45.

48. For an assessment of Van Vechten's contributions as a music critic, see Oja, *Making Music Modern*, 297–302.

49. Carl Van Vechten, "The Great American Composer," *Vanity Fair*, April 1917, 75.

50. Jean Cocteau, "*Parade*: Ballet réaliste, In Which Four Modern Artists Had a Hand," *Vanity Fair*, September 1917, 37.

51. While Cocteau's claims for the scandal created by *Parade* seem overstated (perhaps in an effort to match the reports of the audience reaction to the premiere of *Le Sacre du printemps*), reports of the opening night vary widely, ranging from accounts of outraged yelling to descriptions of "applause and a few whistles" (see Whiting, *Satie the Bohemian*, 473 n. 34).

52. Jean Cocteau, "*Parade*: Ballet réaliste, In Which Four Modern Artists Had a Hand," *Vanity Fair*, September 1917, 37.

53. See Cocteau, *Le Coq et l'arlequin*.

54. Carl Van Vechten, "Erik Satie: Master of the Rigolo," *Vanity Fair*, March 1918, 61.

55. This spate of attention may have been facilitated by Sybil Harris, an American socialite living in Paris who went on to a film career in the 1930s and 1940s. Harris apparently had connections to both Satie and the *Vanity Fair* editorial staff, and in 1921 was involved in an affair with the writer Henri-Pierre Roché, who was part of Satie's wider circle during the early 1920s. Volta and Orledge contend that she commissioned two articles for *Vanity Fair* from Satie (on Stravinsky and Debussy); see Volta's comments in Satie, *Ecrits*, 263–64, 274; and Orledge, "Satie in America," 909–12.

56. Erik Satie, "A Hymn in Praise of Critics, Those Whistling Bell-Buoys Who Indicate the Reefs on the Shores of the Human Spirit," *Vanity Fair*, September 1921, 49. The essay originated as a talk given by Satie at the first public concert by Les Six at the Théâtre du Vieux-Colombier, 5 February 1918. It was first published in the avant-garde French magazine *Action* in 1921; other contributors to this publication included Cocteau, Paul Eluard, André Malraux, and Tristan Tzara (see *Action: Cahiers Individualiste de Philosophie et d'Art 2*, no. 8 [1921]: 8–11).

57. Erik Satie, "A Lecture on 'The Six': A Somewhat Critical Account of a Now Famous Group of French Musicians," *Vanity Fair*, October 1921, 61. The original occasion for the remarks was a concert of music by Les Six and a "Festival Erik Satie" sponsored by Cocteau and Paul Collaer, held in Brussels in April 1921. Satie was compelled to give the lecture when Cocteau, who had originally planned to speak at the event, withdrew at the last minute. Satie presented the same lecture in Rouen in August 1922 (see Satie, *Ecrits*, 273).

58. Satie locates this "modern sensibility" in the works of three members of Les Six—Georges Auric, Francis Poulenc, and Darius Milhaud—and describes the remaining three composers—Louis Durey, Arthur Honegger, and Germaine Tailleferre—as "pure impressionists." "There is no harm in that," he continues. "I myself, thirty years ago, was impressionist" (see Erik Satie, "A Lecture on 'The Six': A Somewhat Critical Account of a Now Famous Group of French Musicians," *Vanity Fair*, October 1921, 61).

59. Erik Satie, "A Learned Lecture on Music and Animals," *Vanity Fair*, May 1922, 64. This commentary originated as a lecture for a conference on "Animals in Music," held on 2 November 1916 and presided over by Satie's friend, the pianist Ricardo Viñes; Satie subsequently presented a revised version of the talk at a "Children's Evening" sponsored by the pianist Jeanne Alvin on 19 December 1919 (see Satie, *Ecrits*, 267). Also, Erik Satie, " La Musique et les enfants," *Vanity Fair*, October 1922, 53. This commentary originated as a lecture for another of Mme Alvin's "Children's Evenings," this time on 17 February 1921. The version of the essay that was published by *Vanity Fair* was typographically faithful to Satie's idiosyncratic manuscript, which incorporated ellipses throughout the text to indicate pauses and silences.

60. Erik Satie, "Igor Stravinsky: A Tribute to the Great Russian Composer by an Eminent French Confrère," *Vanity Fair,* February 1923, 39; Satie, "Claude Debussy," in *Ecrits,* 65. Also apparently requested by Sybil Harris, the article appears in English translation in Wilkins, *The Writings of Erik Satie,* 106–10.

61. Paul Rosenfeld, "The Musician as Parodist of Life," *Vanity Fair,* November 1921, 43.

62. Edmund Wilson, Jr., "The Aesthetic Upheaval in France: The Influence of Jazz in Paris and the Americanization of French Literature and Art," *Vanity Fair,* February 1922. The article was illustrated with reproductions of a work by Francis Picabia, a Dada manifesto, and a poster advertising Blaise Cendrar's "novel filmé," *La Fin du monde.*

63. Ibid.

64. Jean Cocteau, "The Comic Spirit in Modern Art: A Note on the Profound Realism of Exaggeration and Caricature," *Vanity Fair,* September 1922, 66.

65. Ibid., 102.

66. Jean Cocteau, "The Public and the Artist," *Vanity Fair,* October 1922, 61.

67. These include Georges Auric, "Erik Satie and the New Spirit Possessing French Music, *Vanity Fair,* July 1922, 62; Tristan Tzara, "News of the Seven Arts in Europe," *Vanity Fair,* November 1922, 51; Virgil Thomson, "How Modern Music Gets That Way," *Vanity Fair,* April 1925, 46; and Paul Morand, "Modernist Music and the Group of Six," *Vanity Fair,* August 1923, 51.

68. Morand, *Journal d'un attaché d'ambassade,* 28; translation in Steegmuller, *Cocteau,* 169–70.

69. Quoted in Steegmuller, *Cocteau,* 170.

70. Morand, "Modernist Music and the Group of Six," *Vanity Fair,* August 1923, 51.

CHAPTER 6

1. Diana Vreeland, quoted in Grau, *La Haute couture,* 45.

2. Cocteau, *Le Coq et l'arlequin,* 60.

3. Jean Cocteau, "Le Retour de Mademoiselle Chanel," *Le Nouveau Fémina,* March 1954, reprinted in *Cocteau et la mode,* Cahiers Jean Cocteau (new series), no. 3 (Paris: Passage du Marais, 2004), 118.

4. In addition to Wallach, *Chanel,* standard biographies of Chanel include Madsen, *Chanel;* Charles-Roux, *L'Irrégulière, ou Mon itinéraire Chanel;* Kennett, *Coco;* Leymarie, *Chanel;* and Gidel, *Coco Chanel.* Two photo-biographies complement these studies; see Charles-Roux, *Chanel and Her World ;* and de la Haye and Toobin, *Chanel.* Chanel's memoirs, as told to Paul Morand, were published as Morand, *L'Allure de Chanel.*

5. Charles-Roux, *Chanel and Her World,* 32.

6. Wallach, *Chanel*, 9.

7. On the transformation of Vichy and other French spa towns into tourist resorts, see Mackaman, *Leisure Settings*.

8. For a description of the main venues, see Madsen, *Chanel*, 30–31.

9. Life at Royallieu is described in Madsen, *Chanel*, 27–32, and documented in photographs in Charles-Roux, *Chanel and Her World*, 50–67.

10. On the history of the term, see Rey et al., *Dictionnaire historique de la langue française*, s.v. amazone.

11. Morand, *L'Allure de Chanel*, 5.

12. Quoted in Charles-Roux, *Chanel and Her World*, 76.

13. Wallach, *Chanel*, 17. Chanel began at 21 rue Cambon and eventually expanded into numbers 27, 29, and 31 (see Baudot, *Chanel*, 6).

14. Heir to a coal mining fortune, Capel went on to a political career, serving as an aide to Georges Clemenceau and authoring a speculative book on the post-war world that received considerable (if mostly negative) critical attention (see Capel, *Reflections on Victory*). Chanel's relationship with him was serious; she claimed that he was the one man she truly loved, and continued to see him even after he married in 1918 (see Charles-Roux, *L'Irrégulière*, 284).

15. Morand, *Lewis et Irène*.

16. Characterized by Balzac as a "dandy" and by Zola as a "bandit," Charles Auguste Louis Joseph de Morny (1811–65) was the son of Hortense de Beauharnais, who was also the mother of Napoleon III. On his political career and social profile, as well as his development of Deauville, see Rouart, *Morny*.

17. E.G., "Deauville: A Short Season—and Gay," *Vogue* (New York), 1 August 1913, 15.

18. Ibid., 16.

19. Quoted in Morand, *L'Allure de Chanel*, 45.

20. Hollander, *Feeding the Eye*, 26.

21. Quoted in Madsen, *Chanel*, 69.

22. "Paris Hastens to Our Enlightenment," *Vanity Fair*, May 1917, 87.

23. "Bubbles of Fashion Rise to the Surface in Paris," *Vogue* (New York), 15 April 1916, 35.

24. Robert Burnand, "Travel Zones of France, From the Bay of Biscay to the Alps," *Vogue* (New York), 1 June 1924, 42. See, more generally, Vulliez-Laparra, *Gloire de Biarritz*.

25. Robert Burnand, "Travel Zones of France, From the Bay of Biscay to the Alps," *Vogue* (New York), 1 June 1924, 42.

26. Charles-Roux, *Chanel and Her World*, 99.

27. Quoted in de la Haye, *Chanel*, 27.

28. Lipovetsky, *The Empire of Fashion*, 65.

29. Quoted in Leymarie, *Chanel*, 57.

30. Margueritte, *La Garçonne*. The book was not banned in France, but its publication resulted in Margueritte's expulsion from the *Légion d'honneur*.

31. Bizet, *La Mode*, 86.

32. Lurie, *The Language of Clothes*, 74.

33. "Chanel Keeps the Secret of Eternal Youth," *Vogue* (New York), 15 October 1924, 66. As early as 1903, Colette and other actresses had cut their hair, but Chanel brought the look to the upscale mainstream. On Colette's cropped hair, see Thurman, *Secrets of the Flesh*, 130. Chanel's contemporaries viewed her coiffure not simply as a new look but rather as a Bergsonian "expression of the élan vital," as well as a step on the "passage to freedom (see Mary Garden, "Why I Bobbed My Hair," *Pictorial Review*, April 1927, 8). Sleek, unfussy, and provocative, the cut expressed a fantasy of female liberation—even if in reality it required considerable attention in the form of regular cuts, waves, tints, dyes, and shampoos. On its history, see Zdatny, *Hairstyles and Fashion*.

34. On the development of the perfume, see Madsen, *Chanel*, 132–35.

35. On the connection of perfume and clothing in Chanel's enterprise, see Grumbach, *Histoires de la mode*, 107–8.

36. "The Chanel 'Ford'—the Frock That All the World Will Wear," *Vogue* (New York), 1 October 1926, 69.

37. On the history of the term, see Rey et al., *Dictionnaire historique de la langue française* s.v. chic. See also Tiersten, *Marianne in the Market*, 123–28; and Delbourg-Delphis, *Le Chic et le look*, 8–10.

38. Sem, *Le Vrai et le faux chic*. Discussion of the album is included in Troy, *Couture Culture*, 181–91.

39. "Before and After Taking Paris," *Vogue* (New York), 1 November 1924, 100.

40. *Vogue*, 1919, quoted in de la Haye, *Chanel*, 25.

41. The standard biography is Gold and Fitzdale, *Misia*. See also Misia Sert's autobiography, *Misia and the Muses*.

42. A useful overview of the history of *La Revue Blanche* is found in Genova, *Symbolist Journals*, 165–69.

43. Marcel Proust, quoted in Gidel, *Coco Chanel*, 157.

44. On Jouhandeau, see Danon, *Entretiens avec Elise et Marcel Jouhandeau*.

45. The financial details are discussed in Garafola, *Diaghilev's Ballets Russes*, 201–10.

46. See Kochno, *Diaghilev and the Ballets Russes*, 75.

47. See Morand, *L'Allure de Chanel*, 85, for Chanel's confirmation of this figure.

48. See ibid., 121–24.

49. Craft mistakenly attributes this comment to Morand, describing it as "puerile" and arguing that Stravinsky "already wore a monocle in 1915 and . . . could never have been described as timid." For the original comment, see Morand, *L'Allure de Chanel*, 124; for Craft's interpretation, see Stravinsky and Craft, *Stravinsky in Pictures and Documents*, 210 and 627 n. 12.

50. In his autobiography Stravinsky refers to Garches, where he lived in Chanel's villa, simply as "the place where I spent the winter of 1920–21" (see Igor Stravinsky, *An Autobiography*, 91).

51. Stravinsky and Craft, *Stravinsky in Pictures and Documents*; the description of the collection is found on p. 13.

52. Ibid., 210.

53. Taruskin, *Stravinsky and the Russian Traditions*, 1516.

54. Their meeting is recounted in Stravinsky and Craft, *Stravinsky in Pictures and Documents*, 240. Stravinsky biographer Stephen Walsh speculates that the affair with Vera began in July 1921, since Stravinsky was in Paris at the beginning of that month and thereafter the couple celebrated July 14 as their anniversary (see Walsh, *Stravinsky*, 336). They married after the death of Stravinsky's wife Catherine in 1939.

55. Ansermet to Stravinsky, 29 March 1921, in Ansermet, *Correspondance Ernest Ansermet–Igor Strawinsky*, 1:183–84.

56. Stravinsky and Craft, *Stravinsky in Pictures and Documents*, 222.

57. Walsh, *Stravinsky*, 260.

58. Ibid., 262. The tour is the subject of an extensive discussion in Garafola, *Diaghilev's Ballets Russes*, 202–10.

59. Garafola, *Diaghilev's Ballets Russes*, 210. Garafola reports that the tour, underwritten by the Metropolitan Opera and overseen by Nijinsky, who was released from wartime house arrest in Budapest to participate in the performances, lost a quarter of a million dollars.

60. W. J. Henderson, "The 'New Thought' Composers," *Vanity Fair*, January 1915, 45–46.

61. Aybern Edwards, "Serge de Diaghileff's Ballet Russe and a Brief Description of its Leading Dancers," *Vanity Fair*, December 1915, 48. On Edward Bernays, who was a nephew of Sigmund Freud, see Tye, *The Father of Spin*.

62. Baron Adolphe de Meyer, "The Ballet Russe—Then and Now," *Vanity Fair*, January 1917, 69.

63. See Marie Louise Van Saanen, "Paulet Thévenas, Painter and Rythmatist," *Vanity Fair*, August 1916, 49. Thévenas, a friend of Stravinsky as early as 1911, was a specialist in Dalcroze eurythmics. The portrait reproduced in *Vanity Fair* was painted in 1914 (see Watkins, *Pyramids at the Louvre*, 252–53, for a brief overview of his relationship with Cocteau).

64. "Music Notes," *Vogue* (New York), 1 January 1916, 68. The final lines of the column reported that three movements of Stravinsky's first string quartet had been performed at New York's Aeolian Hall by the Flonzaley Quartet; the movements, the critic noted simply, "are very short."

65. Clayton Hamilton, "The Greatest of the Three Arts of Russia," *Vogue* (New York), 1 April 1916, 83.

66. Stravinsky and Craft, *Stravinsky in Pictures and Documents*, 123–25.

67. Charles Tenroc, "Les Ballets Russes," *Le Courrier Musical*, 15 February 1920, 66.

68. Louis Laloy, *Comoedia*, 4 February 1920; trans. and quoted in Stravinsky and Craft, *Stravinsky in Pictures and Documents*, 124.

69. Garafola, *Diaghilev's Ballets Russes*, 135.

70. Crespelle, *Picasso and His Women*, 127–28.

71. Stravinsky, *Comoedia*, 31 January 1920; quoted in Stravinsky and Craft, *Stravinsky in Pictures and Documents*, 183.

72. On this Italian sojourn, see, generally, Rothschild, *Picasso's Parade*; and Clair, *Picasso*.

73. Garafola, *Diaghilev's Ballets Russes*, 90–97.

74. On the materials and compositional process of *Pulcinella*, see Taruskin, *Stravinsky and the Russian Traditions*, 1462–65.

75. See the poster reproduced in Stravinsky and Craft, *Stravinsky in Pictures and Documents*, 182. Taruskin demonstrates that over time Stravinsky took progressively more credit for the ballet as an original composition, and was aided in this effort by numerous commentators and critics (see Taruskin, *Stravinsky and the Russian Traditions*, 1463).

76. Reynaldo Hahn, *Excelsior*, 17 May 1920, quoted in Messing, *Neoclassicism in Music*, 116.

77. Paul Souday, "La Semaine théâtrale et musicale," *Paris-Midi*, 18 May 1920, quoted in Messing, *Neoclassicism in Music*, 115.

78. "Carnaval vénitien." *Femina*, 1 June 1913, 305.

79. "Où l'on trouvera un éloge du carnaval et du carême." *Vogue* (Paris), 1 February 1923, 11.

80. "Colombine à travers les âges." *Vogue* (Paris) 15 January 1922, 3–6.

81. O'Brian, *Pablo Picasso*, 242.

82. The costume designs are reproduced in Clair, *Picasso*, 147–49.

83. Jean Hugo, *Avant d'oublier* (Paris: Fayard, 1931); quoted in Vaill, *Everybody Was So Young*, 101.

84. Madsen contends instead that they met earlier in May when Stravinsky was in Paris for rehearsals of the ballet (see Madsen, *Chanel*, 109).

85. Stravinsky to Ramuz, 23 August 1920; quoted in Walsh, *Stravinsky*, 316.

86. Stravinsky to Ansermet, 22 September 1920, in *Stravinsky: Selected Correspondence*, 1:148.

87. In addition to their schoolwork, the children studied painting and made regular excursions to the museums and art galleries in Paris (see Rousseau-Plotto, *Stravinsky à Biarritz*, 46–47).

88. Stravinsky and Craft, *Memories and Commentaries*, 125.

89. The history of the score publication is detailed in Stravinsky and Craft, *Stravinsky in Pictures and Documents*, 526–33. The parts were sent to Stravinsky at Garches on 29 October 1920 by Otto Kling.

90. On Nijinsky's relationship to Diaghilev and the Ballets Russes at this time, see Acocella, *The Diary of Vaslav Nijinsky, Unexpurgated Edition*, xiv–xviii.

91. Quoted in Michel Georges-Michel, "Les Deux *Sacres du printemps*," *Comoedia*, 11 December 1920; reprinted in Lesure, *Igor Stravinsky, "Le Sacre du printemps,"* 53.

92. Reference to the shimmy in the choreography is made in Emile Vuillermoz, "Chroniques et notes," *Revue Musicale*, 1 February 1921; reprinted in

Lesure, *Igor Stravinsky, "Le Sacre du printemps,"* 60. For the quote regarding music in the household, see Charles-Roux, *L'Irrégulière*, 307. This reminiscence does not appear in the English translation of the book.

93. Taruskin, "A Myth of the Twentieth Century," 15.

94. Michel Georges-Michel, "Les deux *Sacres du printemps,"* *Comoedia*, 11 December 1920; reprinted in Lesure, *Igor Stravinsky, "Le Sacre du printemps,"* 60; see also Taruskin, "A Myth of the Twentieth Century," 6.

95. This history is noted in Taruskin, "A Myth of the Twentieth Century," 12.

96. See the reviews by Michel Georges-Michel, Roland-Manuel, Abel Hermant, Louis Handler, and Emile Vuillermoz, all of which are reprinted in Lesure, *Igor Stravinsky, "Le Sacre du printemps,"* 53–60.

97. On Diaghilev's payroll from time to time, Evans (1871–1945) met Stravinsky when the composer was in London for the Ballets Russes season of 1913, and thereafter was one of his staunchest advocates, authoring one of the first studies devoted to the composer, the book *Stravinsky: The Firebird and Petrushka*. On Evans's status with the Ballets Russes, see Garafola, *Diaghilev's Ballets Russes*, 341 and 482 n. 35. The circumstances of his initial meeting with Stravinsky are detailed in Stravinsky and Craft, *Stravinsky in Pictures and Documents*, 95 and 613 n. 169.

98. Reproduced in Clair, *Picasso*, 147–49.

99. *La Boutique fantasque*, with music by Rossini in an orchestration by Respighi, and choreography by Massine, had its premiere on 5 June 1919 at the Alhambra Theater in London. On the reception of Derain's costumes and decors, see Garafola, *Diaghilev's Ballets Russes*, 336–37.

100. Edwin Evans, "Igor Stravinsky: Contrapuntal Titan," *Musical America*, 12 February 1921, 9. In connecting Stravinsky to Bach in this manner, Evans initiated a strand of commentary linking the two composers that was taken up by Boris de Schloezer and Nadia Boulanger, among others. On the Bach connection, see Messing, *Neoclassicism in Music*, 132–35. For a discussion of the cultural positioning of Bach in debates about neoclassicism in the 1920s, including extensive commentary about Stravinsky, see Taruskin, "Back to Whom?"

101. Edwin Evans, "Igor Stravinsky: Contrapuntal Titan," *Musical America*, 12 February 1921, 9.

102. The Debussy memorial supplement to *La Revue Musicale* was published in December 1920. The title page was illustrated by Raoul Dufy and is reproduced in Taruskin, *Stravinsky and the Russian Traditions*, 1460.

103. "Modernists Build Debussy Memorial 'Tomb' of Music," *Musical America*, December 25, 1920, 10.

104. On Stravinsky's compositional process in *Symphonies*, see Baltensperger and Meyer, *Igor Stravinsky*.

105. Stravinsky significantly revised the score in September 1947, and it is in this version that the piece is best known. For details of the revision, see Baltensperger and Meyer, *Igor Stravinsky*, 31–32.

106. On the historical position of *Symphonies,* see Taruskin, "Back to Whom?" 291–92.

107. As Taruskin notes, the French name more accurately conveys the word "symphonies" in its Greek etymological sense, connoting something akin to the English "concords" (see Taruskin, *Stravinsky and the Russian Traditions,* 1486 n. 58).

108. These discussions are summarized and critiqued in Rehding, "Towards a 'Logic of Discontinuity' in Stravinsky's *Symphonies of Wind Instruments,*" 39.

109. See, e.g., Edward T. Cone, "Stravinsky: The Progress of a Method," *Perspectives of New Music* 1, no. 1 (Fall 1962): 18–26; reprinted in Boretz and Cone, *Perspectives on Schoenberg and Stravinsky*; Somfai, "Symphonies of Wind Instruments (1920)"; Boulez, "Stravinsky demeure" [outlining Messiaen's analysis]; Kramer, *The Time of Music*; and Cross, *The Stravinsky Legacy,* especially chap. 2. Taruskin provides a useful summary of the literature in *Stravinsky and the Russian Traditions,* 1487.

110. Stravinsky, *An Autobiography,* 95.

111. Taruskin, *Stravinsky and the Russian Traditions,* 1488–93; the arguments first appeared in Taruskin, Review of *Igor Stravinsky: Symphonies d'instruments à vent,* by André Baltensperger and Felix Meyer.

112. Ernest Newman, *The Manchester Guardian,* 16 June 1921, 5; quoted in Baltensperger and Meyer, *Igor Stravinsky,* 42.

113. "Misunderstood! Stravinsky Says Audience Did Not Hiss Enough," *Weekly Dispatch,* 12 June 1921; quoted in Walsh, *Stravinsky,* 331. Thus began a heated dispute that played out in the press, with composer and conductor in separate camps, each encircled by a loyal band of followers and critics. In the end, bridges were mended, in no small part because Koussevitsky controlled the publishing house that handled most of Stravinsky's compositions at the time. He also made the conciliatory gesture of inviting Stravinsky to conduct the premiere of his Octet on a program under his direction at the Paris Opéra in October 1923 (see Stravinsky and Craft, *Stravinsky in Pictures and Documents,* 224).

114. Jean Wiéner (1896–1982) was a piano student at the Paris Conservatoire, where he established an enduring friendship with Darius Milhaud. The Concerts Wiéner were mounted from 1921 to 1924. On Wiéner and the "concerts salades," see Taylor, "La Musique pour tout le monde"; see also Mellers, "Jean Wiéner Redivivus."

115. Boris de Schloezer, "La musique," *Revue Contemporaine,* 1 February 1923, 257; quoted in Messing, *Neoclassicism in Music,* 87.

116. As Jane Fulcher has noted, in the 1920s "neoclassicism" connoted not merely a "Zeitgeist," but rather a "national style, synonymous with patriotism, which made it a matrix for political discussion" (see Fulcher, "The Composer as Intellectual," 198). Fulcher seems to draw here on Kenneth Silver's discussion of the Union sacrée as a "national style" marked by "order, proportion, organization and moral purity" (see Silver, *Esprit de Corps ,* 185).

117. Messing, *Neoclassicism in Music*, 89. In lieu of "youthfulness," he uses the term "childlike spontaneity."

118. The earliest notations related to *Symphonies* are found in two sketchbooks used by Stravinsky between 1917 and 1920 (see Baltensperger and Meyer, *Igor Stravinsky*, 28–29, and Plate 2 [p. 39], which is a facsimile of sketches for the chord progression for the Chorale, scored for piano and string quartet).

119. Igor Stravinsky, *New York Times*, 6 January 1925; and "Some Ideas About My Octet," quoted in Stravinsky and Craft, *Stravinsky in Pictures and Documents*, 225 and 217.

120. Silver, *Esprit de Corps*, 185.

121. Boris de Schloezer, "La Musique," *Revue Contemporaine*, 1 February 1923, 257.

122. Quoted by Deems Taylor in a review of the American premiere in 1924; reprinted in Taylor, *Of Men and Music*, 89–90. See also Taruskin, *Stravinsky and the Russian Traditions*, 1486 n. 61.

123. Stravinsky published a revised and rescored version of the work under the title *Eight Instrumental Miniatures* in 1962.

124. Stravinsky and Craft, *Stravinsky in Pictures and Documents*, 217.

125. Taruskin, "Back to Whom?" 292.

126. Stravinsky appears to have begun this work with the understanding that a commission from the Schirmer Company in New York would be forthcoming. *Les Cinq doigts* was first performed by Jean Wiéner at the Parisian Salle des Agriculteurs on 15 December 1921.

127. On the issue of popular music and youth culture, see McClary, "Same As It Ever Was." See, more generally, Bennet, *Popular Music and Youth Culture*; and Whiteley, *Music, Space, and Place*.

128. On their meeting, at a luncheon hosted by Debussy, see Orledge, *Satie the Composer*, 251–53.

129. Stravinsky quoted in Stravinsky and Craft, *Dialogues*, 41. Satie quoted in Satie, *Ecrits*, 38–41. Satie dedicated his song *Le Chapelier* to Stravinsky in 1916.

130. Stravinsky quoted in Stravinsky and Craft, *Dialogues*, 41. Satie's influence on Stravinsky is discussed in Messing, *Neoclassicism in Music*, 89–95.

131. Gillmor, *Erik Satie*, 171.

132. The collection included groups of pieces entitled *Menus propos enfantins*, *Enfantillages pittoresques*, and *Peccadilles importunes*; the compositions were published as a set under the title *Enfantines* by Demets in 1914 (see Orledge, *Satie the Composer*, 300–301).

133. The intricacies of Satie's system are discussed in Orledge, *Satie the Composer*, 192–94.

134. Taruskin, *Stravinsky and the Russian Traditions*, 1507–8, 1517–18. See also Maes, *A History of Russian Music*, 27–29.

135. When he orchestrated *Les Cinq doigts* and published the new version under the title *Eight Orchestral Miniatures* in 1962, Stravinsky renamed this piece "Tempo di tango." The tango had surfaced in other guises in Stravinsky's work by 1921, most memorably as part of a suite of popular dances in *L'Histoire du soldat*.

136. *Stravinsky: Selected Correspondence*, 1:130.

137. Stravinsky and Craft, *Dialogues*, 41.

138. See Stravinsky and Craft, *Stravinsky in Pictures and Documents*, 176; the claim is carried forward in Taruskin, *Stravinsky and the Russian Traditions*, 1473–74, where the source tune as published in the collection owned by Stravinsky is reproduced.

139. Taruskin, *Stravinsky and the Russian Traditions*, 1473–75.

140. As Taruskin has documented, an early draft title page for the work in the Stravinsky Archive reads "Igor Strawinsky / Gran matshitch / Dedié à Arthur Rubinstein" (see ibid., 1475).

141. Hugo, *Avant d'oublier*, 31. Hugo states only that Stravinsky performed a "ragtime he had just composed"; the fact that this was *Piano-Rag-Music* is substantiated by a letter from Poulenc to Stravinsky dated 26 September 1919 (see Chimènes, *Francis Poulenc*, 100).

142. On Milhaud's adaptation of Tupinambá's tune, see Lago, "Brazilian Sources," 1–14.

143. On the Doucet-Wiéner partnership, see Taylor, "La Musique pour tout le monde," 191–208.

144. The "cellular" organization of the work is discussed in Boulez, "Stravinsky demeure," 155–56.

145. Cocteau, *Romans, poésies, oeuvres diverses*, 434–36.

146. When Cocteau's book was reprinted in 1926 under the new title *Le Rappel à l'ordre*, he included a lengthy appendix acknowledging Stravinsky's innovations, entitled "Stravinsky dernière heure" (see ibid., 464–66).

147. Ernest Ansermet, "Russiche Musik," *Melos*, August 1922; quoted in *Stravinsky: Selected Correspondence*, 1:156 n. 83.

148. Boris de Schloezer, "Igor Stravinsky," *La Revue Musicale*, 1 December 1923, 97.

149. Nadia Boulanger, "Concerts Koussevitsky," *Le Monde Musical*, November 1923, 365.

150. "Paris Fashions," *Vogue* (New York), 1 August 1924, 80.

151. "French Ideas Were Never More Simple," *Harper's Bazaar*, March 1924, 78.

152. "1904–1924," *Vogue* (Paris), 1 September 1924, 17.

153. H.B.S., [editorial], *Harper's Bazaar*, January 1921, 25.

154. "Du naturel, de la simplicité, et du monde," *Vogue* (Paris), 1 May 1922, 33.

155. "Why the Parisienne Leads in Chic," *Vogue* (New York), 1 February 1925, 66.

156. "The Paris Openings," *Vogue* (New York), 15 October 1925, 7.

157. "Le Cortège des silhouettes nouvelles," *Vogue* (Paris), 1 April 1925, 60.

158. Hollander, *Seeing Through Clothes*, 62, 128.

159. Quoted in Stravinsky and Craft, *Stravinsky in Pictures and Documents*, 210. Otto Kling, who died in 1926, was director of the London branch of Breitkopf & Härtel, and later of J. & W. Chester.

160. Rousseau-Plotto, *Stravinsky à Biarritz*, 147–57.

161. Interview with Jean Cocteau, *Gazette des Arts*, 10 February 1923; quoted in Charles-Roux, *L'Irrégulière*, 394. On the "myth of the Mediterranean," see *1918–1958: La Côte d'Azur et la modernité*.

162. Quoted in Steegmuller, *Cocteau*, 292–93.

163. Dullin (1889–1942) would have known Chanel from at least 1912, when she studied dance with his lover, Caryathis.

164. Gidel, *Coco Chanel*, 186.

165. Honegger and Cocteau later collaborated on an opera based on Sophocles' *Antigone*; it was premiered in 1927 (see Miller, *Cocteau, Apollinaire, Claudel et Le Groupe des Six*, 178–80).

166. Quoted in Gidel, *Coco Chanel*, 187.

167. Steegmuller, *Cocteau*, 299.

168. "Jean Cocteau nous donne une interpretation moderne de Sophocle," *Vogue* (Paris), 1 February 1923, 63.

169. In 1924 Chanel appointed Etienne de Beaumont as manager and chief designer of her jewelry atelier (see Mauriès, *Jewelry By Chanel*, 33–34).

170. "Jean Cocteau's Production of *Antigone*: A French Poet Rewrites Sophocles for the Modern Stage," *Vanity Fair*, 1 May 1923, 49.

171. Garafola, *Diaghilev's Ballets Russes*, 98.

172. The VIII Olympiad was held in Paris in 1924; the city had hosted the II Olympiad in 1900, concurrent with the Exposition Universelle. The Modern Olympics, which included only Summer Games, began in Athens in 1896.

173. Quoted in Hall, *The Twenties in Vogue*, 69.

174. Picasso signed and dedicated the curtain to Diaghilev. The artist's last major work for the theater, it proved so popular that Diaghilev used it subsequently as a front cloth for his productions (see Steegmuller, *Cocteau*, 331).

175. Nijinska (1891–1972) left the Ballets Russes in 1914 and remained in Russia until 1921. Upon her return, she choreographed *Le Renard*, *Les Noces*, and *Les Biches*, prior to working on *Le Train bleu* (see Baer, *Bronislava Nijinska*; and Garafola, *Diaghlev's Ballets Russes*, 122–25).

176. Quoted in Hall, *The Twenties in Vogue*, 69.

177. On Nijinska's disagreement with Cocteau over the choreography and its popularizing nature, see Garafola, "Reconstructing the Past."

178. Quoted in Ries, *The Dance Theater of Jean Cocteau*, 91.

179. Milhaud, *Notes sur la musique*, 75.

180. Garafola, *Diaghilev's Ballets Russes*, 110.

181. Quoted in Hall, *The Twenties in Vogue*, 69.

182. "The Ballets Russes," *Musical America* (12 December 1924); quoted in Ries, *The Dance Theater of Jean Cocteau*, 99. On the audience reaction, see "Les Ballets Russes," *Concerts et Théâtres de la Côte d'Azur* (supplement to the *Courrier Musical*), 1–15 February 1925, 7.

183. Charles Tenroc, "Les Théâtres," *Le Courrier Musical*, 1 July 1924, 392.

## CHAPTER 7

1. With this title, in which he used the term *soirée* in its singular form, Beaumont recalled the avant-garde literary and arts revue *Les Soirées de Paris*, which was edited by Guillaume Apollinaire and published between February 1912 and July/August 1914.

2. Jean LaPorte, "Les Soirées de Paris à la Cigale," *Vogue* (Paris), 1 July 1924, 25. Three vignettes were played out, including "Bain de minuit," with poetry by Paul Morand, and "Filles mal gardées," in which two girls fought for possession of a lucky four-leaf clover. The conceit of the animated magazine cover was not new—a decade earlier, a charity benefit held at New York's Waldorf Astoria hotel had featured socialites posed in a series of tableaux vivants inspired by *Vogue* and *Vanity Fair* covers, created by artists Helen Dryden and George Plank (see Seebohm, *The Man Who Was Vogue*, 165).

3. Seebohm, *The Man Who was Vogue*, 42. Founded by Arthur Tunure and Harry McVickar, the original *Vogue* was published weekly and sold by subscription or by individual issue, at ten cents per copy. The magazine's history was the subject of a lengthy article in French *Vogue*, "Les Animateurs de *Vogue* en Amérique, en Angleterre, en France," published on the occasion of *Vogue*'s thirtieth anniversary, 1 March 1923.

4. American *Vogue* was distributed to select London newsstands beginning in 1912; by 1914 the magazine was selling between three to four thousand copies in England. A British edition was launched in 1916, and the following year Nast produced a "Continental edition," in English, which was marketed in England and France (see Seebohm, *The Man Who Was Vogue*, 123).

5. "On parle français!" *Vogue* (Paris), 15 June 1920, 3.

6. Seebohm, *The Man Who Was Vogue*, 142.

7. *La Gazette du Bon Ton*, March 1920, 66. Fauconnet had died just a month earlier while designing costumes for Cocteau's farce *Le Boeuf sur le toit*. The lavishly illustrated article was part appreciation and part appropriation, allowing Cocteau to position himself as an adept of Fauconnet's artistic devotion to simplicity, symmetry, and everyday objects, and it was complemented by a cubist-style *pochoir* plate by Eduardo Benito depicting a scene from the production.

8. Seebohm, *The Man Who Was Vogue*, 133.

9. The publication, which included American advertising, initially appeared in the United States under the title *Gazette du Bon Ton*, but this had to be changed because "Bon Ton" was copyrighted to another company (see Seebohm, *The Man Who Was Vogue*, 174).

10. *Pochoir* plates were typically included in the Christmas edition of the magazine. The cost of a ten-issue subscription to the *Gazette du Bon Genre* was $32; individual copies were sold for $4.

11. "On parle français!" *Vogue* (Paris), 15 June 1920, 3.

12. Seebohm, *The Man Who Was Vogue*, 136.

13. "And Here Is *Vogue* in French" (advertisement), *Vogue* (New York), 1 July 1921, iv.

14. "New York Gives a Fashion Show and the Beau Monde Serves as Manikins," *Harper's Bazaar,* June 1920, 96–97. The American Committee for Devastated France was a woman's organization with clubs in twenty U.S. cities and described itself as dedicated to promoting "a permanent partnership between the women of the two countries."

15. "How to Use *Vogue*" (advertisement), *Vogue* (New York), 1 March 1921, 126; "Do You Use *Vogue* or Merely Read It?" (advertisement), *Vogue* (New York), 15 November 1921, 99. The Paris office opened in January 1921; a London office was opened in 1924.

16. Advertisement for *Vogue*'s Information Service, *Vogue* (New York), 1 July 1922, 49.

17. On the issue of reparations and economic decline in France, see Macmillan, *Paris 1919.*

18. See, e.g., J.R.F. [Jeanne Robert Foster], "French Resorts with a Past and a Present," *Vogue* (New York), 1 October 1921, 50.

19. Mary Fanton Roberts, "Ultra-Modern French Art in New York," *Vogue* (New York), 15 January 1922, 50; Ruth de Rochemont, "Peintres américains de la femme," *Vogue* (Paris), 15 December 1920, 5.

20. "Dress Plagiarisms from the Art World," *Vogue* (New York), 15 March 1913, 41–42.

21. Martin, *Cubism and Fashion*. See also the critique of Martin's views in Troy, *Couture Culture*, 376 n. 4.

22. J.R.F. [Jeanne Robert Foster], "Le Cubisme dans le costume," *Vogue* (Paris), 1 January 1921, 45–46.

23. "Modernistic Art Has a Daring Way with the Mode," *Vogue* (New York), 1 June 1925, 21; "Paris Paints its Frocks in Cubist Patterns," *Vogue* (New York), 1 May 1925, 88; quote from "Madame Agnès, Who First Sponsored Modernism in Dress," *Vogue* (New York), 1 October 1925, 71.

24. J.R.F. [Jeanne Robert Foster], "L'Amérique envoie les épices de la vie à l'Europe," *Vogue* (Paris), 1 June 1923, 5.

25. See, e.g., "Music Notes," *Vogue* (New York), 1 April 1912, 104.

26. J.R.F. [Jeanne Robert Foster], "L'Opéra et l'opérette," *Vogue* (Paris), 1 May 1921, 37.

27. Ibid.

28. Discussed in chapter 5, pp. 149–50.

29. J.R.F. [Jeanne Robert Foster], "Conseils d'été," *Vogue* (Paris), 15 June 1920, 15.

30. See Londraville and Londraville, *Dear Yeats, Dear Pound, Dear Ford.*

31. Ibid., 24–26.

32. Ibid., 34.

33. On Shaw and the *American Review of Reviews*, see Graybar, *Albert Shaw of the Review of Reviews*.

34. Jeanne Robert Foster, "Art Revolutionists on Exhibition in America," *American Review of Reviews* 47 (April 1913), 448; quoted in Londraville and Londraville, *Dear Yeats, Dear Pound, Dear Ford*, 47.

35. On Quinn's contacts with modernist artists and writers, see Zilcer, *The Noble Buyer*; and Reid, *The Man from New York*.

36. Quoted in Londraville and Londraville, *Dear Yeats, Dear Pound, Dear Ford*, 157.

37. On Roché's role in this unrealized project, see Mattis, "Theater as Circus."

38. Insight into the Roché / Satie friendship may be gleaned from the composer's correspondence with the much younger writer; see Satie, *Correspondance presque complète*, 1062–77.

39. Ibid., 453.

40. Jeanne Robert Foster, "New Sculptures by Constantin Brancusi: A Note on the Man and the Formal Perfection of His Carvings," *Vanity Fair*, May 1922, 68. See also Richard N. Masteller, "Using Brancusi."

41. Pierre Leroi, "Festival Erik Satie," *Le Courrier Musical*, August–September 1920, 233.

42. Satie, *Correspondance presque complète*, 446.

43. Danon, *Entretiens avec Elise et Marcel Jouhandeau*, 145. Sachs's report that the costume was created by Poiret appears to be a misattribution, particularly since Poiret nowhere takes credit for its design.

44. Ibid.

45. Born Marie-Elise-Gabrielle Caire, she was the inspiration for the popular dance known as the "Gaby Glide." For more on Deslys (1881–1920), see Gardiner, *Gaby Deslys*.

46. Sachs, *Au temps du Boeuf sur le toit*, 177.

47. There were also evenings organized on theme of the "Nouveaux Riches," "Moonlight," "The Circus," and "The Heart of the Sea" (see Musée de la Mode et du Costume, *Paul Poiret et Nicole Groult*, 185–86).

48. One of the first "bar-dancings" was "Harry Pilcer's Dancing," owned by the American star (1885–1961) who gained notoriety as the dance partner of Gaby Deslys before going on to a successful film career (see "Avec la mode," *Vogue* [Paris], 1 December 1923, 68).

49. Musée de la Mode et du Costume, *Paul Poiret et Nicole Groult*, 186.

50. J.R.F. [Jeanne Robert Foster], "A la manière du XVIIIme," *Vogue* (Paris), 15 July 1921, 12.

51. "Poiret prend, cette saison, parti pour l'ampleur," *Vogue* (Paris), 1 November 1920, 11.

52. J.R.F. [Jeanne Robert Foster], "A la manière du XVIIIme," *Vogue* (Paris), 15 July 1921, 13.

53. The original gathering spot for Cocteau and Les Six was the Bar Gaya, located on the rue Duphot; the need for a larger space as the bar became more popular motivated the move to the location on the nearby rue Boissy d'Anglas (see Sachs, *Au temps du Boeuf sur le toit,* 143–44).

54. See Sachs, *La Decade d'illusion,* 22.

55. See chapter 1, p. 1.

56. "Palmyre reçoit sa famille: Ses escapades dans le monde des artistes," *Vogue* (Paris), 1 June 1923, 41.

57. Jean LaPorte, "La Vie nocturne et élégante de Paris," *Vogue* (Paris), 1 December 1923, 4–5.

58. Ibid., 4.

59. Sachs, *Au temps du Boeuf sur le toit,* 148–49; Cocteau quoted in Steegmuller, *Cocteau,* 241–42.

60. "Each Evening Rendez-Vous with Paris is a New Adventure," *Vogue* (New York), 15 May 1925, 162.

61. [Editorial], *Vogue* (Paris), 15 May 1921, 3.

62. According to the advertisement, the parties started at 10 P.M., and ticket prices ranged from 100 francs for a single admission to 2,000 francs for the largest loge.

63. "Les Jupes larges étaient cotoyées par des robes étroite," *Vogue* (Paris), 15 June 1921, 21–22.

64. Although the history of the masked ball can be traced to the reign of Charles VI (1380–1422), the institution of the opera ball did not really begin in France until 1713, when the Académie Royale de Musique was granted permission to hold the event on an annual basis. For a history, see John Hutton, "The Clown at the Ball."

65. "Le Bal du grand-prix à l'Opéra," *Vogue* (Paris), 1 August 1921, 10.

66. J.R.F. [Jeanne Robert Foster], "La Grande semaine," *Vogue* (New York), 1 September 1921, 47.

67. Marcel Astruc, "Les 4 Bals de vendredis de mai," *L'Illustration des modes,* 16 June 1921, 645.

68. Quoted in Hall, *The Twenties in Vogue,* 66.

69. J.R.F. [Jeanne Robert Foster], "La Pleine saison de Paris," *Vogue* (Paris), 15 June 1921, 10.

70. Ibid.

71. Garafola, *Diaghilev's Ballets Russes,* 220.

72. J.R.F. [Jeanne Robert Foster], "La Grande semaine," *Vogue* (New York), 1 September 1921, 48.

73. [Editorial], *Vogue* (Paris), 15 May 1921, 2. Edith de Beaumont was a serious scholar of Greek and later published translations of poems by Sappho; see her *Sapho* illustrated by Marie Laurencin.

74. J.R.F. [Jeanne Robert Foster], "La Grande semaine," *Vogue* (New York), 1 September 1921, 47.

75. Faucigny-Lucinge, *Fêtes mémorables, bals costumés,* 6.

76. Jean LaPorte, "Les Soirées de Paris à la Cigale," *Vogue* (Paris), 1 July 1924, 25.

77. "Chez la Comtesse Etienne de Beaumont certaines entrées furent d'une gaieté étourdissante," *Vogue* (Paris), 1 April 1922, 31.

78. Hugo, *Le Regard de la mémoire*, 208.

79. Ibid.

80. "Chez la Comtesse Etienne de Beaumont certaines entrées furent d'une gaieté étourdissante," *Vogue* (Paris), 1 April 1922, 30.

81. See Harris-Warrick, "Ballroom Dancing at the Court of Louis XIV." As she notes, the entrée originated as a balletic interlude in performances of comedy.

82. [Editorial], *Vogue* (Paris), July 1923, 2.

83. Quoted in Satie, *La Statue retrouvée*.

84. J.R.F. [Jeanne Robert Foster], "La Grande semaine de Paris," *Vogue* (Paris), 1 August 1923, 8.

85. Chimènes, *Mécènes et musiciens*, 158.

86. Satie to Countess Edith de Beaumont, 26 December 1922, in Satie, *Correspondance presque complète*, 511.

87. See Picon, *Jeanne Lanvin*, 166–67.

88. J.R.F. [Jeanne Robert Foster], "La Grande semaine de Paris," *Vogue* (Paris), 1 August 1923, 10.

89. Ibid.

90. "Les Ballets Russes ont remporté de beaux triomphes," *Vogue* (Paris), 1 July 1922, 36. For the English version, see "The Russian Ballet Charms Sophisticated Paris This Summer with Fanciful Slavic Version of Old Nursery Tales," *Vogue* (New York), 1 September 1922, 76.

91. See, especially, Garafola, *Diaghilev's Ballets Russes*, 223–24; and Taruskin, *Stravinsky and the Russian Traditions*, 1509–14.

92. Quoted in Garafola, *Diaghilev's Ballets Russes*, 223.

93. Discussed in ibid., 115–22.

94. The salon was an environment Perrault knew well: having been appointed by Louis XIV as Secretary for Life of the Academy of Inscriptions and Belles-Lettres (one of the five academies of the Institut de France), he was among the king's most influential courtiers and an in-demand guest in private homes (see Soriano, *Les Contes de Perrault*).

95. Taruskin, *Stravinsky and the Russian Traditions*, 1510.

96. These were the "Variation d'Aurore," (No. 15) and the "Entr'acte" (No. 18); see Walsh, *Stravinsky*, 340; and Taruskin, *Stravinsky and the Russian Traditions*, 1529ff.

97. Stravinsky and Craft, *Stravinsky in Pictures and Documents*, 231.

98. Lydia Sokolova, *Dancing for Diaghilev* (London: John Murray, 1960); quoted in Stravinsky and Craft, *Stravinsky in Pictures and Documents*, 230.

99. Quoted in Garafola, *Diaghilev's Ballets Russes*, 343.

100. Jean LaPorte, "La Quinzième saison de Ballets Russes," *Vogue* (Paris), 1 July 1922, 50.

101. See Campbell, "The 'Mavras' of Pushkin, Kochno, and Stravinsky."

102. Jean LaPorte, "La Vie nocturne et élégante de Paris," *Vogue* (Paris), 1 December 1923, 3.

103. "Each Evening Rendez-Vous with Paris Is a New Adventure," *Vogue* (New York), 15 May 1925, 69.

104. Charles-Roux, *Chanel and Her World,* 131.

105. Ibid., 130.

106. Noted in Walsh, *Stravinsky,* 364.

107. "The Russian Aristocracy Finds Refuge in Work," *Vogue* (Paris), 1 February 1924, 61.

108. J.R.F. [Jeanne Robert Foster], "New York's Mid-Season Merriment: Many Balls, Countless Smaller Entertainments, and Varied Fashions have made the Winter the Most Brilliant Since the War," *Vogue* (New York), 1 February 1922, 34–35.

109. Taruskin, *Stravinsky and the Russian Traditions,* 1548.

110. On the reception history, see Opéra National de Paris, *Hommage à Boris Kochno.*

111. As Taruskin has documented, *Mavra* was not, as had been previously reported, a "curtain raiser" for *La Belle au bois Dormant* (see Taruskin, *Stravinsky and the Russian Traditions,* 1592).

112. On Survage, see Loguine, *Gontcharova and Larionov,* 134.

113. Charles Tenroc, "Les Ballets Russes," *Le Courrier Musical,* 1 June 1922, 24.

114. Quoted in Taruskin, *Stravinsky and the Russian Traditions,* 1593, 1595; see pp. 1591–1604 for a full discussion of *Mavra's* reception history.

115. Boris de Schloezer, "La Musique," *Revue Contemporaine,* 1 February 1923, 257, ; quoted in Messing, *Neoclassicism in Music,* 129–30.

116. Jean LaPorte, "La Quinzième saison de Ballets Russes," *Vogue* (Paris), 1 July 1922, 50.

117. Krauss, *The Picasso Papers,* 96.

118. Schloezer, LaPorte, and most of the others who faulted *Mavra* for its qualities of pastiche came quickly back into the Stravinsky fold. For philosopher and critic Theodor Adorno, however, pastiche was Stravinsky's fundamental flaw. Comparing Stravinsky's "music about music" to the twelve-tone compositional approach of Arnold Schoenberg, Adorno assessed Stravinsky's borrowings and quotations as a kind of false modernism, an amalgamation of other styles. See Krauss, *The Picasso Papers,* 11–17, for her perspective on Adorno's arguments; see also Adorno, *Philosophy of Modern Music.*

119. Quoted in Perloff, *Art and the Everyday,* 186.

120. Quoted in Walsh, *Stravinsky,* 346.

121. Jean Cocteau, "The Comic Spirit in Modern Art," *Vanity Fair,* September 1922, 66.

122. Erik Satie, "La Musique et les enfants," *Vanity Fair,* October 1922, 53.

123. Tristan Tzara, "News of the Seven Arts in Europe," *Vanity Fair*, November 1922, 51.

124. Ibid.

125. Jean Cocteau, "A New Dramatic Form," *Vanity Fair*, December 1922, 66.

126. Ibid.

127. Erik Satie, "Igor Stravinsky: A Tribute to the Great Russian Composer by an Eminent French Confrère," *Vanity Fair*, February 1923, 39.

128. Taruskin, *Stravinsky and the Russian Traditions*, 1248.

129. As Taruskin suggests, this may well have been the first instance of these traditions coming into contact (see Taruskin, *Stravinsky and the Russian Traditions*, 1237–46).

130. Before the score was delivered to her (late, in September 1916), the Princesse also agreed to pay designer Michel Larionov's fee of three thousand francs, as well as a fee of five hundred francs to support Ramuz's translation of the texts into French (from whence the title *Le Renard* originated). For background, see Kahan, *Music's Modern Muse*, 197–202.

131. Garafola, *Diaghilev's Ballets Russes*, 238.

132. Originally the Société Anonyme des Bains de Mer et du Cercle des Etrangers à Monaco, the organization was founded by François Blanc, who built the casino at Monte Carlo. On the history of Monte Carlo and the Riviera, see Blume, *Côte d'Azur*.

133. Girard, *Les Années Fitzgerald*, 153.

134. Blume, *Côte d'Azur*, 62.

135. V. V. Derzhanovsky, quoted in Taruskin, *Stravinsky and the Russian Traditions*, 1320.

136. Fergison, "Bringing *Les Noces* to the Stage," 171.

137. Ibid.

138. Ibid., 182.

139. J.R.F. [Jeanne Robert Foster], "La Grande semaine de Paris," *Vogue* (Paris), 1 August 1923, 56.

140. "*Les Noces* de Stravinsky ont remporté un formidable success," *Vogue* (Paris), 1 August 1923, 18.

# Works Cited

*The 1915 Mode as Shown by Paris*. New York: Condé Nast, 1915.

*1918–1958: La Côte d'Azur et la modernité* (exhibit catalog). Paris: Réunion des Musées Nationaux, 1997.

Abram, Joseph. *A. and G. Perret: Le Théâtre des Champs-Elysées, 1913: Le magie du béton armé*. Paris: J. M. Place, 2001.

Acocella, Joan Ross. "The Reception of Diaghilev's Ballets Russes." Ph.D. diss., Rutgers University, 1984.

———, ed. *The Diary of Vaslav Nijinsky, Unexpurgated Edition*. New York: Farrar, Straus, and Giroux, 1999.

Adorno, Theodor W. *Philosophy of Modern Music*. Translated by Anne G. Mitchell and Wesley V. Blomster. New York: Seabury Press, 1973.

Albright, Daniel. *Untwisting the Serpent: Modernism in Music, Literature, and Other Arts*. Chicago: University of Chicago Press, 1999.

Ansermet, Ernest. *Correspondance Ernest Ansermet–Igor Strawinsky (1914–1967)*. Edited by Claude Tappolet. 2 vols. Geneva: Georg, 1990–92.

Apollinaire, Guillaume. *Apollinaire on Art: Essays and Reviews, 1902–1918*. Edited by Leroy Breunig; translated by Susan Suleiman. New York: Da Capo, 1988.

Apollonio, Umbro, ed. *Futurist Manifestos*. Boston: MFA Publications, 2001.

Archer-Straw, Petrine. *Negrophilia: Avant-Garde Paris and Black Culture in the 1920s*. London: Thames and Hudson, 2000.

Baer, Nancy van Norman. *Bronislava Nijinska: A Dancer's Legacy*. San Francisco: Fine Arts Museum of San Francisco, 1986.

Ball, Susan L. *Ozenfant and Purism: The Evolution of a Style, 1915–1930*. Ann Arbor, MI: UMI Research Press, 1981.

Baltensperger, André, and Felix Meyer, eds. *Igor Stravinsky: Symphonies d'instruments à vent, Faksimileausgabe des Particells und der Partitur der Erstfassung (1920)*. Basel: Paul Sacher Stiftung, 1991.

Barthes, Roland. *The Fashion System*. New York: Farrar, Straus, and Giroux, 1983.

———. *Mythologies*. Translated by Annette Lavers. New York: Hill and Wang, 1972.

Baudelaire, Charles. "The Painter of Modern Life." In *The Painter of Modern Life and Other Essays,* translated and edited by Jonathan Mayne, 1–41. London: Phaidon, 1964.

Baudot, François. *Chanel*. New York: Assouline, 2003.

Beaton, Cecil. *The Glass of Fashion*. London: Cassell, 1954.

Beaumont, Edith de. *Sapho: Poèmes de Sapho*. Paris: Compagnie Française des Arts Graphiques, 1950.

Bellanger, Claude, Jacques Godechot, Pierre Guiral, and Fernand Terrou, eds. *Histoire générale de la presse française.* 5 vols. Paris: Presses Universitaires de France, 1969– .

Benedict, Burton. *The Anthropology of World's Fairs: San Francisco's Panama Pacific International Exposition of 1915*. London: Scholar Press, 1983.

Bennet, Andy. *Popular Music and Youth Culture: Music, Identity, and Place*. New York: Palgrave Macmillan, 2000.

Berlin, Edward. *Ragtime: A Musical and Cultural History*. Berkeley: University of California Press, 1980.

Bizet, René. *La Mode*. Paris: F. Rieder, 1925.

Bloom, Peter. "François-Joseph Fétis and the *Revue Musicale* (1827–1835)." Ph.D. diss., University of Pennsylvania, 1972.

———. "A Review of Fétis's *Revue Musicale*." In *Music in Paris in the Eighteen-Thirties,* edited by Peter Bloom, 1–22. Stuyvesant, NY: Pendragon Press, 1987.

*The Blue Book: A Comprehensive Official Souvenir Book of the Panama Pacific International Exhibition at San Francisco, 1915*. San Francisco: Panama Pacific International Exhibition, 1915.

Blume, Mary. *Côte d'Azur: Inventing the French Riviera*. New York: Thames and Hudson, 1992.

Boretz, Benjamin, and Edward T. Cone, eds. *Perspectives on Schoenberg and Stravinsky*. Princeton, NJ: Princeton University Press, 1968.

Boucher, François. *Histoire du costume en occident des origines à nos jours*. Paris: Flammarion, 1996.

Boulez, Pierre. "Stravinsky demeure." In vol. 1 of *Musique russe,* edited by Pierre Souvtchinsky, 151–224. Paris: Presses Universitaires de France, 1953.

Bourdieu, Pierre. *Distinction*. Translated by Richard Nice. Cambridge, MA: Harvard University Press, 1984.

Brooks, Jeanice. "Nadia Boulanger and the Salon of the Princesse de Polignac." *Journal of the American Musicological Society* 46, no. 3 (Fall 1993): 415–68.

Brunhoff, Maurice de, ed. *Collection des plus beaux numéros de* Comoedia illustré *et des programmes consacrés aux ballets et galas russes depuis le début à Paris, 1909–1921*. Paris: De Brunhoff, 1922.

Campbell, Stuart. "The 'Mavras' of Pushkin, Kochno, and Stravinsky." *Music and Letters* 58, no. 3 (July 1977): 304–17.

Canova-Green, Marie-Claude, ed. *Benserade: Ballets pour Louis XIV*. Paris: Klincksieck, 1997.

Capel, Arthur. *Reflections on Victory: A Project for the Foundation of Governments*. London: T. W. Laurie, [1917?].

Castle, Irene. *Castles in the Air*. New York: Doubleday, 1958.

Cate, Phillip Dennis. "Fumism and Other Aspects of Parisian Modernism in Picasso's Early Drawings." In *Picasso: The Early Years, 1892–1906*, edited by Marilyn McCully, 133–36. Washington, DC: National Gallery of Art, 1997.

Chapon, François. *Mystère et splendeurs de Jacques Doucet*. Paris: J.-C. Lattès, 1984.

Charles-Roux, Edmonde. *Chanel and Her World: Friends, Fashion, and Fame*. Translated by Daniel Wheeler. New York: Vendome Press, 2005. Originally published as *Le Temps Chanel* (Paris: Chêne/Grasset, 1979).

———. *L'Irrégulière, ou Mon itinéraire Chanel*. Paris: Grasset, 1974. Translated by Nancy Amphoux as *Chanel* (New York: Harper Collins, 1993).

Chase, Edna Woolman, and Ilka Chase. *Always in Vogue*. New York: Doubleday, 1954.

Chimènes, Myriam. *Francis Poulenc: Correspondance*. Paris: Fayard, 1994.

———. *Mécènes et musiciens: Des salons privés au concerts publics, Paris 1870–1940*. Paris: Fayard, 2004.

Christensen, Thomas. *Rameau and Musical Thought in the Enlightenment*. Cambridge: Cambridge University Press, 1993.

Cicero. *De la république*. Translated by Victor Poupin. Paris: Librairie de la Bibliothèque Nationale, 1911.

Clair, Jean, ed. *Picasso: The Italian Journey, 1917–24*. New York: Rizzoli, 1998.

Clark, Linda. *The Education of French Schoolgirls: Pedagogical Prescriptions and Social and Economic Realities during the Third Republic*. Cambridge, MA: Bunting Institute, 1980.

Clark, Walter Aaron. *Enrique Granados: Poet of the Piano*. New York: Oxford, 2005.

Cocteau, Jean. *Cocteau et la mode*. Cahiers Jean Cocteau (new series), no. 3 Paris: Passage du Marais, 2004.

———. *Le Coq et l'arlequin*. Paris: Stock, 1978.

———. *Portraits-Souvenirs, 1900–14*. Paris: Grasset, 1934.

———. *Romans, poésies, oeuvres diverses*. Paris: Le Livre de Poche, 1995.

Coleman, Elizabeth Ann. *The Opulent Era: Fashions of Worth, Doucet, and Pingat* (exhibit catalog). New York: Brooklyn Museum, 1989.

Collet, Henri. *Albeniz et Granados*. Paris: Alcan, 1925.

Cooper, Douglas. *Picasso Theater*. New York: Harry Abrams, 1987.

Corn, Wanda M. *The Great American Thing: Modern Art and National Identity, 1915–1935*. Berkeley: University of California Press, 1999.

Cottington, David. *Cubism in the Shadow of War: The Avant-Garde and Politics in Paris, 1905–1914*. New Haven, CT: Yale University Press, 1998.

Cowart, Georgia, ed. *French Musical Thought, 1600–1800*. Ann Arbor, MI: UMI Research Press, 1989.

Craft, Robert. *Igor and Vera Stravinsky: A Photograph Album (1921–1971)*. London: Thames and Hudson, 1982.

Crespelle, Jean-Paul. *Picasso and His Women*. Translated by Robert Baldick. New York: Coward and McCann, 1969.

Crosby, Gaige. *Footlights and Highlights*. New York: E. P. Dutton, 1948.

Cross, Jonathan. *The Stravinsky Legacy*. Cambridge: Cambridge University Press, 1998.

Crow, Thomas. *Modern Art in the Common Culture*. New Haven, CT: Yale University Press, 1996.

Daix, Pierre. "Quand Picasso dessinait pour la presse 'parisienne.'" *Les Lettres Françaises*, 3 March 1971.

Damase, Jacques. *Sonia Delaunay: Fashion and Fabrics*. Translated by Shaun Whiteside. New York: Harry Abrams, 1991.

Danon, Jacques. *Entretiens avec Elise et Marcel Jouhandeau*. Paris: Pierre Belford, 1966.

Davis, Mary E. "Modernity à la mode: Popular Culture and Avant-gardism in Erik Satie's *Sports et divertissements*." *Musical Quarterly* 83 (Fall 1999): 430–73.

Davis, Shane Alexander. "Lucien Vogel." *Costume: The Journal of the Costume Society* 12 (1978): 74–82.

de la Haye, Amy, and Shelley Toobin. *Chanel: The Couturiere at Work*. Woodstock, NY: Overlook Press, 1994.

DeJean, Joan. *The Essence of Style: How the French Invented High Fashion, Fine Food, Chic Cafés, Style, Sophistication, and Glamour*. New York: Free Press, 2005.

Delbourg-Delphis, Marylène. *Le Chic et le look*. Paris: Hachette, 1981.

Delpierre, Madeleine. *Dress in France in the Eighteenth Century*. Translated by Caroline Beamish. New Haven, CT: Yale University Press, 1997.

Du Bled, Victor. *La Société française du XVIe siècle au XXe siècle*. IX Série: XVIIIe et XIXe siècles: Le Premier salon de France: L'Académie française: L'Argot. Paris: Perrin, 1913.

Ducros, Françoise. "Ozenfant et le souci de la peinture." In *Amédée Ozenfant* (exhibit catalog). San Quentin, France: Musée Antoine Lécuyer, 1985.

———. "Amédée Ozenfant, 'Purist Brother.'" In *L'Esprit nouveau: Purism in Paris, 1918–1925*, by Carol Eliel, 72–99. New York: Harry Abrams, 2000.

Dulac, Jean. *Charles Martin*. Paris: La Coupole, 1947.

Duncan, Isadora. *My Life*. New York: Boni and Liveright, 1927.

Eliel, Carol S., ed. *L'Esprit nouveau: Purism in Paris, 1918–1925*. New York: Harry N. Abrams, 2001.

Ellis, Katherine. *Music Criticism in Nineteenth-Century France*. Cambridge: Cambridge University Press, 1993.

Evans, Edwin. *Stravinsky: The Firebird and Petrushka*. Oxford: Oxford University Press, 1933.

Ewald, Donna, and Peter Clute. *San Francisco Invites the World: The Panama Pacific Exposition of 1915*. San Francisco: Chronicle Books, 1991.

Eyerman, Charlotte. "The Composition of Femininity: The Significance of the 'Woman at the Piano' Motif in Nineteenth-Century French Culture from Daumier to Renoir." Ph.D. diss., University of California at Berkeley, 1997.

———. "Playing the Market: Renoir's Young Girls at the Piano Series of 1892." In *Music and Modern Art*, edited by James Leggio, 37–60. New York: Routledge, 2002.

Farwell, Beatrice, and Abigail Solomon-Godeau. *The Image of Desire: Femininity, Modernity, and the Birth of Mass Culture in 19th-Century France* (exhibit catalog). Santa Barbara, CA: University Art Museum, 1994.

Faucigny-Lucinge, Jean-Louis de. *Fêtes mémorables, bals costumés, 1922–1972.* Paris: Herscher, 1986.

Fergison, Drue. "Bringing *Les Noces* to the Stage." In *The Ballets Russes and Its World*, edited by Lynn Garafola and Nancy van Norman Baer. New Haven, CT: Yale University Press, 1999.

Flanner, Janet. *Paris Was Yesterday, 1925–1939.* New York: Viking Press, 1972.

Foucault, Michel. "Fantasia of the Library" (1967). Translated by Donald F. Bouchard and Sherry Simon. In *Language, Countermemory, Practice: Selected Essays and Interviews by Michel Foucault,* edited by Donald F. Bouchard. Ithaca, N.Y.: Cornell University Press, 1977.

Fraser, Nancy, and Sandra Lee Bartky, eds. *Revaluing French Feminism: Critical Essays on Difference, Agency, and Culture.* Bloomington: Indiana University Press, 1992.

Fulcher, Jane. "The Composer as Intellectual: Ideological Inscriptions in French Interwar Neoclassicism." *Journal of Musicology* 17, no. 2 (Spring 1999): 197–230.

Garafola, Lynn. *Diaghilev's Ballets Russes.* Oxford: Oxford University Press, 1989.

———. *Legacies of Twentieth-Century Dance.* Middletown, CT: Wesleyan University Press, 2005.

———. "Reconstructing the Past: Tracking Down 'Le Train bleu.'" *Dance Magazine*, April 1990.

———, ed. *The Ballets Russes and Its World.* New Haven, CT: Yale University Press, 1999.

Gardiner, James. *Gaby Deslys: A Fatal Attraction.* London: Sidgwick and Jackson, 1986.

Gaudriault, Raymond. *La Gravure de la mode féminine en France.* Paris: Editions de l'Amateur, 1983.

Gelbart, Nina Rattner. *Feminine and Opposition Journalism in Old Regime France: Le Journal des Dames.* Berkeley: University of California Press, 1987.

Genette, Gérard. *Palimpsests: Literature in the Second Degree.* Translated by Channa Newman and Claude Doubinsky. Lincoln: University of Nebraska Press, 1997.

Genova, Pamela. *Symbolist Journals.* Burlington, VT: Ashgate, 2002.

Gidel, Henry. *Coco Chanel.* Paris: Flammarion, 1998.

Gillmor, Alan. *Erik Satie.* Boston: Twayne, 1988.

Girard, Xavier. *Les Années Fitzgerald: La Côte d'Azur, 1920–1930.* Paris: Assouline, 2001.

Gold, Arthur, and Robert Fitzdale. *Misia: The Life of Misia Sert.* New York: Alfred A. Knopf, 1980.

Goldstein, Robert Justin. *Political Censorship of the Arts and the Press in 19th Century Europe.* London: Macmillan, 1989.

Goubault, Christian. *La Critique musicale dans la presse française de 1870 à 1914.* Geneva: Slatkine, 1984.

Gowers, Patrick. "Satie's Rose-Croix Music (1891–1895)." *Proceedings of the Royal Musical Association,* vol. 92 (1965–66): 1–25.

Grau, François-Marie. *La Haute couture.* Paris: Presses Universitaires de France, 2000.

Graybar, Lloyd. *Albert Shaw of the Review of Reviews: An Intellectual Biography.* Lexington: University Press of Kentucky, 1974.

Griffiths, Antony. *Prints and Printmaking: An Introduction to the History and Techniques.* Berkeley: University of California Press, 1996.

Gronberg, Tag. *Designs on Modernity: Exhibiting the City in 1920s Paris.* Manchester, U.K.: Manchester University Press, 1998.

Grumbach, Didier. *Histoires de la mode.* Paris: Seuil, 1993.

Guilleminault, Gilbert. *La France de la Madelon, 1914–18.* Paris: Denoël, 1965.

Hall, Carolyn. *The Twenties in Vogue.* New York: Harmony Books, 1983.

Harding, James. *Erik Satie.* New York: Praeger, 1975.

Harris-Warrick, Rebecca. "Ballroom Dancing at the Court of Louis XIV." *Early Music* 14, no. 1 (February 1986): 41–49.

Hatin, Eugène. *Histoire politique et littéraire de la presse en France.* Geneva: Slatkine Reprints, 1967.

Hess, Carol A. *Enrique Granados: A Bio-Bibliography.* New York: Greenwood Press, 1991.

Heyman, Barbara B. "Stravinsky and Ragtime." *Musical Quarterly* 86 (1982): 543–62.

Hollander, Anne. *Feeding the Eye.* New York: Farrar, Straus and Giroux, 1999.

———. *Seeing Through Clothes.* Berkeley: University of California Press, 1993.

Huesca, Roland. *Triomphes et scandales.* Paris: Hermann, 2001.

Hugo, Jean. *Avant d'oublier, 1918–1931.* Paris: Fayard, 1976.

———. *Le Regard de la mémoire.* Paris: Actes Sud, 1983.

Hutton, John. "The Clown at the Ball: Manet's Masked Ball of the Opera and the Collapse of Monarchism in the Early Third Republic." *Oxford Art Journal* 10, no. 2 (1987): 76–94.

Iribe, Paul. *Les Robes de Paul Poiret racontées par Paul Iribe.* Paris: Société Générale d'Impression, 1908.

Jeanroy, Alfred, and Aimé Puech. *Histoire de la littérature latine.* 18th ed. Paris: Librairie Classique Mellottée, 1907.

Johnson, James H. *Listening in Paris: A Cultural History.* Berkeley: University of California Press, 1995.

Kahan, Sylvia. *Music's Modern Muse: A Life of Winnaretta Singer, Princesse de Polignac.* Rochester, NY: University of Rochester Press, 2003.

Kennett, Frances. *Coco: The Lives and Loves of Gabrielle Chanel.* London: Victor Gollancz, 1989.

Keynes, Milo. *Lydia Lopokova.* New York: St. Martin's Press, 1982.

Klüver, Billy, and Julie Martin. *Kiki's Paris: Artists and Lovers, 1900–1930.* New York: Harry Abrams, 1989.

Kochno, Boris. *Diaghilev and the Ballets Russes.* Translated by Adrienne Foulke. New York: Harper and Row, 1970.

Koda, Harold. *Goddess: The Classical Mode.* New York: Metropolitan Museum of Art, 2003.

Koza, Julia Eklund. "Music and References to Music in *Godey's Lady's Book,* 1830–77." Ph.D. diss., University of Minnesota, 1988.

Kolosek, Lisa Schlansker. *The Invention of Chic: Thérèse Bonney and Paris Moderne.* New York: Thames and Hudson, 2002.

Kramer, Jonathan. *The Time of Music.* New York: Schirmer Books, 1988.

Krauss, Rosalind E. *The Picasso Papers.* New York: Farrar Straus Giroux, 1998.

La Bruyère. *Oeuvres.* Translated by M. G. Servois. 2nd ed. Paris: Hachette, 1912.

Lago, Manoel Aranha Corrêa do. "Brazilian Sources in Milhaud's *Le Boeuf sur le toit*: A Discussion and a Musical Analysis." *Latin American Music Review* 23, no. 1 (Spring–Summer 2002): 1–59.

Lambert, Constant. *Music Ho! A Study of Music in Decline.* 3rd ed. London: Hogarth Press, 1985.

Lang, Abigail S., ed. *Mode et contre-mode: Une anthologie de Montaigne à Perec.* Paris: Institut Français de la Mode and Editions du Regard, 2001.

Larzul, Sylvette. *Les Traductions françaises des Mille et une nuits: Etude des versions Galland, Trébutien et Mardrus.* Paris: L'Harmattan, 1996.

Laurent, Linda, and Andrée Tainsy. "Jane Bathori et le Théâtre du Vieux-Colombier, 1917–19." *Revue de Musicologie* 70 (1984): 229–57.

Lecercle, Jean-Pierre. *Mallarmé et la mode.* Paris: Séguier, 1989.

Lehmann, Ulrich. *Tigersprung: Fashion in Modernity.* Cambridge, MA: MIT Press, 2000.

Lepape, Claude, and Thierry Defert. *The Art of Georges Lepape: From the Ballets Russes to Vogue.* Translated by Jane Brenton. London: Thames and Hudson, 1984.

Lepape, Georges. *Les Choses de Paul Poiret vues par Georges Lepape.* Paris: Maquet, 1911.

Lesure, François, ed. *Igor Stravinsky, "Le Sacre du printemps": Dossier de presse.* Geneva: Minkoff, 1980.

Lewin, David. *Musical Form and Transformation: Four Analytic Essays.* New Haven, CT: Yale University Press, 1993.

Leymarie, Jean. *Chanel.* Geneva: Skira, 1987.

Lifar, Serge. *Serge Diaghilev: His Life, His Work, His Legend.* New York: G. P. Putnam's Sons, 1940.

Lipovetsky, Gilles. *The Empire of Fashion: Dressing Modern Democracy.* Translated by Catherine Porter. Princeton, NJ: Princeton University Press, 1994.

Londraville, Richard, and Janis Londraville. *Dear Yeats, Dear Pound, Dear Ford: Jeanne Robert Foster and Her Circle of Friends.* Syracuse, NY: Syracuse University Press, 2001.

Loguine, Tatiana. *Gontcharova and Larionov: Cinquante ans à St. Germain des Près.* Paris: Klincksieck, 1971.

Lurie, Alison. *The Language of Clothes.* New York: Henry Holt, 1981.

MacDonald, Nesta. *Diaghilev Observed by Critics in England and the United States, 1911–1929.* New York: Dance Horizons, 1975.

Machlis, Joseph. *Introduction to Contemporary Music.* London: J. M. Dent, 1961.

Mackaman, Douglas Peter. *Leisure Settings: Bourgeois Culture, Medicine, and the Spa in Modern France.* Chicago: University of Chicago Press, 1998.

Mackrell, Alice. *Coco Chanel.* New York: Holmes and Meier, 1992.

Macmillan, Margaret. *Paris 1919: Six Months That Changed the World.* New York: Random House, 2003.

Madsen, Axel. *Chanel: A Woman of Her Own.* New York: Henry Holt, 1990.

Maes, Francis. *A History of Russian Music: From Kamarinskaya to Babi Yar.* Berkeley: University of California Press, 2001.

Mainardi, Patricia. *The End of the Salon: Art and the State in the Early Third Republic.* Cambridge: Cambridge University Press, 1993.

Mallarmé, Stéphane. *Oeuvres complètes.* Edited by Henri Mondor and Jean-Pierre Richard. Paris: Gallimard, 1945.

Mann, Carol. *Paris Between the Wars.* New York: Laurence King, 1996.

Margerie, Anne de. *Valentine Hugo.* Paris: Jacques Damase, 1983.

Margueritte, Victor. *La Garçonne.* Paris: Flammarion, 1922.

Marly, Diana de. *Worth: Father of Haute Couture.* New York: Holmes and Meier, 1990.

Martin, Benjamin F. *France and the Après Guerre, 1918–1924: Illusions and Disappointment.* Baton Rouge: Louisiana State University Press, 1999.

Martin, Richard. *Cubism and Fashion.* New York: Metropolitan Museum of Art, 1999.

Masteller, Richard N. "Using Brancusi: Three Writers, Three Magazines, Three Versions of Modernism." *American Art* 11, no. 1 (Spring 1997): 46–67.

Mattis, Olivia. "Theater as Circus: A Midsummer Night's Dream." *Library Chronicle of the University of Texas at Austin* 23, no. 4 (1993): 43–77.

Mauriès, Patrick. *Jewelry By Chanel.* Translated by Barbara Mellor. Boston: Bulfinch, 1993.

Mayer, Charles. "The Theatrical Designs of Léon Bakst." Ph.D. diss., Columbia University, 1977.

Mazo, Margarita. "Stravinsky's *Les Noces* and Russian Folk Wedding Ritual." *Journal of the American Musicological Society* 43 (1990): 99–142.

McClary, Susan. "Same As It Ever Was." In *Microphone Fiends: Youth Music and Youth Culture*, edited by Andrew Ross and Tricia Rose, 29–39. London: Routledge, 1994.

Mellers, Wilfred. "Jean Wiéner Redivivus." *Tempo* 170 (September 1989): 24–29.

Messing, Scott. *Neoclassicism in Music: From the Genesis of the Concept through the Schoenberg/Stravinsky Polemic*. Ann Arbor, MI: UMI Research Press, 1988.

Milhaud, Darius. *Etudes*. Paris: Claude Aveline, 1927.

———. *Notes without Music*. Translated by Donald Evans. New York: Alfred A. Knopf, 1953.

———. *Notes sur la musique: Essais et chroniques*. Edited by Jeremy Drake. Paris: Flammarion, 1992.

Miller, Bonnie H. "The Mirror of Ages Past: The Publication of Music in Domestic Periodicals." *Notes* 50, no. 3 (1994): 883–901.

Miller, Catherine. *Cocteau, Apollinaire, Claudel et Le Groupe des Six*. Liège: Pierre Mardaga, 2003.

Miller, Michael B. *The Bon Marché: Bourgeois Culture and the Department Store*. Princeton, NJ: Princeton University Press, 1981.

Morand, Paul. *L'Allure de Chanel*. Paris: Hermann, 1976.

———. *Journal d'un attaché d'ambassade, 1916–17*. Paris: Table Ronde, 1948.

———. *Lewis et Irène*. Paris: Flammarion, 1923.

Mosconi, Nicole. *Femmes et savoir: La société, l'école, et la division sexuelle des savoirs*. Paris: L'Harmattan, 1994.

Moureau, François. *Le Mercure Galant de Dufresny (1710–1714) ou le journalisme à la mode*. Oxford: Voltaire Foundation, 1982.

Musée Antoine Lécuyer. *Amédée Ozenfant* (exhibit catalog). Text by Françoise Ducros. San Quentin, France: Musée Antoine Lécuyer, 1985.

Musée Carnavalet. *Au temps des merveilleuses: La société parisienne sous le Directoire et le Consultat* (exhibit catalog). Paris, 2005.

Musée de la Mode et du Costume. *Paul Poiret et Nicole Groult: Maîtres de la mode Art Déco* (exhibit catalog). Paris: Palais Galliéra, 1986.

Musée Nationale d'Art Moderne, Centre Georges Pompidou. *Cocteau* (exhibit catalog). Paris, 2004.

Neuls-Bates, Carol, ed. *Women in Music: An Anthology of Source Readings from the Middle Ages to the Present*. New York: Harper and Row, 1982.

Nichols, Roger. *The Harlequin Years: Music in Paris, 1917–1929*. Berkeley: University of California Press, 2003.

Nijinska, Bronislava. *Early Memoirs*. Translated and edited by Irina Nijinska and Jean Rawlinson. New York: Holt, Rinehart, and Winston, 1981.

Nochlin, Linda. *Realism*. London: Pelican, 1971.

O'Brian, Patrick. *Pablo Picasso: A Biography*. New York: W. W. Norton, 1994.

Oja, Carol. *Making Music Modern*. New York: Oxford University Press, 2000.

Opéra National de Paris. *Hommage à Boris Kochno*. Paris: Opéra National de Paris, 2002.

Orledge, Robert. "Erik Satie's Ballet 'Mercure' (1924): From Mount Etna to Montmartre." *Journal of the Royal Musical Association* 123, no. 2 (1998): 229–49.

———. "Satie in America." *American Music* 18, no. 1 (Spring 2000): 909–12.

———. *Satie the Composer.* Cambridge: Cambridge University Press, 1990.

Ozenfant, Amédée. *Mémoires, 1866–1962.* Paris: Seghers, 1968.

Pasler, Jann. "Concert Programs and Their Narratives as Emblems of Ideology." *International Journal of Musicology* 2 (1993): 249–308.

———. "Stravinsky and the Apaches." *Musical Times* 123 (1982): 403–7.

———, ed. *Confronting Stravinsky.* Berkeley: University of California Press, 1986.

Perloff, Nancy. *Art and the Everyday: Popular Entertainment and the Circle of Erik Satie.* New York: Oxford University Press, 1991.

Perrot, Philippe. *Fashioning the Bourgeoisie: A History of Clothing in the Nineteenth Century.* Translated by Richard Bienvenu. Princeton, NJ: Princeton University Press, 1994.

Picon, Jérôme. *Jeanne Lanvin.* Paris: Flammarion, 2002.

Poiret, Paul. *King of Fashion: The Autobiography of Paul Poiret.* Translated by Stephen Haden Guest. Philadelphia: J. P. Lippincott, 1931. Originally published as *En habillant l'époque* (Paris: Grasset, 1930).

———. *My First Fifty Years.* Translated by Stephen Haden Guest. London: Victor Gollancz, 1931.

Polignac, Princesse Edmond de. "Memoirs of the Late Princesse Edmond de Polignac." *Horizon* (August 1945): 110–41.

Poulenc, Francis. "La Musique: Apropos de 'Mavra' d'Igor Stravinsky." *Feuilles Libres,* no. 27 (June–July 1922): 223–25.

———. *My Friends and Myself.* Translated by James Harding. London: Dennis Dobson, 1978.

Proust, Marcel. *Remembrance of Things Past.* Translated by C. K. Scott Montcrieff and Frederick A. Blossom. New York: Random House, 1927–32.

Purdy, Daniel Leonhard, ed. *The Rise of Fashion: A Reader.* Minneapolis: University of Minnesota Press, 2004.

Ray, Man. *Self Portrait.* 1963. Reprint, London: Bloomsbury Press, 1988.

Rehding, Alexander. "Towards a 'Logic of Discontinuity' in Stravinsky's *Symphonies of Wind Instruments*: Hasty, Kramer, and Straus Reconsidered." *Music Analysis* 17, no. 1 (March 1998): 39–65.

Reid, Benjamin L. *The Man from New York: John Quinn and His Friends.* New York: Oxford University Press, 1968.

Rey, Alain, Marianne Tomi, Tristan Hordé, and Chantal Tanet. *Dictionnaire historique de la langue française.* Paris: Dictionnaires Le Robert, 1992.

Ries, Frank. *The Dance Theater of Jean Cocteau.* Ann Arbor, MI: UMI Research Press, 1986.

Robert, Frédéric. "La musique à travers *Le Mercure Galant.*" In *Recherches sur la musique française classique,* edited by N. Dufourcq with the aid of members of Histoire et Musique, 2:173–90. Paris: A. et J. Picard, 1961–62.

Roberts, Mary Louise. *Disruptive Acts: The New Woman in Fin-de-Siècle France*. Chicago: University of Chicago Press, 2005.

Roche, Daniel. *The Culture of Clothing: Dress and Fashion in the Ancien Régime*. Translated by Jean Birrell. Cambridge: Cambridge University Press, 1994.

Roland-Manuel, Alexis. *Erik Satie: Causerie faite à la Société Lyre et Palette, le 18 Avril 1916*. Paris: H. Roberge, 1916.

Rothschild, Deborah Menaker. *Picasso's Parade: From Street to Stage*. New York: Harry Abrams and The Drawing Center, 1989.

Rouart, Jean-Marie. *Morny: Un Volupteux au pouvoir*. Paris: Gallimard, 1997.

Rousseau-Plotto, Etienne. *Stravinsky à Biarritz*. Anglet: Séguier, 2001.

Sachs, Maurice. *Au temps du Boeuf sur le toit*. 1939. Reprint, Paris: Bernard Grasset, 2005.

———. *La Decade d'illusion*. Paris: Gallimard, 1950.

Sandoz, G.-Roger. *Rapport générale de la Section française, Exposition Universelle et Internationale de San Francisco 1915, Panama Pacific International Exposition Paris: Comité français des Expositions a l'étranger*. Paris: Devambez, n.d.

Satie, Erik. *Correspondance presque complète*. Edited by Ornella Volta. Paris: Fayard, 2002.

———. *Ecrits*. Edited and translated by Ornella Volta. Paris: Editions Champ-Libre, 1990.

———. *La Statue retrouvée*. Edited by Robert Orledge. Paris: Salabert, 1997.

———. *L'Ymagier d'Erik Satie*. Edited by Ornella Volta. Paris: Editions Van de Velde, 1990.

———. *Satie Seen through His Letters*. Edited by Ornella Volta. London: Marion Boyars, 1989.

Saudé, Jean. *Traité d'enluminure d'art au pochoir*. Paris: Editions de l'Ibis, 1925.

Saunders, Edith. *The Age of Worth, Couturier to the Empress Eugénie*. Bloomington: Indiana University Press, 1955.

Schloezer, Boris de. *Igor Stravinsky*. Paris: Claude Aveline, 1929.

Seaman, Gerald. "Pushkin and Music: A Poet's Echoes." *Musical Times* 140, no. 1866 (Spring 1999): 29–32.

Seebohm, Caroline. *The Man Who Was Vogue*. New York: Knopf, 1982.

Sem [Georges Goursat]. *Le Vrai et le faux chic*. Paris: Succès, 1914.

Sert, Misia. *Misia and the Muses: The Memoirs of Misia Sert*. New York: J. Day, 1953.

Severini, Gino. *The Life of a Painter: The Autobiography of Gino Severini*. Translated by Jennifer Franchina. Princeton, NJ: Princeton University Press, 1995.

Shattuck, Roger. *The Banquet Years: The Origins of the Avant-Garde in France, 1885 to World War I*. New York: Vintage, 1968.

Silver, Kenneth. *Esprit de Corps: The Art of the Parisian Avant-Garde and the First World War, 1914–25*. Princeton, NJ: Princeton University Press, 1989.

Somfai, László. "*Symphonies of Wind Instruments* (1920): Observations on Stravinsky's Organic Construction." *Studia Musicologica* 14 (1972): 355–83.

Soriano, Marc. *Les Contes de Perrault: Culture savante et traditions populaires.* Paris: Gallimard, 1989.

Sousa, John Philip. *Marching Along: Recollections of Men, Women, and Music.* Boston: Hale, Cushman, and Flint, 1928.

Steegmuller, Francis. *Cocteau: A Biography.* Boston: David Godine, 1970.

Steele, Valerie. *Paris Fashion: A Cultural History.* New York: Oxford University Press, 1988.

Stern, Radu. *Against Fashion: Clothing as Art, 1850–1930.* Cambridge, MA: MIT Press, 2004.

Stravinsky, Igor. *An Autobiography.* New York: W. W. Norton, 1962.

———. *Stravinsky: Selected Correspondence.* Edited by Robert Craft. 3 vols. New York: Alfred A. Knopf, 1982–85.

Stravinsky, Igor, and Robert Craft. *Conversations with Igor Stravinsky.* 1959. Reprint, Berkeley: University of California Press, 1980.

———. *Dialogues.* London: Faber and Faber, 1982.

———. *Dialogues and a Diary.* 1963. Reprint, Berkeley: University of California Press, 1981.

———. *Expositions and Developments.* 1962. Reprint, Berkeley: University of California Press, 1981.

———. *Memories and Commentaries.* 1960. Reprint, Berkeley: University of California Press, 1981.

———. *Retrospectives and Conclusions.* New York: Alfred A. Knopf, 1969.

———. *Themes and Episodes.* New York: Alfred A. Knopf, 1966.

Stravinsky, Vera, and Robert Craft. *Stravinsky in Pictures and Documents.* New York: Simon and Schuster, 1978.

Sullerot, Evelyne. *La Presse féminine.* Paris: Armand Colin, 1966.

Taruskin, Richard. "Back to Whom? Neoclassicism as Ideology." *19th-Century Music* 16, no. 3 (Spring 1993): 286–302.

———. "A Myth of the Twentieth Century: The 'Rite of Spring,' the Tradition of the New, and 'The Music Itself.'" *Modernism/Modernity* 2, no. 1 (1995): 1–26.

———. Review of *Igor Stravinsky: Symphonies d'instruments à vent*, by André Baltensperger and Felix Meyer. *Notes* 49, nos. 3–4 (1993): 1617–21.

———. *Stravinsky and the Russian Traditions.* Berkeley: University of California Press, 1996.

Taylor, Deems. *Of Men and Music.* New York: Simon and Schuster, 1937.

Taylor, Denise Pilmer. "La Musique pour tout le monde: Jean Wiéner and the Dawn of French Jazz." Ph.D. diss., University of Michigan, 1998.

Taylor, Julie. "Tango: Theme of Class and Nation." *Ethnomusicology* 20 (1976): 273–91.

Templier, Pierre-Daniel. *Erik Satie.* Translated by David French and Elena French. Cambridge, MA: MIT Press, 1969.

Thurman, Judith. *Secrets of the Flesh: A Life of Colette*. New York: Ballantine Books, 1999.

Tiersten, Lisa. *Marianne in the Market*. Berkeley: University of California Press, 2001.

Tollini, Frederick Paul. *Scene Design at the Court of Louis XIV: The Work of the Vigarani Family and Jean Bérain*. New York: Mellen Press, 2003.

Tomkins, Calvin. *Duchamp: A Biography*. New York: Henry Holt, 1996.

Toulemon, Elise. *Joies et douleurs d'une belle excentrique*. Paris: Flammarion, 1952.

Troy, Nancy. *Couture Culture: A Study in Modern Art and Fashion*. Cambridge, MA: MIT Press, 2002.

———. *Modernism and the Decorative Arts in France: Art Nouveau to Le Corbusier*. New Haven, CT: Yale University Press, 1991.

Tye, Larry. *The Father of Spin: Edward Bernays and the Birth of Public Relations*. New York: Crown, 1998.

Vaill, Amanda. *Everybody Was So Young: Gerald and Sara Murphy, A Lost Generation Love Story*. New York: Houghton Mifflin, 1998.

Valotaire, Marcel. *Charles Martin*. Paris: Les Artistes du Livre, 1928.

Varnedoe, Kirk. *A Fine Disregard: What Makes Modern Art Modern*. New York: Harry Abrams, 1994.

———. "Words." In *High and Low: Modern Art and Popular Culture*, edited by Kirk Varnedoe and Adam Gopnik. New York: Museum of Modern Art and Harry N. Abrams, 1990.

Varnedoe, Kirk, and Adam Gopnik, eds., *High and Low: Modern Art and Popular Culture*. New York: Museum of Modern Art and Harry N. Abrams, 1990.

Verba, Cynthia. *Music and the French Enlightenment: Reconstruction of a Dialogue, 1750–64*. Oxford: Clarendon Press, 1993.

Vincent, Monique. *Anthologie des nouvelles du Mercure Galant (1672–1710)*. Paris: Société des Textes Français Modernes, 1996.

Vuillermoz, Emile. "Noces—Igor Strawinsky." *Revue Musicale* 4, no. 10 (August 1923): 69–72.

Vulliez-Laparra, Wanda. *Gloire de Biarritz*. Paris: France-Empire, 1998.

Wallach, Janet. *Chanel: Her Style and Life*. New York: Doubleday, 1998.

Walsh, Stephen. *Stravinsky: A Creative Spring: Russia and France, 1882–1934*. New York: Knopf, 1999.

Watkins, Glenn. *Pyramids at the Louvre: Music, Culture, and Collage from Stravinsky to the Postmodernists*. Cambridge, MA: Harvard University Press, 1994.

Wehmeyer, Grete. *Erik Satie: Bilder und Dokumente*. Munich: Spangenberg, 1992.

Weill, Alain. *La Mode Parisienne: La Gazette du Bon Ton*. Paris: Bibliothèque de l'Image, 2000.

Weiss, Jeffrey. *The Popular Culture of Modern Art*. New Haven, CT: Yale University Press, 1994.

White, Palmer. *Poiret*. New York: Clarkson N. Potter, 1973.

Whiteley, Sheila, ed. *Music, Space, and Place: Popular Music and Cultural Identity*. Burlington, VT: Ashgate, 2004.

Whiting, Steven Moore. *Satie the Bohemian*. Oxford: Oxford University Press, 1999.

Wilkins, Nigel. *The Writings of Erik Satie*. London: Eulenburg, 1980.

Wilson, Elizabeth. *Adorned in Dreams: Fashion and Modernity*. New Brunswick, NJ: Rutgers University Press, 2003.

Wollen, Peter. *Raiding the Icebox: Reflections on Twentieth-Century Culture*. Bloomington: Indiana University Press, 1993.

Zdatny, Steven, ed. *Hairstyles and Fashion: A Hairdresser's History of Paris, 1910–1920*. New York: Berg, 1999.

Zilcer, Judith. *The Noble Buyer: John Quinn, Patron of the Avant-Garde*. Washington, DC: Smithsonian Institution Press, 1978.

# Illustration Credits

Frontispiece: "En Ecoutant Satie," from *Modes et manières d'aujourd'hui*, 1920, plate xx. By permission of the Houghton Library, Harvard University.

1. Eduardo Benito, "Palmyre danse la Sévillane," in *Vogue* (Paris), 1 February 1923, 18. Courtesy of *Vogue*, © Condé Nast Publications Inc.

2. Concert-room evening dress, from *La Belle Assemblée*, November 1809. Photo: Merrill David.

3. Women at the piano, from *La Mode Illustrée*, January 1859. Photo: Merrill David.

4a. Photo of Natalia Trouhanova from *Comoedia Illustré*, program for the Ballets Russes season of 1911. Cliché Bibliothèque Nationale de France, Paris.

4b. Portrait of Natalia Trouhanova, on the cover of *Le Courrier Musical*, July 1913. Cliché Bibliothèque Nationale de France, Paris.

5. "La Mode au Théâtre et au Concert," fashion reportage in *Le Courrier Musical*, June 1922. The title of this column changed from "La Mode à Travers les Arts" in 1921. Cliché Bibliothèque Nationale de France, Paris.

6. Paul Poiret, 1913. Courtesy of the Library of Congress, Prints and Images Division.

7. Paul Poiret, white satin gown overhung with a full tunic of black mousseline de soie outlined with black moss trim and decorated with a corsage of crystal and rhinestones held in place by rhinestone chains, from *Vogue* (New York), 15 April 1912, 37. Courtesy of *Vogue*, © Condé Nast Publications Inc., and Artists Rights Society (ARS) New York/ADAGP, Paris.

8. Horace Vernet and Georges-Jacques Gatine (engraver), "Italian Straw Hat, Scottish Scarf, Wheel Embroideries," from *Costumes d'incroyables et merveilleuses*, no. 13, 1812. Cliché Bibliothèque Nationale de France, Paris.

9. Paul Poiret, "Joséphine," costume by Paul Poiret. © 2005 Artists Rights Society (ARS), New York/ADAGP, Paris.

10. "The Prophet of Simplicity," in *Vogue* (New York), 1 November 1913, 43. Photos by Geisler and Baumann. Courtesy of *Vogue*, © Condé Nast Publications Inc.

11. Paul Poiret, *jupe-sultane* costumes, in *L'Illustration*, no. 3547 (18 February 1911), 104. Photo: Merrill David. © 2005 Artists Rights Society (ARS) , New York/ADAGP, Paris.

12. Aladin perfume, in *Les Parfums de Rosine* (Cannes: Imprimerie Robaudy, n.d.). Photo: Merrill David.

13. Bernard Naudin, program for a concert of chamber music at Poiret's atelier, May 1911. Photo: Merrill David. © 2005 Artists Rights Society (ARS) New York/ADAGP, Paris.

14. Le Butard. Photo: Merrill David.

15. Bernard Naudin, illustration from a program of chamber music hosted by Poiret, May 1911. Photo: Merrill David. © 2005 Artists Rights Society (ARS) New York/ADAGP, Paris.

16. Guy-Pierre Fauconnet, program for Les Festes de Bacchus, 1912. Photo: Merrill David.

17. Paul Iribe, *Les Robes de Paul Poiret racontées par Paul Iribe*, plate 1, 1908. Cliché Bibliothèque Nationale de France, Paris.

18. Georges Lepape, *Les Choses de Paul Poiret*, plate 2, 1911. Cliché Bibliothèque Nationale de France, Paris. © 2005 Artists Rights Society (ARS) New York/ADAGP, Paris.

19. Lucien Vogel with Countess Karolyi, from "We Nominate for the Hall of Fame," in *Vanity Fair*, February 1932, 62. Courtesy of *Vanity Fair*, © Condé Nast Publications Inc.

20. Georges Lepape, "Serais-je en avance? Manteau de théâtre de Paul Poiret," from *Gazette du Bon Ton*, December 1912, plate 6. Photo: Merrill David. © 2005 Artists Rights Society (ARS) New York/ADAGP, Paris.

21. Georges Lepape, "Lassitude, robe de dîner, de Paul Poiret," from *Gazette du Bon Ton*, November 1912, plate 8. Photo: Merrill David. © 2005 Artists Rights Society (ARS) New York/ADAGP, Paris.

22. Georges Lepape, "Dancing, manteau du soir de Paul Poiret," from *Gazette du Bon Ton*, March 1920, plate 12. Photo: Merrill David. © 2005 Artists Rights Society (ARS) New York/ADAGP, Paris.

23. Thayaht (Ernesto Michaelles), "De la fumée, robe de Madeleine Vionnet," from *Gazette du Bon Ton*, August 1922, plate 15. Photo: Merrill David.

24.  Charles Martin, cartoon from *Le Sourire*, January 1911. Photo: Merrill David.

25.  Charles Martin, "De la pomme aux lèvres, travesti de Redfern," from *Gazette du Bon Ton*, February 1913, plate 6. Photo: Merrill David.

26.  Léon Bakst, "Philomèle, robe de Bakst réalisée par Paquin," from *Gazette du Bon Ton*, April 1913, plate 1. Photo: Merrill David.

27.  Suzanne Valadon, portrait of Erik Satie, ca. 1893. Private Collection. Photo: Bridgeman-Giraudon/Art Resource, NY.

28.  Erik Satie, "Le Yachting" (1914), score from *Sports et divertissements*, 1922. Reprinted by permission of the Houghton Library, Harvard University.

29.  Charles Martin, "Le Yachting," design from *Sports et divertissements*, 1922. Reprinted by permission of the Houghton Library, Harvard University.

30.  Charles Martin, "Le Yachting" (1922), illustration from *Sports et divertissements*, 1922. Reprinted by permission of the Houghton Library, Harvard University.

31.  Table of Contents, *Femina*, 15 May 1913. Cliché Bibliothèque Nationale de France, Paris.

32.  Table of Contents, *Sports et divertissements*, 1922. Reprinted by permission of the Houghton Library, Harvard University.

33.  Le "Yachting," *Femina*, 15 May 1913, 270.

34.  Charles Martin, "Pauvre bougre!" in *Sous les pots de fleurs* (Paris: J. Meynial, n.d.). Cliché Bibliothèque Nationale de France, Paris.

35.  Charles Martin, "Le Carnaval" (1914), illustration from *Sports et divertissements*, 1922. Reprinted by permission of the Houghton Library, Harvard University.

36.  Edward Steichen, "Pompon," costume by Paul Poiret, in *Art et Décoration* 29 (April 1911): 105. Courtesy of the Fine Arts Library, Harvard College Library.

37.  Charles Martin, "Le Feux d'artifice" (1914), illustration from *Sports et divertissements*, 1922. Reprinted by permission of the Houghton Library, Harvard University.

38.  Edward Steichen, "Battick," evening coat by Paul Poiret, in *Art et Décoration* 29 (April 1911): 105. Courtesy of the Fine Arts Library, Harvard College Library.

39.  Erik Satie, "Le Golf" (1914), score from *Sports et divertissements*, 1922. Reprinted by permission of the Houghton Library, Harvard University.

40. Charles Martin, "Le Golf" (1914), illustration from *Sports et divertissements*, 1922. Reprinted by permission of the Houghton Library, Harvard University.

41. Charles Martin, "Le Golf" (1922), illustration from *Sports et divertissements*, 1922. Reprinted by permission of the Houghton Library, Harvard University.

42. Erik Satie, "Le Bain de mer" (1914), score from *Sports et divertissements*, 1922. Reprinted by permission of the Houghton Library, Harvard University.

43. Charles Martin, "Le Bain de mer" (1914), illustration from *Sports et divertissements*, 1922. Reprinted by permission of the Houghton Library, Harvard University.

44. Charles Martin, "Le Bain de mer" (1922), illustration from *Sports et divertissements*, 1922. Reprinted by permission of the Houghton Library, Harvard University.

45a. Charles Martin, "Le Water-chute" (1922), illustration from *Sports et divertissements*, 1922. Reprinted by permission of the Houghton Library, Harvard University.

45b. Erik Satie, score for "Le Water-chute" (1914), from *Sports et divertissements*, 1922. Reprinted by permission of the Houghton Library, Harvard University.

46. "Beau Brummels of the Brush," in *Vogue* (New York), June 1914, reproducing Charles Martin's illustration (1914) for "Le Tango (perpétuel)" from *Sports et divertissements*, 1922. Courtesy of *Vogue*, © Condé Nast Publications Inc.

47. Jannin et Denys, illustrated title page for Georges Bizet, *Jeux d'enfants*, Op. 22 (Paris: Durand, 1871). Cliché Bibliothèque Nationale de France, Paris.

48. Adolphe de Meyer, photo of Count Etienne de Beaumont. Cliché Bibliothèque Nationale de France, Paris.

49. Henri Manuel, photo of Germaine Bongard. Cliché Bibliothèque Nationale de France, Paris.

50. "A New Salon for Unique Fashions," in *Vogue* (New York), 1 October 1912, 47. Courtesy of *Vogue*, © Condé Nast Publications Inc.

51. Jacques-Emile Blanche, *Portrait of Les Six*, 1922. Photo: Giraudon/Art Resource, NY. © 2005 Artists Rights Society (ARS) New York/ADAGP, Paris.

52. Amédée Ozenfant, "Le front, le collier de la victoire," on the cover of *L'Elan*, 15 April 1915. Reprinted by permission of the Houghton Library, Harvard University.

53. Albert Chazalviel, "Pas de Wagner à l'horizon," in *L'Elan*, 15 May 1915, 5. Reprinted by permission of the Houghton Library, Harvard University.

54. Photo of Picasso, Olga Koklova, and Jean Cocteau in Rome, 1917. Musée Picasso, Paris, France. Photo: Réunion des Musées Nationaux/Art Resource, NY.

55. Pablo Picasso, curtain for the ballet *Parade*, 1917. Musée National d'Art Moderne, Centre Georges Pompidou, Paris, France. Photo: CNAC/MNAM/Dist. Réunion des Musées Nationaux/Art Resource, NY. © 2005 Artists Rights Society (ARS) New York/ADAGP, Paris.

56. Mary Pickford ca. 1921. Courtesy of the Library of Congress, Prints and Photographs Division.

57. Lydia Sokolova as the "Little American Girl" in *Parade*, 1917. Courtesy of the Harvard Theater Collection, Harvard University.

58. Gino Severini, *La Danse de l'ours au Moulin Rouge*, 1917. Musée National d'Art Moderne, Centre Georges Pompidou, Paris, France. Photo: CNAC/MNAM/Dist. Réunion des Musées Nationaux/Art Resource, NY. © 2005 Artists Rights Society (ARS) New York/ADAGP, Paris.

59. Irving Berlin and Ted Snyder, "Mystérious Rag," in a "new arrangement" by Edouard Salabert (Paris: Salabert, 1913); featuring a photo by Langlois of Manzano and La Mora. Cliché Bibliothèque Nationale de France, Paris.

60. Irving Berlin and Ted Snyder, "That Mysterious Rag" (New York: Ted Snyder, 1911); featuring a photo of Carrie Lilie. Courtesy of the Rare Book, Manuscript, and Special Collections Library, Duke University.

61. Exhibition of French fashion by the City of Paris Drygoods Company, featuring gowns by Madame Valerio, at the Panama Pacific International Exhibition of 1915. Photo: Merrill David.

62. Georges Lepape, "The 1915 Mode as Shown by Paris," cover of the special English-language edition of the *Gazette du Bon Ton* commemorating the Panama Pacific International Exhibition of 1915. © 2005 Artists Rights Society (ARS) New York/ADAGP, Paris.

63. Advertisement for the *Gazette du Bon Genre*, in *Vanity Fair*, July 1921, 91. Photo: Merrill David.

64. "What You Shall Wear for the Tango-Teas," in *Vanity Fair*, December 1913, 65. Courtesy of *Vanity Fair*, © Condé Nast Publications Inc.

65. Photo of Les Six at the Eiffel Tower, in *Vanity Fair*, October 1921, 61. Courtesy of *Vanity Fair*, © Condé Nast Publications Inc.

66. Marie Laurencin, *Portrait of Jean Cocteau*, in *Vanity Fair*, October 1922, 61. Courtesy of *Vanity Fair*, © Condé Nast Publications Inc.

67. Marie Laurencin, *Portrait of Mademoiselle Chanel*, 1923. Musée de L'Orangerie, Paris, France. Photo: Scala/Art Resource, NY. © 2005 Artists Rights Society (ARS) New York/ADAGP, Paris.

68. Chanel and her aunt, Adrienne, at Deauville, 1913, in Edmonde Charles-Roux, *Chanel and Her World* (New York: Vendome Press, 1979), 84.

69. Sem, Caricature of Gabrielle Chanel and Arthur (Boy) Capel, 1914. © 2005 Artists Rights Society (ARS) New York/ADAGP, Paris.

70. Illustration from "Chanel's Charming Chemises," *Harper's Bazaar*, March 1916. Photo: Merrill David.

71. Sem, advertisement for Chanel No. 5, 1921. © 2005 Artists Rights Society (ARS) New York/ADAGP, Paris.

72. Gabrielle Chanel, the "Ford signed Chanel," in *Vogue* (New York), 1 October 1926, 69. Courtesy of *Vogue*, © Condé Nast Publications Inc.

73. "Before and After Taking Paris," in *Vogue* (New York), 1 November 1924, 49. Courtesy of *Vogue*, © Condé Nast Publications Inc.

74. "Paulet Thévenas, Painter and Rythmatist," in *Vanity Fair*, July 1916, 49. Courtesy of *Vanity Fair*, © Condé Nast Publications Inc.

75. Illustration from "Le Bal de l'Opéra," in *Vogue* (New York), 1 September 1921, 47. Courtesy of *Vogue*, © Condé Nast Publications Inc.

76. "Colombine à travers les âges," in *Vogue* (Paris), 15 January 1922, 3. Cliché Bibliothèque Nationale de France, Paris.

77. "Igor Stravinsky, Contrapuntal Titan," in *Musical America*, 12 February 1921, 9. Photo: Merrill David. Courtesy of the Kulas Music Library, Case Western Reserve University.

78. Jean Cocteau, "Stravinski chez Coco Chanel," 1930. Photo: Merrill David. © 2005 Artists Rights Society (ARS) New York/ADAGP, Paris.

79. Vladimir Rehbinder, photo of Genica Atanasiou in Jean Cocteau's production of *Antigone*, 1922, in *Vanity Fair*, May 1923, 49. Courtesy of *Vanity Fair*, © Condé Nast Publications Inc.

80. Lydia Sokolova and Anton Dolin in the first performance of *Le Train bleu*, 1924, costumed by Chanel. Courtesy of the Harvard Theater Collection, Harvard University.

81. Pablo Picasso, *Deux femmes courant sur la plage*, 1922. Photo: CNAC/MNAM/Dist. Réunion des Musées Nationaux/Art Resource, NY. © 2005 Artists Rights Society (ARS), New York/ADAGP, Paris.

82. "The Maecenas of Paris Entertains," in *Vogue* (New York), 1 September 1924, 48. Courtesy of *Vogue*, © Condé Nast Publications Inc.

83. John Quinn, photo of Jeanne Robert Foster, Henri-Pierre Roché, Constantin Brancusi, and Erik Satie on the golf course at St. Cloud, 1923. Musée Nationale d'Art Moderne, Centre Georges Pompidou, Paris, France. © 2005 Artists Rights Society (ARS) New York/ADAGP, Paris.

84. Léon Bakst, poster for a dance recital by Caryathis. Courtesy of the Fine Arts Museums of San Francisco.

85. André Marty, "A L'Oasis," in *Modes et manières d'aujourd'hui*, 8e année (1919), plate 8. Reprinted by permission of the Houghton Library, Harvard University. © 2005 Artists Rights Society (ARS) New York/ADAGP, Paris.

86. Illustration depicting the club Le Boeuf sur le toit, in *Vogue* (Paris), 1 December 1923, 4. Cliché Bibliothèque Nationale de France, Paris.

87. Vladimir Rehbinder, photo of Cécile Sorel costumed as a rosebud for the "Sunset" Ball, in *Vogue* (Paris), 15 June 1921, 20. Cliché Bibliothèque Nationale de France, Paris.

88. Photo of Countess Edith de Beaumont, in *Vogue* (Paris), 15 March 1921. Cliché Bibliothèque Nationale de France, Paris.

89. Vladimir Rehbinder, photo of Princesse Soutzo (Hélène Chrissoveloni) costumed as a Christmas tree for the Beaumont Ball des Jeux, in *Vogue* (Paris), 1 April 1922, 31. Cliché Bibliothèque Nationale de France, Paris.

90. Vladimir Rehbinder, photo of Valentine Hugo costumed as a merry-go-round for the Beaumont Ball des Jeux, in *Vogue* (Paris), 1 April 1922, 31. Cliché Bibliothèque Nationale de France, Paris.

91. Dorys, photograph of the Alsatian entrée for the Beaumont Bal Louis XIV, in *Vogue* (Paris), 1 August 1923, 8. Cliché Bibliothèque Nationale de France, Paris.

92. Vladimir Rehbinder, photo of the Marquise de Polignac, costumed by Chéruit for the Beaumont Bal Louis XIV, in *Vogue* (Paris), 1 August 1923, 12. Cliché Bibliothèque Nationale de France, Paris.

93. "The Russian Ballet Charms Sophisticated Paris," with photos by Vladimir Rehbinder, in *Vogue* (New York), 1 September 1922, 76. Courtesy of *Vogue*, © Condé Nast Publications Inc.

94. "Les Ballets Russes on remporté de beaux triomphes," with photos by Vladimir Rehbinder, in *Vogue* (Paris), 1 July 1922, 36. Cliché Bibliothèque Nationale de France, Paris.

95. "*Les Noces* de Stravinsky ont remporté un formidable succès," with photos by Abde and illustrations by André Marty, in *Vogue* (Paris), 1 August 1923, 16. Cliché Bibliothèque Nationale de France, Paris.

# Index

Page references in italics indicate illustrations.

Académie Colarossi (Paris), 94–95
Académie Julian (Paris), 71
Académie Royale de Musique, 282n64
Acocella, Joan, 52
*Action*, 268n56
Adam, Paul, 135–36
*Adieu, New York!* (Auric), 215–16
Adorno, Theodor, 284n118
advertising, expansion of, 8
"The Aesthetic Upheaval in France"
    (E. Wilson, Jr.), 149, 269n62
*Agri Cultura* (Cato), 111, 112, 113
*L'Aiglon* (Rostand), 258n11
Aladin perfume, *36*, 37
"Alexander's Ragtime Band" (Berlin),
    124, 145
*Alex's Castle* (E. Wilson, Jr.), 149
*Alice in Wonderland* (Carroll), 114–15
"A L'Oasis" (Marty), *219*
Alvin, Jeanne, 268n59
Amédée (Paris), 102
American Committee for Devastated
    France, 206, 280n14
*American Monthly Review of
    Reviews*, 213
American music, 141–45, 148, 149
"American Painters of Women," 208
American press, 129–33. *See also spe-
    cific publications*
"Am I Early" (Lepape), 54, *55*
*ancien régime* style, 219
androgyny, 163

*The Angora Ox* (Satie), 106
Ansermet, Ernest, 170, 191
Antheil, George: *Ballet mécanique*,
    117
*Antigone* (Sophocles), 194
*Antigone* adaptation (Chanel,
    Cocteau, Honegger, and Picasso),
    194–97, *196*
"Les Apaches," 114
Apollinaire, Guillaume, 95, 104, 128,
    147, 279n1
*Après le cubisme* (Ozenfant and Jean-
    neret), 105
*L'Aquarelle-Mode*, 10
*The Arabian Nights*, 34
Aristotle, 112
Arlequinade perfume, 37
*Armide* (ballet), 52
Arnoux, Guy, 44
art and fashion, 22–23, 34–35, 49, 51,
    54–56, 62, 101, 252
Art Deco, 57, 254
*L'Art d'Etre Jolie*, 258n43
*Art et Décoration*: on Poiret, 34; Stei-
    chen's photographs for, *73*, 73, *75*,
    262n34; Lucien Vogel as editor-in-
    chief of, 49
*L'Art Musical*, 14
Art Nouveau movement, 260n48
"The Art of Dress" (Cornu), 34
Astruc, Gabriel, 17–18, 94
Astruc, Marcel, 50–51

Astruc, Yvonne, 115–16
Le Astuzie femminili (Cimarosa), 187
Atanasiou, Genica, 195, 196
Atelier Martine, 35–36
Aubert, 92; "La Vie champêtre,"
  263n49
"Au clair de la lune," 87
Auric, Georges, 95, 100, 268n58;
  Adieu, New York! 215–16; at the
  Bal des Jeux, 229; critical reception
  of, 211; Les Fâcheux, 197, 254; Les
  Mariés de la Tour Eiffel, 197, 246;
  Paris-Sport, 218. See also Les Six
Avant-dernières pensées (Satie),
  95–96, 108, 110, 113
avant-garde, 96, 97. See also Satie,
  Erik

Bacchic rituals, 42
Bach, Johann Sebastian, 274n100;
  "Herr Gott, dich loben alle wir," 69,
  71; and Stravinsky, 274n100
"Le Bain de mer" (C. Martin), 77–78,
  80, 80–81
Bakst, Léon: Ballets Russes–inspired
  fashion collection of, 22; Caryathis
  poster by, 217, 217; colors used by,
  31; "Philomèle," 60–61, 62; Sleeping
  Princess costumes by, 239, 248–49
Balanchine, George, 174
Bal Baroque, 230–34, 231, 234, 239
Le Balcon perfume, 36–37
Bal des Jeux, 227–29, 228–29, 230
Baliyev, Nicholai, 240, 242
Ballet mécanique (Antheil), 117
Ballets du cour, 42, 238
Ballets Russes: American tour of,
  171–72, 174, 210, 272n59; Armide,
  52; audience for, 16–17, 52, 128–29,
  235; Les Biches, 197, 278n175; La
  Boutique fantasque, 180, 274n99;
  Carnaval, 52; and Chanel, 168, 179
  (see also Le Train bleu); Chout, 225;
  Cléopâtre, 33, 52; and Cocteau, 94;
  Le Coq d'or, 54; criticism of, 19;
  Cuadro flamenco, 225–26; Daphnis
  et Chloé, 52; decline during WWI,

168; Diaghilev as impresario of,
  15–16, 33; Le Dieu bleu, 52; elitism
  of, 119; Les Fâcheux, 197; finances
  of, 171, 235, 249, 272n59; The Fire-
  bird, 171; La Gazette du Bon Ton
  on, 52–57, 55–56; Jeux, 53; L'Après-
  midi d'un faune, 52; Le Mariage de
  la Belle au Bois dormant, 234–35;
  Midas, 54; Midnight Sun, 117–18;
  in Monaco, 249; in Monte Carlo,
  249–50, 252, 254; Narcisse, 52; Les
  Noces, 171, 179, 180–81, 250–52,
  253, 278n175; Les Orientales, 33;
  Petrouchka, 52, 117–18, 171, 175;
  popularity of, 15, 22, 52, 225; press
  coverage of/publicity for, 15–19,
  18–19, 21; programs for, 17–18, 18;
  Pulcinella, 174–78, 238, 246; retro-
  spective classicism of, 238; Russian
  season of 1922, 235, 236–37,
  240–43; Salomé, 18, 53; Schéhé-
  razade, 33, 46, 52; The Sleeping
  Princess, 235, 238–40, 248–49, 252;
  The Song of the Nightingale, 174;
  Les Sylphides, 117–18; at the
  Théâtre Gaîté-Lyrique, 224–26;
  Le Train bleu, 197–201, 198–99,
  278n174; Vanity Fair on, 171–72;
  Vogue on, 224–26, 235, 236, 237.
  See also Mavra; Parade; Le Renard;
  The Rite of Spring
Balsan, Etienne, 155–56
"Les Bals des 4 Vendredis de Mai,"
  223–24, 282n62
Balzac, Honoré de, 256n20, 270n16;
  "Treatise on the Elegant Life," 9,
  256n23
Barbier, Georges, 54–55
bar-dancings, 218, 281n48
Bar Gaya (Paris), 282n53
Bartók, Béla, 181
"Battick" (design by Poiret, photo-
  graph by Steichen), 73, 75, 262n34
Baudelaire, Charles, 9
The Bear at the Moulin Rouge (Seve-
  rini), 124, 125
Beaton, Cecil, 48, 52, 133

Beau Brummels of the Brush, 55, 57, 71, *85*. *See also* Barbier, Georges; Benito, Edouardo; Brissaud, Pierre; Boutet de Monvel, Bernard; Martin, Charles; Marty, André

Beaumont, Edith, Countess de, 226, 227, 228–29, 230, 232, 282n73. *See also* Beaumont Balls

Beaumont, Etienne, Count de, 94, *95*, 220, 226, 228–29, 232, 278n169, 279n1; *Trois pages dansées*, 202–3, *204*, 279n2. *See also* Beaumont Balls

Beaumont Balls, 226–34, *228–29*, 231, 234

Beaux, Ernest, 164

Beer, Gustav, 135

Beethoven, Ludwig van, 14, 39; "Twelve Variations on a Russian Dance from Wranitsky's Das Wald-mädchen," 187

*Bel Ami*, 156

Bell, Clive, 133

*La Belle Assemblée*, 7, *8–9*

*La Belle excentrique* (Caryathis and Satie), 216–18, *217*

Belline, Ira (Irina Belyakin), 241

*Bel Respiro* (Garches), 170, 178–79

Benchley, Robert, 133

Benito, Eduardo, 1, 2, 205, 220, 279n7

Benois, Alexandre, 239

Bentley, Alys E., 143

Bérain, Jean, 4, 256n11

Bergson, Henri, 102

Berlin, Irving: "Alexander's Ragtime Band," 124, 145; "That Mysterious Rag," 124–27, *126–27*

Bernays, Edward, 172, 272n61

Bernhardt, Sarah, 25, 37, 258n11

Biarritz (Basque coast), 160–61

*Les Biches* (Laurencin, Nijinska, and Poulenc), 197, 278n175

Bidou, Henri, 49–50, 260n9

Bizet, George: "L'Escarpolette," 88, *89*; *Jeux d'enfants*, 87–89, *88*, 187; *Petite suite d'orchestre*, 87–88; "Quatre coins," *90*, 91

Bizet, René, 1, 163

Black and White Ball, 224, 282n62

"The Blacksmith and His Son," 189–90

*blague*. See *ton de blague*

Blanc, François, 285n132

Blanche, Jacques-Emile: *Portrait of Les Six*, 98, *100*

Blum, Lise-Léon, 51–52, 53–54, 261n14

Blum, René, 51–52

Blume, Mary, 249

bobbed hairstyle, 163, 271n33

Boccherini, Luigi, 39

*Le Boeuf sur le toit* (ballet; Cocteau and Milhaud), 190, 197, 211, 215–16, 220, 221

Le Boeuf sur le toit (nightclub, Paris), 1, 220–23, *222*, 282n53

Bois de Boulogne, 65, 67, 139, 226

Boismortier, Jacques Bodin de: *Diane et Actéon*, 42

*Bois sacré*, 37

Bongard, Germaine, 93, 97, 98, *98*. *See also* Bongard salon; Galerie Thomas

Bongard salon: artists exhibited at, 93; clientele of, 98; concert at, 93–94; couture/culture at, 97–102; *L'Elan* headquartered at, 102; Granados's works performed at, 93, 113; Satie at, 93–94, 97, 106–8, 113–15; in *Vogue*, 97, *99*

Bonita, 125–26

Le Bon Marché, 10

Bonnard, Pierre, 194

*le bon ton* (good manners in a given situation), 49–50, 260n6

The *Bookman*, 266n27

Bordes, Charles, 15, 63

Bordoni, Irene, 221

*Boris Godunov* (Pushkin), 240

Borodin, Aleksandr: *Prince Igor*, 19

*Boston-American*, 212–13

Boulanger, Nadia, 39, 191, 274n100

Boulet, Denise (Denise Poiret), 26, *30*, 33

Bourdieu, Pierre, 128

Boutet de Monvel, Bernard, 34, 54–55, 131–32

*La Boutique fantasque* (Derain, Massine, and Respighi), 180, 274n99

Brahms, Johannes, 184

Brancusi, Constantin: at Le Boeuf sur le toit, 220; Foster on, 214; "The Kiss," 214; and Quinn, 213; and Satie, 96, 214, *215*; in *Vanity Fair*, 133

Braque, Georges, 57–58, 96, 161–62

Breton, André, 96, 195

Briscoe, Johnson, 142

Brissaud, Pierre, 54–55, 205

Brunhoff, Cosette de (Cosette Vogel), 48–49, 205

Brunhoff, Jean de, 48–49

Brunhoff, Maurice de, 16, 48–49, 63–64

Brunhoff, Michel de, 48–49

Buchanan, Charles, 143–44

Bunyan, John: *Pilgrim's Progress*, 129–30

Busoni, Ferruccio, 144

*Cabinet des Modes*, 5

*Cadeau* (Ray and Satie), 264n12

Cage, John, 92

cakewalk, 82–83, 262n37

Callot Soeurs, 135, 224, 225

Calvocoressi, Michel, 107

Capel, Arthur ("Boy"), 156–57, 158, *159*, 160, 168, 270n14

*Les Caractères ou les moeurs du siècle* (La Bruyèré), 111–12

Carantec, 170–71

*Carnaval* (ballet), 52

"Le Carnaval" (C. Martin), *72*, 73

carnival, 175–78, *177*

Carroll, Lewis: *Alice in Wonderland*, 114–15

cartoons/visual puns, 58–61, *60–62*

Caryathis (Elise Jouhandeau), 168, 278n163; *La Belle excentrique*, 216–18, *217*

Casas, Ramon, 96, 263n9

Catalan artists, 96, 263n9. *See also specific artists*

Cato: *Agri Cultura*, 111, 112, 113

Caveau Caucasien, 241

Cendrars, Blaise, 95, 220; "Le Music Kiss Me," 96

censorship, 8, 256n21

The *Century Illustrated Monthly Magazine*, 266n27

Cercle Musicale, 107

Chadwick, George, 142–43

Chalupt, Linette, 114

Chalupt, René: and Satie, 114–15

Chanel, Coco, 153–201; *Antigone* adaptation, 194–97, *196*; appearance of, 163; background of, 154; and the Ballets Russes, 168, 179 (see also *Le Train bleu*); and Balsan, 155–56; Bel Respiro home of, 170, 179; Biarritz shop of, 160–61, 193; at Le Boeuf sur le toit, 220; and Capel, 156–57, 158, *159*, 160, 168, 270n14; and Caryathis, 216, 278n163; Chanel No. 5 introduced by, 36, 163–64, *164*; chic style of, 165–67, 201; classless style of, 158; and Cocteau, 154, 193–97; and Diaghilev, 168, 169; dominance of fashion, 252; and Dullin, 216, 278n163; fame of, 161; on fashion as coming up from the streets, 153–54, 158, 192; fashion press coverage of, 161; hairstyle of, 163, 271n33; hats by, 156; involvements with artists, generally, 153–54; jersey separates of, 161–62, 192; jewelry business of, 196, 278n169; little black dress introduced by, 164–65, *165*, 192, 209; modern music promoted by, 154; and Morand, 152, 156, 169; and Pavlovich, 169, 193, 241; popularity/success of, 156, 158, 160–63; portrait of, *155*; and practicality/fashionability in the war years, 160–67, *162*; resort style invented by, 157–60 (see also *Le Train bleu*); and Reverdy, 193; rue Cambon shop of, 156, 160, 270n13; rue Gontaut-Biron shop of, 158, *159*, 160; Russian phase of, 241; and Misia Sert,

167–68, 169; simple/natural style of, 153, 154, 158, 161–62, 165, 167, 192; singing career of, 154–55; and Les Six, 154; social/artistic standing of, 158, 167, 196–97; and Igor Stravinsky, 154, 168–71, 178–80, 193–94, *195*, 271n49, 50, 272n54, 273n84; *Le Train bleu*, 197–201, *198–99*, 278n174; in Vichy, 154–55; in *Vogue*, 158, *165*, *166*; youthful style of, 156, 163, 192

Chantilly racetrack, 226

"Le Chapelier" (Satie), 113–15, 276n129

*Chapitres tournés en tous sens* (Satie), 107–8, 216

*Charakteres* (Theophrastus), 112

Charles-Roux, Edmonde, 241

Charlotte, princess of Monaco, 249

Chase, Edna Woolman, 49

Château Basque (Biarritz), 193

Chauve-Souris. *See* Théâtre de la Chauve-Souris à Moscou

Chazalviel, Albert: "No Wagner on the Horizon?" 104, *105*

Chéruit, Madeleine, 135, *228*

Chevalier, Sulpice-Guillaume (Gavarni), 9, 229

chic, 165–67, *166*, 193, 201

Choate, Joseph Hodges: "What We Owe to France," 132

Chocolat (clown), 121–22

chorale tradition, 69

*Les Choses de Paul Poiret* (Lepape), *46*, 46–47

*Chout* (Larionov and Prokofiev), 225

*La Chronique Musicale*, 14

Cicero: *De re publica*, 111–13

Cimarosa, Domenico: *Le Astuzie femminili*, 187

*Les Cinq doigts* (*Eight Instrumental Miniatures*; I. Stravinsky), 185–86, 187–88, 190–91, 276n123, *126*, 277n135

Ciro Club Coon Orchestra (London), 221

Cirque Médrano, 121–22, 151

classicism: and Cubism, 104–6, 116; retrospective, 238; in Satie's work, 106, 112–13; and youth, 186–90

"Class Publications" (Nast), 130–31

Claudel, Paul, 93

Clemenceau, Georges, 270n14

*Cléopâtre* (ballet), 33, 52

Cocardes (Poulenc), 215–16

Cocteau, Jean, 17, 52, *120*; *Antigone* adaptation, 194–97, *196*; and Astruc, 94; and the Ballets Russes, 94; at Le Boeuf sur le toit, 220, 221; *Le Boeuf sur le toit*, 190, 197, 211, 215–16, 220, 221; at Bongard salon, 93; and Chanel, 154, 193–97; "The Comic Spirit in Modern Art," 149, 246–47; *Le Coq et l'harlequin*, 146, 149–50, 191, 211, 277n146; costume design for Caryathis, 216–17; critical reception of, 211; *Le Dieu bleu*, 94; on Fauconnet, 205, 279n7; "Festival Erik Satie" sponsored by, 268n57; *Le Grand Ecart*, 194; "Hommage à Erik Satie," 96; and Honegger, 194, 278n165; *Les Mariés de la Tour Eiffel*, 197, 246; on *Mavra*, 246–47; *A Midsummer Night's Dream* produced by, 214; and Morand, 150–51; *Le Mot* founded by, 102–3; "A New Dramatic Form," 150, 247; *Plain-Chant*, 194; portrait of, 149, *151*; "The Public and the Artist," 149–50; on realistic theater, 149; and Satie, 94, 96, 263n7; Satie portrait by, 96; *Schéhérazade*, 44; and the Société Lyre et Palette, 95, 96; on Igor Stravinsky, 146, 149, 246–47, 277n146; "Stravinsky chez Coco Chanel," 194, *195*; Thévenas, portrait of, 172–73, *173*; Thomas l'Imposteur, 194; *Le Train bleu*, 197–201, *198–99*, 278n174; in *Vanity Fair*, 147, 149–50, *151*; *Vogue* on, 195, 211; war duties of, 94. See also *Parade*

Coleman, Elizabeth Ann, 23, 24

Colette, 133, 271n33

Collaer, Paul, 268n57

Collet, Henri, 95

*Collier's Magazine*, 130

*La Colombe* (Gounod), 254

"The Comic Spirit in Modern Art" (Cocteau), 149, 246–47

*Comoedia* (newspaper), 16

*Comoedia Illustré* (journal; *later named Le Théâtre et Comoedia Illustré*), 16–18, *18*, 37, 257n41

*Concerto for Piano and Winds* (I. Stravinsky), 254

*Concertino for String Quartet* (I. Stravinsky), 179, 180–81, 184

*Concerts salades*, 184, 275n114

*Le Conseiller des Dames*, 256n20

Contamine [de Latour], José-Maria Vincente Ferrer, Francisco de Paula, Patricio Manuel, 96

Copeland, Charles Townsend, 212

*Le Coq d'or* (ballet), 54

*Le Coq et l'arlequin* (Cocteau), 146, 149–50, 191, 211, 277n146

Cormon, Fernand, 55, 71

Corneille, Thomas, 256n7

Cornu, Paul: "The Art of Dress," 34

Côte d'Azur, 249

Coudert, Clarisse, 131

Couperin, François, 39–40

*Le Courrier Français*, 4

*Le Courrier Musical*, 18–21, *19–20*

*couture à façon* (dressmaking for the individual), 23

Craft, Robert, 186, 193, 271n49; *Stravinsky in Pictures and Documents*, 169–70

crinolines, 9

Croche, Monsieur. *See* Debussy, Claude

*Croquis et agaceries d'un gros bonhomme en bois* (Satie), 107–8

Crosby, Nina. *See* Polignac, Marquise de

Crowninshield, Frank, 133; *Manners for the Metropolis*, 266n27

*Cuadro flamenco* (de Falla and Picasso), 225–26

Cubism: and classicism, 104–6, 116; in *L'Elan*, 104; in fashion, 208–9; in

fashion plates, 57–58, *58–59*, 74; Ozenfant on, 104–5; *Parade* as influenced by, 119–20, 128; and Purism, 104, 105; *Vogue* on, 208–9

Cummings, E. E., 133

Dalbaicín, Maria, 225–26

Dalcroze, Jacques, 216

dance: *entrées*, 230–33, *231*, 283n81; and fashion, 139, *140*, 141; Grizzly Bear, 125; *maxixe*, 190; minuet, 139; ragtime, 142, 143; Satie's parodies of, 81–86, *83*; social dancing, 81, 200. *See also* tango

"Dancing" (Lepape), 57, *58*

*Danse* (Satie), 106

"Danseuse" (Satie), 91–92, 263n49

"Daphénéo" (Satie), 95–96, 113–14

*Daphnis et Chloé* (ballet), 52

Daquin, Louis-Claude, 39–40

Darty, Paulette, 81–82

Deauville, 157–58, 160

Debray, Victor, 19

Debussy, Claude, 53; Cocteau on, 146; death of, 181; *Feux d'artifice*, 87; *Jardins sous la pluie*, 109; memorial to, 181, 274n102; *Pelléas et Mélisande*, 218; "Pierrot," 87; in *La Revue Blanche*, 167; and Satie, 96, 107, 147

Delacroix, Eugène, 32

"De la fumée" (Thayaht), 57, *59*

"De la pomme aux lèvres" (C. Martin), 59–60, *61*

Delaunay-Terck, Sonia, 247

Delgrange, Félix, 115–16

De Max, Edouard (Edouard Alexandre Max), 38

*Les Demoiselles d'Avignon* (Picasso), 115, *116*

department stores, 10

Derain, André, 44; at Le Boeuf sur le toit, 220; *La Boutique fantasque*, 180, 274n99; in *L'Elan*, 104; and Foster, 214; at the Galerie Thomas, 101; and Satie, 96; and the Société Lyre et Palette, 95; in *Vanity Fair*, 133

*De re publica* (Cicero), 112–13
*La Dernière Mode*, 10
Derzhanovsky, Vladimir, 250
*Descriptions automatiques* (Satie),
    107–8
Deslys, Gaby (Marie-Elise-Gabrielle
    Caire), 217, 281n45
DeSylva, Buddy: "Do It Again," 221
*Deux femmes courant sur la plage*
    (Picasso), 198, *199*, 278n174
*diabolus in musica*, 84
Diaghilev, Sergei: as Ballets Russes
    impresario, 15–16, 33; and Chanel,
    168, 169; and Cocteau, 94; death of,
    168, 249; and the media, 15; and
    *Mir Iskusstva*, 15–16; and Picasso's
    *Deux femmes courant sur la plage*,
    278n174; and Poiret, 33, 37. *See also*
    Ballets Russes
*Diane et Actéon* (Boismortier), 42
*Le Dieu bleu* (ballet), 52, 94
Directoire style (Directory style), 28,
    97, *99*, 193
Dirys, Jeanne, 156
"La Diva de l'Empire" (Satie), 83
Doeuillet, Georges, 135
"Do It Again" (DeSylva and Gersh-
    win), 221
Dolin, Anton, *198*
Donneau de Georges Vise, Jean, 4,
    256n7
Dorys (Jerzy Benedykt), *231*
Dorziat, Gabrielle, 156
Doucet, Clément, 190
Doucet, Jacques, 24–25, 135
*Dress and Vanity Fair*, 129. See also
    *Vanity Fair*
dress styles. *See* fashion; *and specific
    styles*
Duchamp, Marcel, 58, 96, 261n25
Ducros, Françoise, 104, 264n31
Dufresny, Charles, 3, 256n8
Dufy, Raoul, 35, 274n102
Dukas, Paul, 181
Dullin, Charles, 194–95, 278n163
Duncan, Isadora, 35, 37
Dunoyer de Segonzac, André, 34, 43,
    44

Durand-Ruel gallery (Paris), 264n13
Durey, Louis, 95, *100*, 268n58. *See
    also* Les Six

Ecole des Beaux-arts, 55, 71
Ecole des Hautes Etudes Musicales,
    210
Ecorcheville, Jules, 107
*L'Education manqué* (Gounod), 254
Edwards, Alfred, 167
Eglise Métropolitaine d'Art de Jésus
    Conducteur, 63
"1811" gown, 28–29
*Eight Instrumental Miniatures*. See
    *Les Cinq doigts*
*L'Elan*, 102–6, *103*, *105*
*élan vital*, 102
*Les Elégances parisiennes:* on Chanel,
    161
Eliot, T. S., 213
Ellis, Katherine, 14
Els Quatre Gats Café (Barcelona),
    263n9
*Embryons desséchés* (Satie), 107–8,
    109
*Enfantillages pittoresques* (Satie),
    276n132
*Enfantines* (Satie), 107–8, 187,
    276n132
*En Habit de cheval* (Satie), 107
*entrées*, 230–33, *231*, 283n81
"L'Escarpolette" (G. Bizet), 88, *89*
Escudier, Léon, 14
l'esprit nouveau, 128
Eugénie, empress of France, 9, 23
Evans, Edwin, 180–81, *182*, 274n97,
    100
*Evgeny Onegin* (Pushkin), 240

Fabert, Henri, 263n48
*Les Fâcheux* (Auric), 197
Falla, Manuel de, 174, 181; *Cuadro
    flamenco*, 225–26
*Fantaisie pittoresque* (Glinka), 187
"Le Fard" (Lully), 263n49
Fargue, Léon-Paul, 114, 233
fashion: androgyny in, 163; and art,
    22–23, 34–35, 49, 51, 54–56, 62,

fashion *(continued)*
101, 252; chic, 165–67, *166*, 193,
201; corseting used in, 26; Cubist,
208–9; and dance, 139, *140*, *141*;
desublimation of, 161; Directory, 28;
Hellenic gowns, 28; historicizing
styles, 26, 28–29, *28–29*; neoclassical
style in, 24, 26–29, *27–30*, 31,
192–93; and practicality in the war
years, 160–67, *162*; seasonal cycle
of, 65; simplicity as an ideal in,
29–31, *30*, 191–92; as uniquely
French, 135. *See also* fashion press;
*and specific styles and designers*
fashion press: birth of, 2–5; illustra-
tions/fashion plates in, 6–7, *7*, *9*,
11, 256n16; music in, 3–7, *7*,
11–15, 21 (*see also* Ballets Russes);
nineteenth-century growth of,
8–13, 256n18, *20*; as pastiche,
245–46; photography in, 16–17,
34, 258n43; rise of, 5–7; sheet
music published by, 11–12. *See also*
*specific magazines and journals*
Faucigny-Lucinge, Jean-Louis, Prince
de, 227
Fauconnet, Guy-Pierre, 42, *43*, 44,
205, 279n7
"Faun and Shepherdess" (I. Stravin-
sky), 240
Faure, Elise: "Qui qu'àvu Coco dan le
Trocadero," 154
Fauré, Gabriel, 18
feather ornaments, 27
Fellowes, Daisy, 232
*Femina*, 38; on female golfers, 76;
games/outdoor life as focus of, 65,
67; and Satie's *Sports et divertisse-
ments*, 67–68; table of contents of,
*68*; on the tango, 84; Lucien Vogel's
role at, 49, 65; on yachting, *70*
Fergison, Drue, 250
*Le Festes de Bacchus* (Lully), 42–43
Festes de Bacchus party, 40, 42–43, *43*
"Festival Erik Satie" (Paris, 1920), 216,
268n57
"Festival Erik Satie–Maurice Ravel,"
94, 95–96, 263n7

Fétis, François-Joseph, 13
Feuillard, Louis, 39
*Les Feuillets d'Art*, 92
"Feux d'artifice" (C. Martin), 73–74,
*74*
*Feux d'artifice* (Debussy), 87
*Le Fils des étoiles* (Satie), 96–97,
106–7, 264n13
*The Firebird* (I. Stravinsky), 171
*Fireworks* (I. Stravinsky), 171
Firouz, prince of Persia, 178
First International Congress on
Women's Rights and Feminine
Institutions (Paris, 1889), 32
Fitzgerald, F. Scott, 133
Flaubert, Gustave, 32
*Le Follet*, 8–9
Fontainebleau music conservatory,
210
Fontenelle, Bernard Le Bovier de,
255n5
le footing (daily promenade in the
Bois de Boulogne), 65, 67
Footit, 121–22
Foster, Jeanne Robert, 211–15, *215*,
218–19, 225, 231–32, 233–34,
251–52
Fouquier, Baronne, 224
*Fragment des symphonies d'instru-
ments à vent pour Claude Debussy*,
181
*La France Musicale*, 14
Franco-American alliance, 131–32,
134, 135–36
Fratellini brothers, 121–22
French Directory (1795–99), 26
*French Doll* (Gershwin), 221
French Revolution, 26
French rococo, 40, 44, 52
French Union for Women's Suffrage
(UFSF), 259n23
"Frère Jacques," 86
Friar's Frolic (New York City), 124
Fry, Roger, 133
Fulcher, Jane, 275n116
"Furniture Music" *(musique
d'ameublement)* (Satie), 96–97,
211–12, 215, 264n13

Gabriel, Ange-Jacques, 39
Gaby Glide, 281n45
*galant*, 255n4
Galerie Barbazanges (Paris), 44, 46–47, 215–16, 219
Galerie Thomas (Paris), 115; benefits for artists held at, 100–101; *Mercure de France* on, 101; modernism of, 111–12; Purist exhibition at, 105–6, 264n31
*La Gallerie des modes*, 260n9
Garafola, Lynn, 16, 171, 197, 235, 238, 249, 272n59
*La Garçonne* (Margueritte), 163, 270n30
*garçonne* look, 163
garment industry, 10, 257n27
Gavarni, Paul (Sulpice-Guillaume Chevalier), 9, 229
*La Gazette Artistique de Nantes*, 15
*Gazette de France*, 3, 255n5
*La Gazette du Bon Genre*, 137–38, *138*, 205, 279n9, 280n10
*La Gazette du Bon Ton:* on the Ballets Russes, 52–57, *55–56*; on *Le Boeuf sur le toit*, 220; on carnival festivities, 176; cartoons/wit in, 58–60, *61–62*, 69, 86; Cubism in fashion plates of, 57–58, *58–59*, 74; demise of, 48; elitism of, 50–51; establishment/inauguration of, 47, 48; fashion as art in, 49, 51, 54–55, 62; Franco-American alliance reinforced by, 135–36; on French couture at the Panama–Pacific Exhibition, 135–36, *137*, 263n47; goals of, 49–50; on golf attire, 75; "Le Goût au Théâtre," 51; illustrations/fashion plates in, 51, 54–62, *55–56*, *58–59*, *61–62*, 205; influence of, 48, 62; modernism of, 48, 57, 62 (see also *Sports et divertissements*); modernist art in, 205; Nast's role at, 137, 205; publication ceased at, 205; publication suspended/resumed at, 91, 136–37, 205, 263n47; reviews in, 51–52; and Satie's *Sports et diver-*

*tissements*, 62, 68–69, 71, 92; vs. *Vogue*, 205
*La Gazette Musicale de Nice*, 15
Georges-Michel, Michel, 179
Géraldy, Paul, 205
Gérôme, Jean-Léon, 32
Gershwin, George: "Do It Again," 221; *French Doll*, 221
*Gesamtkunstwerk*, 34
Gibson, Charles Dana, 212
"Gibson Girl," 212
Gide, André, 220
glass harmonica, 6
Glazunov, Aleksandr, 19
Gleizes, Albert, 104
Glinka, Mikhail, 243; *Fantaisie pittoresque*, 187
Gluck, Christoph Willibald, 13, 39–40
Godebski, Cipa and Ida, 114
Godebska, Mimi, 114
Godebski, Jean, 229
Gogh, Vincent van, 55–56
golf, 75–76, 77
"Le Golf" (C. Martin), 75–77, *77–78*, 80
Goncharova, Natalia, 218, 239; *Les Noces*, 250–52
Goncourt brothers, 9, 108, 265n35
Goossens, Sir Aynsley Eugène, 181
Gounod, Charles: *La Colombe*, 254; *L'Education manqué*, 254; *Le Médecin malgré lui*, 254; *Mireille*, 115; *Philémon et Baucis*, 254
Grand Prix Ball at the Opéra, 224, 282n64
Gramont, Duchess de, 34–35
Granados, Enrique, 93, 113
*Le Grand Ecart* (Cocteau), 194
Grande Semaine, 223–24, 230, 234–40, 251
"Grand French Festival" (Monte Carlo), 252, 254
Grass-Mick, Augustin, 96
"The Great American Composer" (Van Vechten), 145
"La Grenouille" (Satie), 114
Grimaldi family, 249
Gris, Juan, 95, 98

Grizzly Bear, 125
Gross, Valentine. *See* Hugo, Valentine
Groult, Nicole, 216, 217, 263n1
Guillaume, Paul, 96, 110
Guilmant, Alexandre, 63
*The Gut of Paris* (Zola), 218
*Gymnopédies* (Satie), 106–7, 112–13,
    115–16

Hadley, Arthur, 142–43
Hahn, Reynaldo, 175; *Le Dieu bleu*, 94
"Hail California" (Saint-Saëns),
    134–35
Hamilton, Clayton, 174
harem pants *(jupes-culotte)*. See *style*
    *sultane*
*Harper's Bazaar*, 130, 161, 162, 191,
    192
Harris, Sybil, 268n55
Harry Pilcer's Dancing, 281n48
haute couture, 9–10, 22–23, 24, 29,
    164–65
Haydn, Joseph, 14
Hearst, William Randolph, 130
Hearst Newspaper Corporation, 212
Hellenic gowns, 28
"Hello Frisco," 145
Henderson, W. J., 144, 171–72
"Herr Gott, dich loben alle wir"
    (Bach), 69, 71
*Heures séculaires et instantanées*
    (Satie), 108, 110
*L'Histoire du soldat* (I. Stravinsky),
    171, 277n135
historicizing styles, 26, 28–29, 28–29
hobble dress, 31
Hollander, Anne, 158, 192–93
"Hommage à Erik Satie" (Cocteau), 96
Honegger, Arthur, 95, 100, 115–16,
    268n58; *Antigone* adaptation,
    194–97, 196; and Cocteau, 194,
    278n165; critical reception of, 211;
    *Les Mariés de la Tour Eiffel*, 197,
    246. See also Les Six
*A House in Kolomna* (Pushkin), 240
Hoyingen-Huene, George, 133
Hugo, Jean, 178, 190, 216, 217, 229,
    277n141

Hugo, Valentine (Valentine Gross), 63,
    64, 94, 190, 261n29, 262n46,
    228–29, *229*; *Trois pages dansées*,
    202–3, *204*, 279n2
Hugo, Victor, 9, 256n20
Huxley, Aldous, 133
"Hymn in Praise of Critics" (Satie),
    147, 268n56

*Idrofile et Filgrane* (Muller and
    Reboux), 218
*L'Illustration*, 26, 33
*L'Illustration des Modes*, 49, 91–92,
    263n49
illustrations/fashion plates: *Les*
    *Choses de Paul Poiret vues par*
    *Georges Lepape*, 46–47, *46*; in fash-
    ion magazines, 6–7, *7*, 9, 11, 256n16
    (*see also specific magazines*); poch-
    oir in, 45, 260n48; Poiret's refash-
    ioning of, 44–47, *45–46*; *Les Robes*
    *de Paul Poiret racontées par Paul*
    *Iribe*, 44–46, *45*, 260n47, 49
*images d'épinal*, 45
*L'Impatience* (Rameau), 42
"Impérial-Napoléon" (Satie), 106
Indy, Vincent d', 63
"Instant Erik Satie," 96
*Interpreters and Interpretations* (Van
    Vechten), 144
Iribe, Paul: as a cartoonist, 58;
    Chanel–hat illustration by, 156; *Le*
    *Mot* founded by, 102–3; *Les Robes*
    *de Paul Poiret racontées par Paul*
    *Iribe*, 44–46, *45*, 260n47, 49;
    *Schéhérazade*, 44; at *Vogue*, 205

Jacob, Max, 95, 104, 220
Jacquemire, René, 233
James, William, 212
Janet, Gustave, 10
*Jardins sous la pluie* (Debussy), 109
Jaurès, Jean, 63
jazz, 148, 149, 150, 209–10, 221, 223,
    226, 254
Jeanneret, Charles Edouard (*pseud.* Le
    Corbusier), 100–101; *Après le*
    *cubisme*, 105

Jenny (couture house), 135
jersey separates, 161–62, 192
"Je te veux" (Satie), 82
*Jeux* (ballet), 53
*Jeux d'enfants* (G. Bizet), 87–91,
  *88–90*, 187
*Le Jongleur* (Poulenc), 218
Joséphine, empress of France, 26, 39
"Joséphine" gown, 28–29, *29*
Jouhandeau, Elise. *See* Caryathis
*Le Journal de Musique*, 13, 257n33
*Le Journal de Musique, Historique,*
  *Théorique et Pratique*, 13, 257n33
*Journal des Dames et des Modes*, 6,
  51, 256n16
*Journal des Dames*, 5–6
*Le Journal des Demoiselles*, 8–9
*Journal des Modes*, 11
*Journal des Savants*, 3, 255n5
Joyce, James, 213
Julien, Adolphe, 244
Jurgenson (Russia), 171

*Kamarinskaya* (Russian folk dance),
  187
Karolyi, Countess, *50*
Karsavina, Tamara, *54*
Kasbeck, 241
Katinka (Zhenya Nikitina), 170, 193,
  242
kimono coats, 73
Kisling, Moise, 96
"The Kiss" (Brancusi), 214
Kling, Otto, 193, 278n159
Kochno, Boris, 168. See also *Mavra*
Koklova, Olga, 119, *120*
"Ko Ko Ri Ko," 154
Korngold, Erich, 144
Koussevitsky, Serge, 184, 275n113

La Bruyère, Jean de: *Les Caractères ou*
  *les moeurs du siècle*, 111, *112*
La Fontaine, Jean de, 71
Lagut, Irène, 208
Laloy, Louis, 18, 174
La Mésangère, Pierre de, 6, 51
lampshade (Minaret) tunics, 37–38
Landowska, Wanda, 232

Lanvin, Jeanne, 135, 220, 233; *Trois*
  *pages dansées*, 202–3, *204*, 279n2
Laparcerie, Cora, 37
LaPorte, Jean, 220–21, 244–45, 246,
  284n118
*L'Après-midi d'un faune* (ballet), 52
Larionov, Michel, 285n130; *Chout*,
  225
La Rochefoucauld, Antoine de, 107
"Lassitude" (Lepape), 56, 56–57
Latour, Contamine. *See* Contamine
  [de Latour]
La Tour, Maurice-Quentin de, 256n17
Laurencin, Marie: *Les Biches*, 197,
  278n175; costume design for Cary-
  athis, 216; *Portrait of Jean Cocteau*,
  149, *151*; *Portrait of Mademoiselle*
  *Chanel*, *155*; in *Vanity Fair*, 133;
  *Vogue* on, 208
Laurens, Henri: *Le Train bleu*,
  197–201, 278n174
Lavallière, Eve, 37
"A Learned Lecture on Music and
  Animals" (Satie), 147, 268n59
Le Butard (near Paris), 39–40, *41, 42*
LeClair, Jean-Marie, 39
Leclerc, Sébastien, 51
Le Corbusier. *See* Jeanneret, Charles
  Edouard
"A Lecture on The Six" (Satie), 147,
  268n57
Léger, Fernand, 93, 101
Lejeune, Emile, 94–95
Lenglen, Suzanne, 198
Lepape, Georges, 34; "Am I Early,"
  54, *55*; as a cartoonist, 58; *Les*
  *Choses de Paul Poiret*, 46, *46–47*;
  and Cocteau's *Antigone* adaptation,
  195; "Dancing," 57, *58*; illustration
  for French/English edition of
  *Gazette du Bon Ton*, 137; "Lassi-
  tude," 56, 56–57; at *Vogue*, 205
Le Pautre, Jean, 4, 256n11
Leroi, Pierre, 216
Lewis, Wyndham, 133
*Lewis et Irène* (Morand), 156
Lhote, André, 95, 101, 104
Lifar, Serge, 250

*Life,* 49
lifestyle modernism, 197, 201
Lilie, Carrie, 125–26, *127*
Lipovetsky, Gilles, 161
lithography, 8, 256n18
little black dress, 164–65, *165,* 192, 209
Longchamp, 160, 226
Loos, Anita, 133
Lopokova, Lydia, 225–26
Louis-Philippe, king of France, 8, 9
Louis XIV, king of France: death of, 13; *fêtes* organized for, 219; La Bruyère on, 111, 112; Perrault at court of, 283n94; pleasure/amusement in court of, 2–3; styles/tone set by, 4
Louis XV, king of France, 39
Louis XVI, king of France, 39
Le Louvre (department store), 10
Lowry, Vance, 221, *222*
*Lu,* 49
*Ludions* (Satie), 233
Lully, Jean-Baptiste, 13, 92; "Le Fard," 263n49; *Le Festes de Bacchus,* 42–43; "Trouble de Coeur," 263n49
Lurie, Alison, 163
Lyre et Palette Society. *See* Société Lyre et Palette

Madsen, Axel, 273n84
magazines, 1–2, 5, 255n2; as pastiche, 245–46. *See also* fashion press; *and specific magazines*
Mahler, Gustav, 184
Maillol, Aristide, 133
Maison Worth, 25–26
Mallarmé, Stéphane, 10
Malipiero, Gian Francesco, 181
*Ma mère l'oye* (Ravel), 114
Mangeot, Edouard, 14–15
*Manners for the Metropolis* (Crowninshield), 266n27
Manuel, Henri, 97, *98*
Manzano and La Mora, 125–26, *126*
Mardrus, Joseph Charles, 34
Mardrus, Lucie Delarue, 38
Margueritte, Victor: *La Garçonne,* 163, 270n30

Marianne (feminine emblem of France), 102
*Les Mariés de la Tour Eiffel* (Auric, Cocteau, Honegger, Milhaud, Poulenc, and Tailleferre), 197, 246
Marinetti, Filippo Tomasso, 121
Mariton, Louis-Joseph, 8–9
"La Marseillaise," 87
Martial et Armand, 135
Martin, Charles, 54–55; background of, 71; "Le Bain de mer," 77–78, 80, *80–81*; "Le Carnaval," 72, *73*; as a cartoonist, 58–60, *60–61*; "Danseuse" illustrations by, 92; "De la pomme aux lèvres," 59–60, *61*; "Feux d'artifice," 73–74, *74*; "Le Golf," 75–77, *77–78*, 80; "Lily? Yes dear, she has married," 59, *60*; as a magazine/book illustrator, generally, 71; *Sous les pots de fleurs,* 71, *72*; *Sports et divertissements* illustrations by, *66–67*, 71, 72, 73–74, *74,* 76–77, *77*; "Le Tango (perpétuel)", 84, *85,* 86; at *Vogue,* 205; "Le Yachting," *66–67*
Martin, Richard, 208–9
Marty, André, 54–55, 263n49; "A L'Oasis," *219*; *Les Noces* illustration, 251, *253*; "The Opera Ball," *176*; at *Vogue,* 205
Maryinsky Theater (St. Petersburg), 235, 238
masked balls, 229–30, 282n64
Massine, Léonide, 119, 168, 174, 179, 229; *La Boutique fantasque,* 180, 274n99; "La Statue retrouvée," 232–33
Mathews, Mrs. E. Roscoe, 141–42
Matisse, Henri, 55–56; classical themes explored by, 194; colors used by, 31; exhibited at Bongard Galerie Thomas, 93, 101; and Quinn, 213; and the Société Lyre et Palette, 95, 96; *The Song of the Nightingale,* 174; in *Vanity Fair,* 133
Matisse, Madame Henri, 98
*Mavra* (Kochno, Nijinska, I. Stravinsky, and Survage), 234–35, 240,

242–48, 248–49, 252, 284n111, 118

*maxixe* (Brazilian dance), 190

McVickar, Harry, 279n3

*Le Médecin malgré lui* (Gounod), 254

Mediterranean, myth of, 194

"Memoirs of an Amnesiac" (Satie), 107

*Le Ménéstrel,* 14

*Menus propos enfantins* (Satie), 64, 276n132

*Le Mercure de France:* on the Galerie Thomas, 101

*Le Mercure Français,* 255n3. See also *Le Mercure Galant*

*Le Mercure Galant,* 2–6, 255n3, 4, 256n7, 8, 11

Merimée, Prosper, 71

"Merveilleuse" (Vernet), *28*

Merveilleuses, 26–28, *28,* 193

Messing, Scott, 184, 191, 276n117

*Metropolitan Magazine,* 266n27

Metropolitan Opera (New York City), 171, 210, 272n59

Metzinger, Jean, 95, 104, 205

Meyer, Adolphe de, *95, 133, 172*

Meyer, Marcelle, 98, *100*

*Midas* (ballet), 54

middle-class women, 10–11

*Midnight Sun* (Rimsky-Korsakov), 117–18

Milhaud, Darius, 1, 92, 95, *100,* 115–16, 268n58; at the Bal des Jeux, 229; *Le Boeuf sur le toit,* 190, 197, 211, 215–16, 220, 221; *Les Mariés de la Tour Eiffel,* 197, 246; *Le Train bleu,* 197–201, *198–99,* 278n174. *See also* Les Six

Millay, Edna St. Vincent, 133

Millerand, Alexandre, 223–24

*Le Minaret,* 37

Minaret tunics, 37–38

Miomandre, Francis de, 205

*Mireille* (Gounod), 115

*Mir Iskusstva (World of Art),* 15–16

Mistinguett (Jeanne Bourgeois), 37

*La Mode,* 9, 256n23

*La Mode Artistique,* 10

*La Mode Illustrée,* 8–9, 12

Modern Olympics, 278n172

Modigliani, Amedeo, 93, 95, 96, 101

Molière, 233, 254

Mollet, Armand-Claude, 39

Monaco Lecture Society, 249

*Le Monde Musical,* 14–15

Monte Carlo, 249, 252, 254, 285n132

Montesquieu, Charles de Secondat, baron de, 32

Montparnasse, 119

Moonlight Ball, 224, 282n62

Morand, Paul: and Chanel, 152, 156, 169; and Cocteau, 150–51; *Lewis et Irène,* 156; on Les Six, 150–52; on Igor Stravinsky, 151; in *Vanity Fair,* 133, 150

Morny, Charles Auguste Louis Joseph, Duc de, 157

Mortimer, Raymond, 239

*Le Mot,* 102–3

Moussinac, Léon, 71

Mozart, Wolfgang Amadeus, 14

Muller, Charles, 219; *Idrofile et Filgrane,* 218

*Munsey's Magazine,* 266n27

Murat, Lucien, Princesse, 220, 224

*Le Musée des Modes: Journal des Tailleurs,* 8

*Le Muse Historique,* 4

Museum of Modern Art, 133

*Musica,* 15, 107

*Music After the Great War* (Van Vechten), 144

*Musical America,* 200

*Musical Times,* 107

*Music and Bad Manners* (Van Vechten), 144

music-hall shows, 120–26

"The Musician as Parodist of Life" (Rosenfeld), 147–48

"Le Music Kiss Me" (Cendrars), 96

*La Musique à Bordeaux,* 15

*Musique d'ameublement* (Satie), 264n13

"La Musique et les enfants" (Satie). *See* Furniture Music

Musset, Alfred de, 71
Musorgsky, Modest, 146, 168

*Nabuchodonosor*, 37
Napoleonic Civil Code, 32, 259n22
Napoleon III, emperor of France, 9,
 154
*Narcisse* (ballet), 52
Nast, Condé, 129; "Class Publica-
 tions," 130–31; and Lucien Vogel,
 133, 135–37. See also *La Gazette du
 Bon Ton; Vanity Fair; Vogue* (U.S.)
Natanson, Thadée, 167
National Council of French Women
 (CNFF), 259n23
Naudin, Bernard, 34, 40, *40–41*, 42
neoclassicism: in fashion, 24, 26–29,
 *27–30*, 31, 192–93; of Poiret, 24,
 26–29, *27–30*, 31; of Erik Satie,
 186–90; of Igor Stravinsky, 184–93,
 201; usage of, 184, 190–91,
 275n116, 276n117
"A New Dramatic Form" (Cocteau),
 150, 247
Newman, Ernest, 184
"News of the Seven Arts of Europe"
 (Tzara), 247
"New Spirit," 147
"new thought" composers, 144
New York Armory Show (Interna-
 tional Exhibition of Modern Art,
 1913), 132, 213
*New Yorker Magazine*, 31
*The Nightingale* (I. Stravinsky), 171
Nijinska, Bronislava: *Les Biches*, 197,
 278n175; *Les Noces*, 171, 179,
 180–81, 250–52, *253*, 278n175; *Le
 Train bleu*, 197–201, *198–99*,
 278n174. See also *Mavra; Le
 Renard*
Nijinsky, Vaslav, 17, 37, 53, 272n59
*Les Noces* (Goncharova, Nijinska, and
 I. Stravinsky), 171, 179, 180–81,
 250–52, *253*, 278n175
*Nocturnes* (Satie), 216
Nossenko, Catherine, 170, 272n54
Nouveaux Jeunes. *See* Les Six

"No Wagner on the Horizon?" (Chaz-
 alviel), 104, *105*

Oasis club, 218–20, *219*, 239, 281n47
*L'Observateur de la Mode*, 8
ocean swimming, 77–78
Olivier, Fernande, 96
Olympic Games (Paris, 1900),
 278n172
Olympic Games (Paris, 1924), 197,
 278n172
"O Magâli, ma bien-aimée" (folk
 tune), 115
opera ball, 224, 282n64
opera-buffa, 240
*Les Orientales* (ballet), 33
orientalism in France, 32, 33–34, 38
Orledge , Robert, 268n55
Ortiz de Zarate, Manuel, 95
Ozenfant, Amédée, 100–102, 104,
 264n31; *Après le cubisme*, 105. See
 also *L'Elan*

Paine, John Knowles, 142–43
La Paix (department store), 10
Pallavicino, Benedetto, 42
Palmyre (fictional character), 1, 2
Palmyre, Madame (French *cou-
 turière*), 255n1
Panama Canal, 134
Panama Pacific International Exposi-
 tion (San Francisco, 1915), 133–36,
 *136–37*
*panikhida* (Russian Orthodox office
 for the dead), 183
*Papillons* (Schumann), 109
Pâquerette, 115
Paquin, Jeanne, 22, 50, 135
*Parade* (ballet; Cocteau, Picasso, and
 Satie), 116–33, 263n7; Acrobat char-
 acters, 118, 121; and Americanism,
 127–28; American magazines on,
 129; Apollinaire on, 128; as art of
 the sophisticated commonplace,
 197; Chinese Prestidigator charac-
 ter, 118, 121; Cocteau on, 146, 150,
 267n51; Cubist influence on,

119–20, 128; and fashionable life, 128–29; interpretations of, 119; Little American Girl character, 118, 122–28, *123*; modernism of, 117, 119–20, 146; music-hall influence on, 118, 120–26, 128; nonmusical noises in, 128; Picasso's costumes for, 121–22; Picasso's *rideau rouge*, 119–20, *121*; premiere of, 117–18, 145, 168, 191, 267n51; reception of, 118, 119, 129, 146, 267n51; revival of, 129; "Steamship Ragtime," 124, 125–28; storyline/setting of, 118–19; surrealism of, 128; *Vanity Fair* on, 145–46

*Parade* (piano duet; Satie), 216

Parent Quartet, 39

*Les Parfums de Rosine*, 36, *36–37*

Paris: Americans in, 141–42; musical season in, 210–11; Russianization of, 235, 240–43; social calendar of, 223

*Paris-Sport* (Auric), 218

Parker, Dorothy, 133

pastiche, 245–46, 284n118

Pavlovich, Dmitri, Grand Duke, 169, 193, 241

*Peccadilles importunes* (Satie), 276n132

Péladan, Joseph, 264n13

Pergolesi, Giambattista, 175, 176

*The Perils of Pauline*, 122

Perrault, Charles, 283n94; *Sleeping Beauty*, 238

"Pesante" (Tempo di tango"; I. Stravinsky), 187–88, 277n135. See also *Les Cinq doigts* (I. Stravinsky)

Petipa, Marius: *Sleeping Beauty*, 235, 238

*Le Petit Courrier des Dames*, 8

*Petite suite d'orchestre* (G. Bizet), 87–88

*Petrouchka* (I. Stravinsky), 52, 117–18, 171, 175

*Philémon et Baucis* (Gounod), 254

Philomela, 60–61

"Philomèle" (Bakst), 60–61, *62*

piano: and fashion illustration, 11–13, *12*, 108–10

*Piano-Rag-Music* (I. Stravinsky), 171, 190, 277n140, 141

Picabia, Francis, 55–56, 96, 194; *Relâche*, 254

Picasso, Pablo, 57–58; *Antigone* adaptation, 194–97; at Le Boeuf sur le toit, 220; as a cartoonist, 58, 261n25; classical themes explored by, 194; collages/*papiers collés* of, 57–58, 161–62; *Cuadro flamenco*, 225–26; *Les Demoiselles d'Avignon*, 115, 116; *Deux femmes courant sur la plage*, 198, *199*, 278n174; in *L'Elan*, 104; at Els Quatre Gats Café, 263n9; exhibited at Bongard Galerie Thomas, 93, 101; and Foster, 213–14; and Koklova, 119, *120*, 178; as a *pasticheur*, 245; portrait of Evans, 180; *Pulcinella*, 174–78, 238, 246; and Quinn, 213; and Satie, 96; Satie portrait by, 96; social ambitions/circumstances of, 119; and the Société Lyre et Palette, 95, 96; "La Statue retrouvée," 232–33; *Le Train bleu*, 197–201, *199*, 278n174. See also *Parade*

Piccinni, Niccoló, 13

Pickford, Mary, 122, *122–23*

Pierre, prince of Monaco, 249

"Pierrot" (Debussy), 87

Pilcer, Harry, 281n48

*Pilgrim's Progress* (Bunyan), 129–30

*Plain-Chant* (Cocteau), 194

Plato, 112

*pleine saison*, 223–26, *225*, 243, 250

Pleyel piano company, 193

*pochoir*, 45, 260n48

Poiret, Paul, 23–47, *25*; *ancien régime* excess in designs of, 219; art collections of, 24–25, 44; as an artist, 23; background/early career of, 24–26, 258n11; "Battick," 73, *75*, 262n34; at Le Boeuf sur le toit, 220; *bon vivant* lifestyle of, 37–38; on Chanel, 153; clientele of, 25, 98; colors used

Poiret, Paul *(continued)*
by, 31; costume design for Cary-
athis, 216, 281n43; costume parties
of, 38, 40, 42–43, *43*, 218; couture
salon of, 26; critical reception of, 29,
*30*, 31; defamation lawsuit by, 32,
259n26; and Diaghilev, 33, 37; and
Doucet, 24–25; fashion empire/
ideals of, 34–37, *36*; fashion plates
refashioned by, 44–47, *45–46*;
Galerie Barbazanges, 44, *46*, 47,
215–16, 219; influence/reputation
of, 23–24, 26, 37, 38–39, 252,
259n26; kimono coats popularized
by, 73; at Le Butard, 39–40, *41*, 42;
library of, 24; Martine atelier,
35–36; military duty of, 25; as
musical tastemaker, 38–40, *40–41*,
42–44, *43*, 218; and the neoclassical
ideal, 24, 26–29, *27–30*, 31; and
Nijinsky, 37; Oasis club of, 218–20,
*219*, 239, 281n47; Opera Ball of
1921 designed by, 224; "Pompon,"
73, *73*, 262n34; Rosine perfumes,
36–37, 164; simplicity in designs of,
29, *30*, 31; *style sultane* of, 31–34,
*33*, *46*, 73–74, *74*; theatrical connec-
tions of, 37–38; war duties of, 135
Polaire, 154
Polignac, Jean, Count de, 233
Polignac, Marquise de, 224, *234*
Polignac, Melchior de, 224
Polignac, Princesse de, 216, 224,
248–49, *250*, 285n130
Polotzoff, Countess, 228
Pompadour, Marquise de, 256n17
"Pompon" (design by Poiret, photo-
graph by Steichen), 73, *73*, 262n34
*Poor Little Rich Girl*, 122
*Portrait of Jean Cocteau* (Laurencin),
149, *151*
*Portrait of Les Six* (Blanche), 98, *100*
*Portrait of Mademoiselle Chanel*
(Laurencin), *155*
Poulenc, Francis, 12, 95, *100*, 268n58;
at the Bal des Jeux, 229; *Les Biches*,
197, 278n175; *Cocardes*, 215–16; *Le*

*Jongleur*, 218; *Les Mariés de la Tour
Eiffel*, 197, 246. *See also* Les Six
Pound, Ezra, 213
"les précieuses," 111
*Préludes flasques (pour un chien)*
(Satie), 107–8, *109*
Premet (couture house), 135
*Premier menuet* (Satie), 92, 216
Prévost, Marcel: "The United States
and France," 131
*Pribaoutki* (I. Stravinsky), 171
*Prince Igor* (Borodin), 19
Le Printemps (department store), 10
printing, industrialization of, 8
Prokofiev, Sergei: *Chout*, 225
Proust, Marcel, 24, 118, 167
Prunières, Henry, 181
"The Public and the Artist" (Cocteau),
149–50
*Pulcinella* (Picasso and I. Stravinsky),
174–78, 181, 238, 246
Purism, 100–101, 104, 105–6
Pushkin, Alexsandr: *Boris Godunov*,
240; *Evgeny Onegin*, 240; *A House
in Kolomna*, 240

"Quatre coins" (G. Bizet), *90*, 91
*Querelle des Bouffons*, 13
Quinn, John, 213, 214, *215*
"Qui qu'à vu Coco dans le Trocadero"
(Faure), 154

Radiguet, Raymond, 1, 220, 229
ragtime, 142, 143, 145; in *Parade*,
122–27
*Ragtime for Eight Instruments*
(I. Stravinsky), 171
Rainbow Ball, 224, 282n62
Rameau, Jean-Philippe, 13, 39; *L'Im-
patience*, 42; *Oeuvres complete*, 42
*Le Rappel à l'ordre* (Cocteau),
277n146
*Rapsodie espagnole* (Ravel), 218
Ravel, Maurice: Cocteau on, 146; as a
dandy, 110; "Festival Erik Satie–
Maurice Ravel," 94, 95–96, 263n7;
Tombeau for Debussy, 181; *Ma*

*mère l'oye*, 114; *Rapsodie espag-
nole*, 218; and Satie, 106–7, 110;
*Valses nobles et sentimentales*, 81,
110
Ray, Man, 96, 196, 264n12; *Cadeau*,
264n12
ready-to-wear clothing, 10
"A Real Girl," 124
realistic theater, 149–50
*Rebecca of Sunnybrook Farm*, 122
Reboux, Paul, 219; *Idrofile et Filgrane*,
218
Récamier, Mme, 26
*Red* (Van Vechten), 144
Régnier, Henri de, 50–51
Rehbinder, Vladimir, *196*, 225, 228–29,
234
Réjane (Gabrielle Réju), 24, 37,
258n11
*Relâche* (Picabia and Satie), 254
*La Renaissance Politique, Littéraire, et
Artistique*, 32, 259n26
*Le Renard* (Nijinska and I. Stravin-
sky), 171, 180–81, 234–35, 248–49,
*236*, 252, 278n175, 285n129, 130
resort style, 157–60. See also *Le Train
bleu*
Respighi, Ottorino: *La Boutique fan-
tasque*, 180, 274n99
retrospective classicism, 238
Reverdy, Pierre, 95, 193
*La Revue Blanche*, 34, 167
*La Revue du Monde Musicale et Dra-
matique*, 14
*La Revue Musicale (La Revue et
Gazette Musicale de Paris)*, 13–14,
181, 257n35, 274n102
*Revue Musicale S.I.M.*, 107
Rimsky-Korsakov, Nikolai, 19, 146;
*Midnight Sun*, 117–18
*Le Rire*, 58
*The Rite of Spring* (I. Stravinsky), 53,
54, 117, 168, 174, 179–81, 238
Rittenhouse, Anne, 141
Rivera, Diego, 104
Riviera, 194, 249
*robe de style*, 233

*Les Robes de Paul Poiret racontées par
Paul Iribe* (Iribe), 44–46, *45*,
260n47, 49
Roché, Henri-Pierre, 213–14, *215*,
268n55
Roger, Lucienne, 156
Roger-Marx, Claude, 50–51
"Le Roi soleil de plomb" (Satie), 106
Roland-Manuel, Alexis, 96, 106
Rosenberg, Paul, 245
Rosenfeld, Paul: "The Musician as
Parodist of Life," 147–48
Rosicrucians, 264n13
Rossini, Gioacchino: *La Boutique fan-
tasque*, 180, 274n99
Rostand, Maurice, 71; *L'Aiglon*,
258n11
Rothschild, Baronne de, 228
Rothschild, Deborah Menaker, 120
*roubachka* (peasant blouse), 241
Roussel, Albert, 181
Royallieu, 156
Rubenstein, Ida, 37
Rusiñol, Santiago, 96, 263n9
Russicher Musik Verlag (Berlin), 171,
179

Sachs, Maurice, 221
Saint-Aubin, Gabriel de, 51
Saint-Saëns, Camille, 104, *105*; "Hail
California," 134–35
Salabert, Edouard, 125, 126, *126*
Salle Huyghens (Paris), 94–95, 101,
115
Salmon, André, 95, 115
*Salomé* (ballet), 18, 53
Salon d'Antin (Paris), 115–16, 265n44
Salon d'Automne, 35, 57
Salon Rose + Croix, 264n13
Salzedo, Maggie, 263n49
San Francisco, 134
San Francisco Exposition. *See* Panama
Pacific International Exposition
"La Sans-Gêne," 263n49
"Sao Paulo Future," 190
*Sarabandes* (Satie), 106–7, 115–16
Sarcey, Francisque, 265n37

"Sa Taille" (Satie), 188–89, *189*

Satie, Erik: *The Angora Ox*, 106; artist friends of, 96–97; attire of, 63; *Avant-dernières pensées*, 95–96, 108, 110, 113; on Bach, 71; at the Bal Baroque, 232–33; *La Belle excentrique*, 216–18, *217*; at the Bongard salon, 93–94, 97, 106–8, 113–15; and Brancusi, 96, 214, *215*; and Braque, 96; and Breton, 96; *Cadeau*, 264n12; and Chalupt, 114–15; "Le Chapelier," 113–15, 276n129; *Chapitres tournés en tous sens*, 107–8, 216; chronology of works of, 96; church of, 63; classicism of, 106, 112–13; and Cocteau, 94, 96, 263n7; critical reception of, 107; *Croquis et agaceries d'un gros bonhomme en bois*, 107–8; *Danse*, 106; "Danseuse," 91–92, 263n49; "Daphénéo," 95–96, 113–14; death of, 63, 186; and Debussy, 96, 107; on Debussy, 147; and Derain, 96; *Descriptions automatiques*, 107–8; "La Diva de l'Empire," 83; drawings/paintings of, 63, *64*, 96, 107; and Duchamp, 96; *Embryons desséchés*, 107–8, 109; *Enfantillages pittoresques*, 276n132; *Enfantines*, 107–8, 187, 276n132; *En Habit de cheval*, 107; and Fargue, 114, 233; "Festival Erik Satie" (Paris), 216; "Festival Erik Satie" (Brussels), 268n57; "Festival Erik Satie–Maurice Ravel," 94, 95–96, 263n7; *Le Fils des étoiles*, 96–97, 106–7, 264n13; and Foster, 214, 215, *215*; Tombeau for Debussy, 181; "Furniture Music," 96–97, 211–12, 215, 264n13; "La Grenouille," 114; and Gross, 63–64, 94, 261n29, 262n46; *Gymnopédies*, 106–7, 112–13, 115–16; *Heures séculaires et instantanées*, 108, 110; high/low music integrated by, 106–8, 186–87; humoristic piano suites by, 107–10, 186; "Hymn in Praise of Critics,"

147, 268n56; "Impérial-Napoléon," 106; "Instant Erik Satie," 96; "Je te veux," 82; "A Learned Lecture on Music and Animals," 147, 268n59; "A Lecture on The Six," 147, 268n57; lifestyle of, 63; *Ludions*, 233; "Memoirs of an Amnesiac," 107; *Menus propos enfantins*, 64, 276n132; on the modern sensibility, 147, 268n58; "La Musique et les enfants," 147, 247, 268n59; *Nocturnes*, 216; *Parade* piano duet, 216; *Peccadilles importunes*, 276n132; and Picabia, 96; and Picasso, 96; popularity/stature of, 93–94, 96, 107; popular music by, 106–7; *Préludes flasques (pour un chien)*, 107–8, 109; *Premier menuet*, 92, 216; and Quinn, 214, *215*; and Ravel, 106–7, 110; and Ray, 96, 264n12; *Relâche*, 254; and Roché, 214, *215*; "Le Roi soleil de plomb," 106; and the Rosicrucians, 264n13; *Sarabandes*, 106–7, 115–16; "Sa Taille," 188–89, *189*; at the Schola Cantorum, 63, 69; Socialist politics of, 63; and the Société Lyre et Palette, 95, 96, 110; *Socrate*, 216; songs commissioned for *La Gazette du Bon Ton*, 91, 262n46; "La Statue de bronze," 95–96, 113–14, 233; "La Statue retrouvée," 232–33; and Igor Stravinsky, 147, 186–90, 247–48, 276n129; text, music, and the *ton de blague* used by, 108–10, 111–13; *Trois mélodies*, 113–15; *Trois morceaux en forme de poire*, 95–96, 106, 107, 263n7; *Trois petites pieces montées*, 215–16; *Trois poèmes d'amour*, 91, 114, 262n46, 263n48; *Les Trois valses distinguées du précieux dégoûté*, 96, 108, 110–13, 114, 188–89; and Tzara, 96; and Valadon, 63; in *Vanity Fair*, 147–48, 268n55, 58, 59; *Véritables preludes flasques (pour un chien)*, 107–8; "Le Veuf," 106; *Vieux sequins et vieilles*

cuirasses, 107–8; and Lucien Vogel,
91–92; *Vogue* on, 1, 203, 211–12.
See also *Parade; Sports et diver-
tissements*
*Sauf vot' Respect,* 37
*Schéhérazade* (ballet), 33, 46, 52
*Schéhérazade* (magazine), 44
Schervachidse, Alexander, prince, 198
Schirmer Company, 276n126
Schlesinger, Maurice, 257n36
Schloezer, Boris de, 184–85, 191, 244,
274n100, 284n118
Schmitt, Florent, 181
Schoenberg, Arnold, 144, 284n118
Schola Cantorum, 15, 63, 69
Schumann, Robert, 39; *Papillons,* 109
Schwabe, Carlos, 264n13
Sée, Camille, 259n24
Seebohm, Caroline, 131
Sem, *159,* 160, *164;* "True and False
Chic," 166
*La Semaine Littéraire,* 174
Séon, André, 264n13
Sert, José-Maria, 167–68, 169, 178,
230
Sert, Misia Godebska, 114, 116,
167–68, 169, 178, 220
Severini, Gino, 95, 98, 102, 104; *The
Bear at the Moulin Rouge,* 124, 125
Shaw, Albert, 213
sheet music, 11–12
*SIC (Sons—Idées—Couleurs),* 115
*Siegfried* (Wagner), 210–11
Silbelius, Jean, 144
Silver, Kenneth, 185, 275n116
simplicity as an ideal, 190–92
Les Six ( *formerly* "Nouveaux
Jeunes"), 95–96, 147–48, *148,*
268n56, 57, 58; at Le Boeuf sur le
toit, 220; and Chanel, 154; Morand
on, 150–52; portrait of, *98, 100. See
also* Auric, Georges; Durey, Louis;
Honegger, Arthur; Milhaud, Darius;
Poulenc, Francis; Tailleferre, Ger-
maine
*skazki* (Russian folk tales), 248,
285n129

*skomorokhi,* 248, 285n129
*Sleeping Beauty* (ballet; Petipa and
Tchaikovsky), 235, 238
*Sleeping Beauty* (story; Perrault), 238
*The Sleeping Princess* (ballet), 235,
238–40, 248–49, 252
Slobodskaja, Oda, 247
Snyder, Ted: "That Mysterious Rag,"
124–27, *126–27*
social dancing, 81, 200
Socialist Party, 63
Société des Amis Américains des
Musiciens de France (New York
City), 210
Société des Bains de Mer, 249,
285n132
Société Lyre et Palette (Lyre et Palette
Society), 94–95, 96, 110, 111–13
Société Musicale Indépendante, 106–7
*Socrate* (Satie), 216
"Soirée de Paris," 202–3, 254, 279n1, 2
Sokolova, Lydia, *123, 198*
*The Song of the Nightingale* (I. Stra-
vinsky and H. Matisse), 174
Sophocles: *Antigone,* 194
Sorel, Cécile, 168, 224, *225*
Souday, Paul, 176
*Le Sourire,* 58, 60
Sousa, John Philip, 82, 262n39
*Sous les pots de fleurs* (C. Martin), 71,
72
Soutzo, Princess, 228, *228*
Spectacle-Concert (Comédie des
Champs-Elysées, 1920), 215–16
Spinelly, Andrée, 34
*Sports et divertissements* (Satie): *Le
Bain de mer,* 77–80, *79–81;* "La Bal-
ançoire," 88, *89;* calligraphy in,
68–69; composition of, 186; "Les
Courses," 87; critical reception of,
92; dance parodies in, 81–86; dead-
lines/payments for, 64–65, 91; fash-
ion/music linked in, 65, 92, 108,
110; and the fashion press, 84, 86;
and *Femina,* 67–68; "Le Flirt," 87;
and *La Gazette du Bon Ton,* 62,
68–69, 71, 92; *Le Golf,* 75–76,

*Sports et divertissements (continued)*
76–78, 77, 80; illustrations/fashion
plates in, *66–67, 71, 72, 73–74, 74,
76–77, 76–83*; lavishness/elegance
of, 68–69; modernism of, 62, 92;
musical borrowings in, 86–89,
*89–90, 91,* 187; musical score of, *66,
68–69, 71–80, 76, 79, 83,* 86–91; "Le
Pique-nique," 82–83; "Les Quatre
coins," 89, 90, 91; "Le Reveil de la
mariée," 86; table of contents of, *69*;
"Le Tango (perpétuel)", 83–84, 86,
141, 187–88, 262n40; title page of,
68; *Unappetizing Chorale, 69,* 71;
Lucien Vogel's role in, 64–65,
261n29; "Le Water-chute," 81–82,
*82–83*; wit in, 69; "Le Yachting,"
*66–67*
St. Denis, Ruth, 213
"La Statue de bronze" (Satie), 95–96,
113–14, 233
"La Statue retrouvée" (Massine,
Picasso, and Satie), 232–33
steamship travel, transatlantic, 127–28
Steegmuller, Francis, 194, 262n46
Steichen, Edward, 34, *73, 75,* 133,
262n34
*Le Stéréoscope,* 10
Stoll, Oswald, 238
"Storm Cloud" (I. Stravinsky), 240
Strauss, Richard, 18
Stravinsky, Igor, 53, 64; appearance of,
151, 169, 181, 271n49; and Bach,
274n100; in Carantec, 170–71; and
Chanel, 154, 168–71, 178–80,
193–94, *195,* 241, 271n49, 50,
272n54, 273n84; *Les Cinq doigts,*
185–86, *187–88, 190–91,* 276n123,
126, 277n135; Cocteau on, 146, 149,
246–47, 277n146; *Concerto for
Piano and Winds,* 254; *Concertino
for String Quartet,* 179, 180–81;
diatonicism used by, 187; and Evans,
180–81, *182,* 274n97, 100; family's
enjoyment of Paris life, 179,
273n87; "Faun and Shepherdess,"
240; finances of, 171; *The Firebird,*
171; *Fireworks,* 171; *Fragment des
symphonies d'instruments à vent
pour Claude Debussy,* 181; *L'His-
toire du soldat,* 171, 277n135; and
Katinka, 170, 193, 242; at Les
Rochers, 193; "March," 189–90;
Morand on, 151; neoclassicism of,
184–186, 190–93, 201; *The Nightin-
gale,* 171; *Les Noces,* 171, 179,
180–81, 250–52, *253,* 278n175; as a
*pasticheur,* 245, 284n118;
"Pesante," 187–88, 277n135;
*Petrouchka,* 117–18, 171, 175;
*Piano-Rag-Music,* 171, 190,
277n140, 141; popularity of,
171–72, 173, *174,* 178; portrait of,
*172, 173,* 272n63; *Pribaoutki,* 171;
*Pulcinella,* 174–78, 181, 238, 246;
*Ragtime for Eight Instruments,*
171; reputation of, 171; and Satie,
147, 186–90, 247–48, 276n129; sim-
plicity/clarity/elegance in works of,
181, 183, 190–91; and *The Sleeping
Princess,* 238–39; *The Song of the
Nightingale,* 174; "Storm Cloud,"
240; *Suite No. 2 for Small Orches-
tra,* 242; *Symphonies d'instruments
à vent,* 180–81, 183–86, 190–91,
274n105, 275n107, 113; at the
Théâtre de la Chauve-Souris à
Moscou, 242; *Three Easy Pieces,
188–90, 189; Three Pieces for String
Quartet,* 115–16, 171, *172,* 272n64;
*Vanity Fair* on, 171–72; *Vogue* on,
172, 203, 272n64. See also *Mavra;
Le Renard; The Rite of Spring*
Stravinsky, Vera, 169–70, 193, 239,
242, 272n54
"Stravinsky chez Coco Chanel"
(Cocteau), 194, *195*
Stravinsky Festival (Théâtre ed la
Gaîté-Lyrique, 1921), 226
*Stravinsky in Pictures and Documents*
(Craft and V. Stravinsky), 169–70
Stroeva, Dora, 240–41
*Le Style Parisien,* 49
style sultane, 31–34, *33, 46, 73–74, 74*

Sudeykin, Sergey, 242
Sudeykina, Vera. *See* Stravinsky, Vera
Sue, Eugène, 9
Süe, Louis, 34
*Suite No. 2 for Small Orchestra*
    (I. Stravinsky), 242
Sunset Ball, 224, *225*, 282n62
sur-réalisme, 128
Survage, Leopold. See *Mavra*
*Le Sylphides* (ballet), 117–18
*Symphonies d'instruments à vent*
    (I. Stravinsky), 180–81, 183–86,
    190–91, 274n105, 275n107, 113

Tailleferre, Germaine, 95, *100*, 216,
    268n58; *Les Mariés de la Tour Eif-
    fel*, 197, 246. *See also* Les Six
*Tais-toi, tu m'affolles*, 124–25
*The Tale about the Fox, the Cock, the
    Tomcat* (I. Stravinsky). See *Le
    Renard*
"Le Tango (perpétuel)" (C. Martin),
    84, *85*, 86
tango (color), 84
tango (dance and music), 83–84, *85*,
    86, 139, 141, 187–88, 277n135
tango gowns, 139, *140*, 141
Tango-Teas, 139, *140*, 141
Taruskin, Richard: on the Ballets
    Russes's 1922 season, 235; on the
    Chanel/Stravinsky affair, 170; on
    *Les Cinq doigts*, 187; on *Mavra*,
    240; on *Le Renard*, 248, 285n129;
    on *The Rite of Spring*, 180; on
    *skazki* and *skomorokhi*, 285n129;
    on *The Sleeping Princess*, 238; on
    *Suite No. 2 for Small Orchestra*,
    242; on the *Symphonies d'instru-
    ments à vent*, 183, 275n107
Tchaikovsky, Peter Ilich: *Sleeping
    Beauty*, 235, 238; Stravinsky on,
    239
Templier, Pierre-Daniel, 63
*Le Temps*, 265n37
Tenroc, Charles, 200–201, 243–44
"That Mysterious Rag" (Berlin and
    Snyder), 124–27, *126–27*

Thayaht (Ernesto Michaelles): "De la
    fumée," 57, *59*
Théâtre de l'Atelier (Montmartre),
    194
Théâtre de la Chauve-Souris à
    Moscou (The Bat Theater of
    Moscow), 240–41, 242
Théâtre de la Cigale (Montmartre),
    202, 254
Théâtre des Champs-Elysées, 53, 180,
    223–24, 261n14
Théâtre du Colisée, 218
Théâtre de la Gaîté-Lyrique, 224–26
Theophrastus: *Charakteres*, 112
Thévenas, Paulet, 172, *173*, 272n63
*Thomas l'Imposteur* (Cocteau), 194
Thousand and Second Night party, 38,
    40
*Three Easy Pieces* (I. Stravinsky),
    188–90, *189*
*Three Pieces for String Quartet*
    (I. Stravinsky), 115–16, 171, *172*,
    272n64
Tiersten, Lisa, 165–66
Titanic, 127–28
*ton de blague*, 108–10, 112, 265n35
Toulouse-Lautrec, Henri de, 55–56
*Le Train bleu* (Chanel, Cocteau, Lau-
    rens, Milhaud, Nijinska, and
    Picasso), 197–201, *198–99*, 278n174
"Treatise on the Elegant Life"
    (Balzac), 9, 256n23
*La Tribune de Saint-Gervais*, 15
*Tristan und Isolde* (Wagner), 210–11
*Trois mélodies* (Satie), 113–15
*Trois morceaux en forme de poire*
    (Satie), 95–96, 106, *107*, 263n7
*Trois pages dansées* (Beaumont, V.
    Hugo, and Lanvin), 202–3, *204*,
    279n2
*Trois petites pièces montées* (Satie),
    215–16
*Trois poèmes d'amour* (Satie), 91, 114,
    262n46, 263n48
*Les Trois valses distinguées du pré-
    cieux dégoûté* (Satie), 96, 108,
    110–13, 114, 188–89

"Trouble de Coeur" (Lully), 263n49
Trouhanova, Natalia, 17–19, *18–19*, *37*, *38*
"True and False Chic" (Sem), 166
Tucker, Allen: "Why France?", 132–33
Tucker, Sophie, 125
Tunure, Arthur, 279n3
Tupinambá, Marcelo, 190
Turner, W. J., 239
"Twelve Variations on a Russian Dance from Wranitsky's Das Waldmädchen" (Beethoven), 187
Tzara, Tristan, 96; "News of the Seven Arts of Europe," 247

Udine, Jean d', 18
"Ultra-Modern French Art in New York," 208
Union Sacrée, 275n116
"The United States and France" (Prévost), 131
U.S.–French alliance, 131–32, 134, 135–36
Utrillo, Miguel, 263n9

Valadon, Suzanne, 63, *64*
Valerio, Madame, *136*
Valéry, Paul, 92
*valse-chanté* (sentimental song style), 81–82
*Valses nobles et sentimentales* (Ravel), 81, 110
Vanderbilt, Mrs. Whitney, 157–58
Van Dongen, Kees, 216
*Vanity Fair*, 129–33; agenda for, 130; on America's relationship to France, 131–32; on the Ballets Russes, 171–72; Cocteau in, 147, 149–50, *151*; on Cocteau's *Antigone* adaptation, 195, 196, *196*; and fashionable modernism, 145–52, 268n55, 56, 57, 58, 59, 269n62; founding of, 129; French art/culture promoted by, 132–33, 138–42; French fashion reporting in, 138–39; *Gazette* writers/illustrators hired by, 136–37; on *Mavra*, 246–47; modernism of, 133, 211; music in, 130, 142–45; on

*Parade*, 129, 145–46; "The Paris Mode," 138; Satie in, 147–48, 268n55, 58, 59; on Igor Stravinsky, 171–72, 246–47; on Tango-Teas, 139, *140*, 141; on World War I, 131
Van Vechten, Carl: "The Great American Composer," 145; *Interpreters and Interpretations*, 144; *Music After the Great War*, 144; *Music and Bad Manners*, 144; *Red*, 144; on Satie, 147; in *Vanity Fair*, 133
Varnedoe, Kirk, 58
Vaudoyer, Jean-Louis, 50–51
Verdi, Giuseppe, 14
*Véritables préludes flasques (pour un chien)* (Satie), 107–8
Vernet, Horace, 256n16; "Merveilleuse," *28*
"Le Veuf" (Satie), 106
Vichy, 154–55
"La Vie champêtre" (Aubert), 263n49
*Vieux sequins et vieilles cuirasses* (Satie), 107–8
Viñes, Ricardo, 114, 216, 268n59
Vlaminck, Maurice, 44, 101
Vogel, Cosette. *See* Cosette de Brunhoff
Vögel, Herman, 48
Vogel, Lucien: background/career of, 49; connections of, 48, 49; and Countess Karolyi, *50*; and Nast, 133, 135–37, 205; and Poiret, 46–47, 48; and Satie, 91–92 (see also *Sports et divertissements*). See also *La Gazette du Bon Ton*
*Vogue* (New York): on the arts, 203, 208–9; Bakst-Paquin collection in, 22; on the Ballets Russes, 236, 283n90; on the Beau Brummels, *86*; on the Beaumont Balls, 226; on Le Boeuf sur le toit, 222; on the Bongard salon, 97, *99*; on the Caveau Caucasien, 241; on Chanel, 158, 161, *165*; on chic, *166*, 166–67; on Cocteau, 195; on Cubism, 208–9; on Deauville, 157; "Dress Plagiarisms from the Art World," 208; on fashion as art, 155–56; female-oriented

culture of, 205–8; founding/history of, 203, 279n3, 4; Franco-American culture promoted by, 202–3, 206, 207–8, 209; *Gazette* writers/illustrators hired by, 136–37, 205; Information Bureau, 206–7, 280n15; on the Kasbeck, 241; "The Maecenas of Paris Entertains," 202–3, *204*; Martin's *Le Tango (perpéteul)* in, 85, 86; on Minaret tunics, 37–38; on Poiret, 27, 29, 30, 31; Nast's transformation of, 130, 203; on resort life, 207; on simplicity, 191; on Igor Stravinsky, 172, 203, 272n64; and *Trois pages dansées*, 202–3, 204, 279n2; on "Ultra-Modern French Art in New York," 208; on World War I, 160. See also *Vogue* (Paris)

*Vogue* (Paris): on "American Painters of Women, 208; on the Bal Baroque, 230–34, *231*, *234*; on the Ballets Russes, 224–26, 235, *237*; Beau Brummel artists at, 205; oon the Beaumont Balls, 226–34, *228–29*; on Le Boeuf sur le toit, 220–23; on carnival, *177*, *178*; on chic, *166*, 166–67; on Cocteau, 195, 211; Cubism in, 209; fashion shows sponsored in U.S., 206, 280n14; Foster as critic for, 211–12, 214–15, 218–19, 225, 231–32, 233–34, 251–52; founding/history of, 203–4; Franco-American culture promoted by, 205–06, 208, 222–23; vs. *La Gazette du Bon Ton*, 205; on history of American *Vogue*, 279n3; on *Mavra*, 244–45, 284n118; music in, 203, 209–12; on *Les Noces*, 251–52, 253; on Oasis, 218–20; "L'Opéra et l'opérette," 210; photo studio at, 206; on the *pleine saison*, 223–26, *225*; on Poiret, 218–19; and public art vs. private entertainment, 203–4; on Russian refugees, 241–42; on Satie, 203, 211–12; on simplicity, 191–92; on *Le Train bleu*, 197, *199*, *200*; Lucien Vogel at, 49, 205. See also *Vogue* (New York)

Volta, Ornella, 268n55
Voltaire, 32
Vsevolozhsky, Ivan, 238
*Vu*, 49
Vuillermoz, Emile, 244, 246

Wagner, Richard: *Siegfried*, 210–11; *Tristan und Isolde*, 210–11
"Waiting for the Robert E. Lee," 145
Walsh, Stephen, 272n54
waltz, 81–82
water roller coasters, 82, *82*
Watteau, Antoine, 51
Weiss, Jeffrey, 120
"What We Owe to France" (Choate), 132
White, Palmer, 24
White, Pearl, 122–23
"Why France?" (Tucker), 132–33
Wiéner, Jean, 184, 190, 275n114, 276n126
Wilson, Edmund, Jr., 133; "The Aesthetic Upheaval in France," 149, 269n62; *Alex's Castle*, 149
Winchell, Walter, 133
Wodehouse, P. G., 133
Wollen, Peter, 32, 38
women: education of, 32, 259n24; as golfers, 76–77, *77*; leisure activities of, 65, 67; making music, images of, *7*, *7*, 256n17; milieux for portrayals of, 57; music identified with, 6, 11; ocean swimming by, 77–78; pant-wearing by, 31–32; as pianists, 11–13, *12*; postwar freedoms for, 163; social dancing by, 81, 139–41; voting rights for, 259n22, 23
women's movement (France), 32, 259n23
Woolcott, Alexander, 133
World's Fairs, 134. *See also* Panama Pacific International Exposition
World War I: casualties/sufferings of, 207; economic crisis during/following, 207; Martin on, 71; practicality/fashionability in, 160–67, *162*; style/taste changes during, 73, 74,

World War I (*continued*)
76–77; transportation during, 160;
U.S. involvement in, 131–32; *Vanity
Fair* on, 131–32; *Vogue* on, 160
Worth, Charles Frederick, 22–23, 24
Worth, Gaston, 25–26
Worth, Jean-Philippe, 25–26
Worth, Maison, 135

"Le Yachting" (C. Martin), *66–67*
Yeats, John Butler, 213
youth and classicism, 186–90

Zemlinsky, Alexander, 144
Zola, Émile, 270n16; *The Gut of Paris*,
218
Zuloaga, Ignacio, 96, 263n9

Designer: Victoria Kuskowski
Text: 10/13 Aldus
Display: Futura Book, French Script
Compositor: Sheridan Books, Inc.
Indexer: Carol Roberts
Printer and Binder: Sheridan Books, Inc.

FEB        2007